Udo Kultermann

The New Painting

FREDERICK A. PRAEGER, Publishers
New York · Washington

BOOKS THAT MATTER

Published in the United States of America in 1969
by Frederick A. Praeger, Inc., Publishers
111 Fourth Avenue, New York, N.Y. 10003

Translated from the German by Gerald Onn

Library of Congress Catalog Card Number: 75-89604
Printed in Germany

CONTENTS

The new painting

In this book we propose to investigate the reality of contemporary culture. In doing so, we shall be reviewing all those developments which provide significant information about the art of the present period and consequently about the people of that period and their view of the world.

The selection and arrangement of the material will not be determined by preconceived categories, but by the sensuous appeal of contemporary art, by its inherent qualities and its power to fascinate. The chapters of this book will be given over, not to a sequence of different styles or trends, but to comparisons between different developments of a corporate whole, since this procedure, which has already gained wide currency in other disciplines, is more appropriate to the investigation of a polyvalent culture such as ours. Jacob Burckhardt went to the heart of the matter when he said he wished the continuous history of art courses could be replaced by a continuous appreciation of art on the part of the public.

To recapitulate: this book is conceived, not as a sequence but as a circle, in which – as in Kurt Badt's book on Cézanne – each chapter represents a different point on the circumference, from which it is hoped to find a different way to the centre.

Many authors have misconstrued contemporary art, and many have tried to evade the issues which it raises by concentrating on its formal aspects. However inadequate the result may prove to be, we propose to investigate its content. Kurt Badt insists that the formal aspects of any work of art depend for their significance, and even for their existence, on the total import of the work. In this, he is echoing Wassily Kandinsky, who said in 1912 that the most important thing [about a work of art] is not the question of form (objective or abstract), but the content (spirit, inner sound).

But there is also a celebrated statement by Juan Gris which has long been used as a yardstick with which to beat the adherents of the new movement in modern art: "Those who believe in abstract painting are like weavers who think they can create a texture with only one set of threads, forgetting that a second set of threads is needed in order to hold the first together." Although Gris was undoubtedly referring to the representation of figures and space when he made this statement and to nothing else, it is in fact equally applicable to the phenomena of contemporary reality. Seen in this light, it takes on a new significance with the result that it remains as valid today if extended to new experiences in contemporary reality as it was when it was first made half a century ago.

In this book, it is not assumed that the expert, the art historian or the art critic possesses *a priori* knowledge, that – unlike the layman – he has at his disposal particular means by which to evaluate contemporary art. The nineteenth century writer, Conrad Fiedler, summed up our present situation in precise terms when he wrote: "One of the things we must do, if we are to establish a new attitude to art, is to destroy the sense of certainty which is one of the principal legacies of the historical school [of art criticism]. The individual would then be able to make his own value judgements, for he would regain a certain measure of timidity, which is a prerequisite for any really productive attitude to art based on intimate knowledge."

Siegfried Giedion has reminded us that the viewer and the work which he is viewing are interrelated phenomena, the extreme poles of a complex situation. This is something we must not forget.

Introduction

Unlike sculpture and architecture, painting has now been forced towards a defensive position. Some critics have suggested that it exercises a regressive function within the general context of modern culture, others have rejected it as being of no further relevance. And yet no other artistic discipline in our day has produced such a wide variety of speculative and abstract ideas, which have virtually concealed from view the reality underlying contemporary pictorial forms. We shall try to assess here both the significance and the limitations of contemporary painting by developing new concepts and interpreting new pictorial forms in the light of current reality. This is not a historical approach; our purpose is to grasp the complexity and vitality of the present period.

The enduring element is the work of art, which has nothing to do with the great multitude of styles postulated by so many official critics, who seem to confuse the art world with the world of fashion. Some of these critics, who regard contemporary painting as a commercial enterprise which in no way reflects the times in which we live, dismiss it out of hand as "manipulated art". But, with or without its commercial bias, this basic view of the contemporary movement as a succession of purely formal stylistic exercises is in fact quite illusory.What has really happened is that the restrictive and reductive processes of the 1950's were followed, from 1960 onwards, by a new and far less rigorous development, which has favoured the growth of a large number of apparently different trends: monochromism, nouveau réalisme, kinetic art, pop art, destructive art, nouvelles tendances, minimal art and systemic painting, hard edge and op art, psychedelic art, arte nucleare, post-pop, nouvelle narrative, post-painterly abstraction, land art, conceptual art, arte povera, and environmental art. But, although at first sight these developments appear to be antithetical, they actually represent different aspects of the same cultural situation, which has determined the course of art in the 1960's.

The multiplicity of allegedly new and modish trends which have been singled out in this way, and the imprecise, misleading names which have been given to them, are symptomatic of the helplessness of the majority of art critics in the face of the phenomena which now assail them. Sol le Witt recently observed that he had never met a single artist who was prepared to apply any one of these names to his own work, and he concluded therefore that the whole thing was "part of a secret language that art critics use when communicating with each other through the medium of art magazines."

But, of course, the artist is always in a forward position when he comes to grips with reality. It is only after he has done so that names are coined for his work: by dealers and critics, who try to assess him, and by journalists, who rarely understand him. It is hardly surprising, therefore, that their labels are not to his liking. There are some critics who specialise in the naming of new artistic phenomena, and who not infrequently engage in public argument over the authorship of particular designations, a practice which does little to clarify and much to obscure the central issue – which is the understanding of art.

The two concepts which have taken the firmest grip on the imagination of the art public – and which have had a particularly damaging effect – are those of op and pop art. Josef Albers, one of the old masters of twentieth-century art, does not take at all kindly to such phrases. He has a particular aversion to the concept of "op art", for which he has produced an analogue: "walking on foot". He maintains that "to describe a painting as a work of 'optical art' is quite as meaningless as speaking of acoustic music or tactile sculpture."

All pictorial art is optical since it depends for its effect on the exercise of the optical sense. But then, all names are imprecise and so, provided this is constantly borne in mind, it is legitimate to use them in a hypothetical sense. Art always was and always will be a means of acquiring a personal share in reality, a means of survival. It held a

similar meaning for the cave dweller as it does now for the contemporary artist. This basic proposition was put forward in trenchant terms by Walter de Maria when he said: "I think art and life are a matter of life and death." All art – including contemporary painting – is 'essential' in this fundamental sense of the word. Our relationship to reality is expressed in our pictures of reality, which are executed in media that are relevant to our own times."

Today, the subject matter of painting is virtually unlimited. We have at our disposal a vast store of historical themes, and we also have new themes which are specific to our own age, such as consumer fetishes and religious idols, pictures of which the viewer himself forms an integral part, which he can alter at will, and even create. In addition, the old hierarchical principle which once governed our assessment of pictorial themes has been abandoned. A madonna by Salvador Dali can now be exhibited next to Andy Warhol's "*Soup Can*" and a variable work by Fahlström, Agam or Bury next to spatial signs by Barnett Newmann, Yves Klein or Morris Louis without creating a sense of incongruity.

A parallel development to this is the recent trend towards the abolition of the special position accorded to the artist in civilised societies. This custom, which was very much in vogue in the 1800's and continued unabated right up to 1950, is now on the wane. Primitive tribes have never had artists in the old European sense of the word, because in a primitive tribe everybody is an artist. Today, we too can look forward to a social order, in which "artists" will no longer be needed because the whole population will be able to partake in artistic activity. This is what Piet Mondrian had in mind when he said that a time would come when paintings would be superfluous because we would be living in a world of art. As a result of the cultural situation which has now emerged, contemporary artists have acquired a quite unprecedented degree of freedom, which has affected both the form and the content of their work. The process was inevitable. As society changed, artists – who are required to provide information about the world in which they live and not just a facsimile reproduction of its external appearance – had to reflect the change in their work. This then led to the development of new formal techniques with which to express the new artistic content. There is, of course, a natural limit even to such an open-ended process as this, although it would seem that this limit is more likely to be reached as a result of the artists' shortcomings, than as the result of any restriction imposed on the artists by the system. Even the crucial demarcation line between art and life, which has been the main prop of all aesthetic systems to date, is now being called into question.

Of recent years, various open-ended systems and organisational structures (Group Form and Collective Form) have been evolved with the object of providing theoretical information about this new phase of human development. Our communications systems have become so advanced that we are able to span the globe. But, although we have overcome the earth's gravitational field, and although our computers have opened up vast new areas of human enquiry, we still need art, for only art can forge a link between these sophisticated achievements of the human mind and nature.

What is a picture?

How is this link forged? How can the new forms, which have been incorporated into painting, graphic art and photography, effect this reconciliation? In order to answer this question, we must first establish just what a picture is, just what is meant by this fundamental concept, which stretches back through the millennia and has given rise to so many false interpretations. Marcel Proust described it as follows: "A picture is rather like the unveiling of some small part of a secret world, many of whose aspects are already known to us through other pictures by the same artist." In the first chapter of his book *Icon and Idea* (Harvard Press. Cambridge/Mass., 1955), which bore the heading "The Essential Painting", Herbert Read analysed the new conception of what constitutes a picture in the light of the theory advanced by Conrad Fiedler, whilst in his *Philosophy of Symbolic Forms*, Cassirer also created a flexible basis for further enquiry.

Today it has become apparent that man's conception of what constitutes a picture has always been in a state of flux and will always remain so. But in this sphere – as in the human sphere – there are some constant factors. Cassirer once said that art, myth and religion "all have their being in strange picture worlds, which do not simply reflect a static, empirical condition but which – on the contrary – are constantly recreated by them [art, myth and religion] in accordance with some independent action principle."

The English word icon, which is derived from the Greek *eikon*, means a painting or image of a (sacred) person that is itself sacred. Our word idol is derived from the Greek *eidolon* and denotes an image of a deity or – more often – a false deity and, by extension, a phantom. These are cognate with the Latin *imago*, from which the word image is derived.

Clearly, these expressions once possessed a significance which transcended the sphere of purely formal art. This special meaning was later to be demonstrated beyond all possible doubt in the struggle between the Byzantine iconoclasts and idolaters in the eighth and ninth centuries, in the iconoclastic outrages of the Reformation, in the attitude adopted to pictures in our own century, and also – albeit on a totally different basis – in the fear of pictures evinced by primitive peoples who believe that a man's soul is contained in his image.

All pictorial forms have one factor in common: they are all based on the artistic *cum* mythical representation of reality. According to W. Dürig, the Ancients considered a picture to be the "emergence of the essence of a thing". And that is precisely what it is. The definition covers a wide spectrum, ranging from the "magical meanings" discovered by Leo Frobenius in Africa, to the use of perspective, which was evolved much later and in totally different conditions. In his perceptive study *Die Perspektive als symbolische Form* [Perspective as a Symbolic Form], Erwin Panofsky has traced the whole development of this method from its introduction in early times to its abolition in our own, non-perspective age, in which different kinds of perception and different kinds of pictures have become possible.

Siegfried Giedion has established that both prehistoric and present day pictorial forms are polyvalent, that Paul Klee and the Ancient Egyptians "saw things in the same way" and – most important of all – that cave paintings were "spatial", and that they were essentially magical representations and not individual works of art based on perspective or illusionist techniques. Hans Bischoffshausen has pinpointed another pictorial function, which he calls the "totalisation of memory". By this he means that the consciousness expressed in a picture is not strictly the product of the individual artist concerned, but is derived from the collective memory of his group and of generations of groups.

The end-object of art, which always stems from reality, i.e. from the highly complex interaction between the individual and his environment, is to enable man to go on living in the world. Consequently men have at all times tried to evolve new forms,

methods, techniques and constructions with which to express their condition of life and their hopes for the future.

Today this relationship between pictures and reality has entered into a new phase, for the conditions under which men live and to which they react have undergone a transformation. And yet the principle underlying the organisation of a picture is still analogous to the universal principle underlying the organisation of the world. Goethe stated that "all things full and beautiful in art are reproductions in miniature of all that is most beautiful in the fullness of nature" – and it has been restated in our own day by Walter Hess in his interpretations of personal statements by contemporary artists (1956): "The small, closed world of the work of art and its structure, in which all the individual elements are combined into a higher and meaningful whole, this microcosm has always served as an analogy for the import and structure of the world itself, and it should still serve this purpose today." And in point of fact, the pictures of contemporary artists have also undergone a transformation, one that is often so intense and radical that we have difficulty in bringing them into line with traditional pictorial forms.

c. 1960

In Plato's doctrine of mimesis, the artist appears as an imitator, whose only object is to produce an exact likeness of natural phenomena. This conception of Plato's remained the basic stipulation underlying all artistic activity until late in the eighteenth century, when Immanuel Kant published his *Genielehre* (Doctrine of Genius). This new doctrine, in which the artist – far from being a mere imitator of nature – actually produces natural laws by virtue of his genius, paved the way for a new conception of art.

A little later, August Wilhelm Schlegel realised that art, like nature itself, was based on a formative principle – in other words, that the fundamental criterion of artistic endeavour was not imitation, but a mode of activity analogous to the natural laws of growth. By extension, works of art themselves became "living works", which were essentially the same as works of nature. This new view, which is to be found in the writings of Goethe, Winckelmann and Shaftesbury, was the precursor of the modern theories of art formulated by nineteenth and twentieth-century writers, the most lucid of whom is perhaps Paul Klee: ("The artist should not fashion from nature but like nature.")

Conrad Fiedler recognised that such a crucial change in our attitude to art presupposed a corresponding change in our attitude to reality, an idea which has since become an integral part of art theory. But the artist's relationship to reality has undergone further changes, the most recent of which and the one with which we are concerned in this enquiry having taken place in c. 1960. In the first half of the twentieth century Paul Klee, Wassily Kandinsky, Piet Mondrian, Frank Kupka and Kasimir Malevich (ill. 1) established a view of reality that enabled later artists to perceive and portray changing aspects of a corporate and unchanging whole, which is incapable of artistic representation as such. Kandinsky evolved an emotional, spiritual and almost mystical view of the world which appears to have been grounded in theosophical beliefs similar to those held by Mondrian. It is not without significance that Kandinsky should have named Dante Gabriel Rossetti as one of the pioneers of modern art. Malevich, who was also a mystic at heart, wanted to bring about a total change, not only in the political but also in the social and artistic spheres. But, although he was one of the champions of the 1917 Revolution, his conception of the new world order was grounded in the suprematism of psychic excitation and not in materialist slogans. Not surprisingly, his work soon fell out of line with the doctrinaire views espoused by the Soviet political administrators, whose bureaucratic machine first undermined and

then – after the death of Lenin – completely destroyed the aims pursued by the early revolutionaries. The new conceptions subsequently evolved by Rodchenko, Tatlin and El Lissitzky, who built on the foundation laid by Malevich, deprived art of what Walter Benjamin has called its aura, i.e. the symbolic significance which typified a past era. The epoch–making achievement of these artists has yet to be fully appreciated.

From the early 1920's onwards, Surrealism has been one of the most important factors affecting the development of modern art. It has found expression, not only in the theories and manifestos of André Breton but also – and more significantly – in the pictures of René Magritte (ill. 149, 183, 185), Max Ernst and Salvador Dali (ill. 56, 100, 384, 385). Magritte's paintings constitute a further development of the pioneering work of the Italian artist Giorgio de Chirico. Ernst and Dali prompted a reassessment of late nineteenth century art.

The period immediately following the Second World War saw the emergence of a new technique which made it possible for the painters of that period to interpret the new aspects of reality with which they had been confronted. This technique, which was adopted both by the artists who had embraced the new trends and by those who were still working in the Surrealist and Constructivist traditions, involved systems of signs, which were used to represent conditions of psychic excitation and apperceptions of psychic phenomena. The emotions underlying these signs were prompted in the first instance by the events of the recent war, which meant that signs tended to assume national characteristics. But it also meant – since this new development constituted a genuine reaction to reality – that a possibility existed of creating a whole new world of art. And, in point of fact, in Clyfford Still's work (ill. 6), American painting achieved a condition of autonomy which has opened up new vistas. Pollock (ill. 5), Tobey and Riopelle in America and Wols, Hartung and Mathieu (ill. 4) in France are doubtless the most important exponents of this particular type of composition. Wols, who emigrated to France from Nazi Germany, resembles Giacometti in so far as he, too, has created an artistic record of failure. In an interview in 1947 Wols said: "No good has come from the war against the evil of Hitler. The whole world is drenching itself with larger and larger doses of the same corruption, misery and affliction which prevailed in Hitler's Germany..." Mathieu regards art as a sort of language, which he calls a "transcendence of signs". In his view, the artist translates the emotions of the individual human being into communication signals. These are then stored in his work, where they are accessible to all. Consequently, when the viewer looks at this complex system of communicating signs, he is able to discover new phenomena. Psychic energies – which had not been fully exploited in the sphere of art prior to this period – played a crucial part in such works.

In the case of Pollock and Mathieu, there were two other important factors: physical involvement and speed of production. These also opened up new artistic paths, e.g. that of improvisation, which was very much in vogue in the immediate post-war period, when it played a significant role in the development of jazz. When the "*Nuit de la poésie*" [Night of poetry] was produced in Paris in 1956, Georges Mathieu completed a painting on the stage of the Sarah Bernhardt Theatre in twenty minutes.

The characteristic "formlessness" and "destructiveness" of the art of this epoch, which was still being assessed in largely negative terms long after the event, have to be weighed against the innovations established by the artists concerned. It is also necessary to bear in mind the war which prompted such paintings and – before proceeding to a definitive judgement – to effect a comparison between them and the works which followed. It was during this period that Tobey, Masson and Mathieu rediscovered Chinese calligraphy. A number of Asiatic artists also gave a fresh impetus to Western culture by adapting ancient Eastern techniques. For example, the Japanese Kumi Sugai (ill. 218, Plate XIV) revitalised ancient Japanese symbols, transforming them into aggressive pictorial signs which are compounded of both old and new elements. Ad Reinhardt was another Western artist influenced by the East. In the 1950's he named Chinese art as one of his chief sources of inspiration.

Other post-war artists tried to achieve actuality and authenticity by incorporating materials such as sand, stone, textiles and wire into their pictorial world. The foremost exponents of this type of composition – in which reality is presented in varying degrees of deformity – are Fautrier, Dubuffet, Burri, Waagemaker, Crippa, Tapies (ill. 13), Scarpitta (ill. 11) and Rivera. These artists have all tried to create reality in specifically pictorial terms whilst reducing composition to a minimum. Dubuffet's figurations of people, animals, tables, cupboards and doors appeal to preconscious and even primitive emotions (ill. 3). The objects, landscapes and structures of the Spaniard Antoni Tapies relate to organic, not man-made, phenomena. Consequently Tapies works with sand, glue and fragments of organic matter. After an early Spatialist phase, in which he often expressed psychic forces in the style of the atom model, Roberto Crippa also incorporated real objects into his work in the form of pieces of bark and timber.

The early material pictures of Robert Rauschenberg (ill. 7) and Jasper Johns (ills. 10, 230, 368, 369) were probably the most influential works created within this category. They subsequently provided a working basis for a group of younger artists who, after pursuing these trends still further, have now resolved the problems which faced the post-war generation and moved on to new forms. But then, if art is to develop, the past must not only be handed on, it must also be destroyed. Rauschenberg had already begun to incorporate objects into his paintings in the early 1950's, using them to the same end as that pursued by the Dadaists and Surrealists, and also by his fellow countryman Jackson Pollock. He revealed a preference however for consumer objects, which appealed to him as relics of modern urban life. This attitude of his was crystallised in "*The Bed*" of 1955, a work which clearly demonstrated the new movement towards a re-evaluation of the commonplace aspects of the environment.

Works such as this – which are not the product of a single, clearly defined line of thought – are susceptible to multiple interpretations. Their meaning changes over the course of time. The American Alan Solomon has observed that the enigmatic contrasts in such works seem to call for an explanation and force us to examine them more thoroughly. Their real significance, he suggests, is to be found in this simple fact for the more closely we look, the more complex they become. Their real value lies in their diversity.

Pursuing a parallel line of development to Rauschenberg, Johns also moved away from traditional pictorial forms at much the same time. In the early 1950's, he created his pictures of flags (ill. 10), in which he gave a new meaning to a familiar sign. These were followed in 1955 by his "*Target with Plaster Casts*", in which he broke the bounds of established pictorial form by incorporating modelled limbs. Later the same year he produced his "*Target with Four Faces*", a work of great authenticity. Alan Solomon has also commented on this phase of Jasper Johns' work. He points out that Johns was trying to separate the work of art from the artist, to isolate it as a self-sufficient entity that would be independent of the artist's needs, desires and weaknesses. Solomon tells us that Johns regarded the artist as a mere agent who, in creating his picture, simply established a set of conditions, in which the pictorial objects themselves were then able to fulfil their completely independent functions.

Surprisingly enough, views such as this are very much in line with contemporaneous statements made by European artists like Yves Klein (ills. 8, 9), Jean Tinguely (ill. 18), and Arman and Gustav Metzger (ill. 14) which also helped to prepare the ground for the great change that came in *c*. 1960. But the most convincing manifestation of future trends, and one that appeared terrifying to many people was the machine built by the Swiss artist Jean Tinguely in 1959, which he called the "*Painting Machine*" (ill. 18). This was tantamount to a manifesto opposing the development of post-war art – including the art of the 1950's – in which painters had continued to project their feelings on to the picture surface in the time-honoured way with the object of preserving their subjective identity for posterity. This was not all. Quite apart from its programmatic function, Tinguely's machine also existed in its own right. It was an autonomous

work, a kinetic structure, which was not only fascinating in itself but also involved the viewer, whose participation constituted an essential part of its total import.

This work of Tinguely's was a sign of things to come. His machine mass-produced the sort of pictures which the artists of various schools had striven so hard to create. In doing so, it unmasked the stereotyped emotionalism and uniformity of "subjective" paintings, demonstrating their lack of credibility and showing that, although they laid claim to the highest honours in the name of inner truth, they were really just run of the mill affairs, the sort of products that could be turned out by a machine. Warhol's comment, that he would like to work like a machine, then opened up a new dimension. In the following year, when he erected his "*Hommage à New York*" in the garden of the Museum of Modern Art, Jean Tinguely set the scene for a new departure. This particular machine, which was self-destroying, constituted a process, a manifesto, a sculpture and a happening all in one. In the same year Gianni Bertini, Jean-Clarence Lambert and Jean-Jacques Levèque staged a "*Striptease poétique*", which further undermined the compositional tradition (ill. 16). The end of an epoch had been reached, one that had reflected the chaos of war-time and post-war reality.

Like Tinguely's "*Painting Machine*", Gustav Metzger's "*Destruction of a Picture*", which was first enacted in June 1960, marked a turning point in the development of art (ill. 14). Metzger himself described this process, in which he destroyed a stretched but unpainted canvas, as an "action painting". The description was accurate in so far as during the "painting" process, the canvas appeared in varying degrees of disintegration. Lucio Fontana's cut canvases (ills. 328, 329) are based on the same principle, although it must be said that Fontana's pictures are of an entirely different order and go far beyond Metzger's purely demonstrative work. Roy Lichtenstein's "*Big Painting*" of 1965 (ill. 17) is a parody of the 1950's style.

Now that this pictorial development, prompted by the intensity of emotions generated by the war had come to an end, artists were no longer bound by a specific and clearly defined view of painting. A new freedom had been established, which then found expression in the countless variations and conceptions produced in the course of the 1960's. Although artists like Pollock and Michaux, Fontana, Mathieu, Tinguely, Rauschenberg and Johns had prepared the ground for this new advance, it was not until 1960 that the actual breakthrough was made.

Pictures of people

The revolution of youth, which has taken place in every part of the world, has led to a reassessment of physical values. The human body is no longer regarded with distaste as man's "mortal coil". Instead of being hidden from view, it now occupies a central position. The present situation was well described by Merleau-Ponty when he said: "My body is the fabric into which all objects are woven." Indeed, the body may now be said to have assumed the role which it once played in Eastern mythology as a symbol of the cosmos.

The human figure has become one of the central artistic themes of our day, both in traditional pictorial compositions and in works involving mechanical processes. With his "Body Impressions" Yves Klein has evolved a special kind of process which presupposes an entirely new conception of pictorial form. The "living brush" and the work which it produces are related to one another in direct physical terms (ill. 8). Moreover, the contemporary artist has again assumed a visionary role. He depicts the future potential of this new physical freedom, and his works bear an astonishing resemblance to the art forms of the pre-archaic era. The rediscovery of the body has led to the reaffirmation in our own time of the perennial ideal of the unity of body, mind and soul. We are now re-evaluating the human body and its functions, and are trying to live our lives in conformity with this fundamental aspect of reality, which we

also depict in our art. In our society – as in primitive societies – the life of the individual and the life of the community have fused into an indissoluble whole. But this new condition differs from that obtaining in the industrial societies of the nineteenth and early twentieth centuries, for ours is essentially a post-technical age, in which it is possible to treat flowers and love symbols as serious and positive facets of reality.

It is scarcely possible to exaggerate the importance of this revolution. Life itself has suddenly become more important than abstract theories about life and man is now on the way to resolving the split between thinking, feeling and living. (Yves Klein issued a publication in 1959 under the title "*Le dépassement de la problématique de l'art*" [Passing beyond the Problematics of Art]). This revolution, which is making its presence felt in politics, society and art, is based on a new conception of humanism, one that makes due allowance for the achievements of modern technology, and is therefore calculated to overcome its inherent problems. Although it has not yet been possible to identify the basic principles underlying this new movement in the specific spheres in which it is operating, it has undoubtedly established a new ethic, a new aesthetic, a new morality and a new form of communal living. It may well prove to be the first Humanist movement of the post-Christian era.

Like his fellow countryman Paul Delvaux, René Magritte has painted a large number of nudes, all of them female. Magritte's male figures, on the other hand, are always painted wearing traditional dress, which gives them what is virtually a "period" look. This significant antithesis reflects something of the dialectical relationship which exists between nature and art. The most celebrated Surrealist nude is Magritte's "*Le Viol*" [The Violation] of 1934 (Mrs. Jean Krebs Collection, Brussels), in which the head and body of a woman are identified with one another: the eyes become the breasts, the nose the navel and the mouth the vulva. In this work, Magritte created a psychic analogy which goes far beyond Freud. But, although the overall impression created by this ironical and demonic metamorphosis is highly irrational, the individual components are all taken from the world of reality. The influence exerted by this painting was immediate and widespread, for Breton used it as a frontispiece for his publication "*Qu'est-ce-que le Surréalisme*" (Brussels 1934), which reached an international public. It was an apt choice, for "*Le Viol*" perfectly illustrates the essential quality of Surrealism and the general movement towards free association which set in from *c*. 1930 onwards.

With his picture "*Les liaisons dangereuses*" of 1935 (Mr. and Mrs. Henri Jeanson Collection, Paris), Magritte carried the fusion of different levels of reality still further. In this work, he painted a front view of a three-quarter length nude holding a mirror, which covered her body from the neck to the top of the thighs, and which reproduced an antithetical mirror image of a female nude painted from the rear and slightly from the side. The effect produced by this picture stems from the contrast between the possibility of mirror images in general and the impossibility of this mirror image in particular. This fusion of ideas demonstrates the complexity of the relationship between illusion and reality (and, one is tempted to add, between art and nature) which is the essence of Surrealism.

In 1965, Dakota Daley and Nicholas Quennell photographed themselves in numerous variations as "*Adam and Eve*" (ill. 20), reproducing in artistic form and with the aid of modern photographic techniques, the new feeling for the body which has emerged in the present decade. By placing their self-portraits within a traditional, iconographic schema, these two artists recall, not only the compositions of the early Christian illustrators, but also the kind of pictorial forms used in the nineteenth century, for example by Rejländer in his monumental photographic work "*Two Paths of Life*" (1856) and also the ballet "*Relâche*" by Francis Picabia and Eric Satie (1924), in which Marcel Duchamp and an actress figured as Adam and Eve in the nude after the model of a painting by Lucas Cranach. Where they differ from their predecessors is in their dispassionate use of prefabricated photographic motifs, and their acceptance of their own bodies.

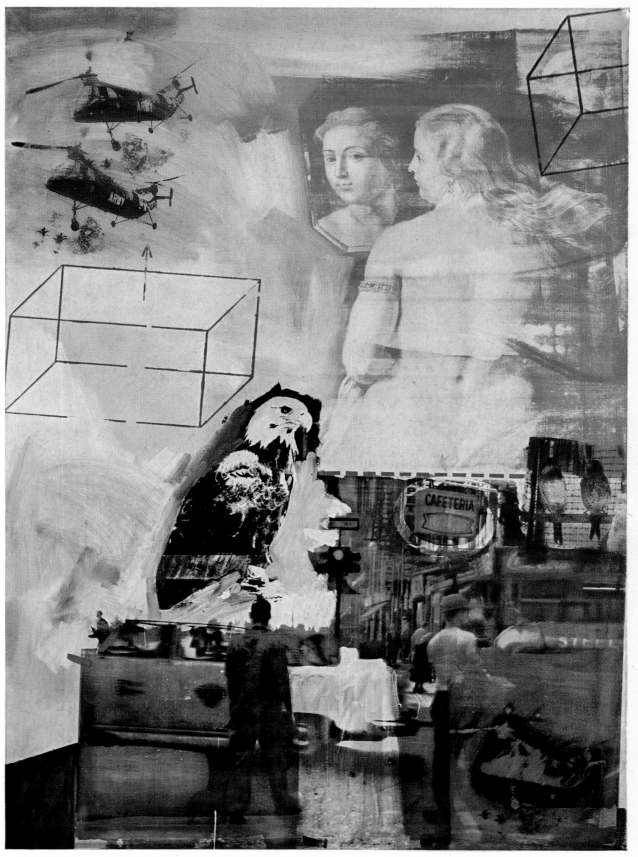

I Robert Rauschenberg *Tracer* 1964

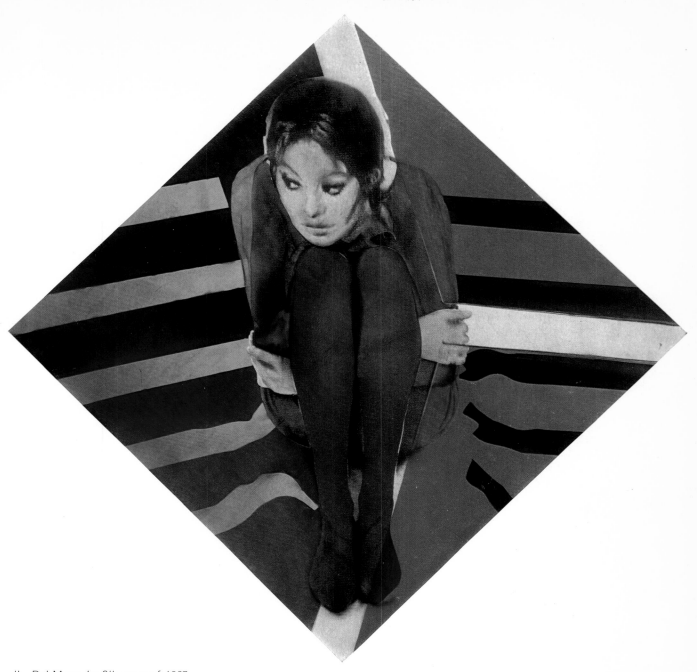

II Pol Mara *La fille en œuf* 1967

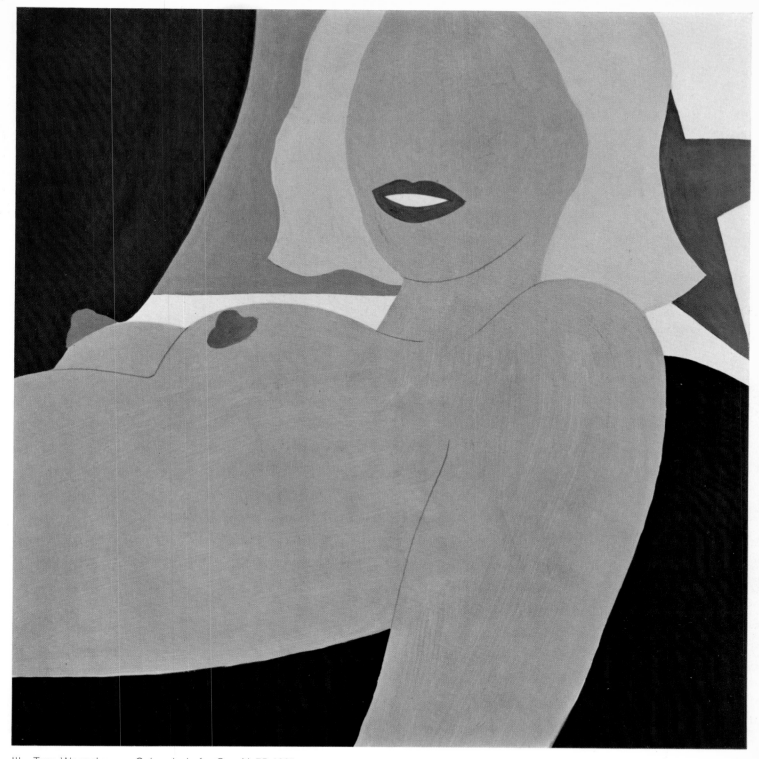

III Tom Wesselmann *Color study for Gan N. 75* 1965

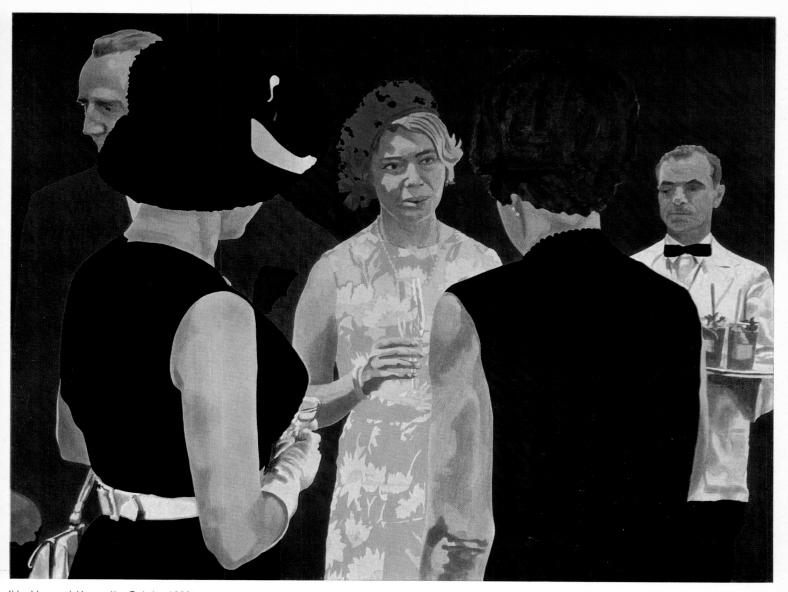

IV Howard Kanovitz *Drinks* 1966

But the work of these two Californian artists is also reminiscent of paintings from the second half of the nineteenth century, e.g. the "*Sixth Day*" from Edward Burne-Jones' cycle "*The Angels' Creation*" (ill. 19). In this composition, angels dressed in flowing robes hold Adam and Eve in a glass sphere, which symbolizes the Victorians' attitude to corporeality. Other artists have also made frequent use of the same iconographic schema based on Adam and Eve (Raysse [ill. 22], Baj [ill. 40], Ceroli, Festa).

Further examples of this particular trend are to be found in Bruce Nauman's "*Self-portrait as a Fountain*" of 1966 and Alain Jacquet's nude photographs. Jacquet alters and manipulates these nudes with the aid of modern techniques and frequently presents them in the guise of historical personnages (ill. 132).

With its biting satire and its complicated narrative sequence – two ideal nudes, a man and a woman are shown in an ideal home – Richard Hamilton's collage "*Just what is it that makes today's homes so different, so appealing?*" of 1956 (ill. 23) is still very much a product of the 1950's. In the 1960's, the bias is quite different. The artists of this new period, equipped with an extremely conscious approach, are producing apparently unproblematical and sensuously simple works, which are certainly uncomplicated, if not naive. A number of these artists have systematically applied themselves to the task of representing the human body and have produced paintings whose realism is more than surprising in this day and age. On the other hand, everything about these works would suggest that the artists concerned have successfully integrated the pictorial forms used by earlier Realists, and have acquired a measure of contemporaneity which distinguishes them from their predecessors.

Time and again in his paintings and drawings, Harold Kanovitz has investigated the forms of the female body (ills. 24, 25, 30). Using a technique modelled as closely as possible on photography, he tries to achieve the maximum degree of Realism without indulging in expressive deformations. Paradoxically, this has sometimes produced Expressionistic compositions. Kanovitz is trying to acquire a more precise, more open, more authentic view of reality, which means, of course, that he has no interest whatsoever in the idealised, timeless and alienated world of earlier Realistic artists. His reality consists of the big city on the one hand, and the female body on the other. To be more precise, it consists of his own particular life in the city of New York. He chronicles the lives of his fellow New Yorkers, and he does so in a completely legitimate and independent manner.

William Bailey is another New Realist who has successfully absorbed earlier Realistic trends. Although his compositions bear a formal resemblance to the works produced by the members of the New Objectivity from *c.* 1930 onwards, the techniques which he uses in order to document the contemporary scene are entirely new. In his nude paintings and drawings, he investigates the forms of the female body and creates pictorial equivalents for particular parts of the body (ills. 26, 27). He uses the same process to represent objects in his still lifes. The classicistic overtones of Bailey's pictorial world of form and colour have been one of the characteristic features of American art in the 1960's.

The nudes of Philip Pearlstein, who uses traditional techniques in both his drawings and his paintings, reveal a totally different outlook. The drawings are built up from dotted lines and washes, which are reminiscent of Do-it-yourself paintings (ills. 28, 29). Pearlstein portrays the human figure in set attitudes, using both diagonal views and foreshortening. By making his models adopt the kind of poses insisted on by the old-fashioned academicians, he creates contrasting effects of intimacy and alienation. The new qualities in his work are to be found primarily in the relationship between the different figures. The picture frame, the foreshortening, the play of light on the bodies and the traditional style of painting all serve the ends of a New Realism that is even able to incorporate and put to appropriate use pictorial forms of past eras which have long been objects of general ridicule. Pearlstein uses the most commonplace and banal forms, which have nothing in common with *avant-garde* attitudes, as a medium for his contemporary art. In 1969 Lowell Nesbitt painted a series of male nudes, in which

accurate psychological perception is combined with precise technical handling. These figures stand out against the background which is quite devoid of atmosphere.

All of Gerhard Richter's pictures, including the one of a nude woman going downstairs ("*Emma-Nude on a Staircase*", Dr. Ludwig Collection, Aachen), are based on photographs (ill. 37). By blurring the body of this nude, he has managed to give her a transitory quality. She looks as if, having first withdrawn her foot, she is about to set it down again in front of her. Although the only link between this work – in which the figure is reproduced full face with photographic accuracy – and Duchamp's picture of a nude going downstairs lies in the theme, Richter has achieved something very similar to his great mentor: the representation of movement in a picture in which there is no real movement.

In his "*Quiet Painting*" (ill. 31) of 1964, which he composed from a photograph, elements of *collage* and sculptural components, Martial Raysse depicted a passive, ideal reality that is specifically European. He is comparable to the American Tom Wesselmann, who once went through a phase in which he painted only nudes. His objectified female bodies, which are based on the kind of image created by the contemporary mass media, appear as components of still life type compositions (Plate III). In his series "*The Great American Nude*" and his "*Bedroom Paintings*" he has created stereotypes which illustrate the sex appeal of the female body. In his "*Little Great American Nude*" (The Harry N. Abrams Family Collection, New York) of 1965, he identified this basic motif by introducing a pin-up photo of a film star. In his "*Great American Nude No 31*" of 1962, the pin-up was a star of the art world: the Mona Lisa (ill. 32).

In 1963, Wesselmann's fellow countryman, Ben Johnson, painted a three-quarter length female nude with a blue necklace and a fashionable hat, to which he gave the ironic title "*Blue Beads*". The forms of the body in this work, which are intentionally simplified, look as if they had been derived from Matisse, who – like the Italian Modigliani – had a predilection for such subjects.

The Englishman Allan Jones has also concentrated on sex appeal. The dominant feature in his abbreviated compositions is the contrast between the clothed and unclothed parts of his female bodies. His "*Perfect Match*" of 1966–7, a vertical triptych showing a partly clothed female body in three sections, may conceivably have been prompted by a motif which René Magritte had evolved in 1930. In "*L'Evidence éternelle*" Magritte had painted fragments of a female body on five separate pieces of canvas, which he then joined together to form a picture of a nude. By means of this Surrealist trick, he was able to convey the idea of dissolution and discontinuity in a corporate work. The different sections of this picture, which show the head, the breast, the vulva, the knees and the feet, also possess their own intrinsic validity. This has become more apparent today, since many artists are now painting pictures of individual parts of the human body.

Mel Ramos mixes photographs of girlies with consumer objects, a combination frequently encountered in real life in the advertising world. The angry or sentimental response which these works elicit from the viewer constitutes a large part of their effect, which is not dissimilar to that produced by the French salon painter Lefèbre (ill. 85). On occasions, James Rosenquist also incorporates nude photographs into his works, but only as a contrast. His "*Playmate*" of 1966 is a case in point (ill. 39) (Playboy Magazine Collection).

The Italian Enrico Baj paints nudes in the kind of style favoured by the illustrators of magazines, and contrasts these with phantastic apparitions, which he has identified as inhabitants of strange continents (ill. 40). The shock effect produced by these paintings, in which art and *Kitsch* are both ridiculed, derives from the juxtaposition of realistic and abstract pictures of the human form. The strange creature with the upraised left arm in "*Adamo e Eva*" of 1964 is said to be the God of wrath (ill. 40).

Tom Wesley places the female body in an ornamental setting by juxtaposing a large number of nude silhouettes (ills. 42, 44), whilst Ben Mahmoud is obsessed by combi-

nations of nudes and plants, e.g. fungi. The associations which he is trying to suggest are basically Surrealist. In the "*Perfumed Garden*" of 1966, Peter Holbrook composed two five-part groups, each of which illustrates details of the female body (bosom, hip etc). The sum of the parts, which are all conceived in terms of glamour, reflects a total view of the body.

Even before the 1960's, the Surrealist Hans Bellmer produced drawings and sculptures in which he constructed artificial girls with controllable limbs in order to emphasize the erotic element in the female body (ill. 133). His illustrations for Baudelaire's poems are conceived entirely in this vein. Yehuda Neiman (ills. 48, 49) and Marc Adrian, Yasuhiro Yoshioka (ills. 46, 47) and Tilo Keil (ill. 51) have used both photographs and mirror surfaces to create constellations of figures, which also show that today equal importance is attached to all parts of the body. And so, an age-old theme is now finding contemporary expression in a great diversity of forms. Here too consistency is vouchsafed by authenticity, by the lively portrayal of the human body, which appears quite as natural as in real life.

The work of Robert Whitman is indicative of this. In the environments which he constructs for his Cinema Pieces, he incorporates smooth surfaces, such as windows, television screens, mirrors or curtains, on to which he projects film strips of women performing ordinary everyday functions: undressing, making up, taking a shower etc. (ill. 52). By introducing these real life films into an artistic context, Whitman has created a totally new effect. The age-old theme of the human body has entered into its own again.

The portrait

The portrayal of men and women as individual human beings and, more particularly the portrayal of their faces as unique phenomena, as mirror images of their personalities, has also provided painters and graphic artists with one of their major themes throughout the centuries and – in a sense – throughout the millennia. At the same time, the art of portraiture has undergone, and is undergoing, far-reaching transformations. In our own day, the functional photograph (for identification purposes, as in a passport, filing index) and, above all, the omnipresent image on the television screen have brought about a reappraisal of portraiture as an artistic medium. Not surprisingly in view of its origins, this new trend is less concerned with the interpretation of inner realities than with the reproduction of external appearances.

In his "*Bildnisstufen*" [Stages of Portraiture], Ernst Buschor has conducted a probing analysis into the various transformations through which this branch of art has passed from ancient Egyptian times right through to the twentieth century. It seems that, whereas in antiquity great importance was attached to plasticity and portraits were frequently modelled on death masks, the modern era produced a growing movement towards two-dimensional structures, which was influenced in its later stages by the discovery of photography. In his fascinating book, Buschor has evolved new categories of portraiture. "Mirror portraits" and "perspective portraits" are just two of a whole range of concepts which help to elucidate the development of this art form.

In 1954 Alfred H. Barr wrote: "Portraiture, once a major branch of painting, has largely sunk into the hands of fashionable specialists." Since 1960, this has no longer been the case, for the present decade has seen a revival of this medium. When we look for a *Leitmotif* in contemporary portraiture, we find ourselves confronted with paraphrases of present-day man. The way man sees himself and the way he would like to be are important factors. The one common trait, which is even found in the works of painters with diametrically opposed techniques, is a tendency towards objectivity, sobriety and precision, this last reaching almost mechanical proportions. The incorporation of photographs – a perfectly legitimate device – strengthens this tendency.

In their portraits, the Expressionists tried to present a highly emotional conception of man (Corinth, Dix, Grosz). Their subjects were depicted as special creatures caught up in some unusual situation, which induced a condition of psychic excitation. Early portraits by Picasso, Beckmann and Kokoschka, which include many powerful works, provide ample evidence of this. Later examples of Expressionist portraiture are less convincing. Oscar Kokoschka's "*Adenauer*", in which a simple pose is combined with an Expressionist manner, is not really effective, whilst Buffet's half modish, half expressive stereotypes ("*Charles de Gaulle*", "*Ludwig Erhard*") are quite beyond the pale. Graham Sutherland's portraits ("*Maugham*" of 1949, "*Beaverbrook*" of 1951 and "*Churchill*" of 1954) occupy a point midway between the emotional conception of the Expressionists and the sobriety of contemporary artists. An earlier work than these – Klaus Richter's "*Hitler*" of 1942 – constitutes a unique achievement within the sphere of modern portraiture. This experienced artist unveiled facets of Hitler's personality which had been carefully suppressed by the National-Socialist propagandists.

The Surrealists were concerned with the metamorphosis of the personality, with mental torsion, with fusion and ambiguity. The Surrealist artist tried to illustrate the complexity and incommensurability of the individual human being in terms of Freudian psychology, which had superceded old style character assessment. Salvador Dali's "*Portrait of My Dead Brother*" (ill. 56), a late work executed in 1963, is still essentially a product of the Surrealist tradition. In this painting, a whole world of ideational references is represented in figurative scenes, abstract sequences and transitional states (half figure, half design). The basic motif is a vision of a portrait stereotype.

In his "*Untitled*" of 1966 (Susan Sontag Collection, New York), Joseph Cornell introduced Man Ray's portrait of André Breton into one of his mysterious boxes. In the same year, Ray Johnson produced a portrait of Picasso based on a photograph, which he then composed by means of a *collage* technique ("*Picasso*", 1966, ill. 63).

In his "*Portrait of Hugh Gaitskell as a Famous Monster of Filmland*" of 1964, Richard Hamilton used a variety of techniques, composing a picture of Gaitskell which is reminiscent of Surrealist type deformation. Jan Francoforoni also emulated the Surrealists in his "*Autobiografica – intenzionalità della coscienza 4*" of 1968, by arranging the scenic details in such a way that things which actually happened at different times appear in the picture as simultaneous events.

Will Barnett's portraits, such as his "*At the Piano*" of 1966 and his "*Self-portrait*" and "*Portrait of Ruth Bowman*" of 1967, are executed in a simplified, almost a primitive manner that is reminiscent of certain stylistic trends evolved by the members of the New Objectivity in c. 1930, whilst the portraits by Alex Katz, as for instance his "*Kenneth Koch*" (ill. 60), and his "*Ada*" of 1967, and his double portraits, such as his "*Ada and Vincent*" of 1966 (which shows Katz's wife and son) and his "*Alain and Laure*" of 1967, are also based on highly simplified forms, which are executed with great precision by means of old style pictorial techniques. But, although technically traditional, Katz's portraits have something of the generosity and structural simplicity of poster art and early photography. The large faces, which fill the whole of the picture surface, are framed by schematically conceived backgrounds or stylized plants.

In his portrait of "*Yves Klein*" of 1961, Larry Rivers drew a pencil sketch of his subject, concentrating on specific features, which he then organised into a rigorous two-dimensional schema. But Rivers' "*Stravinsky Painting*" of 1966 was composed from a photograph of Stravinsky, music paper and other such elements.

Fairfield Porter and James Gill have produced numerous portraits. They present their subjects in specific environments, and sometimes use modified spatial forms after the manner of Francis Bacon to express certain facets of their personalities. James Gill did this in his portrait of "*Felix Landau*" (ill. 66), which he painted from a photograph in 1964, and Fairfield Porter in his "*Portrait of James Dealy*" of 1967.

Like the Romantics, contemporary artists enjoy painting their friends, although popular personalities of the day and important figures of the art world are also favourite subjects. Art dealers such as Sidney Janis, Felix Landau, Iris Clert, and Carl

Laszlo ("*Ritratto di Carl Laszlo*" [Portrait of Carl Laszlo] by Pietro Gallina, 1967, ill. 67), and art critics such as Frank O'Hara, Pierre Restany and Arnold Bode are featured time and again.

We have already seen that photography plays a considerable role in contemporary portraiture. On the other hand, portraiture, which prior to the nineteenth century had been the exclusive domain of painters and miniaturists, has also provided a welcome stimulus for the photographer. Nadar and Julia Margaret Cameron took superb early photographs. Laszlo Moholy-Nagy created a Self-portrait (ill. 54), in which he employed experimental techniques. Frederick Sommer produced a specific transformation in his portrait of Max Ernst (1946) by using a double exposure. In 1948, Richard Avedon took a magnificent photograph of Ezra Pound meditating with his eyes closed. Otto Steinert created an impressive portrait of Karl von Frisch (ill. 62) in 1962. A full sixty years earlier, in 1902, Edward Steichen had established the iconographic layout of "*The Artist and His Work*" with his "*Auguste Rodin and his Sculpture of Victor Hugo and The Thinker*", a schema which has since been employed by countless photographers.

The importance of photographic models to the contemporary painter can scarcely be overestimated. Many artists use photographs which they have taken themselves. Robert O'Dowd is a case in point. When he produced his "*Hefferton Polaroid*" in 1962, he worked from his own photograph of the subject, using it in exactly the same way as earlier artists would have used a preliminary sketch; and by adapting and modifying his snapshot, he gradually established the artistic reality of the finished picture. Pol Bury has gone one step further. He activates sequences of photographs by subjecting them to rhythmical distortions. In fact, he adapts the principles applied in the ironical treatment of Futurism, which he has also used in his New York series, to portraiture.

The Icelander Erro employs a wide variety of styles in his pictures, in which he consciously creates interrelating motifs. In his portrait of "*Giacometti*" of 1966, the Swiss sculptor appears in duplicate (a device which is frequently found in Andy Warhol's work). The head of each of these figures is divided into two and one half of each head is executed after the manner of Giacometti, whilst in Erro's ambiguous "*Papa Capogrossi*" of 1965, which is also divided into two sections, the back of Pope John XXIII's head appears on the right hand side, and his face is reproduced on the left. The two sides are linked by horizontal and vertical strips featuring structural signs executed in the style of the Italian artist Capogrossi.

In his "*Self Portrait*" of 1966–7 (Whitney Museum, New York), Alfred Leslie has produced an utterly banal picture of his own body, consciously avoiding meaningful associations so as to preclude all possibility of arousing the viewer's sympathy. Sobriety, objectivity and the authenticity of a purely external reality set the mood of this painting. The complete absence of anything in the nature of illusion, and the absolute insistence on the physical theme are reminiscent of a semi-nude study by Albrecht Dürer, which also illustrates external reality to the exclusion of spiritual qualities. In his nude portrait of "*Linda B. Cross*" of 1967, Leslie carried this photographic realism to such an extent that he finished up by producing a Neo-Verist work.

Wayne Thibaud reverted to the stylistic simplicity which characterised the early years of the modern movement in his portrait of "*Betty Jean*" of 1965, and in the same year, Howard Kanovitz painted his portrait of "*Mary*".

Photographs play a crucial part in the works of Andy Warhol, Dakota Daley and Nicholas Quennell. Warhol has produced a number of paintings which are masterpieces of contemporary portraiture. These include his serigraphs; his self-portrait of 1964 (ill. 61); his "*Seven Decades of Sidney Janis*" of 1967, which provides a pictorial biography of the celebrated art dealer from his youth up to the year 1967; his "*Texan*" of 1962 (ill. 70), in which he portrays Robert Rauschenberg; and two sequences – one consisting of seven, the other of three portraits – which are based on the stereotyped polyphoto, and which resemble his sequence of portraits of the art collector Ethel Scull. With his

simplified processes which he puts to artistic use, and his mass production methods, Warhol directly reflects the contemporary situation.

The Greek artist Nikos is another contemporary painter who incorporates photographs into his portraits, which include "*Mr. H*", "*Mme I. H*" and "*Pierre Restany and G. Marchiori*" (all 1965), which depicts the two art critics Restany and Marchiori in eight different scenes, whilst the photographer Bert Stern has used new techniques such as electronic fixing in the production of his photographic portraits ("*Marcel Duchamp*", 1967, ill. 59).

Although intended as a general study, Pistoletto's "*Tête d'homme avec cigarette*" [Head of Man with Cigarette] of 1962 (ill. 58) actually takes on the character of a portrait due to the authenticity of the photographic model. In their series of nude portraits of Adam and Eve, which we have discussed above, Dakota Daley and Nicholas Quennell also used individual photographs, e.g. the one of Eve's face. Here too, the photograph fulfilled the function of a preliminary sketch.

The group portrait

In the past, especially in seventeenth century Holland, the individual portrait was complemented by the group portrait. This is also the case today. Artists like Howard Kanovitz, Wynn Chamberlain and Martial Raysse have all produced group portraits. Wynn Chamberlain has painted his artist friends both in the nude against neutral backgrounds, and in the sort of poses used for studio portraits by official photographers (ill. 73).

In Martial Raysse's "*Tableau New Yorkais*", which was created in New York in 1965, well-known New York artists and critics are portrayed strung out in a stereotyped row. Howard Kanovitz's famous group portrait "*New Yorkers*" of 1966 (ill. 74) shows a group of writers, artists and critics in front of a window, which affords a view of the houses on the other side of the street. In this painting, which has something of the quality of a snapshot, the New Yorkers are depicted in a typical attitude and in their typical environment. Kanovitz has also painted family portraits, in which he has treated this traditional subject in a new and original way, but without distorting the features of his sitters ("*The Sterns*" of 1965, "*The Breits*" of 1965). In works like "*The Dinner*" of 1965 (ill. 75), "*The Dance*" of 1965, "*Drinks*" of 1965 (Plate IV [Kultermann Coll., Leverkusen]) and "*The Opening*" of 1967 (ill. 76), which derive their expressive power from the composition, Kanovitz has captured the New York art public in stereotyped postures. In these works, the instantaneous quality of the prefabricated photographs, some of which were taken by Kanovitz himself, combine with the extreme sophistication of the composition and traditional painting technique to produce a new and original synthesis, which makes a direct appeal to the viewer.

Kanovitz carried out an unusual experiment in 1966 with his series "*The Spectators*". By using both drawing and graphic techniques, he was able to introduce a wide range of variations into these works. The bodies of the people portrayed were prefabricated by a graphic process, a practice that was quite common in the early days of portrait painting, when travelling artists would arrive at a wedding or a shooting match with their canvases already complete save for the heads, which they sketched in to order. Kanovitz adopted this procedure for "*The Spectators*", producing a wide variety of facial expressions ranging from an attentive look to an air of excitement or outrage. These spectators of his are, of course, the New Yorkers whose lives he habitually chronicles.

Clearly, there are varying degrees of reality in portraiture. First, there is the official portrait executed in a photographic studio. Next comes the photograph used as the basis for a painting, which is either pictorially composed by means of a *collage* technique, or is integrated as it stands into a larger framework. Then there are pictures

which are painted from photographs, some composed, some uncomposed, some alienated. There are sequences of photographs, both double and multiple. And, finally, there are pictures in which the artist uses a photographic technique, i.e. in which he paints his subject with painstaking precision. This means, of course, that he concentrates on external appearances and does not attempt a psychological interpretation.

There are two main types of subject in present day portraiture: popular idols and members of the artist's personal circle. Like his Romantic counterpart, the contemporary portraitist is interested in his immediate environment. He paints his wife, his friends, his art dealer and the people who come to his private views. In doing so, he is perpetuating a tradition that has existed since time immemorial.

Stereotyped pictures

In the past, the reason why human beings appeared in paintings was quite simply that artists wanted to portray particular individuals. This is no longer exclusively the case. The portrayal of the human figure in present day art is largely based on the popular image of our contemporary idols which, because it also serves non-artistic purposes, is propagated by the mass media every day. Of recent years, the Comic Strip has greatly influenced the pictorial representation of the human form, and as a result contemporary artists have evolved new techniques in order to give artistic force to these stereotyped pictures.

Roy Lichtenstein is one of our foremost Comic Strip painters. By adapting the prefabricated images of man contained in these stereotypes, he has greatly extended our artistic vocabulary (ill. 78). These images, which influence millions of people daily, provide a point of departure for his pictures, in which he uses screen-processing techniques and homogeneous colours. Like Mondrian, he limits his colour range to red, yellow, blue, black and white. Both by increasing the scale of his models and also by modifying their forms, Lichtenstein creates effects which always transcend but never efface their banal origins. Thus, a phenomenon which had previously operated subliminally has now been raised to the level of consciousness.

But not all of Lichtenstein's motifs are derived from the Comic Strip. He is interested in all aspects of the day to day reality of big city life, and also uses manufacturers' instructions, advertising drawings and items in department store catalogues as starting points for his pictures. (Although he employed different techniques, Kurt Schwitters pursued a similar objective prior to the Second World War). Lichtenstein reveals a completely catholic taste in his choice of subjects. Even the works of art advertised in the department store catalogues are just so much grist to his mill. He has already produced "translations" of works – or, to be more precise, of reproductions of works – by Cézanne, Picasso and Mondrian. In principle, of course, Lichtenstein is at liberty to use all traditional techniques and subjects and all available symbols. By the same token other artists may – and do – borrow from him. Richard Hamilton used a detail from his "*Hopeless*" for "*A Little Bit of Roy Lichtenstein for . . .*" whilst Alain Jacquet enlarged his "*Hot Dog*" and sold the resulting picture in sections (ill. 193).

Together with a number of kindred artists in America and Europe, Lichtenstein has established a new perception of reality. He has opened up new areas of experience to the artist which had previously been closed to him. He has had recourse, not only to reality in the old sense of the word, but also to the stereotype of reality which dominates our mass media and which exerts a far greater influence on our civilisation than its so–called genuine counterpart. Lichtenstein's "*Head White and Yellow*" of 1962, his "*Drowning Girl*", "*Hopeless*" and "*It is . . . with me*" of 1963, his "*Crying Girl*" of 1964 and his "*Girl*" of 1965 (ill. 78) were all conceived in the spirit of the Comic Strip. The prefabricated image of man which he depicts is, of course, a substitute theme and

is openly regarded as such by the broad masses. Lichtenstein has also incorporated complete Comic Strips into his works. For example, in 1964 he painted a three-part narrative picture entitled "*When I Opened Fire...*". But even his individual pictures acquire an open–ended, narrative quality thanks to the juxtaposition of visual images and the written word, a combination which was often significant in the past, and is certainly significant today. Moreover, Lichtenstein's pictures not only tell a story, they tell a different story to different viewers.

Many contemporary artists have based their pictures on posters, as, for instance Karl Wirsum ("*Gila Teen*" and "*Udoo*"), Richard Merkin ("*Every Day is D-Day, Under the El*", 1968, ill. 113), Valerio Adami and Fritz Köthe. Köthe has produced new, complex and often ironical paintings by combining poster girls with car advertisements and traffic signs (ill. 81).

Not surprisingly, film stars are frequently featured in contemporary pictures. As early as 1930, Hannah Höch produced a *collage* commemorating the legs of "*Marlene*". "*Joan Crawford*" has been painted by James Rosenquist, "*Shirley Temple*" by Ray Johnson, "*Pola Negri*" by Red Grooms (1966) and "*Greta Garbo*" by Tita Maselli (1964). Bruce Connor has created a "*Homage to Mae West*" (1961) and a "*Homage to Jean Harlow*" (1963). The famous peroxide blonde of the 1930's is also the subject of Gerald Laing's "*Jean Harlow*" of 1964. Pauline Boty ("*Monica Vitti Heart*") and Bob Stanley ("*Monica Vitti*") have both portrayed Antonioni's leading lady. Martial Raysse painted a "*Portrait of Sophia Loren*" in 1963, whilst Andy Warhol has produced series of paintings of both Elizabeth Taylor (ills. 94, 95) and Holy Solomon. In Christo's "*Portrait du B. B. empaqueté*" [Wrapped Portrait of B. B.] of 1963 (ill. 96), a photograph of Bardot on the title of an illustrated magazine is seen through a plastic cover. In Peter Phillips' "*For Men Only Starring MM and BB*", Bardot appears together with Monroe in a painting resembling a juke box.

Marilyn Monroe was, of course, a star of the 1950's. Willem de Kooning, whose explosive art evolved from Abstract Expressionism, had incorporated her image into his work as early as 1954. But it was after her sensational sucide in 1962, that she became really firmly established as an idol of contemporary art. Since then, she has appeared in countless paintings, which have given birth to what is virtually a Marilyn Monroe iconography. 1962, the year of her death, produced a spate of Monroe paintings including Andy Warhol's "*Gold M. M.*", James Rosenquist's "*Marilyn Monroe 1*" (ill. 102) and Jorge Eielson's "*Requiem*" (ill. 101). Bert Stern's famous "*Document*" (ill. 103), which consists of a series of Monroe photographs showing the film idol in characteristic scenes and poses, was produced in the same year. These photographs, which Stern has arranged in a row and hung up as if for selection, have all been crossed through except one which bears the comment "*OK*". In a second Monroe work entitled "*Marilyn Monroe's Lips*" which he did in 1962, Andy Warhol arranged physical details of the actress, such as her open mouth, in sequence, whilst in his "*Marilyn*" triptych (ill. 97), which also dates from 1962, James Gill depicted various phases of the actress's career in a quasi-religious style. In 1963 the Monroe image featured in *collages* by Mimmo Rotella and in Martial Raysse's "*Marilyn*". In 1965 it reappeared in Richard Hamilton's "*My Marilyn*" and Allan Jones' "*Custom Made Marilyn*". In 1967 George Segal introduced a still photograph of Marilyn Monroe into his environmental sculpture "*The Movie Poster*" (ill. 99), and Rosalind Drexler also used a Monroe still – one taken from her last film – in her "*Something's Got to Give*" of 1967, whilst Newman and Avedon have made Monroe the subject of photographic works. Robert Indiana's "*The Metamorphosis of Norma Gene Mortensen*", Richard Lindner's "*Marilyn was Here*" and Dali's brilliant combination "*Mao Marilyn*" (ill. 100), which all date from 1967, also form part of the Marilyn Monroe iconography. In his unique "double" portrait, Dali has brought together two diametrically opposed figures who have both exerted a tremendous influence on the masses, one commercially, the other politically.

But, although popular idols constitute an important part of present day art, we never find an actor portrayed as a human being. On the contrary, it is his prefabricated

Alain Jacquet
La vierge et l'enfant 1966 ▷

24

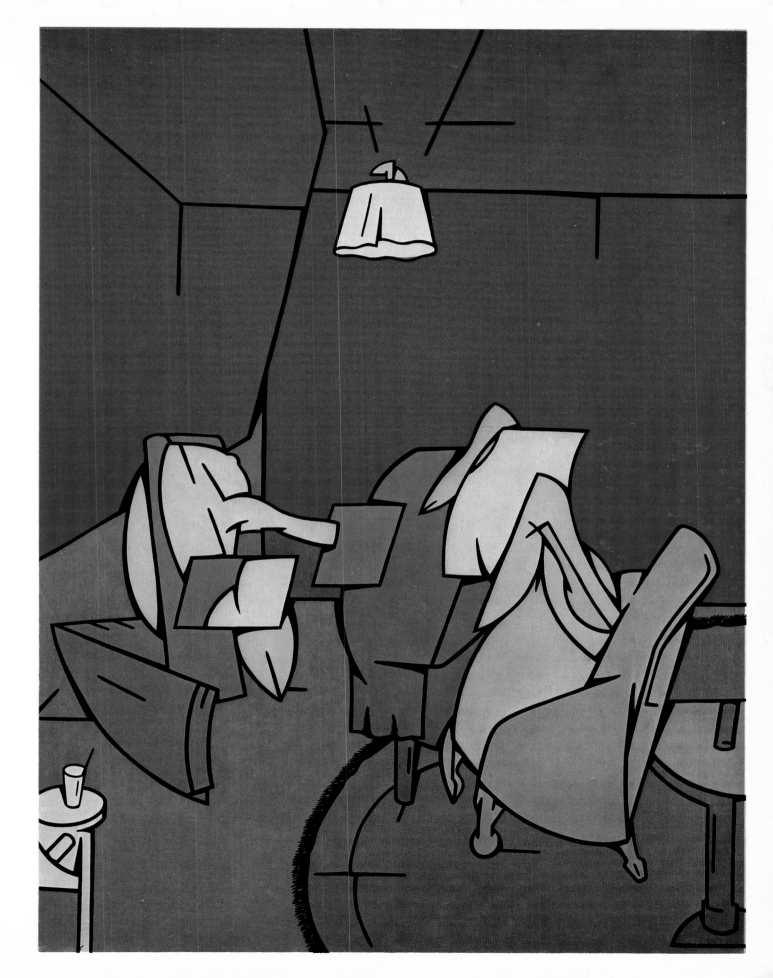

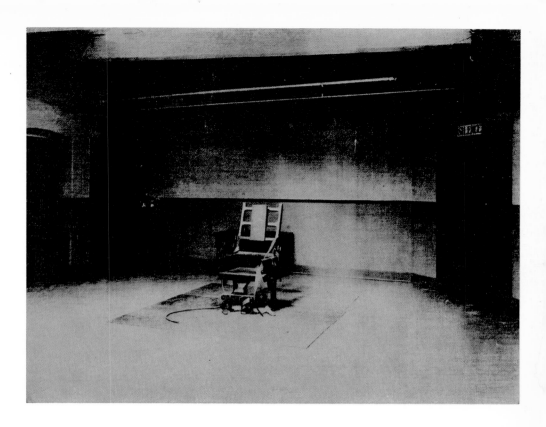

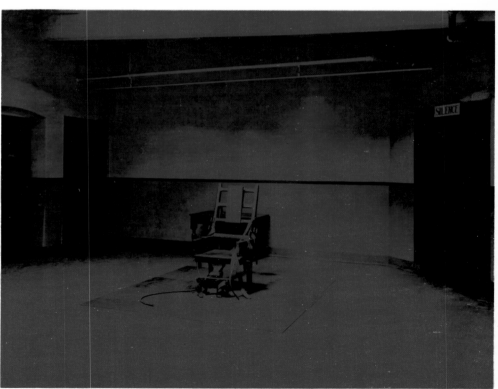

VII Andy Warhol *Electric Chairs* 1964

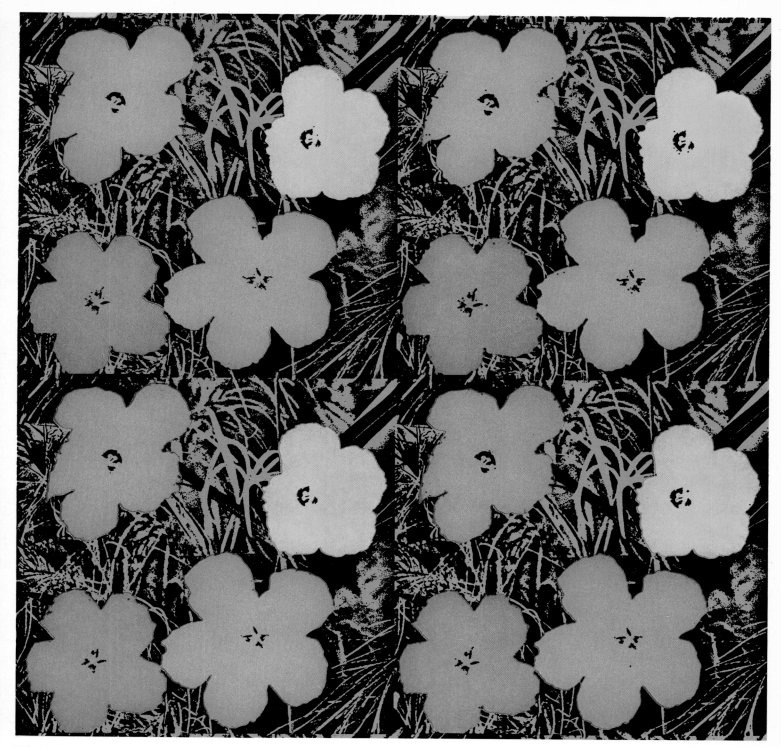

VIII Andy Warhol *Flowers* 1964

photograph, his stereotype, which forms the basis of the contemporary picture. The star is presented as a star, a popular idol, an image built up by the publicity department. The artist, of course, has had to develop special techniques with which to express this image, namely the stereotype, screen-processing and the sequence.

Stars of the Pop world are also a favourite theme of contemporary art. Elvis Presley, the forerunner of the Beat singers, has appeared in various paintings (Peter Blake, Andy Warhol). Peter Blake has also painted "*The Beach Boys*" (1964, ills. 92, 93) and "*The Beatles*" (1964). Bob Stanley has devoted a whole series of his vibrant colour compositions to the Beatles (ill. 91).

Another popular theme – one which has been treated primarily by city artists – is that of sport. Fernand Léger painted many sportsmen. In America, where baseball players incite some pretty vehement hero–worship, Roy Lichtenstein painted his "*Baseball Manager*" in 1963 (Joseph Helman Collection, St. Louis/Mo.), whilst William Copley produced a baseball series in 1966 (ill. 112). Kendall Shaw's "*Hunt Beckman Takes the Ball*" dates from 1965. In Germany, Konrad Lueg has painted boxers and footballers.

The spaceman is another popular idol who has featured in contemporary pictures, such as Joe Tilson's "*Yuri Gagarin, 12 April 1961*" (ills. 108, 109), Martial Raysse's "*Gordon Cooper*" of 1963 (ill. 106), Kitaj's "*Aureolin*" of 1964 and works by Rubino, in which astronauts are confronted with figures taken from the history of art. Tony Burgering painted a series of astronaut pictures (1967–8), in which he concentrated on the first practical demonstration of weightlessness in space. Paul van Hoeydonck, who regards himself as the chronicler of the space age, has frequently depicted spacemen in his drawings and tableaux, whilst Hajo Bleckert has published an astronaut's manual compiled from photographic etchings.

Politicians influence public opinion. Consequently, they too have appeared as stereotyped figures in contemporary painting. John F. Kennedy, for example, has been portrayed by many young artists. National emblems also play an important part in this sphere and are beginning to rival erotic and commercial symbols as artistic themes. Flags, emblems of sovereignty and the entrance to Arlington Military Cemetery are all perfectly admissible motifs.

John F. Kennedy is the central figure in Rauschenberg's "*Retroactive I*" and "*Retroactive II*" (ills. 116, 117), where he is depicted in the company of a paratrooper, a blurred image of one of Rubens' women looking into a mirror and various other peripheral motifs. This extremely complex picture shows the kind of influences to which people today are exposed. Jacqueline Kennedy, the murdered president's widow, has also been featured in many contemporary works, as in Andy Warhol's "*Jackie*" of 1964 (ill. 105). As late as 1967, Victor Kord incorporated a photograph of her into one of his montages.

In his "*Man of Good Will*" (1963), a painting of Pope John XXIII based on D. Kessel's photograph in Life Magazine, Frederick Wight tried to establish an image of the pope as the representative of a new ecclesiastical conception. President Johnson has also appeared in many recent pictures. In his "*L B J*" of 1967, Ray Reshoff placed a press photograph which showed the former president's body after an operation against a background of stars. In the same year, no less than thirty artists exhibited portraits of Johnson in the Richard Gray Gallery in Chicago.

Robert Nelson uses stereotyped pictures of popular heroes such as Charles Lindbergh, or of American presidents such as Washington, Lincoln etc. Like Sante Graziani in "*Red, White and Blue*" of 1966 (ill. 128), he incorporates these prefabricated symbols into a larger, artistic context.

In his "*Junta*" of 1962, R. B. Kitaj presented a sequence of portraits of the leaders of a revolution. This sequence fulfilled a dual and antithetical function, for it served both to isolate and to link the various subjects. James Gill also treated a political theme in "*In His Image*" (ill. 120), which he painted in 1965. Here we see a politician speaking before an official body, in conjunction with a newspaper headline reporting his speech. In this *contraposto* combination of a painted photograph and a painted news-

paper, the time factor is all important, for the incident and the newspaper report of the incident are seen simultaneously.

Boris Lurie ("*No-Posters*", "*Adieu Amérique*") and H. P. Alvermann are trying to exert a direct influence on public opinion. Political realities and political clichés – especially those relating to the dissemination of Asiatic influences in the Western world – constantly appear in works of contemporary art. Thomas Bayrle (ills. 123, 124, 125) and Gerhard Richter have both painted Mao portraits, in which the Chinese leader is presented as a popular idol. In 1965, Umberto Bignardi created a painting on glass entitled "*Asia*" (ill. 126), which he reproduced in multiple form by projecting its image on to the walls of the exhibition room. We have already mentioned Salvador Dali's excursion into the political sphere with his inimitable "*Mao-Marilyn*" (ill. 100).

In the full flush of his new-found freedom *vis-a-vis* environmental objects, the contemporary artist has not hesitated to incorporate advertising signs and trade marks into his works. Peter Phillips did so in his "*Philip Morris*" of 1962 and his "*Kewpie*" of 1963–4. In 1963, Leslie Kerr painted his "*Kodak*", Herb Hazelton introduced advertisements for corsets into his "*Maria Lupe*", whilst Anthony Berlant used cigarette advertisements in his "*King Size 1*".

Andy Warhol also gave the lead in this sphere, for his "*Campbell's Soup Can*" (ill. 195) and his "*Hundred Cans*" (Buffalo Museum, N.Y.; ill. 196) both date from 1962. In the second of these two works, the cans, which are given as realistically as possible, are arranged in rows as in the original display. By reproducing real objects in this way – i.e. with complete fidelity and without a trace of subjective emotion – the contemporary artist has succeeded in freeing the workaday world from the state of aesthetic isolation to which it had been reduced. His willingness to come to terms with basic phenomena and to depict them as they appear to the ordinary man in daily life has had considerable repercussions on the relationship between art and society.

The incorporation of national emblems into contemporary art is also indicative of this trend for, in so far as they symbolise the nation, these emblems also symbolise national aspirations. Jasper Johns' pictures of the American flag of 1954 and his "*Three Flags*" of 1958 are typical examples. The American flag is also featured in Claes Oldenburg's "*Flag Fragment*" and William Copley's "*Model for 'American Flag'*" of 1961 and in John Wesley's "*Service Plaque for a Small Legion Poster*" of 1962. In Wally Hedrick's "*Peace*" of 1953, it serves as a ground for the printed word "PEACE".

Apart from national flags, contemporary artists have also used devices such as the American and Russian star, the swastika and the hammer and sickle. Other emblems which have been adopted since the late 1950's are those appearing on coins, bank notes and official documents. Roy Lichtenstein's "*Ten Dollar Bill*" was painted in 1956, whilst Robert O'Dowd's "*$5.00*" dates from 1962, the year in which Philip Hefferton painted his "*Winking Lincoln*", a parody of a portrait of the sixteenth president. In the following year, O'Dowd used the image of George Washington – which also appears on the American dollar note – for his "*Silver Certificate*", whilst in 1965, Larry Rivers produced his "*French Money*", which featured the French 100 Franc note. In his "*Red, White and Blue*" of 1966 (ill. 128), a work consisting of nine symmetrical panels, Sante Graziani painted miniature portraits of four famous American presidents, which he interspersed with five pictures of stars. The incorporation of popular emblems and images is a technique which has found widespread application in our present decade. By using these familiar symbols, the contemporary artist is able to produce an extremely powerful effect simply by reproducing an object or image from the world of reality. Andy Warhol's series on the "*Electric Chair*" (Plate VII) affords a particularly telling example of this process.

Every aspect of contemporary reality is now finding appropriate expression in the works of the younger generation of artists. Today the artist plays his role in his own day and age, treating the subjects with which he is confronted in our mass society. In doing so, he inevitably reflects the pictorial world of the mass media.

Documentary pictures

The fact that historical, religious and documentary pictures constitute a special branch of contemporary painting casts a significant light on our present situation. In 1922–3 Otto Dix reproduced the reality of the First World War in his "*Schützengraben*" [The Trench], a work executed by traditional techniques, whilst in 1936 Dali painted his hallucinatory "*Premonition of the Civil War*". Today, of course, photography has become all important in the documentary sphere, for the camera is able to create a precise and objective record of contemporary events. Brassai once said: "I make no comments with my camera. My camera sees all the different kinds of people and with impartiality transfixes on the negative whatever I see and I feel about the people the camera sees – this is the result." Helmut Gernsheim made a similar point when discussing Reg Butler's "*Monument to the Unknown Political Prisoner*": "In my opinion, the photograph of a demented political prisoner, for whom liberation came too late, is an infinitely more expressive symbol of persecution than Reg Butler's prize-winning metal construction which is to be set up in Berlin." The photograph he referred to was taken by an anonymous photographer in 1945. It is a splendid work and lends great weight to Gernsheim's thesis, namely that reality is far more effective in the raw than when it is artistically transposed. The unadulterated presentation of reality, which had been rejected by artists for centuries as irrelevant, is so effective in this photograph that we have no option but to classify this anonymous photographer as an artist. Werner Bischof, Bert Hardy, George Oddner and Dorothea Lange have also taken photographs which create a direct, artistic impact whilst Cecil Beaton, the film and society photographer, took a photograph in 1940 entitled "*After the Raid*", which was used as a cover picture by Life magazine and contributed in no small measure to America's entry into the Second World War.

Photography has many facets. It can be documentary and it can be used to record a set scene or group; it can produce a psychogram and – in the instantaneous snapshot – it can be a purely fortuitous phenomenon. Because of their precision and objectivity, photographs exert a tremendous influence on the general public. They can influence people's lives, spark off conflicts, provide a source of documentary evidence, and elicit emotional reactions on a nation-wide scale, as for example in the case of the false montages of 1914. Above all, photographs appeal to both sentiment and reason at one and the same time, especially when used as cover pictures for mass circulation magazines.

Contemporary painters are also concerned with the documentation of events, and consequently they have frequent recourse to photographic techniques. In his "*Corteo*" of 1965, Michelangelo Pistoletto depicted two demonstrators, carrying flags. R. B. Kitaj's works, such as "*The Murder of Rosa Luxemburg*" of 1960, "*Erie Shore*" and "*The Production of Waste*" of 1963, are conceived in a similar vein. Giovanni Rubino juxtaposes documentary photographs with fruits and vegetables. This satirical Surrealist combination, in which powerful documentary photographs are integrated into a traditional setting with still life details, demonstrates the richness of reality and permits a wide variety of interpretations. In his "*F – 111*" (Metropolitan Museum, New York), James Rosenquist made a fighter aircraft the focal point of a large format painting. Other contemporary artists – like their predecessors at the time of the Spanish Civil War – have dealt with current events of historical importance. For example, Allan d'Arcangelo incorporated the Kennedy assasination into a *collage* which he produced in 1965. In this work, a number of traffic signs and signposts, including one which reads "Federal Highway 77, Texas", are combined with driving mirrors, one of which has been shattered by several shots. Boris Lurie's "*Immigrants No-Box*" of 1963 is a montage consisting of photographs of concentration camps and swastikas. The title NO, which appears at the top, is also repeated within the painting. In his "*Stalingrad*" of 1964, Erro contrasted a battle scene based on a Second World War photograph with the "*Crucifixion*" of Rogier van der Weyden, whilst Andy Warhol chose the explosion of the atom bomb as the subject of his "*Red Explosion*" of 1965.

The Spaniard Juan Genoves has also treated political themes in his pictures. He creates crowd scenes, showing various phases of a given action in a temporal sequence that reveals the influence of the motion picture. In his "*Calendario Universal*" [Universal Calendar] of 1967 (ill. 142), he portrays men facing a wall with their hands raised above their heads, whilst policemen are engaged in herding together crowds of people. His "*El avión*" [The Aeroplane] of 1968 is divided into two separate panels by a horizontal line. In the upper panel, which is painted on a pale background, the dark silhouette of an aeroplane is shown flying above a crowd of fleeing people, who also appear as silhouettes, whilst in the lower panel, which has a dark background, people are seen scurrying away like ants. Genoves' "*Opposite Ways*" of 1967 is also divided by a horizontal line. In the upper panel of this painting, we see armed individuals, and in the lower panel unarmed groups, all running in different directions. Here, too, the figures are depicted as silhouettes. In "*Cielo y tierra*" [Heaven and Earth], we find the same combination of human beings and aeroplanes, but the human silhouettes are minute and are seen only at the very bottom of the picture, whilst the aircraft appear as mere shadows at the top. The persecution of the masses is Genoves' constant theme. For him, men are divided into two classes: the hunters and the hunted. He depicts the individual as an insignificant pawn, caught up in a situation from which there is no escape. It is a theme which is as valid today as it was in the days of the Spanish Civil War.

Silhouettes

The fact that a large number of contemporary paintings are given over to silhouettes does not detract in any way from the current striving after authenticity and precision in the portrayal of the human figure. This technique, incidentally, may well be as old as painting itself. Cave paintings and the works of the early Greek artists would certainly suggest that such is the case. The important thing is that these simple silhouettes, which were very popular in the eighteenth century and have now been taken up by many of our younger artists, represent an entirely authentic facet of reality.
In "*La nuit espagnole*" [The Spanish Night] of 1922, Francis Picabia painted a black silhouette on a white background on the left hand side of his picture, and a white silhouette on a black background on the right. In this formal dialectical relationship, Picabia contrasted man and woman. In 1933, when Surrealism was at its peak, René Magritte created a silhouette by painting in part of a door, thus establishing a paradoxical relationship between the solid timber and the gap, which was reflected in the title of the work: "*Unexpected Reply*" (ill. 149). Oskar Schlemmer also created silhouettes for the window paintings, which he produced in 1942. By painting silhouettes instead of figures at that time, he was able to disguise his true political position.
The sculptors Mario Ceroli and David Jacobs have constantly represented the human figure in the form of a silhouette. So, too, have painters like Martial Raysse (ill. 148), Berto Ravotti (ills. 150, 151, 152), Pietro Gallina (ill. 156), Sergio Lombardo, Lourdes Castro (ill. 153), Laura Grisi and Nikos. In his "*Portrait double: Série hygiène de la vision*" of 1968, Martial Raysse superimposed a small full face portrait on to the silhouette of a head made from synthetic material. Berto Ravotti has painted superimposed sequences of silhouettes in varying shades, producing effects rather like that created when a film is exposed several times over. These figures are seen executing clearly defined gestures and performing various tasks, such as making a 'phone call, or dressing themselves.
Lourdes Castro has been working with silhouettes on sheets of plexiglass since 1964. She mounts these in pairs one behind the other, so that when the viewer steps a little to one side, he sees a double image which varies according to the angle from which it is viewed. Castro's "*Im Café*" [In the Cafe] of 1964 (Kultermann Collection, Leverkusen; ill. 144) is the first of a series of multilayer works, which also includes his "*Ombre*

portée négatif et positif" [Negative and Positive Silhouette] and his "*Ombre portée Linhof et Orange transparent*" (both 1967). All of these works are characterised by the "presence of absence", a phrase coined by Pierre Restany to describe the essential quality of Castro's work. Laura Grisi has incorporated a self-portrait executed as a silhouette into her "*West Window*" (1966), whilst by using photographic techniques, Nikos has reduced his silhouettes to a "*Phantasmagoria of Identity*", in which he depicts the ephemeral personality of contemporary man; in his "*Futurismo revisitato a colori*" [Futurism re-examined in colours] (1966), Mario Schifano used a silhouette based on a group photograph of the Futurists.

The American Kendell Shaw is more interested in silhouettes of people in action, and the majority of his silhouette pictures depict sportsmen performing strenuous feats (ill. 155). In 1964, he produced a number of works in which positive and negative silhouettes are contrasted on boxes. Other artists have produced similar effects by means of spatial arrangements, as, for instance, Roy Adzak in his still lifes and figure compositions.

In 1965–6, Howard Jones combined human silhouettes with electrical installations. In his "*Solo 2*" (ill. 154), a silhouette of a man appears behind a transparent screen, which is lit up by series of lights, which provide a sort of pendant to the viewer, who takes up his position in front of the screen.

Other artists have used highly simplified silhouettes, which show a bare outline of the human body. George Cohen did this in 1966 in "*Girl on Glass*", and in "*Set IIA*" and "*Set IIB*" (ills. 160, 161), the human body is reduced to what is virtually an embryonic form. Ernest Trova's recent paintings and graphic works are very similar. In his "*Falling Man*" of 1968 (Nancy Singer Collection, St. Louis, Mo.; ill. 159), in which the juxtaposition of reds and blues produces an effect rather like hard edge painting, three partial silhouettes are placed diagonally across the picture, although – due partly to their unexpected position and partly to their fragmentary state – they are not immediately recognisable as such. In his new graphic prints, Trova has used silhouettes as a framework for two-dimensional topographical compositions. With these works, he has shown that he is able to treat his central theme of the falling man, not only in sculptures, but also in paintings and graphic compositions. Indeed, he has even incorporated it into studies for landscapes, and has created endless variations on this one basic concept.

In all of these pictures, in which the human body has been reduced to a mere outline, humanity is expressed in precise terms, which are un-psychological, un-individual, impersonal and anti-intimate. But then, in big city life, man tends to regard his neighbour as a computerised creature devoid of personal characteristics. However, these pictures show at the same time the shadows cast by those who died at Hiroshima: the men have died, but their shadows are real.

Animal pictures

Unlike contemporary sculptors, contemporary painters have been able to do relatively little with animals. Where animal subjects are concerned, sculpture affords far greater opportunities for creating an immediate impression. True, Franz Marc and Max Ernst achieved a synthesis of animal forms and human emotions in the early decades of the century, but their kind of symbolism is no longer relevant today.

Picasso, of course, has created numerous animal sculptures, paintings and graphic compositions. One of these, "*Diurnes-la-chèvre à la caisse d'emballage*" which he produced in conjunction with the photographer Jacques Villers in 1960, makes a significant contribution to contemporary art. Joseph Cornell often placed animals in his documentary style boxes, although he also used birds ("*Habitat for a Shooting Gallery*", 1943 and "*Habitat with Owl*", 1946) and insects (series of *Butterfly Habitats*,

c 1940). Occasionally, he featured larger animals, as in his "*American Rabbit*" (1945–6). In their elemental works, Jean Dubuffet and Francis Bacon have had constant recourse to animal motifs. For example, in his "*Dog*" (1952; Museum of Modern Art, New York), Bacon used as his model a photograph by Muybridge (whose movement studies have also attracted many younger artists such as Bignardi). From this objective model, he fashioned a psychic, highly suggestive, almost threatening composition, whose overall effect is greatly strengthened by the interlacing shadows on the ground.

In his "*Speckled Cow*" of 1954, Dubuffet painted a completely primitive animal form, which he integrated into his earthy, textured style that is so reminiscent of children's drawings. Graham Sutherland has painted whole series of animal pictures, e.g. his "*Bestiary*" of 1968. So, too, has Brett Whiteley, e.g. in "*Swinging Monkey*" of 1956, in which he made use of photographs. Surprising as it may seem, animal study also played a significant role in the early work of Victor Vasarely. In his "*Zebra*" of 1938, he used parallel lines to create a mock relief that is reminiscent of the skin structure of a zebra.

Meanwhile, a new phase of animal painting has been introduced in America. In 1959–60, Larry Rivers painted his "*Horses*" (Stanley Bard Collection, New York; ill. 174), in which he combined blurred, full-face sketches of horses and riders with the printed name "HORSES", whilst in his "*Untitled*" of 1963, Lee Friedländer portrayed a young dog barking in the window of a pet shop. In 1966, William Theo Brown painted a dog fleeing across an open, desolate landscape. In this picture, which he called "*White Dog*", Brown used an animal as a symbol of fear, whilst in his "*Dog*" of 1966 (ill. 178) Wayne Thibaud has sought to create a traditional animal study. Clarence H. Carter has also painted animal studies, as "*Over and Above No. 13*".

In John Wesley's coloured prints and pictures animals appear, not only individually, in pairs and in rows, but also in association with human beings. The central theme of his "*Holstein*" of 1964 is a mottled cow. His "*Squirrels*" of 1965 is a satirical composition. In his prints, Wesley has also portrayed rhinoceroses, and in his "*Camel*" of 1966, a silhouette of a camel appears together with a human figure with a horse's head.

Roy Lichtenstein has painted a picture of three stereotyped birds sitting on a branch. Andy Warhol has also used a stereotyped image for his "*Cow Wallpaper*" (1966; ill. 173). In this work, he created a wallpaper print by reproducing the kind of prefabricated image of a cow's head usually used in milk advertisements.

In his "*Gorilla Couple*" of 1965, which he painted from a photograph, Joe Raffaele contrasted various details of the animal form. Other artists have also based animal pictures on photographs, e.g. Howard Kanovitz ("*The Horse*", Kaplan Collection, New York; 1965), Gerhard Richter ("*Tiger*"; 1965), Malcolm Morley ("*Cutting Horse*"; 1967; ill. 175) and Karl Heinz Krüll ("*Leo*"; 1968). Umberto Bignardi used photographs by Muybridge as models for his paintings, whilst Thomas Bayrle, Richard McClean and Wim Gijzen have all composed pictures of cows from advertisements. However, none of these artists portray animals in their natural setting. On the contrary, their works are firmly grounded in the animal image established by advertising, especially television advertising. In fact, this is the only type of animal picture being produced in contemporary art.

On the other hand, involvement with stereotyped images has led – in sculpture as well as in painting – to the incorporation of "real" elements. Jacques Kaplan, for example, used real animal skins in his "*Reassembled Zebra*" of 1967 (ill. 181).

Still lifes

Although at first sight the still life would appear to be a distinctly "unmodern" branch of painting, it constitutes in fact an essential aspect of contemporary art. The representation of trivial environmental objects such as fruit, crockery, cutlery, food and

flowers is as important today as it was in the sixteenth century. This is not really so surprising if we consider that the objects which surround us form part of the universal process, and are therefore as relevant to us as they were to our ancestors.

It also follows from this that a still life is more than a formal arrangement of objects which just happen to be available. In still life, as in all other branches of painting, the artist's principal objective is to express his relationship to the world in which he lives. It is no mere accident that important artists such as Rembrandt, Zurbaran, Goya and Cézanne should have concerned themselves with still lifes, and evolved a symbolism for this genre which penetrated far beneath the surface of the objects represented. Van Gogh's observation that a feeling for objects is more important for the artist than a pictorial sense is apposite here.

Giorgio de Chirico, one of the great pioneers of twentieth century painting, once defined the big city as an open-air still life. His desolate townscapes, in which the abandoned houses, the dolls and the strange instruments seem to be linked with one another in a mysterious and intangible relationship, exerted a crucial influence on Surrealist painting. René Magritte, who owed his initial inspiration to de Chirico, then took the step which carried the still life forward into the present. In paintings such as "*La Chambre d'écoute*" [Listening Place] (1953; William N. Copley Collection; New York) and "*Le Tombeau des Lutteurs*" [The Tomb of Wrestlers] (1960; Henry Torczyner Collection, New York), in which different levels of reality are combined and transformed in an inimitable fashion, he gave objects an independent existence. These works, in which an apple or a rose fills a whole room, are reminiscent of Alice in Wonderland. By altering the scale of his paintings, Magritte attributed to his objects a degree of importance which was far in excess of their actual value. In his still life "*Le bon sens*" [The Right Direction] (1954; Mrs. Krebs Collection, Brussels), he depicted a bowl of fruit lying on a framed canvas which had been placed on a table. The ironical and illusionist impression produced by this work stems from the pictorial juxtaposition of different levels of reality. In the closing years of his life, Magritte still painted masterly still lifes such as "*Le jeu de mourre*" [The Game of Mora] (1966; ill. 183) and "*L'aimable vérité*" [Lovable Truth] (1966). In "*L'aimable vérité*", he painted a table with fruit, a bottle, a glass and a loaf of bread – i.e. simple objects from the repertoire of Classical still life, which he projected on to a wall that was broken up by mysterious niches.

In *c* 1949, Alberto Giacometti also painted a number of still lifes, in which, as in his figure compositions, the tone of the picture is set by the distances between the various pictorial objects. Still lifes make up an essential part of Giorgio Morandi's output. Morandi places the principal emphasis on colour, which he uses as a means of linking different objects, thus demonstrating the essential unity of the object world.

In the still lifes painted from *c* 1960 onwards, the emphasis has been placed on fruit, foodstuffs, confectionery etc. In a sense, therefore, they constitute an extension of the culinary still lifes which have been produced since the sixteenth century, especially in Holland. Robert Bailey has painted eggs arranged on tables with a realism which matches the realism of traditional artists, but which also incorporates the disciplined structures typical of our own era (ill. 186). Peter Dechar has painted gigantic pears, which he conceives as monumental studies, singly, in pairs and in groups (ill. 184). These are reminiscent of Magritte's apple in "*Le jeu de mourre*", although they lack the Surrealist irony at the heart of the Belgian's work. Dechar provides a factual account of objective situations. With him objects are what they are. He uses precise outlines, delicately modelled surfaces, and the interplay of light and shade to structure the pictorial surface.

Wayne Thibaud has produced still lifes of a very different kind, in which he creates an image of American society with a delicacy of touch that is in keeping with his subject. His "*Cakes*" – both the oil painting of 1963 (ill. 191) and the pastel of 1967 – shows a selection of cakes, one of which has been cut, mounted on stands and set out in rows as in a shop window. The stands are very slender and look like stalks, so that the

viewer is given the impression that the cakes are actually growing, like a plant. This, combined with the rigid layout, produces an obsessional effect. In his "Four Cones" of 1964, depicting four ice cream cones, Thibaud uses a similar layout. In another still life, he portrays a sausage and cheese shop as seen by the customer.

James Rosenquist and Tom Wesselmann are two American artists who have made a speciality of contemporary still life. In his "Still life 34" of 1963, Wesselmann depicted cigarettes, a coca-cola bottle, pears, flowers and a glass, using the collage technique evolved for his relief compositions. In "Still life 44" of 1966 (ill. 190), he painted an orange in front of a glass on a greatly enlarged scale. This close-up technique is reminiscent of Peter Dechar's "Pears". But, whereas Dechar is engaged in a form of demonstrative painting, Wesselmann tries to reproduce objects as faithfully and "photographically" as possible. The precise modelling of the surface of the orange in "Still life 44" provides a good example of his style.

James Rosenquist also employed this close-up technique for his "Orange Field" of 1964 (ill. 188), in which the whole of the picture space is occupied by a plate of spaghetti Neapolitani and the prongs of a fork. In his "Silhouette" of 1964 (ill. 187), which is also enlarged, he painted a woman's hand holding a slice of Gruyère cheese. There are cracks running across the whole surface of this painting, which makes it look like a jigsaw puzzle. One piece of the picture is missing, a device which gives the work not only a second level of meaning in the manner of Magritte, but also an artificial, synthetic quality, as if it were a dummy hand which had been produced for advertising purposes. In this, it resembles Edward Ruscha's "Glass of Falling Milk" (Iolas Gallery, New York; 1967), which also calls to mind an advertising dummy. Ruscha's realistic portrayal of movement in this work forms a pictorial counterpart to Claes Oldenburg's sculpture of falling potatoes. Roy Lichtenstein has also painted numerous pictures of consumer articles and foodstuffs. The best known of these is his "Hot Dog", which Alain Jacquet used as a model for his "Peinture – Souvenir" [Memory–Painting] of 1963 (ill. 193).

In his paintings, Robert Watts has concentrated on place settings. In his "TV Dinner for Two", he produced a stereotype of the prefabricated meal, the sort of thing served in aircraft, at parties etc. Roy Adzak has also created still lifes of bottles and place settings. In his "Bottles" of 1966 (Stael Collection, Brussels), he portrayed the negative forms of bottles of different shapes set out in line on a neutral background. Adzak's pictures obtain their effect from the interplay of negative and positive forms, light and shade, shadow and substance. In his "Six Setting" (Burt Kleiner Collection, Los Angeles), a variable composition which he executed in 1965–6, G. Cohen burst the bounds of pictorial form by combining place settings with mirrors and movable hands, arms and legs, on a six-part tableau.

By combining two different branches of painting, namely landscape and still life, the Icelander Erro has created an entirely new and distinctly obsessive category which he calls "Foodscape" (ill. 194). In 1964, he painted all the wrappers of food consumed during a visit to America. Commenting on this procedure, he said: "The materials for "Foodscape" were collected in Times Square and in New York shops. I had to eat all these products because I needed the wrappings for the picture." In 1963, Erro had already tried to portray the subject of food in the form of a "Garden of Displeasures". The title which he gave to this supposedly culinary still life was "L'appétit est un crime: La peinture de la cuisine: ou les cent mille nourritures; ou: L'homme est ce qu'il mange; ou: La nourriture dans la physique contemporaine, etc. . . . [Appetite is a crime: The painting of the kitchen: or A hundred thousand foods; or: Man is what he eats; or: Food in contemporary physics, etc. . . .].

James Rosenquist has combined large numbers of fragments of objects in his still life compositions. The title of one of these works – "Vestigial Appendage" of 1962 – indicates the rudimentary nature of its component elements. Rosenquist also used combinations of fragments for the two large format works which he produced in the same year: "Homage to the American Negro" and "White Cigarette", as well as for the enor-

IX Laura Grisi *Racing car, 3-dimensional, detail of a group of neon-boxes standing on an aluminium square*

X Peter Phillips *Tiger – Tiger* 1968

XI Peter Stämpfli *Super Sport* 1966

XII Jacques Monory *Ariane, hommage à Gesualdo* 1967

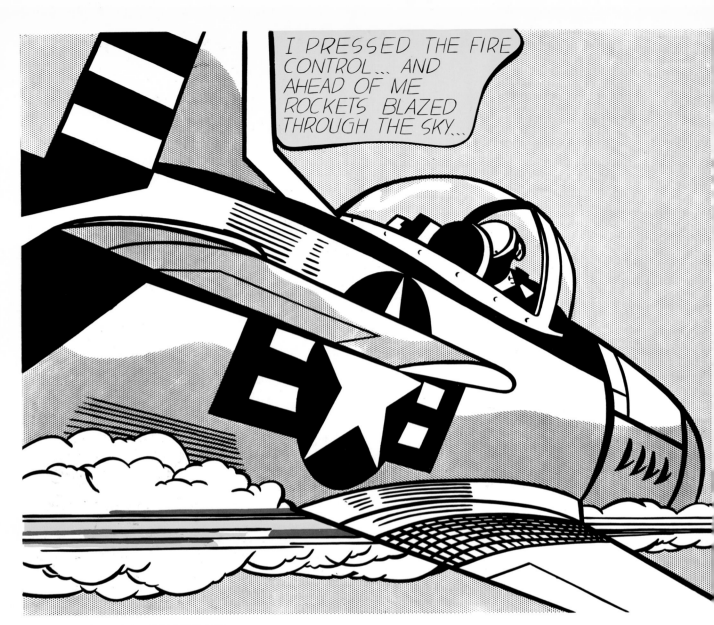

XIII Roy Lichtenstein *WHAAM!* 1963

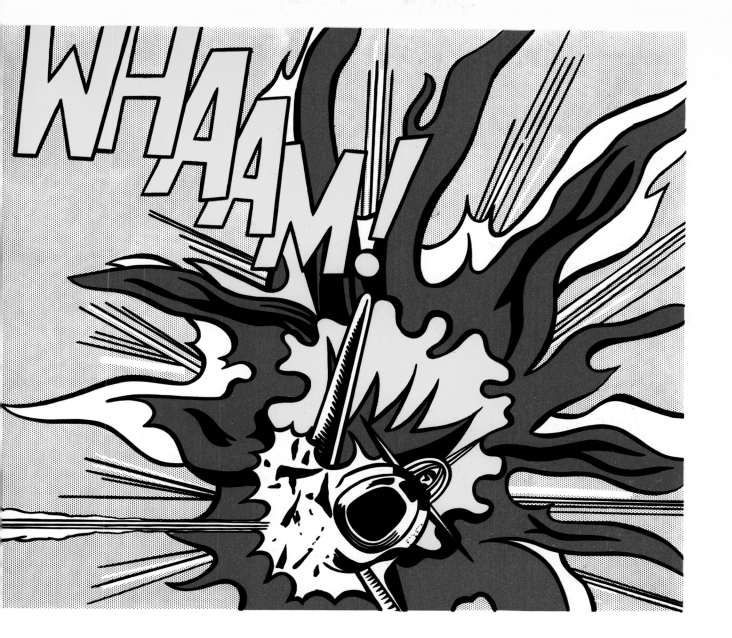

mous wall painting (ill. 189) which he created for the curved outer face of the New York State Pavilion, designed by Philip Johnson for the 1964 World Fair. Similar combinations are to be found in the works of painters like Antonio Diaz ("*Sans Titre*"; 1967) and Victor Kord ("*Mid-Western Landscape No 2*", 1967).

Many contemporary still lifes have been inspired by completely mundane objects. The first of these was produced by Jasper Johns as early as 1958, in a lithograph entitled "*The Coathanger*". Johns made no attempt to give symbolic force to this very ordinary consumer object, which is used quite unthinkingly by millions of people every day. On the contrary, he did his utmost to depict it precisely as it is in real life and in doing so, he overcame the "pictorial" view of reality which had held sway until then. Yves Klein and Piero Manzoni achieved the same thing at the same time in Europe, albeit in quite a different way.

The Japanese painter Arakawa then developed Johns' basic concept, combining it with photographic techniques. In 1964, he produced his "*Light Shines Through the Net Making Half an Umbrella*", in which a clothes-hanger also plays a central part. But, unlike Johns, Arakawa had incorporated various other concepts into his work at that time. In "*The Comb Cuts Into the Jump*", also of 1964, he integrated silhouettes of combs, which were partially superimposed on one another, with photographs of four different phases of a somersault performed by a gymnast. The specific character of this work, in which oils are used in conjunction with photographs, is produced by a technique involving blurring, cutting, double exposure and superimposition, which interact with positive and negative images and horizontal and vertical sequences.

Jim Dine has also contributed greatly to the re-emergence of the still life in contemporary painting. Dine has depicted tools, articles of clothing and instruments of all kinds, some of which are painted, others real. His "*Shoe*" of 1961 (ill. 199), in which he portrayed a man's shoe with the subtitle "SHOE" on an otherwise blank surface, was a revolutionary work of its kind.

Other objects represented in contemporary paintings include cases (Lourdes Castro: "*Ombre portée d'une valise*" [Silhouette of a Case; 1966], telephones (as in Martial Raysse's silhouette of a telephone in neon lighting; Verne Blosum's telephone of 1964, and pictures by Konrad Klapheck), deckchairs (Jennett Lam; 1966) and furniture. Enrico Baj painted cupboards in his "*Mobile*" of 1961, a series of decorative and ornamental *collages* which parody the folklore tradition. Robert Rauschenberg combined pieces of real sheets and blankets with painted areas in his "*Bed*" (Leo Castelli Collection, New York) as early as 1955. In his "*Untitled*" of 1962, Lee Friedländer painted the lower half of a bed with a television set in front of it, a perfectly normal view of reality for millions of people. The television set is also placed in a living context in Monory's "*Dimanche Matin*" [Sunday Morning] of 1966. There, however, it gains an added dimension from the contrast with external reality, which can be seen through the balcony door, and from the enormous rose at the top right of the picture. Gnoli is another artist who has treated the subject of the bed ("*Le Lit*" [The Bed]; 1965).

Articles of clothing and fashion accessories are also included in the contemporary artist's range of subjects. Jim Dine is perhaps the foremost exponent of this particular trend. His "*Three Palettes*" of 1964 and his numerous paintings of ties are typical products. The Greek artist Pavlos has used shirts, ties, hats (ill. 197), suits, coats and even whole wardrobes for his paper constructions. In his "*No. 4235. Tour de Cou 15½*" [No. 4235. Neck size 15½], Domenico Gnoli painted a monumental shirt, which occupies the whole of the picture space, whilst for his "*Camicia*" [Shirt] of 1962, Jorge Eielson used a real shirt, which he first spread out over the picture surface and then integrated into the material structure of the work, which is faintly reminiscent of Alberto Burri's material pictures. Burri, a 1950's artist, frequently incorporated real shirts into his paintings, whilst hats form the subject of C. F. Reuterswärd's "*Looping the Loop the Masters*" of 1959 and also of Arman's more recent work, e.g. "*I Cappelli di Max Gritte*" [The Hats of Max Gritte] of 1965. In this picture, a single red hat stands out in bold relief from others painted in white and pale and dark ochre. In his "*Les six*" [The Six] of

1964, Tony Berlant placed six dresses in line, and then organised them in a way which produced what is virtually a magical effect. In his "*Silhouett*" of 1964, Peter Stämpfli contrasted the figure of a man dressed in a cloak, and viewed from the rear, with a hand holding a cigarette which appears in the foreground and extends into the picture, and in his "*Gala*" of 1965, which is characterised by bold outlines and harsh lighting, he portrayed a gloved hand holding a second glove. His "*Slow*" of 1963, which presents a close-up view of a lady's shoes and feet, is conceived in terms of the advertising photograph. Unlike Jim Dine (ill. 199), Stämpfli has used a symbolic title, which provides an interpretation of this work for the viewer.

Konrad Klapheck has created a highly original form of still life. For the past ten years or so, he has painted mechanical and household objects in a bold and highly realistic style based on traditional techniques, which gives his works an aura of mystery and magic. They also acquire an element of irony from the antithetical titles which Klapheck accords them. His "*Supermann*" [Superman] of 1962 (ill. 205) depicts a typewriter which extends below the bottom edge of the picture space. "*Die Pleite*" [Failure] of 1967 is a painting of a single track shoe, with menacing-looking spikes protruding from its sole. "*Das Leben in der Gemeinschaft*" [Life in the Community] (Prof. Josef Zander Collection, Heidelberg; 1964) is symbolised by a subtle arrangement of shoehorns. "*Die Antwort der Sibylle*" [The Sibyl's Reply] of 1965 consists of a series of pipes and a key on a dish. A picture of a telephone receiver, whose cord disappears into thin air, bears the title "*Die Kapitulation*" [The Capitulation] (1966). In a second telephone picture executed in the same year, Klapheck depicted a complete telephone with the receiver resting in its cradle and the whole apparatus closely entwined in the cord. This work received the title "*Der Kuss*" [The Embrace]. If we compare "*Die Schwiegermutter*" [The Mother in Law] (ill. 203; 1967) with the advertisement for a steam iron which served as a model for this picture, we see Klapheck's great strength as a realistic artist – which is reminiscent of Magritte – and also the process whereby this realistic painting is transformed by its title into a highly imaginative, poetic and even magical work.

Both the American Lowell Nesbitt and the Spaniard Anzo have concentrated on the representation of electronic processing machines. Nesbitt's "*IBM 1440 Data Processing System*" (ill. 206) and his "*IBM 6400*" (ill. 207) date from 1965. By the cool precision with which he has depicted these products of our modern electronics industry, Nesbitt has shown that today every object can be put to appropriate artistic use.

Howard Kanovitz's "*Second Avenue Still Life*" of 1965 resembles his figure compositions in so far as it too constitutes an attempt to document the life of New York. In this work, the still life objects lying around on the table – books, prints, coins, a bottle etc. – are combined with a view through the window of typical New York house façades, which reflect the shadows of fire escapes.

Still lifes of flowers

In the past, flowers provided one of the principal themes for the painter of still lifes. Today, after a long period of neglect, they have come into their own again, for they reflect the wishes of the younger generation with particular force. They are better suited than any other symbol to portray the twin concepts of "Love" and "Flower Power", which between them characterise the attitudes of contemporary youth. Consequently, we find that flowers are now being painted by many artists and in many different ways.

Alex Katz painted his "*Violet Daisies*" in 1966 and his "*Tulips*" in 1967 (ill. 211). The Trinidadian artist Betandies introduced exotic flowers into his "*A ce soir*" [Until this Evening], where they appear as demonic entities, half plant and half creature, with garlands emerging from their calyces assuming the shape of arms, hands and faces.

In this work, the flowers are combined with the face of a woman, whose eyes are reproduced at various places in the picture. Lowell Nesbitt's "*Iris*" of 1965 (Hanford Yang Collection, New York) acquires a new quality through the use of a close-up technique, whilst Wayne Thibaud executed his "*Rose in Glass*" of 1966 in a realistic style that is decidedly "painterly". In his "*Love is an Offering – Length of a Chain IV*" (ill. 209), which shows two fingers extending from the edge of the picture space and fondling the petals of a rose, Stevenson also used a close-up technique, and in James Rosenquist's "*Sightseeing*" of 1962, roses are seen showing through the printed letters of the word "SIGHT", which extends beyond the picture on three of its sides.

We have already observed that in Monory's "*Dimanche Matin*" of 1966, the huge rose at the top of the picture helps to change the atmosphere of an interior scene. Jannis Kounellis has produced a *collage* of a rose (1967) from pieces of cloth assembled on a canvas, and has also produced various pictures of fireflowers. Peter Stämpfli's "*4 Roses*" of 1966 with its circular form is a particularly effective work. In his "*Yellow Rose*" of 1964, Martial Raysse painted a rose in a woman's hair.

Flowers also play an important part in other works by Raysse. In 1964, for example, he created a neon flower, whilst in his "*Spring*" (ill. 213), he superimposed the word "SPRING", which he executed in neon letters on to a ground entirely covered with wild flowers. In his series of "*Flowers*" (ills. 210, Plate VIII), Andy Warhol has dealt radically with the flower motif, transforming it into a universal symbol. His basic design is a stereotype composed of four flowers on a square ground of grass. Using a serigraphic technique and working in a kind of frenzy, he fashions from this basic design a visionary entity with new spatial dimensions, whose format and colour composition vary from work to work.

This theme reflects the ideas of modern youth and the key words for this particular genre are: non-violence, youth, flowers, beauty. We should avoid misinterpreting the flower as an esoteric and purely ornamental device. The truth of the matter is that the art of flower painting has now acquired new dimensions. The flowers depicted by contemporary artists, like those which the Hippies paint on their bodies, are directly related to the political reality of the day.

As in other branches of painting, so too in contemporary still life, the world around us is being observed and documented. Unlike his predecessors, the contemporary artist is not too proud to portray the trivial events and objects of daily life. Instead of subscribing to "higher" pictorial values, he concentrates on the environment, rediscovering and recording the beauty of objects with a tolerance and a *naiveté* that are quite new.

Landscapes and townscapes

Contemporary landscape and townscape painters are able to draw on the whole of the traditional repertoire, and can also incorporate much that is new. In the western world, this branch of painting has existed for some five hundred years and in China for very much longer. What are its basic constituents? What makes it a relevant vehicle for the emotions of contemporary man?

Whereas in past centuries the landscape was firmly grounded in nature, in our technological age it is based on an artificial view of nature, the sort of view that has been propagated by the travel and packaging industries in their posters and trademarks. Large numbers of our city dwellers know nothing else, and consequently contemporary artists have incorporated these synthetic images into their works.

Since the nineteenth century, landscape photography has also exerted a crucial influence on our relationship to external reality. Landscape photographers like Edward Weston and Ansel Adams have established new artistic attitudes to reality which are wholly convincing and fully elaborated. More recently, Otto Steinert (ill. 215), Paul

Keetman and Detleff Orlopp (ill. 227) have produced even newer forms of artistic landscape photography.

Since the turn of the century, land- and townscape painters have produced many splendid works, which are now regarded as classics in their own right. Artists like Cézanne, Monet, Picasso, Braque and the Surrealists built up a great tradition. From the contemporary point of view, the Surrealists were perhaps the most important, for they were able to advance from the physical environment into the intangible depths of human emotion. The ground was actually prepared for this kind of work by Caspar David Friedrich, whose works might well be reassessed in these terms.

Magritte, Dali, Tanguy, Oelze and Bellmer are amongst the most important of the Surrealist land- and townscape painters. Hans Bellmer's landscapes are composed of interlacing female forms. Yves Tanguy – arguably the most influential of the Surrealist landscapists – consolidated and extended the new dimensions indicated by de Chirico, transforming the landscape into a symbol of inner sensitivity which, although realistic and effective in itself, remains mysterious and intangible in its implications. This was an entirely new pictorial world, one compounded of miracles and magic. From c 1926 onwards, Tanguy has incorporated unreal figures into unreal landscapes, a combination which reflects the present relationship existing between man and nature. The only real thing about these works are the hallucinatory sensations they incite.

Between his splendid figure compositions, Magritte painted occasional land- and townscapes. In his "L'Empire des lumières" [The Empire of Light] of 1950 (Museum of Modern Art, New York), he also produced hallucinatory impressions. But, unlike Tanguy, he did not rely for his effects on the dream-like quality of transfigured forms. On the contrary, he accentuated the realistic elements of his work, thus throwing the unreal elements into sharp relief. "L'Empire des lumières" combines a nocturnal view of a street with trees, and a street lamp with a daytime view of the sky.

In the townscapes of Francis Bacon and Sidney Nolan, reality is transformed in such a way that the physical and the psychical components of their works are indissolubly merged.

Mark Tobey is another modern artist who has concentrated on townscapes, especially of big city life. In his early period, he frequently painted the market place in Seattle, Washington, and also the Broadway scene in New York with its great conglomeration of people and objects. As a result, he evolved a new Pointillist technique based on heavy concentrations of dots, which he used to construct a pictorial cosmos that reflected the life of the masses rather than the individual. This whole process, incidentally, was prompted by an increasingly contemplative attitude towards the world. Tobey also introduced Chinese calligraphy into his cosmic townscapes ("Edge of August", Museum of Modern Art, New York).

The works of the Austrian artist Friedrich Hundertwasser present a diametrically opposed attitude to reality. His labyrinthine landscapes with their paths, fences, plants and people depict a fairy tale world, in which everything is enchanted. These naive paintings have much in common with children's drawings for, like them, they represent a completely poetic view of reality, in which there is not even a hint of irony.

James Rosenquist has also painted landscapes, but of a very different kind. His famous "Front Lawn" of 1964 (ill. 217) shows a typical American garden lawn with a path, low steps and shrubs, which acquires a new dimension through the simplicity and realism with which it is represented. David Hockney has extended the normal scope of this branch of painting: one of his works is entitled "Theatrical Landscape" (1965). In her "Nuages sur le champ" [Clouds on the Field] of 1968, Milvia Maglione painted a field of leafy shrubs with a narrow strip of sky above them, and placed wooden cloud forms on the lower section of the field (ill. 222), whilst Antonio Carena always paints the same subject – the sky with shifting cloud formations ("Cielo oggettionato" 1967).

René Bertholo paints landscapes with houses, trees, clouds and sky, and also seascapes with jumping dolphins and steamers ploughing through the waves. For these works he employs the same mechanistic technique which characterises his still lifes,

with the result that they resemble collections of mechanical components. Not unnaturally, these components lose much of their existential quality, like the objects of children's drawings. Bertholo has also constructed landscapes in the form of mobile machines. In his "*Nuage*" [Cloud] of 1967, he painted clouds in a diagrammatic arrangement. Laura Grisi constructed waves and clouds in a number of seascapes in 1966. In these works, the actual composition is enclosed within a circle of plexiglass so that it looks like a view through a porthole. Despite their distinctly contemporary technique, these paintings constitute something approaching a new form of Romanticism. Martial Raysse has also created a new type of landscape which is well illustrated by three works painted in 1966: "*Paris beau et khôn*", "*La vision est un phénomène sentimental*" [Visions are a Sentimental Phenomenon] and "*Preserved Spring*". Raysse uses every available technique, including neon lighting. Consequently, he has been able to exploit artificial, man-made objects to the full. He is an artist who has shown us the beauty of our modern world of artificial materials and artificial lighting, now competing with the beauty of the natural world.

Since 1964, Roy Lichtenstein has been producing landscapes based on a simple and – in some cases – a mass-production technique. His "*Arctic Landscape*" (1964) is an early example. It shows the horizon of a Polar landscape with a broad expanse of sky and a narrow strip of cloud extending across the entire picture. His "*Seascape*" of the same year, which was also produced by screen processing, is an even more disciplined composition. In 1965, Lichtenstein's landscapes became more dramatic. The gigantic sky in his "*Kinetic Seascape No 3*" of 1966 (ill. 220) is a *collage* composition made from iridescent material. The specific forms assumed by this picture, which produce a highly dramatic effect, stem solely from the material, which the artist has left unchanged. His "*Night Seascape*" of 1966 (ill. 221) is a cloth print processed on felt and reproduced in quantity. It could, therefore, be used to decorate a room, like Warhol's "*Cow Wallpaper*". Despite his dispassionate and rational use of stereotyped forms, Lichtenstein's landscapes have a certain poetic quality; they radiate an entirely new kind of Romanticism.

In 1965, Lucio Fontana also turned to landscapes. Since then, he has created a series of works in this genre which, although basically a development of the "*Concetti Spaziali*" [Spatial Concepts] of his earlier period, also incorporate space, light and colour. In these paintings, in which tree silhouettes are frequently placed in front of deep backgrounds, the spatial relationship between the two pictorial levels is an important factor. Like his fellow artists of the present decade, Fontana is not concerned with the nineteenth century type of landscape composition. What interests him are stereotype images of the landscape, which enable him to use some familiar object in order to illustrate his new impressions of space.

New landscape forms are to be found in the pictures of Llyn Foulkes. In "*The Canyon*" of 1964 (ill. 225), he painted two almost identical versions of a rock face and placed them next to one another. The absolute simplicity of this work gives it a highly dramatic effect, and the duplication of the rock formations elicits an emotional response from the viewer, who is inclined to compare the two versions with one another. In his "*Untitled*" of 1966 (ill. 226), Foulkes has depicted a group of enormous rocks which reveal figurative qualities. It would seem, however, that these anomalies are due to natural causes and not to any specific intention on the part of the artist.

Many contemporary townscapes have been inspired by the city of New York. In 1963, for example, Letty Eisenhauer created her box "*Souvenir of New York City*", which shows a view of Manhattan from the water, whilst Peter Brüning used a photograph of a similar view for his "*NY NY NY NY*" (ill. 238), in which he alienated the townscape by means of signs (dots, curved lines, interlacing lines, letters and circles) arranged in menacing formations.

Gerhard Richter is another artist who has been concerned with the big city. His "*Alster*" acquires its peculiar atmosphere from the use of a blurring technique, whilst in his "*Milan*", "*Munich*" and "*Madrid*" (ill. 237), which all date from 1968, he produced

a series of townscapes based on bird's eye views. Like the "*Alster*", these works were derived from photographic models. In this new perspective, the big city appears as a mere speck on the surface of our planet. George Deem also uses photographs or paintings as models for his landscapes, which he then arranges in sequence (ill. 228), and in his "*Rainbow over Inness 'Lackavanna Valley'* " (ill. 223) of 1965, Sante Graziani has combined a painting by this American artist with a rainbow.

The contemporary landscape transcends the natural scene. By depicting the topography of large areas of the earth, it acquires a cosmic significance. Yves Klein's planetary reliefs, which he constructed from blue sponges, typify one aspect of this development ("*Europe-Afrique*" [Europe-Africa], 1961). Another is exemplified by Jasper Johns' "*Double White Map*" of 1965 (ill. 229). In this work, Johns painted two identical maps of the United States, which he then placed one above the other. The names of the individual states are printed in. Larry Rivers has produced a similar double map of Africa, whilst Mario Ceroli has created a wooden relief map of Europe. Johns returned to this cartographical theme in 1967, producing his "*Map*" (ill. 230), in which he expressed Buckminster Fuller's universal view in visual and artistic terms on a map of the world. This projection of the world is not represented as a globe, but as a series of spatially integrated triangular forms. The result is an entirely authentic work, in which the artist uses contemporary techniques to create a total view of the world.

Landscapes and roadscapes

A number of our younger artists have presented entirely new aspects of the contemporary reality of big city life by introducing into their pictures those facets of modern technology and transportation which have exerted such a crucial effect on the landscape. For example, Allan d'Archangelo, whose works are based on stereotypes, has painted a number of roadscapes which are realistic in a technical sense. Today, most people experience nature from a motor car, which means that their view of nature is reduced to a series of images because of the speed at which they pass through it. D'Archangelo has depicted this kind of view in paintings such as "*US Highway*" of 1963 (ill. 219), "*Guard Rail*" of 1964, "*Untitled*" of 1965 (ill. 216), and "*Proposition No 6*" of 1966.

Since 1964, the Japanese artist Kumi Sugai has been painting roadscapes which create an impression of dynamism and tension, speed and impending catastrophe (ill. 218). These include his "*Dimanche Matin*" [Sunday Morning] and "*280 km heures*" [280 km per hr] of 1965, his "*Autoroute 911*" and "*Route Nationale No 6*" of 1966 and his "*Mercure*" [Mercury] of 1967, a large format work of cosmic significance.

In 1967, the Spanish artist Anzo also painted a number of landscapes with roads, bridges and motorways, for which he used a spatial technique based on colour composition.

The architectural picture

A further consequence of the new view of reality which has developed over the past decade has been the incorporation of architectural themes into painting. This applies not only to the new structures which have been added to our traditional environment, but also to the older buildings which make up the major part of municipal architecture. Today, a documentary record is being established of buildings dating from the early industrial era. As far back as the 1930's, Dorothea Lange was assembling a comprehensive photographic record of agricultural and industrial expansion, of population shifts and the growth of technology, and also tried to come to grips with the human problems which these entailed. Many different aspects of this difficult period of transition have found expression in her pictures.

For many years now, the photographers Bernd and Hilla Becher have been taking pictures of pithead installations, cooling towers, gasometers and similar buildings from the early days of the technological era which are no longer able to cope with modern output requirements and will shortly be demolished (ills. 231, 232). Their detailed technical knowledge and passionate involvement give an artistic dimension to what is essentially a documentary record.

The Californian artist Edward Ruscha has specialised in the portrayal of petrol stations. His "*26 Gasolin-Stations*", a book of photographs which he published in 1962, is far more than a technical exercise; these pictures possess a definite artistic quality. In a further book on the Strip, he provided a pictorial record of all the buildings on this important Los Angeles street. In 1963, Ruscha created a picture of a petrol station which he called "*Standard Station Amarillo; Texas (Day)*", and in 1965–6, he portrayed the same petrol station in flames ("*Burning Gas Station*", ill. 240).

Many contemporary artists have responded to the fascination of New York City. Pol Bury has created a whole series of dynamic deformations of places like the Seagram Building, Washington Bridge, the Main Post Office and the Pan-American buildings. In these works, in which Bury subjects his original photographs to a process which he calls "Cinétization", the buildings and installations are so transformed that they appear to be moving. Eduardo Paolozzi has also created a series of pictures of New York buildings. So, too, has Valerio Adami, who applied the foreshortening and contraction techniques which characterise his figure compositions to a civic environment, as in "*Plain Air No 2*" (ill. 236) of 1968, which depicts the Guggenheim Museum, and "*Plain Air No 1*", which depicts other New York buildings. Richard Hamilton has portrayed Frank Lloyd Wright's Guggenheim Museum, the most splendid of all New York buildings, in prints, paintings and reliefs, whilst the Italian artist Laura Grisi has also been inspired by certain New York scenes. Her "*East Village*" of 1967 (ill. 244), a colourful ensemble of light, plexiglass, human silhouettes and printed signs, is a typical example. In his "*Aislamiento – 12*" [Isolation] of 1967 (ill. 235), the Spanish artist J.I.A. Anzo portrayed a view of a visionary city made up of glass skyscrapers with curved walls.

Lowell Nesbitt is concerned with quite a different sort of structure. In his historicising pictures, he depicts the cast iron architecture which was so revolutionary when it first appeared in the mid nineteenth century. These buildings, most of which are enriched with Neo-Classisistic ornamentation, still cover a large part of southern Manhattan. Nesbitt's "*Black Windows*" of 1965 (ill. 233), which reveals a positive obsession with the historical aspect of this style of architecture, is executed with such absolute sobriety and precision that the work acquires a value far in excess of its status as a historical document. His achievement is really twofold. On the one hand, he offers a reappraisal of the underestimated architecture of his native city, now threatened with destruction, whilst on the other hand, he revives the Realism of 1930's American art, which is also underestimated.

Thomas F. Akawie is another artist whose pictures betray a passionate concern with the history of architecture and artistic form. The plans of churches and old buildings

which form the subject of so many of his works, and the traditional details which frequently determine their form, are clearly derived from his knowledge of the history of art. Such knowledge is, of course, a characteristic feature of the present generation for all young artists today are versed in the historical background to their work.

Roy Lichtenstein's "*Temple of Apollo*" of 1964 has little to do with a Greek temple in the historical sense. On the contrary, it was inspired by the stereotyped image of antiquity put out by the travel agencies (ill. 234). And yet this work is none the less the product of a historicising or, to be more precise, a "classicising" mind. It also contains an allusion to national characteristics in so far as Greece was the cradle of democracy.

XIV Kumi Sugai
Matin d'autoroute 1964 ▷

XV Giuseppe Capogrossi *Superficie 626* 1963–68

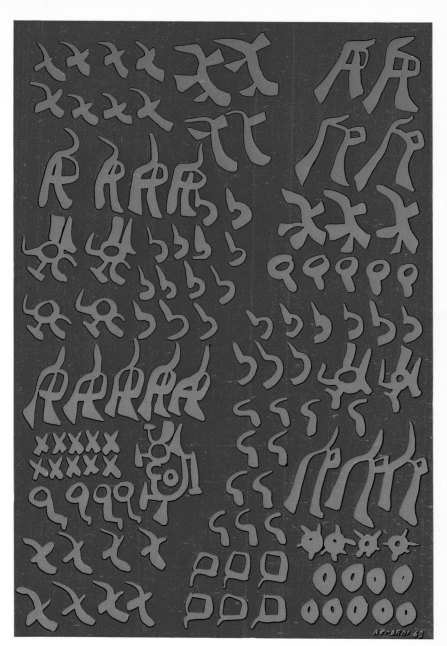

XVI Carla Accardi *Pittura* 1963

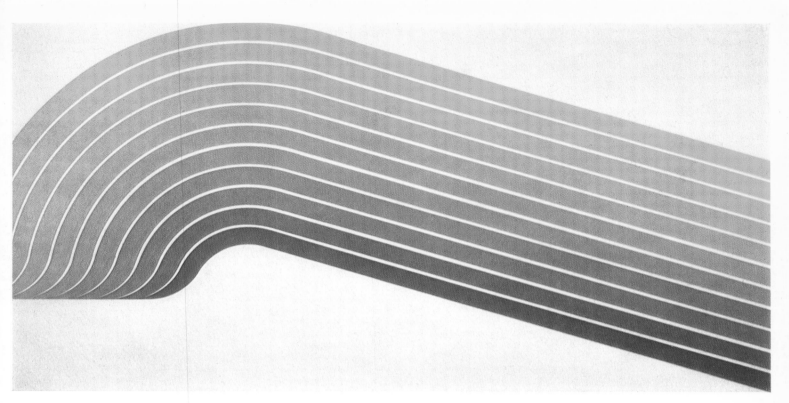

XVII Herbert Oehm *Nr. 6/31– 67* 1967

Interiors

Interiors provide our younger artists with one of their favourite themes, and one that is well suited to the presentation of contemporary phenomena. James Rosenquist ("*Untitled*", 1963; The Harry N. Abrams Family Collection, New York) and Tom Wesselmann ("*Interior No 4*", 1964) have both produced works in this genre. In 1964, Richard Hamilton created a *collage* interior composed entirely of stereotyped images culled from furniture catalogues, whilst in 1965, David Hockney painted his "*Blue Interior*". In his "*Anton Webern Opus 5 No 3*" of 1963 (ill. 249), George Mueller presented an interior which incorporated the view through a window of a street with two symmetrically placed trees backed by house façades, the whole composition being rhythmically organised by means of holerith-type signs.

Interiors play a central part in Lowell Nesbitt's programmatic work. He paints clearly defined objects in unoccupied rooms, as in "*Claes Oldenburg's Studio*" (ill. 247), "*Louise Nevelson's Studio*" (ill. 248), and "*John Willenbecher's Studio*" (Johnssen Collection, Essen; all 1967). Nesbitt has also painted details of interiors – "*Cabinet*" (1966) and "*Chair and Ladder*" (1967) – in which the pictorial objects lead an isolated life of their own. The human figure has been entirely banished from these works. Even the air seems to have been expelled by the intensely realistic objects, which occupy the whole of the picture area and give these works a ghostly and inanimate character.

In his technical interiors, Anzo shows man isolated from his fellow beings and surrounded by the mechanical slaves which he himself has made. "*Aislamiento – 29*" [Isolation] of 1968, which is made up of two component pictures executed in the style of advertising photographs and placed one above the other, is a typical example of his work.

Valerio Adami is yet another contemporary artist who has taken an interest in interiors. His "*Scena Borghese*" [Bourgeois Scene] of 1966, his "*Le Vacche da Bagno*" [The Cow in the Bathroom] and "*Per un Grand Hotel*" [For a Grand Hotel] (ill. 241) of 1967 present heavily foreshortened interiors with figures and objects. But, not all of his pictures are executed in the same style. Unlike Nesbitt, who always employs the same realistic means, Adami varies his technique. By and large, he has tended to concentrate on sanitary interiors, as in "*Latrine in Times Square*" (1968).

Malcolm Morley's interiors are based on photographic models. His "*First Class Cabin*" of 1965 is derived from the sort of photographs used in travel brochures to advertise ocean voyages. Gerhard Richter has also had recourse to photographic models. His "*Grosser Vorhang*" [Big Curtain] of 1965 (ill. 253) is an extremely ingenious work which hints at the existence of an enclosed interior by the simple expedient of a drawn curtain. In his "*Fünf Türen*" [Five Doors] of 1967 (ills. 251, 252), he constructs an unreal interior from real components.

The interiors created by contemporary artists depict man's relationship to his environment, and also to his own inner personality. Consequently, they symbolize human patterns of behaviour in our time. In literature Proust, Rilke, Kafka and Beckett have shown that the interiors of buildings are viable symbols of the human condition. The same holds good in painting.

Transportation

Transportation plays a major part in big city life, where it influences and to some extent controls, human activity. Not surprisingly, therefore, it has also been one of the themes of twentieth century painting. Railways, of course, had already featured in nineteenth century art, but it was not until the Futurist Marinetti contrasted a racing car with the "*Winged Victory of Samothrace*" that transportation was established as an integral part of a specific artistic programme.

Two of our major modern systems of transportation have suffered an almost total eclipse of recent years. After being hailed as a revolutionary means of communication in the mid 1900's, the railways are now little more than a romantic relic in both America and Africa. The great ocean liner has also become something of a nostalgic symbol. Today, steam has given way to petrol, and it is the motor car and the aeroplane which symbolize our present era.

But, in the course of the twentieth century, many artists have also been inspired by the bicycle and the motorcycle. The bicycle will no doubt have found its way into art because it happened to be the most suitable machine available at a time when painters felt the need to express mechanical movement in pictorial form. Edward Muybridge created whole series of cycling photographs. Lyonel Feininger ("*Radfahrer*" [Cyclist] of 1912) and Depero Fortunato ("*Cyclista Veloze*" [Sprint Cyclist] of 1922) both used the bicycle for Futuristic compositions, and in his "*Peregrinations of George Hughel*" of 1935, the Surrealist artist Domingues depicted it in combination with an animal. In 1959, when he painted his "*L'Etat de Grace*" [State of Grace] (William Copley Collection, New York), René Magritte combined a burning cigar with a bicycle. This a-logical study, which evokes the world of Lautréamont, is an extremely effective piece of Surrealist art. Francis Bacon incorporated a bicycle into one of his pictures: "*Portrait of George Dyer Riding a Bicycle*" of 1966. So, too, did Gerald Goochs in his "*Wrong Way, Doctor*", a sequence of fifteen painted scenes which also dates from 1966. In the previous year, Kendell Shaw had created his "*Bicycle 2*" whilst in 1964, Chabaud had portrayed a cycle race in his "*Fiche Vélodrome*".

Lowell Nesbitt has adopted the bicycle as a permanent feature of his pictorial repertoire (ill. 255). None the less, if we recall the fascination which bicycles once held for the poet Alfred Jarry, it is clear that today they have lost much of their appeal. They are now featured in the works of only a few artists.

The motorcycle, on the other hand, remains an important theme. Our younger artists find it an appropriate symbol of the protest of modern youth against the established generation. Peter Phillips, for example, has painted numerous pictures, in which motorcycles are represented as living creatures, the modern counterpart of the nineteenth century cowboy's horse. In his "*Pennzoil Eleven*" of 1963, Richard Pettibone also used the motorcycle as a teenage symbol, incorporating it into a striped landscape to create an impression of high-speed driving. Billy Al Bengtson painted a two-dimensional motorcycle in black, white, orange and blue which he modelled on an advertising picture ("*Skinny's 21*", 1961). Alberto Moretti also treated this theme in his "*Motociclisti*" [Motorcyclists] of 1964, whilst Bob Stanley interpreted the motorcycle as a teenage status symbol in his serigraph "*Motorradfahrer*" [Motorcyclist] of 1967.

Cars – especially racing cars – are, of course, a much more important contemporary theme. As early as 1947, Wright Morris used a photograph showing a rear view of an early Ford for his "*Model T*". In the 1950's, William Copley produced numerous pictures of cars, and in 1965, Robert Bechtle painted an old, inefficient model under the title "*46 Chevy*". Peter Phillips has repeatedly incorporated racing cars into his pictures, where they serve to illustrate the new dynamism and the new subject matter of contemporary art. In 1964, Tom Wesselmann produced a side view of a Volkswagen, to which he gave the ironic title "*Landscape*". In 1968, the Volkswagen was also featured in "*VW Käfer*" [VW Beetle] by Jiri Kolar, who used a photograph as a working model. By contrast, Ercole Pignatelli introduced theatrical colour effects into his

"*Breve sosto sull' autostrada*" [Short Stop on the Autostrada] of 1968 in order to heighten its sentimental romanticism.

Details of cars, traffic signs and advertising signs issued by the motor car industry have also featured in numerous paintings. So, too, have the badges of various automobile associations and the kind of emblems displayed by juvenile gangs (e.g. in Peter Phillips' "*Motor Psycho Club Tiger*" of 1962). Engines and engine parts have been depicted by Alain Jacquet, in his "*Car Engine*" of 1967 and his "*Rolls Royce Jet Engine*" of 1968.

Laura Grisi ("*Model Racing Car*", 1967) and Gerald Laing ("*Lotus 1*", 1963, ill. 258) have also treated the subject of the racing car. Like Richard Hamilton ("*Homage to Chrysler Corp*" of 1957 and "*Hers is a Lush Situation*" of 1958) and Peter Stämpfli, James Rosenquist has combined details of motor cars with other objects, as in his "*Director*" of 1964 (ill. 257). In "*I Love You With My Ford*" of 1961, Rosenquist had already produced a cryptic car painting, the key to which lay in the title.

Rancillac has contrasted a view of the front section of a motor car with the head of a driver, which extends into the picture from the foreground, and cars or spare parts of cars also appear in Fritz Köthe's paintings of torn posters, usually in conjunction with more or less naked female bodies. In his "*Truck Stop*" of 1966 (ill. 260), Alex Colville reverted to a 1930's type Realism which he brought up to date by his use of sectional and close-up techniques.

Once the motor car had been incorporated into contemporary art, it was soon followed by various attendant phenomena, chief amongst them the motor car accident. Meanwhile, this theme has become so dominant that we now possess what amounts to an iconography of accidents. This was probably initiated by Andy Warhol in 1963 with his "*Orange Car Crash*" (ill. 263), a serigraph processed from a news photograph, although Mario Schifano's "*Incidente*" [Accident] dates from the same year. In his "*Saturday Disaster*" of 1964, Warhol composed a corporate picture from photographs of two separate motor car accidents (ill. 264), and Bob Stanley based his "*Crash 1966 Indianapolis 500*" (ill. 261) on the great pile-up which occurred at Indianapolis in 1966. The French artist Monory has also treated the accident theme in his "*Ariane, Hommage à Gesualdo*" [Ariane, Homage to Gesualdo] (Plate XII) which shows a body lying in a motor car, whilst Brett Whiteley has combined a photograph of a wrecked car with an advertising photograph of the same car in perfect condition in a two-part composition entitled "*No*" (1968, ill. 262).

The railways, which helped to shape a whole era in the nineteenth century, are rarely featured as such in contemporary art. But locomotive wheels have proved a source of constant fascination, not only to painters, but also to photographers and film makers of modern times. Albert Renger-Patzsch took photographs of locomotive wheels as early as 1923, and of recent years his work has been continued by Paul Keetman, albeit along highly original lines.

Sheeler, who was both a photographer and a painter, produced his "*Wheels*", a painting based on an original photograph, in 1939. His oil painting "*Rolling Power*" was also based on one of his own photographs. In both of these pictures, therefore, the photographic model was really more in the nature of a preliminary study. What Sheeler was trying to do was to capture an impression of movement in precise pictorial terms. His paintings are simplified and abstracted, and the original photographs have been composed so as to lend permanence and definition to the finished works. Although his technique must have appeared surprising and even paradoxical to those of his own generation, when considered against the background of present day developments, it seems entirely appropriate.

Magritte incorporated a railway train into "*Le Rossignol*" [The Nightingale] (Max Ernst Collection), which he painted in 1962. But Magritte was, of course, a Surrealist and his train is seen running across the sky, where it encounters a Zeus-like figure seated on a cloud.

Ships, aircraft and rockets are rarely found in contemporary paintings. When they are,

they are always derived from photographs, comic strips or films. Lichtenstein used aircraft in his "*Tex*" of 1962 and his "*Hot Shot*" of 1964 to symbolise the new environment of the Comic Strip hero. They are also featured in Smerck's "*Recueil Portatif*" of 1964, and in pictures by Juan Genoves and Colin Self ("*Lockheed SR-7 Taking Off*" of 1967). Although James Rosenquist depicted a sailing boat in his "*TV Boat 1*" of 1966, he was not trying to portray a real sailing boat. On the contrary, what he was concerned with was the status value of the sailing boat image as seen on television (ill. 266). Gerhard Richter's "*Motorboot*" [Motorboat] of 1965 (ill. 267) is a work of a similar order. Ships play an important part in Malcolm Morley's works, as in "*Amsterdam*" of 1966 (ill. 269) and "*United States*" of 1965 (ill. 268). But here, too, the ships are based on stereotypes, which Morley has taken from travel brochures. Like his shipboard interiors and his groups of figures lounging on sundecks, his New Realist ships are firmly grounded in a photographic reality which, having been employed for advertising purposes, is no longer entirely credible. Furthermore, by his use of phrases such as "dream voyage", Morley implies that the whole concept of sea voyages has now become unreal.

Pictorial signs for organic phenomena

The whole burden of Paul Klee's theoretical ideas is contained in his dictum: "Art does not render what is visible, art renders visible." An important part of recent painting is based on this conception, and constitutes an attempt to render in pictorial form the forces, energies and laws of growth underlying natural phenomena. In such works plants, flowers, trees, etc. are portrayed by signs, which are structured and organised to represent organic processes. And so painters like Wols, Hans Hartung, Julius Bissier, Giuseppe Capogrossi, Carla Accardi, Mauricio Nanucci, Elisabeth Mamorsky, Kawashima and many others, whose iconography has yet to be fully established, are actually working in the Klee tradition.

Since the 1950's, Capogrossi has been painting sequences of calligraphic signs designed to reflect natural processes. These pictures, which bear the generic title "*Superficie*" [Surfaces], call to mind the sort of images which appear on the screens of technical apparatuses, although this resemblance does not in any way detract from their fundamentally organic character ("*Superficie*" of 1965, Plate XV).

For her paintings, in which she appears to be treating the subject of growth and maturation, Carla Accardi chooses structures which are more closely associated with the organic and vegetable world. Her early works in this genre, such as "*Integrazione rosso-nero*" [Red-black Combination] of 1960 and *Pittura* (Plate XVI), are two-tone compositions, in which she has combined pairs of colours, e.g. red and black, black and white, blue and white. She later heightened the dramatic effect by introducing violent colour contrasts. Recently, however, she has reverted to the harmonious colour combinations of her early period. Like Elisabeth Mamorsky, Accardi represents nature in terms of its inner laws and not its external appearance.

For some time now, Herbert Oehm has been evolving new structural patterns based on spatially organised curved forms to depict organic phenomena on a two-dimensional plane (Plate XVII). This process (which constituted a complete departure from the Constructivist compositions of his early period) is illustrated by his "*6/59–68*", a work that is reminiscent of a painting by Sophie Täubner, and his "*6/56–68*". Carmen Gloria Morales, the Chilean artist, has also used spatial curves in her colour compositions to represent natural phenomena, although her structures differ from Oehm's in so far as they reflect the findings of more recent research.

Paolo Patelli has developed these nature-oriented pictorial structures to the point where he is able to produce them in quantity, and has also assimilated them with analogous scientific forms. Mauricio Nannucci has followed a similar trend inasmuch as he too works in quantity, producing positive and negative calligraphic forms which

appear to correspond to natural laws of growth ("*Modello scalare*") of 1967. In their works, these painters are providing new insights into natural processes, which correspond to the morphological phenomena that are assuming growing importance in the spheres of architecture and sculpture.

The Japanese Kawashima and the German Bubenik have reduced their signs to scientific ciphers which, for all their sober authenticity, still retain vital organic or sexual links. The cosmic sexuality of Kawashima's organic composition is well illustrated by his "*New York XIII*" (ill. 273), a work composed of twenty-five identical squares, each of which contains a different organic form. Bubenik presents his pictures, which are based on chemical or cellular processes, in the guise of scientific illustrations or demonstrations (ill. 274). But, although he reproduces spinal structures and various functions of the sense or sexual organs apparently without any kind of deformation, his luminous colours impart to these objects an independent artistic existence.

There are many artists working in this field, and their works are often misunderstood. Contrary to popular belief, they are not concerned with formal or ornamental arrangements. In fact, their works reflect the complex morphological processes discovered by scientific research.

Pictures for order

There is no art without an object. Consequently there is no non-objective art. Despite the many misunderstandings to which this concept has given rise, art still remains what it has always been: a means of communicating with people. The essentially objective nature of art was recognised and elucidated by Picasso in a conversation with Christian Zervos in 1935: "There is no abstract art; you have to start with something. You can wipe out the traces of reality afterwards. But by then, there is no longer any danger, because the idea of the object has meanwhile created an indelible sign."

In assessing the subject matter of contemporary art, we must remember that although our present day reality has gradually evolved over the centuries, in the course of that evolution the impact of industrialisation, technology, transportation, mass society, space travel, the electronics industry etc. has produced fundamental changes in our environment, so that the world now appears to be totally different from the world which existed two hundred years ago. This new world, with its relics of past cultures, constitutes our reality. We all live in it – artists and public alike – and we must all accommodate ourselves to it, though the artist is also in the position to create new perspectives which help us to find our direction.

Barnett Newman wrote about this basic problem in connection with one of his paintings: "It [the painting] is full of meaning, but the meaning must come from the seeing, not from the talking. I feel, however, that one of its implications is its assertion of freedom, its denial of dogmatic principles, its repudiation of all dogmatic life. Almost fifteen years ago, Harold Rosenberg challenged me to explain what one of my paintings could possibly mean to the world. My answer was that if he and others would read it properly, it would mean the end of all state capitalism and totalitarianism. That answer still goes."

In the twentieth century, this particular objective has been sought primarily by those artists following the various branches of Constructivism, whose basic tenets were formulated by Naum Gabo in 1937: "The Constructive Idea in art presupposes an entirely new approach to the essence of art and to its function in life." Gabo also pointed out that the component elements of this art form are not abstract signs but direct, organically-based equivalents for human emotions, the kind of components, in fact, which have been used in Classical Western art for centuries.

Because it was fundamentally opposed to chaos, Constructivist art established close links with architecture. It was no accident, therefore, that many Constructivist artists

went over to architecture, and that many others collaborated with architects trying to express the new ideas in their buildings.

Kasimir Malevich carried Constructivism to the point where he no longer differentiated between its artistic and its social components: "Painting has long been outdated, and today the painter is no more than a prejudice handed down from the past. We now have to turn to concentrations of colour as such, and try to find in them the crucial forms. The movement of these masses of reds and blues and greens cannot be reproduced in representational drawings. This dynamism constitutes a revolt on the part of the pictorial masses, which are determined to free themselves from the object."

The Constructivist tradition is still being carried on today by contemporary artists, who try to create order in a disordered society and controlled movement in a world of flux. The function previously fulfilled by Malevich, Mondrian, van Doesburg, Kupka and their associates has now been taken over by artists such as Herbin, Vasarely, Mortensen and Stazewsky. Herbin creates his equivalents by combining colour and space ("*Paradis*" of 1959); Mortensen creates graduated spatial effects by means of colour combinations; Stazewsky paints coloured blocks which radiate into space like reliefs, whilst Vasarely obtains his spatial effects from numerical sequences.

In the works of younger artists like Howard Mehring (ill. 278), Guido Molinari (ill. 277), Miriam Schapiro (ill. 281), Michael Vaughan, John Hoyland, Robin Denny and John Plumb, who also use colour sequences to create spatial effects, the "relief" principle, by which the pictorial forms appear to stand out from the picture surface, is important. The paintings of Jim Bishop, Eva Hesse and John McLaughlin are dominated by large, rectangular forms. Ivan Picelj paints Illusionist sequences, whilst up to 1966 Neil Williams was producing spatial compositions by combining diagonal forms. These pictures of order in movement are Classical in composition and are still related to reality, albeit in a new way. Other contemporary artists such as Masuho Ohno (ill. 298), Gottfried Honegger (Plate XIX), Marcolino Morandini (ill. 283), Peter Stroud, Kaspar Thomas Lenk, Günter Fruhtrunk, Jack Canepa (ill. 280), and Pia Pizzo have succeeded in producing vibrations by combining and overlapping their pictorial forms. These painters – whose works are directly concerned with reality, with buildings, walls, squares, and with the organisation of the external area – produce kinetic effects without departing from the traditional techniques of two-dimensional painting.

Larry Poons also produces kinetic effects, but he does so by a combination of colour and compact design. His technique is well illustrated by his "*Orange Crush*" of 1963 (ill. 275), his "*Richmond Ruckus*" of 1963–4 (ill. 276) and his "*Aqua Regia*" of 1964, which consist of optical particles set out in accordance with a preconceived design. Jeremy Moon has created similar organisational systems in his "*Eiger*" of 1965. His circles – like Poons' particles – follow an apparently irregular pattern. Bridget Riley has produced an illusion of movement and overlapping action by arranging lines and dots in patterns which blur the viewer's vision. Her "*Crest*" of 1964 (ill. 285) and her "*Exposure*" (ill. 284) are typical examples.

Apart from Poons and Riley, Jeffrey Steele and – above all – Frank Stella have also evolved new conceptions along these lines. Stella's works in this genre include his "*Fez*" of 1964, "*Jill*" of 1959 (ill. 286), "*Quathlamba*" of 1964 (ill. 288) and "*Ileana Sonnabend*" of 1963 (ill. 287). With their repeating and in many cases symmetrical patterns of parallel lines, these works demonstrate the fusion of object and representation which has typified the art of the 1960's. Stella has commented on the relationship between space and plane, which is the principal problem encountered in this type of painting: "A symmetrical configuration on an open plane does not produce an illusion of space. My solution – there are probably others, but this is the only one I know – was 'density of colour', by which I mean that by using a regular pattern, I made the picture produce its own illusion of space." In 1966, Stella changed his technique. Since then, he has been using more intense colours, more rounded forms and asymmetrical combinations.

Other artists such as Wojciech Fangor (ill. 309), Gerald Laing, Richard Smith (ills. 334, 335, 336), Franco Fabiano (ill. 347), Paolo Scheggi, Sven Lukin (ill. 343) and Giulio Paolini have allowed their dynamic configurations to extend into the external area in the physical sense. By doing so, they have, of course, broken the bounds of panel painting and entered the sphere of environmental art.

But even in two-dimensional painting, this particular kind of composition is grounded in a highly dynamic view of reality, in which the relationships between the component objects are subject to constant change. Although popular acceptance of this trend was deferred for many years due to the mistaken belief that is was alienated from reality, it has always been – and still is – an entirely legitimate genre, in which artists have sought to create order out of chaos. In doing so, they have established a number of basic forms which we must now consider. They are: the circle, the square and the curve.

The circle

The circle played a special part both in the ancient art of China and India and the art of Mediaeval and Renaissance Europe. In so far as it is a complete form and a symbol of perfection, it is hardly surprising to find that twentieth century artists have also made extensive use of it, albeit for different purposes than those adopted by their predecessors of the Italian Renaissance. Wassily Kandinsky explained why the circle was so important to him.
"It is:
1. the most modest and the most self-assertive form,
2. precise but infinitely variable,
3. both stable and unstable,
4. both quiet and loud,
5. a tension, which contains innumerable other tensions."
Today, the circle is frequently represented by the rotating disc, which constitutes an analogue to the rotating wheels of modern machinery. Marcel Duchamp's Rotoreliefs of 1920, which followed Robert Delaunay's cosmically oriented works, are early and fully elaborated examples of this twentieth century development. In these reliefs, which were amongst the very first kinetic works ever produced, Duchamp used rotating discs to produce concentric patterns of movement.
Ella Bergman's "*Archimedes 1*" of 1928 stems from the same basic conception. So, too, do Bruno Munari's "*Die Stunde X*" [X Hour] of 1945/63 and Pol Bury's "*Punctuation 380*" of 1960. The central motif of Bury's work is formed by the movement of circular holes in a circular disc. Jean Tinguely has also treated this theme in a number of works, in which moving wires are mounted on circular discs, whilst Heinz Mack has produced Rotoreliefs and Light Dynamos from aluminium discs, which rotate slowly behind a sheet of patterned glass. Günther Uecker has created circular nail reliefs, which also rotate. Other artists who have incorporated the circle into their work include: Wolfgang Ludwig (ills. 294, 295, 296), Kuwayama, Les Packer ("*Constructed Relief, Blue Series*, 1967), Ilya Bolotowsky, Milan Dobes (ill. 290), Tadasky (ill. 289), Robert Irwin, William Leete and Bernard Aubertin (Plate XXX).
Bridget Riley and Marina Appollonio (ills. 292, 293) have used circles to create optical effects, whilst Getulio Alviani has employed them for his steel reliefs, e. g. "*Superficie atestura vibbratile circolare*" of 1965 (ill. 300), and also for his ornamental extravaganzas, e.g. "*Orecchino*" [Earring] of 1967 (ill. 301), and "*Abito*" [Dress] (ill. 299).
The Japanese artist Masuhu Ohno has introduced circular forms into highly complex compositions, in which they combine with light and shade and with graduated horizontal and vertical lines of force (ill. 298). The circles in Edward Avedisian's works, which are patterned with stripes, appear to float on the neutral ground, whilst in their

paintings, the South American Rogelio Polesello (ill. 291) and the Czech Milan Dobes (ill. 290) depict partial circles within perfect circles. German artists like Uwe Poth and Hermann Krupp have had constant recourse to circular forms, which also provide the central motif for many of Jiri Kolar's and Ferdinand Kriwet's visual poems.

The versatility of the circle motif is demonstrated by the target pictures of Jasper Johns and Jaak Frenken, a Dutch artist who often incorporates sculptures into his work. For example, one of Frenken's pictures shows a small statuette of Christ in the centre of the target.

The circular pictures and *décollages* of Reinhold Köhler, works by Raimund Girke, certain kinetic works by Gerhard von Graevenitz, works by Martha Botho ("*Déplacement Optique*" [Optical Displacement] of 1966 and "*Diffractions lumineuses*" [Luminous Diffractions] of 1966–7), Demarco's kinetic light reflections, William Leete's coloured circles, Howard Jones' light pictures ("*Skylight 1*" of 1966) (Nancy Singer Collection, St. Louis. Mo.), pictures by Turi Simeti in which regular ovals are arranged in specific formations, Enrico Castellani's "*Superficie bianca*" [White Surface] of 1967, works by Hermann de Vries', works by Claude Tousignant, such as his "*Accélération chromatique*" [Chromatic Acceleration] of 1967 in which a circle composed of different colours creates an impression of rotation, and similar paintings by Ivan Picelj, who has had constant recourse to this motif, may be included in this category.

The Pole Wojciech Fangor (Plate XXV) is another contemporary artist who uses colour to produce an impression of circular movement. His dynamic compositions are technically comparable to the works of the Americans Robert Irwin and Kenneth Noland (Plate XXIV) and the Englishman Peter Sedgeley, although it must be admitted that each of these artists uses the circle motif in a completely individual manner.

Getulio Alviani and the Japanese artists Juko Nasaka and Ay-O have also made the rotating circle the focal point of various works, for which they have used new methods including mechanical processes. Gerhard von Graevenitz and the Chinese artist Li-Yuan Chia have mounted rotating discs, driven by magnets, on neutral backgrounds. In Robert Rauschenberg's "*Image Wheels*" of 1967 (ill. 297) – a multilayered, rotating composition made of aluminium and plastics – the movement and the circular form serve to underline the universal theme.

Once the circle had been established as a central motif, the sphere followed. This logical extension of the original theme is now found in works by artists such as V. Richter, Otto Piene (who made spheres from electric lamps) and François Morellet (who evolved his spheres from earlier pictorial forms).

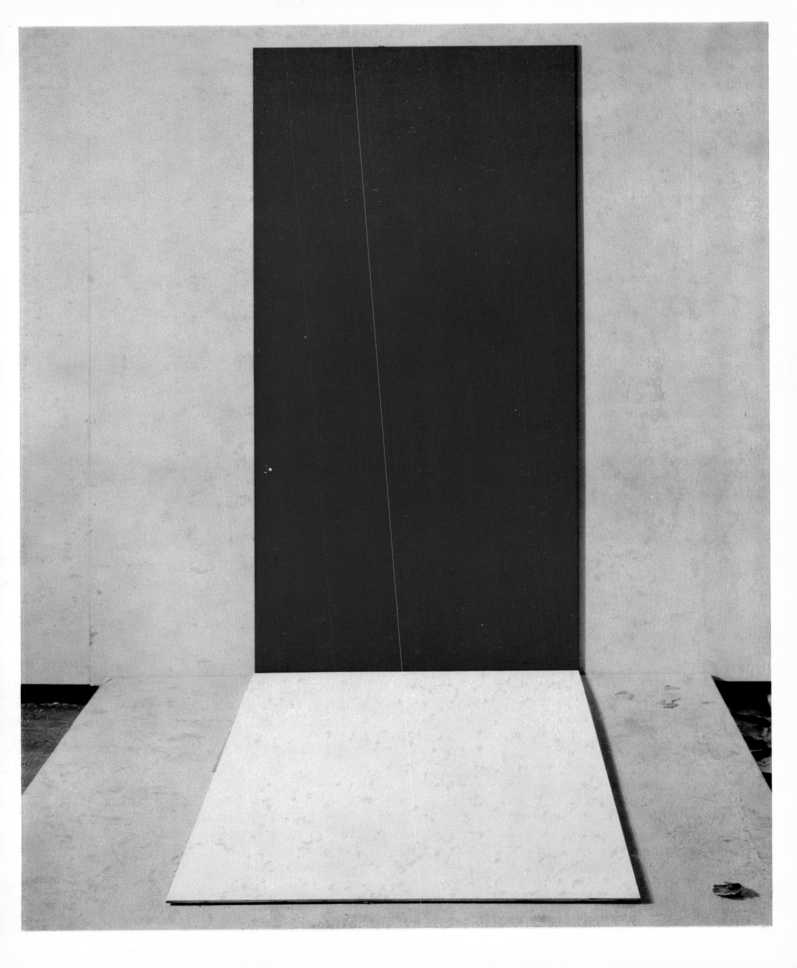

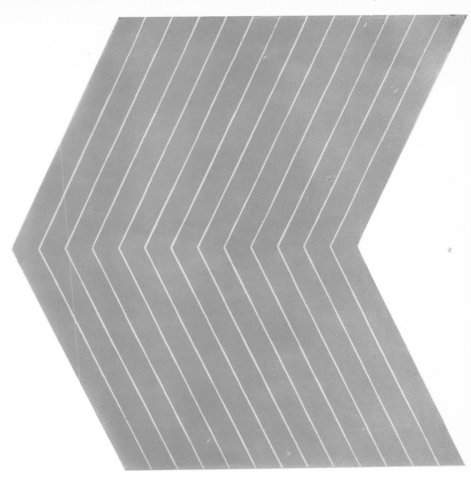

XXIII Frank Stella *Sketch Zinc Chromate* 1964

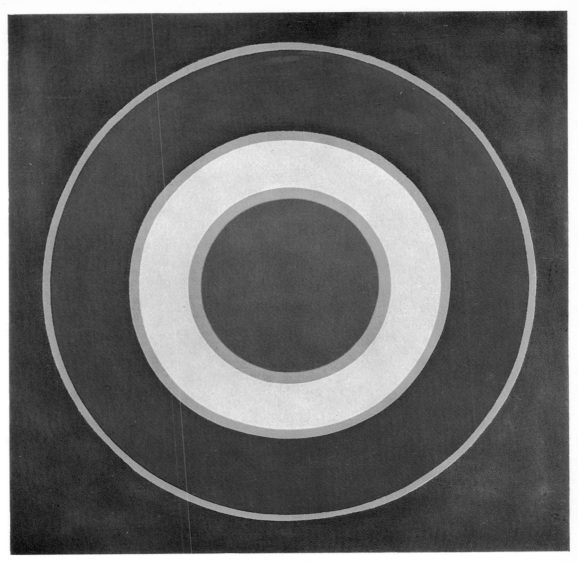

XXIV Kenneth Noland *Mercer* 1962

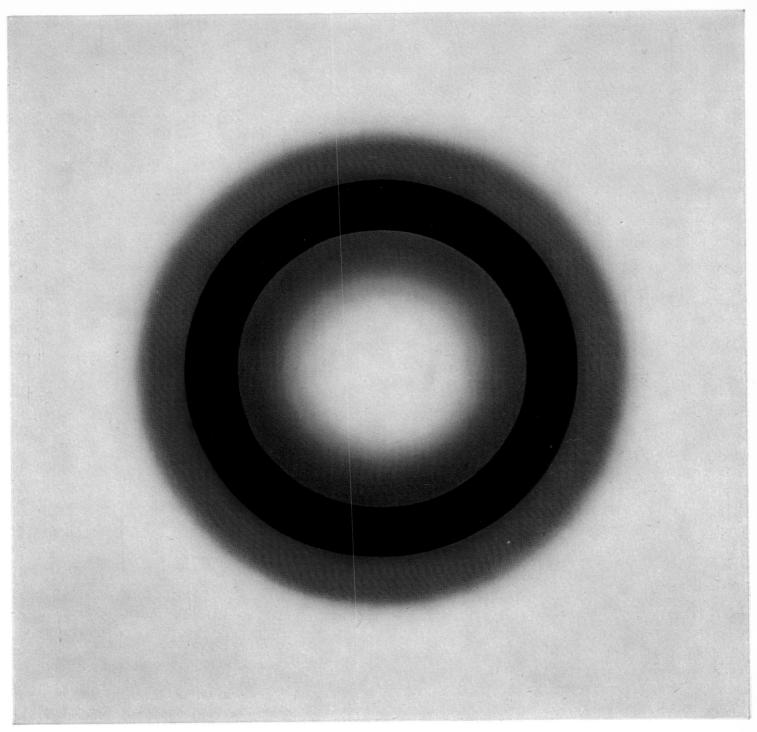

XXV Wojciech Fangor *B 15* 1964

The square

Like the circle, the square is an elemental form, and one that has provided a starting point for numerous developments within modern art. The architecture of Frank Lloyd Wright was based on it. Above all, it inspired Kasimir Malevich to paint his programmatic picture of a white square on a white ground. Then, in c 1930, it was taken up by the "Cercle et Carré" which, as its name implies, was concerned with the circle and the square.

Apart from Malevich, there is one other twentieth century artist who has played a really important part in the development of this motif, namely the Westphalian Josef Albers, whose spatial colour compositions are nearly all modelled on the square (ill. 307). Because of its dual nature – it is both restricted and open at one and the same time – the square has much in common with Schönberg's twelve-tone technique: the limitations imposed also give it greater freedom.

Due primarily to the crucial influence exerted by Albers on the younger generation, the square continues to play an important role in contemporary art. The paintings of many of our present day artists contain direct allusions to Albers' work. In fact, his celebrated "Homage to the Square" has virtually become a "Homage to Albers". This title was actually used by Gregorio Vardanega for one of his light boxes, and by Carlos Cruz-Diez for one of his physicromes.

Bruno Munari has carried out an independent investigation into both the circle and the square and has written a book on each ("Discovery of the Square", New York, 1965). Victor Vasarely has also used the square motif, as in his "Tau-Ceti" (1955–65), whilst Mary Vieira, like Gregorio Vardanega, has treated the square in a sculptural context ("Square and Movement = Space", 1953–8).

The Swiss artist Gottfried Honegger has produced a portfolio of biseautages entitled "Hommage à Cercle et Carré" [Lit. = Homage to Circle and Square]. In these works, as in his paintings, Honegger has created a wide range of variations and settings, which exploit the full potential of these two mathematical signs. Max Bill, Jesus Raphael Soto ("Relief relations pure", 1965) and Richard Anuskiewicz ("12 Quadrate [12 Squares], ill. 306) have also presented the square motif in a new light, and in works like "Cato Manor" of 1962, Frank Stella has used it as a starting point for spatial compositions. The long list of artists who have paid "Homage to the Square" also includes Karl Gerstner ("Karo 64", 1956–61), Hermann de Vries ("Random Objectivation", 1963), Dieter Hacker ("Cubes", 1963; "Eat Picture", 1965; series of lithographs, 1962–4, ills. 303, 304), Paul Talman ("Untitled Work", 1964), François Morellet, Gregorio Vardanega, Martha Botho, Agnes Martin ("The Rose", 1966), Gordon House, Dan Flavin ("Untitled", 1966) and Sol Lewitt ("A–8", 1966).

The square has been constantly featured in works produced by the members of various artists' associations, who carry out systematic investigations into artistic phenomena. These associations include the "Groupe recherche d'art visuel" [Research Group for Visual Art] in Paris, the "Gruppo N" in Padua and the "Effekt" group in Munich. The square is in fact an international motif. It is used by Marc Adrian, who lives in Vienna, and it is used by Kuwayama, who lives in New York.

Just as the circle was extended to form the sphere, so too, the square has been extended to form the cube. The artists who have made this progression include Lucas Samaras, Yayoy Kusama, Larry Bell, Tony Smith, Max Bill, Carlos Raul Villanueva (Venezuelan pavilion, Expo' 67 Montreal), Tetsumi Kudo, Robert Morris, Donald Judd and Pia Pizzo. They have shown that this basic form is capable of infinite variation, not only in painting, but also in sculpture and architecture.

The curve

Oscillation curves, i.e. the curved lines used to denote movements of energy, have long been a feature of scientific research. With the advent of Jefferson's wall at the University of Virginia, Hogarth's *"Line of Beauty"* and Gaudi's buildings, the curve was also established as an independent artistic principle. But it was a long time before this principle was acted upon. In *c* 1930, the Polish artist Vladislav Strzeminsky painted a number of pictures which resembled the oscillographic reproductions of the sounds of a gramophone record. After this, a long gap occurred until, in 1960, curved structures were established as movement symbols in the sphere of art, where they have provided the contemporary artist with an entirely new theme.

Wojciech Fangor has dealt with this theme in a number of important works such as *"Bild Nr. 35"* [Picture No 35] of 1963 (Kultermann Collection, Leverkusen, ill. 309). This picture, consisting of a vertical black curve on a white background, obtains its effect from the juxtaposition of black and white, movement and repose, precision and imprecision, which we might perhaps interpret as rational and emotional elements. In 1963, Fangor also produced pictures consisting of horizontal curves. It is important to realise that these works of his are not intended simply as illustrations of the new natural phenomena discovered by scientific research. They constitute rather an independent attempt to consider these phenomena at an artistic level. His *"M 89"* of 1967 is a more recent example of this type of picture. From 1964 onwards, Fangor has also treated this theme in specifically spatial compositions. He applies the various colours of these works one after the other, thus producing an impression of a temporal sequence in space, which corresponds to the impression of movement produced by his serpentines. Fangor's paintings are always spatial, even in those cases where he works with traditional techniques.

Other artists, such as William Turnbull (*"3–1964"*), have used similar methods and achieved basically similar results. The artist Bridget Riley has also tried to produce spatial effects by means of curves. But unlike Fangor, who relies on colour, she employs a linear technique (ills. 284, 285). In fact, her pictures are closely akin to optical illusions, for she uses her serpentine curves to create an illusion of movement and depth. These lines do not begin or end within the picture area. Consequently, they appear to extend into the external area in all directions, and so acquire a spatial dimension. In Riley's work, too, the impression of movement is entirely subjective, i.e. it lies in the eye of the beholder and is not due to any real movement in the work itself. In his early paintings, the Moroccan artist Mohammed Melehi created variations on the curve motif by inserting breaks in his curved lines, which then produced spatial effects. Since 1967, he has obtained similar effects by painting horizontal curved bands at varying distances from one another.

This type of composition is also featured in the work of a number of younger Italian artists, e.g. Franco Grignani and Sergio Lombardo. In his *"Super-Quadro"* of 1966 (ill. 310), Lombardo produced a curve which structures, not only the wall on which it is exhibited, but also the space before it. In a later work, *"Elemento supercomponibile"* of 1967, he created a spatial composition from flat quarter-circles which encroach on to and structure the external area. The interweaving pattern of movement to which this gives rise is entirely novel and has led to the establishment of a new spatial principle. It should, however, be pointed out that this process was first initiated by Fangor ten years earlier, albeit with a different end in view.

Colour

It is possible that the recent reassessment of the function of colour in art is connected with the invention of colour photography, technicolour films and colour television. In any event, colour has been virtually rediscovered by contemporary artists following a long period of neglect in earlier decades. This could well mark the onset of a more vital period, during which both life and art will be guided by the living force of human emotion.

In prehistoric religion and thought, great significance was attached to the colour white. Subsequently, however, this colour suffered an eclipse, and it was not until it had been revived as a literary symbol by writers like Melville, Poe and Mallarmé, that it was able to reassert itself in the art of the twentieth century. In the poetry, music, painting, fashion and architecture of *Art nouveau*, white came to signify a new beginning. In 1925, Hans Arp spoke in his poem "*Opus Null*" [Opus Zero] of "eine edelweisse Wohlgeburt" [a high birth, noble and white]. With his white suprematism, a manifestation of pure feeling, Kasimir Malevich evolved a new, mystical philosophy that was to have incalculable consequences on twentieth century culture. This movement was later promoted by Lucio Fontana in his *Manifesto Bianco* [White Manifesto] (1946). The white paintings executed by Fontana (ill. 328), Manzoni (ill. 311), Klein, Castellani, Piene, Uecker and Holweck were all conceived in terms of the need to bridge the growing gap between intellectual Western man and nature.

In American painting of the same period, as in the works of Sam Francis, Robert Rauschenberg (ill. 312), and Jasper Johns, white also played a crucial role. American art was passing through a process of reduction and purification at that time, which paved the way for the new, luminous colour compositions that were to come. The programmatic white light reliefs produced by Camargo, Tomasello, Demarco, Soto, Bonalumi, Uecker, von Graevenitz and Gambone indicate a period of reflection, during which artists attempted to come to grips with essentials and clarify their pictorial techniques. But, for all their rationality, they were unable to banish the associations of terror and emptiness, of horror and primaeval depths which had impinged on this colour ever since Mallarmé. In fact, these white pictures paved the way for an era which allowed artists to explore every avenue.

Blue has quite different symbolic associations. Rainer Maria Rilke once commented: "It is conceivable that somebody might write a monograph on the colour blue". Kurt Badt has actually provided a working draft for such a project in the chapter "Blau" [Blue] of his book "*Die Kunst Cézannes*" [The Art of Cézanne], where he lists the various connotations attributed to this colour. Cézanne and Anquetin used blue in a very special way; Picasso had his blue period; "*Der blaue Reiter*" [The Blue Rider] was the name of a famous artists' association, whilst "*Der Turm der blauen Pferde*" [The Tower of the Blue Horses] of 1913 was one of the key works of the animal painter Franz Marc. The association with the blue flower of the Romantics is quite evident.

In Yves Klein's works, which were based on a monochrome conception, this colour has played a major role (ills. 9, 327). The blue sky, which embraces the earth, constituted his point of departure. Klein once recalled a significant quotation from Paul Claudel. When asked: "What is blue?" Claudel replied: "Blue is the invisible made visible."

The symbolism of red is different again. In fact, red and blue are opposite poles: negative and positive, cold and warm, life and death, aggressive proximity and unbounded distance. Red is the colour of life, of love, of kings, the colour of blood and power. Colours play an important part in the iconography of Christianity. For example, Mary's coat is always blue but her dress is red. The martyrs in paradise are always portrayed in red clothes, and with garlands of red roses to recall their martyrdom. Certain ceremonial vestments of the Roman Church are red, as, for instance, the Cardinal's biretta and the papal robes. Satan was also thought to have close links with this colour, and his minions were often called red devils. This probably had a dual

derivation. On the one hand red is associated with hell fire, and on the other hand, it is associated with the blood which is traditionally used for signing contracts with Satan. In past centuries, the public executioner was always dressed in red, whilst to-day, the red flag of the revolutionary pays living tribute to this ancient symbolism. Prior to 1960, twentieth-century artists had made relatively little use of this colour. Since then, however, it has reasserted itself. We find it in works by Mark Rothko (ill. 320) and Yves Klein, in the fire paintings and the red nail pictures of Bernard Aubertin (Plate XXX), in paintings by Rupprecht Geiger (who frequently contrasts red and blue), in the pictures of the Englishman William Turnbull, and in the works of many of our younger artists.

Although yellow is a pure colour, it has seldom been used in modern painting as a symbol. On the one hand, it stands for envy, evil and all things conducive to discord, whilst on the other hand – for example in Beardsley's "*Yellow Book*" – it is an extremely sophisticated colour. In her "Yellow talk", Yoko Ono placed a very high value on it: "Yellow is the colour of the sun at its height. Other colours are shades of yellow in varying degrees which have been given different names, as if each of them existed independently, purely for ideological purposes." But, despite this positive assessment, very few painters have regarded yellow as a particularly effective colour. Occasionally, it serves as a substitute for gold but, by and large, it is simply used to indicate light, as in children's drawings. Otto Piene's screen-processed pictures illustrate this technique.

Gold, which reached its peak in the golden grounds of the Middle Ages, has undergone a revival in contemporary art. Since 1956, Lucio Fontana has been producing his golden "*Concetti Spaziali*", [Spatial Concepts] whilst in 1960, Yves Klein produced a series of golden monochromes which, in their original form, had real gold leaf fluttering from their surfaces. Anna-Eva Bergmann has also used leaf in her pictures, whilst Louise Nevelson has constructed golden shrines. Otto Piene incorporated gold into his works in 1958–9, and Herbert Oehm did so in the 1960's.

In the Middle Ages, gold was a symbol of the supernatural. Subsequently, during the transition to the Renaissance, it came to represent the sacral element within the context of the natural world, and was used in conjunction with bright colours which characterised this setting. The sacral character of pure gold is still evident in contemporary works, especially those of Klein, Fontana and Nevelson.

Black also has a multiple tradition, which stretches back into prehistory. It has frequently been used in an apparently antithetical sense to its complementary colour white. Osiris, for example, was called "The Black One" in Ancient Egypt. In our Western tradition, black was the colour favoured by the Mannerists, although it has also been used by painters like Frans Hals, Velasquez, Zurbaran, Goya, Manet and Picasso. Kandinsky, on the other hand, saw no virtue in black. To him it was entirely without character and devoid of potential, an unusable colour.

In the painting of the 1960's, black has fulfilled a more active function. Ad Reinhardt produced a series of black pictures in *c* 1960 (ill. 314) with the declared intention of getting away from colours which, he said, "were barbaric, corporeal, unstable and suggest life". But Reinhardt's black fulfils the same active function as other colours, for in these works, the monochrome designs emerge from the picture area and enter the external area occupied by the viewer.

Because black looms large in their national tradition, which dates from the Counter-Reformation, numerous Spanish artists like Tapies, Millares and Saura have made it the focal point of their pictures. This colour has been designated as a chthonic symbol by Georges Mathieu. In an analysis of the works of Louise Nevelson, he said: "The earth as the realm of secret places, which are cut off from the light, is symbolised by black, the black of the grottoes, the black of the gorges. It was only in the West that black came to fulfil a secondary role as an emblem of denial and negation. Chthon embodies the fertile earth and, in its secret world, black denotes a change of being." The black light reliefs of Francesco Lo Savio ("*Metallo nero opàco uniforme*" [Uni-

form black opaque metal], 1959, Kultermann Collection, Leverkusen, ill. 330) provide a striking example of this negative emblem, for it is only from the play of light on the black surface that Lo Savio is able to produce the effects he wants. In fact, black is the only colour he ever uses.

Other artists who have produced, or are still producing, black pictures include: Frank Stella (ills. 286, 287, 288), Agostino Bonalumi, Turi Simeti and Aldo Tambellini. Tambellini has even called his New York gallery "The Black Gate". The Chinese artist Li Yuen-Chia, who now lives in Italy, has produced a brief synopsis of colour values, in which black is characterised as "the beginning and the end": "The colours black, red, gold and white are the graphic symbols of the universe. Black: the beginning and the end; red: blood, life; gold: nobility; white: purity."

Colours, whose indefinable properties exert such a powerful influence on our organs of sense and on our relationship to the world, are burdened by traditions which stretch back into early antiquity. Although the significance of these traditions is not always recognised, they are always present to some extent in the pictures of every era, including our own. And because the pictures of contemporary artists trigger off a multiplicity of associations, they not only create effective forms with which to bridge the gap between the inner and the outer cosmos, but also recall long forgotten impressions of life. Between them, the suggestive power of colour and the imaginative powers of the viewer are able to unite these two separate functions and treat them as one.

Colour as a spatial force

The spatial properties of colour have been the dominant factor in works executed by a large number of contemporary painters. These include: Barnett Newman, Mark Rothko, Wojciech Fangor, Morris Louis, William Turnbull, Elsworth Kelly, Ad Reinhardt, Jules Olitsky and Ron and Gene Davis. For these artists painting consists primarily – and in some cases solely – of handling paint, which exists on its own account as a spatial force without any linear qualities and without figurative detail.

These painters are no longer concerned with the creation of illusion in depth which has been the dominant feature of European art since the invention of perspective in the fifteenth century. Nor are they concerned with the material properties of the colour particles on the picture surface. What interests them is the radiant power of colour, which emerges from the picture and passes over into the external area occupied by the viewer. Because of this radiant effect, the picture is invested with the power of spontaneous movement and with an inbuilt dynamism, which is, of course, ultimately grounded in the eye of the viewer. Thus the viewer and the work form interrelating parts of an artistic field of force.

Mark Rothko's colour icons (ill. 320) are based on a mystical view of reality. Rothko considers that the artist should be able to perform miracles. "Pictures", he said, "must be like miracles: the moment a picture is finished, the intimacy between the creator and his creation is also finished." Rothko's pictures are both technically and thematically dynamic; the radiant power of the colour creates a spatial effect of great intensity, whilst the subject matter is so open-ended that Rothko is able to express numinous qualities.

Rothko is a Russian, who has preserved the icon tradition of his native land. Wojciech Fangor, who is also concerned with the spatial effects of colour (Plate XXV), is a product of the Polish tradition. For the most part, Fangor obtains his effects by means of extremely subtle nuances of mixed colours although – as we have already seen in the chapter on the curve – he has also used colour in temporal sequences to create an impression of movement in space.

In 1959–60, William Turnbull began to exploit the spatial effects produced by large areas of colour (ill. 340). Subsequently, his work acquired what appeared to be a

Constructivist quality from the introduction of outlines, a technique which has now acquired the misleading name of "hard-edge". Peter Coviello is another artist who has used the spatial potential of colour to produce kinetic effects. So, too, has Peter Stroud, whose compositions – vertical bands of colour on monochrome backgrounds – are designed to set up a spatial vibration that is reminiscent of the work of Barnett Newman.

In his blue and black pictures of c 1960, which were actually conceived as a protest against the use of colour, the American artist Ad Reinhardt established a new evaluation of colour nuances (ill. 314). Although it might be thought, and has been thought, that in these works Reinhardt was trying to produce a two-dimensional Constructivist-type synthesis, this was not in fact the case. Like Newman and Rothko in similar paintings, he was concerned with the creation of spatial gradations. If we look at his pictures long enough, certain details appear to stand out from the rest, seeming either to emerge from or recede into the picture area. It is the apparent movement within the picture surface which constitutes the real import of these works.

Ellsworth Kelly has used colour to produce spatial effects in both paintings and sculptures (Plate XXII). His large monochrome compositions, some of which actually extend into external space, are impressive examples in this genre.

Morris Louis, originally influenced by Jackson Pollock, uses a very different method in his spatial compositions, in which colour is presented as a phenomenon in its own right, and with its own essential beauty. His style is well illustrated in his large-format work "Alpha" (1960, Albright Knox Gallery, Buffalo, N.Y.) (ill. 318). The big, irregular stripes of colour running down both sides of this painting make it look wider than it actually is. This illusionist technique, in which glazing plays an important part, is reminiscent of the work of Mark Rothko. At the same time, however, it also anticipates the symmetrical compositions which have been such a characteristic feature of the 1960's. Louis not only used colour to create spatial effects, he actually made this colour-space combination the theme of his painting. In his work, colour functions in its own right, but never as a surface component. On the contrary, it is a force which acts upon the surface. And yet, although the colour operates as a spatial force and is therefore responsible for the grandeur and monumentality of these works, it is so finely shaded and so restrained, that it also invests them with a certain lyrical quality. The result is an extremely interesting and decidedly paradoxical antithesis based on the active and the passive properties of colour.

After an early period, during which he was influenced by Morris Louis, Kenneth Noland (Plate XXIV, ill. 319) introduced geometrical structures into his spatial colour compositions. But, although this process has been progressive, it has not eliminated the original, spatial component. Because of this freedom of expression, which stems from his successful integration of Abstract Expressionism, Noland differs from European painters like Bill, Lohse and Glarner, whose work is firmly grounded in Constructivism. Max Bill's paintings are based on numerical laws and the relationships that exist between the physical properties of colour, whereas Noland's works, like Louis', are determined by his newfound freedom.

Other artists work in the same way as Noland, artists whose pictures appear to follow strictly geometrical designs, which are, in fact, essentially spatial. Gene Davis, for example, paints vertical coloured stripes, which are a product of this new medium and not of geometrical constructivism (ill. 279). The same applies to Ellsworth Kelly's "Spectrum" and Doug Ohlson's "Cythera" (1967, ill. 315). The Greek artist Nassos Daphnis (ill. 316) was one of the first exponents of this art form. As early as 1960, he produced spatial pictures in this genre which bear a superficial resemblance to Barnett Newman's work. The Japanese Takehiro Nabekura ("Untitled" of 1965), the Swiss Müller-Brittnau (No 11, 1967/1968") and the American Robert Huot (ill. 317) are now tackling similar problems.

Jules Olitski drew the inspiration for his works from Morris Louis and Mark Rothko. In 1966, he produced his "Iron and Powder" and "Cross Spray", in which the radiant

power of the finely shaded colours creates an impression of a veiled dream reality. Neill Williams and Seymour Boardman (ill. 321) create fields of colour with a similar veiled appearance, often in an unusual format.

Ron Davis has carried this process one step further. In his works, which also appear to be based on geometric forms, he has used the spatial effect produced by the radiant power of his coloured areas to create an illusion of perspective (ills. 323, 324, 326). Moreover, his colour acquires an added effect from the texture of the synthetic material which he uses in place of paint. The overall result has been a novel, dialectical and masterly fusion of two basically contrasting functions: perspective and spatiality.

Joe Baer, Michael Asher, Hsiao Chin, Naohiko Inukai and (of recent years) William Turnbull have produced spatial effects with monochromes in their work. Baer frequently paints diptychs and triptychs, whose spatial character is naturally proportionately greater. In 1967–8, William Turnbull painted monochromes with white borders, in which the borders form an integral part of the composition.

The works of Craig Kauffman and Göta Tellesch, whose relief-like vaulted forms are broken up by bands of powerful colour, constitute a special category of spatial composition. Like Fangor, these artists incorporate a temporal element into their pictures. Thomas Downing has also produced new spatial effects in colour compositions, which are reminiscent of the work of Ron Davis ("*Sixteen*" of 1967, ill. 325). In all of these pictures colour has acquired a new vitality, a new sensuality and a new freedom, qualities which mark them as products of the 1960's.

Light and space

Paul Valéry once said: "For some years now matter, space and time have not been the same..." When he published his *White Manifesto* in 1946, Lucio Fontana called for a type of art which would incorporate colour, tone, movement, time and space within a psycho-physical entity. He then went on to say that, if this new art form was to be realised, all man's energies would have to be harnessed and integrated. Since 1960 one group of artists has been trying to do just this. By investigating the fundamental tenets of composition, they have sought to clarify artistic techniques and open up new areas of activity.

There are, of course, historical precedents for this kind of approach: the paintings of Delaunay, Malevich and Rodschenko, the Polish Unism of Stzreminsky and Stazewsky and the Constructivist monochromes. But in 1959–60 new forms of this unifying art were developed by painters like Marc Tobey, Mark Rothko, Barnett Newman Ad Reinhardt, Yves Klein, Piero Manzoni and Lucio Fontana. Fontana, who was the first in the field, is also the most representative of this new spatial conception. The holes and cuts in his monochromes, e.g. in "*Attese*" of 1959, have the effect of opening up his pictures, of exposing them to the fluctuating effects of light and space. As a result, the painting as a work of art – which has long been a fixed and immutable object – assumes variable characteristics. In his "*I Quanti*" of 1959 (ill. 328), a variable work consisting of three, four and five-sided forms, Fontana also dispensed with the customary rectangular picture frame.

The principal characteristics of this new trend are its open-ended structure, its preoccupation with light and space and the originality of the works which it has engendered. At first glance, it seems paradoxical that this new art form, which incorporates many industrial components, should be more individual than traditional forms. But, despite their external uniformity, these machine-made parts are entirely original. As soon as they are integrated into a spatial context, their individuality is immediately apparent. Francesco Lo Savio's works are a case in point. These range from his "*Filtro Luce*" [Light Filter] of 1959 (ill. 331), which consists of three layers of transparent paper all showing the same design (a circle enclosed in a rectangle), to paintings and sculptures and even architectural and civic structures. Lo Savio sets out to depict a new conception of space influenced by light, and finishes up by establishing a new conception of artistic activity. His light filters are highly differentiated works which deal with the twin subjects of transparency and opacity. Lo Savio's compositions differ from those of Morris Louis in so far as he uses no colour, but none the less, these two artists would appear to be pursuing similar objectives.

Lo Savio has pursued his enquiry into the problematics of light and space in his paintings, which also contain the same basic motif of the circle set in a rectangle, although in some cases this is so faint that it is scarcely visible. The rectangle, in this case, is formed by the picture frame, but in these works, too, the aim is to create an impression of spontaneous movement.

In 1959–60, Lo Savio began to construct black metal reliefs (ills. 313, 330), which were fixed to a wall and consisted of two machine-made sheets of metal mounted one on top of the other, the higher one having a protruding flange. This fan-like structure serves as a light trap, and the interplay of light on the surface, which is the real theme of this work, gives rise to a dialectic of negative and positive values.

Lo Savio had, of course, already incorporated the reality of the natural world into his paintings and sculptures in order to heighten their effect. But this process became far more pronounced in his architectural and civic structures, which are virtually unknown. For these, he adopted the structural organisation of the human body, using it as a basis for a modular architectural system and for general plans for the utilisation of space, which cover every contingency from the formation of the smallest cell to the organisation of whole areas. They do this totally and not theoretically, as was the case at the Bauhaus.

XXVI Yves Klein
RE 6 Relief éponge 1960 ▷

56

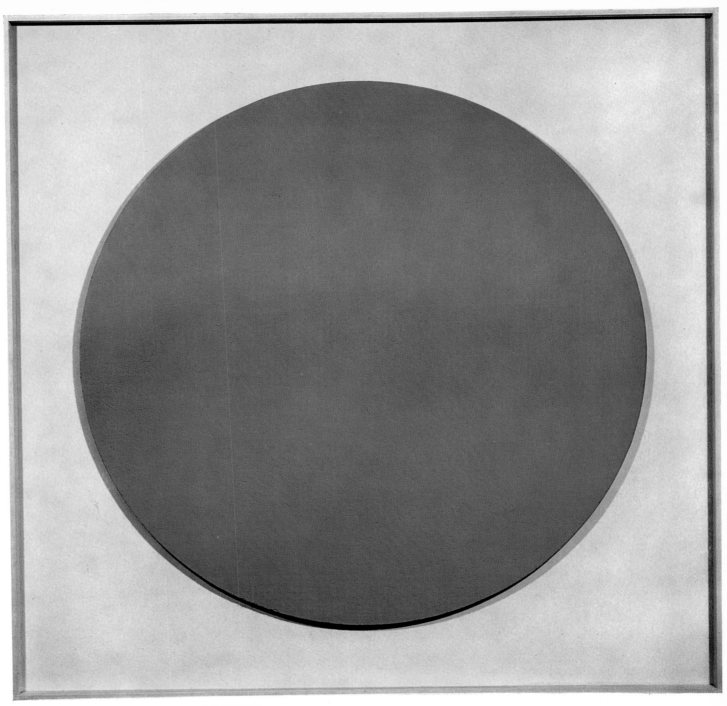

XXVII Jef Verheyen *Coucher de soleil* 1966/67

XXVIII Jesus Rafael Soto *Grand Bleu* 1964

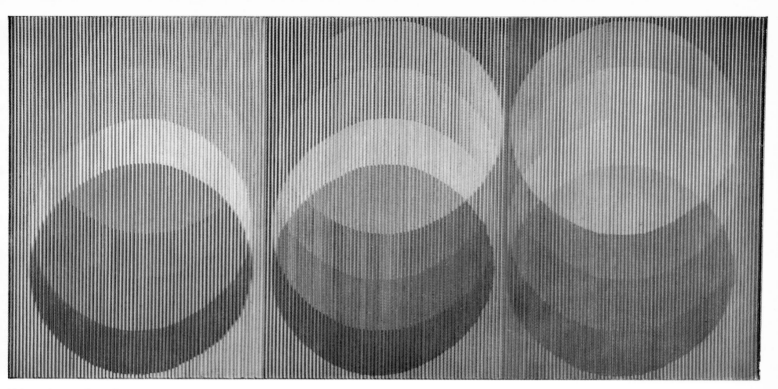

XXIX Carlos Cruz-Diez *Physiochromie 267* 1966

XXX Bernard Aubertin
Disque de feu tournant 1961

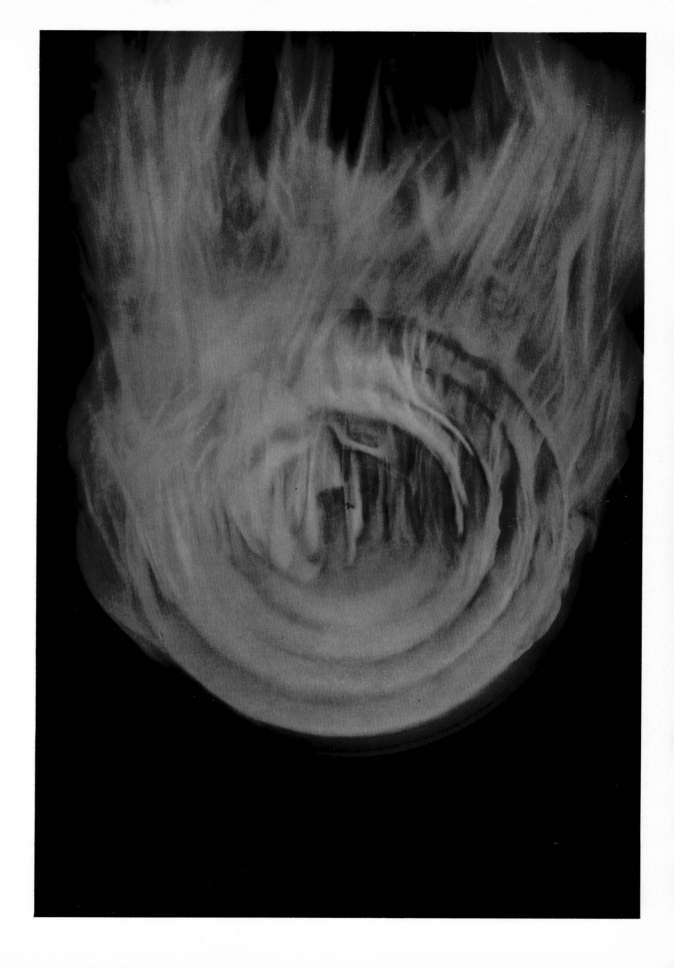

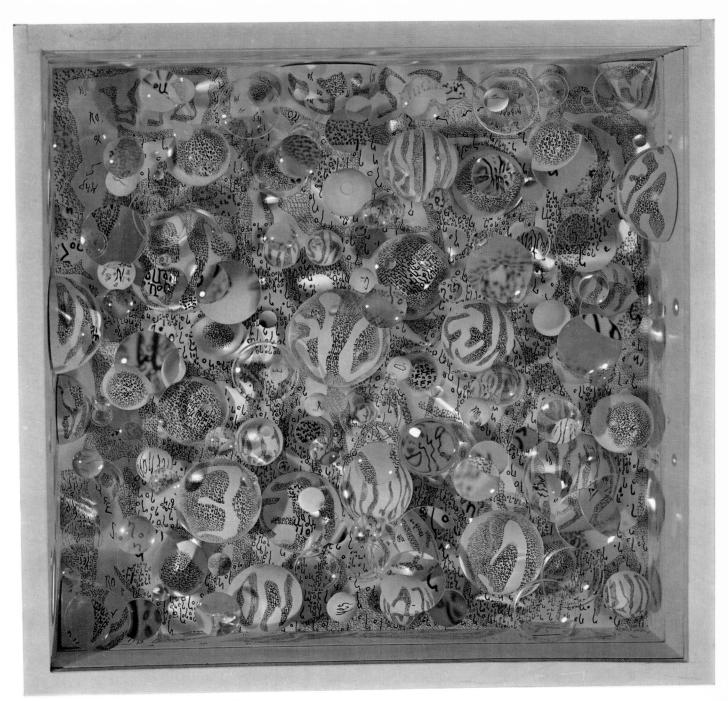

XXXI Mary Bauermeister *Neither-Or* 1966

Although light and space are not the only themes treated by Piero Manzoni, they form none the less an extremely important feature of his work. Manzoni, a highly influential and diverse artist, has investigated the effects of light on formed surfaces constructed from plastic, plaster, and roughened cellulose and fibreglass (ill. 15, 333). This is not the only resemblance between his work and Lo Savio's, for apart from incorporating natural phenomena, he also tends to use open-ended structures and to involve the viewer in the artistic process.

Enrico Castellani, another Italian, produced light reliefs in 1959–60, which he called "*Superficie bianche*" [White Surfaces]. In these works, which are made of cloth, the play of light on the undulating surfaces creates an impression of spontaneous activity. Other artists who have used this technique include Agostino Bonalumi, Andreas Christen and Nurio Imai.

The English artist Richard Smith has developed a type of composition that is basically similar to Lo Savio's black metal reliefs. These works, which have been called shaped canvases, are, in fact, coloured reliefs which protrude into the external area. Smith's "*Seawall*" of 1967 (ill. 335) consists of nine foreshortened rectangular surfaces, each with one corner bent forwards, rhythmically organised by the play of light within a variable spatial structure. In his "*Parking Lot*" (ill. 336), which is a similar work, the rectangular areas have been replaced by four or five–sided forms set out in a straight line.

Light has also been treated as a pictorial theme by Gene Charlton. His pictures, which consist of veiled rectangular structures on rectangular backgrounds, are executed in fine shades of colour, which look as if they had been filtered. Although Charlton's basic premise is quite different, his works none the less form a parallel to those of Morris Louis in America.

Artists like Arnulf Rainer (Plate XXXIII), Christo, Kolar (ill. 83), Aubertin (Plate XXX), Oldenburg, Kusama (ill. 398) and Samaras are all concerned with the same total conception which, although it always involves concealment, has none the less revealed a new potential. In Christo's *empaquetages* and Rainer's overpaintings, objects which have been rendered invisible continue to produce a definite effect. Rainer is obsessed by this new method and regards ordinary paintings as just so much raw material for his overpaintings.

Light and colour are also featured in the works of Almir Mavignier, Otto Piene, Heinz Mack, Oskar Holweck, Herbert Oehm and Raimund Girke. The paint particles, the brushwork, the lines, the roughened materials and the screen-processing techniques used by these artists simply provide a framework for the play of light on paint and picture surfaces, which is the real theme of their works. The result is an impression of vibration and a sense of spontaneous movement, which radiate from the work and enter the area occupied by the viewer. Mavignier actually went one step further than this in the compositions which he produced in *c* 1959 ("*Gestörte Fläche*" [Disturbed Surface] and "*Teilung und Störung*" [Division and Disturbance], Leverkusen Museum). Using a screen-processing technique, he produced black and white areas which vibrate at different speeds, and so create an impression of colour, whilst the Flemish artist Jef Verheyen achieved a comparable result with what appear at first sight to be uniform areas of paint. But, if the viewer looks at these areas for a long time, a delicate veiled modulation is revealed. Ad Reinhardt, of course, has used a similar technique, albeit in a very different way. In Verheyen's case, however, the combination of delicate colouring and light produces a spatial effect.

In *c* 1966, Robert Mangold produced a series of works (ills. 337, 338, 339) in which spatial effects were combined with a reductive composition. By arranging identical geometric forms – segments of circles, triangles and rectangles – in pairs, he created composite figures (i.e. two forms in one), thus producing an impression of reduction, which is offset by the antithetical impression of expansion arising out of the spatial characteristics of these pictures. Like Warhol, Foulkes and various other painters, Mangold uses this two-way technique as a magical motif.

Kuwayama is another artist who divides his pictorial surface into symmetrical sections, which engage the viewer's attention by their interrelating structure and spatiality (ill. 308). Similar works have been executed by Sven Lukin ("*Untitled*" of 1961), Thomas Downing (ill. 325) and Sandro de Alexandris (ill. 341). The symmetry, which is such a dominant feature, not only of these works, but of so many aspects of contemporary art, is of a ritual order. It functions both as a formal and as a thematic element, and serves to create a sense of spatiality.

Franco Fabiano and Getulio Alviani have created light rhythms from the interplay of light and shade on specially prepared grounds. Fabiano uses undulating wooden panels which break the light into bright and dark zones that begin to vibrate as soon as the viewer shifts his position ("*Bianco*" [White], 1965, Kultermann Collection, Leverkusen, ill. 347). Alviani, on the other hand, obtains his effects from the rhythmical structure of his reliefs, which are made up of aluminium or steel strips, ground to different finishes. But these metal strips fulfil a further function for, although the overall surface of these works is actually completely flat, it appears to be indented, due to the juxtaposition of these different finishes. Alviani's "*Lichtlinien*" [Lines of Light] (Kultermann Collection, Leverkusen, 1962, ill. 348) is a good example of his technique. When confronted with this work, the viewer finds that certain of the metal strips appear to recede, others to protrude. Moreover, when he shifts his position, the pattern of receding and protruding strips also shifts, so that he finds himself caught up in a continuous dynamic relationship with the work. In fact, the viewer becomes a necessary component of the whole artistic conception. Nor is that all, for the light, a part of reality, has also become a component part of the artistic composition. Here, therefore, we find a work of art placed in an entirely new context, in which it assumes an open-ended character, as if it were awaiting completion. In fact, that is precisely what it is doing, for it needs the collaboration of both physical and human nature before it can be completed. This indicates a reappraisal of the human factor. The viewer is accepted as a partner, as an active participant. He has acquired a new status in art.

Kinetic pictures

In view of the highly dynamic character of modern life, kinetic art is an entirely appropriate conception. As early as the 1910's, the Futurists made speed and movement the focal point of their compositions. This two-dimensional view of movement was then succeeded by the representation of real movement when Marcel Duchamp produced his Rotoreliefs in 1920. As it happens, these also constituted an early form of industrial art, since Duchamp's discs were replaceable, factory-made units.

Initially, kinetic pictures depended for their variability on the angle from which they were viewed. In other words, the pictures moved when the viewer moved, and without this movement they were incomplete. Agam, Soto, Cruz-Diez, Alviani and others have produced works of this kind. Later, however, Jesus Raphael Soto evolved an entirely new conception of dynamic art (ills. 349, 350). At first, he also painted pictures which varied according to the position adopted by the viewer ("*Spatial Constructions*", 1956), but gradually these were replaced by linear compositions, which produced spatial vibrations and so set up a field of force embracing both the viewer and the work. After painting his angular pictures in the 1950's ("*Peinture Polyphone*" [Polyphonic Painting], 1955, ill. 351), which also vary according to the viewer's angle of vision, Yaacov Agam progressed to pictures capable of direct movement in 1960 ("*Sensibilité II* [Sensibility II], ill. 352). Pol Bury has also created real movement. In his 1961 series "*Ponctuation*" [Punctuation] (ill. 353), a set of cords, which are driven by motors, execute mechanical movements in front of monochrome backgrounds. In his "*Polariscop*", Bruno Munari constructed a programmatic kinetic composition from discs which constantly form new designs.

Italian artists like Boriani have used magnets to produce movement in their works. So, too, has the American Roland Mallory ("*Organa*", 1965, ill. 356). Comparable effects have been produced by Gerhard von Graevenitz, who uses magnets to drive his rotating metal discs, by Li-Yuan Chia ("*Cosmagenetic Multiple White on White*" of 1968) and by Paul Talman, whose variable works involve the viewer's participation.

The exploitation of light, electronic steering and photo-electric cells has now opened up new areas of kinetic art. The pioneer work in this field was carried out by Nicolas Schoeffer, Frank Malina, Julio le Parc and Howard Jones (ill. 354). Martha Hoepffner's variochromatic light objects show the point of transition from the kinetic picture to the motion picture whilst in his "SPCE" ("*Strutture Polycicla a Controllo Electronico*" [Polycyclic structure with electronic control]), Eugenio Carmi has created an entirely new kind of kinetic composition, in which he combines painting with elements of film and literature and, in some case, with musical factors (ills. 374, 375, 376, 377).

Öyvind Fahlström's kinetic works are of a different order. Using what is basically a photographic technique, Fahlström creates variable tableaux from stereotyped images, which the viewer is able to arrange in whatever pattern he chooses. These are, in fact, "play pictures", but play pictures from which it is possible to create, not only formal, but also significant, combinations. Popular images, Comic Strip characters and electronic techniques are all incorporated into these composite works, which include "*The Cold War*" of 1963–5 (ill. 358), "*Dr. Schweitzer's Last Mission*" of 1964–6 (ill. 360), "*Eddy in the Desert*" of 1966 (ill. 359), "*Roulette*" of 1966 (Dr. Ludwig Coll., Aachen; ill. 357), and "*Life Span III Marilyn Monroe*" of 1967.

A large number of younger artists have adopted Fahlström's technique. In her "*Le gôuter*" [Afternoon tea] (ills. 364, 365) of 1967, Hanlor combined an aerial view of a table top and a few articles of crockery with four interchangeable silhouettes. The Peruvian artist Carlos Revilla also produces variable pictures, in which telephones, dolls and little girls with incomplete facial characteristics are combined with mysterious figurations (ills. 362, 363).

In her "*Transparent Door*" of 1965 (ill. 361), Laura Grisi arranged silhouettes of trees, people and curves in different layers, capable of lateral movement, which can therefore be rearranged to produce different constellations.

Thomas Bayrle achieved variability in his works by means of a built-in winder mechanism. This technique is illustrated by his "*Objekt Mao*" [Mao Object] (ills. 123, 124, 125) of 1967, a picture composed of a large number of individual forms, which can be realigned by means of this mechanical device to make various large designs. The impression created by Bayrle's compositions is similar to one produced in 1965 in the Stadium in Peking, when school children carrying different coloured banners were grouped on the enormous stands so as to form a pictorial design (ills. 366, 367). In his pictures, he combines stereotyped images taken from the advertising world with political reality. In "*Objekt Mao*", for example, he used a large number of small, individual forms to construct a variable composition which can be transformed from a portrait of Mao-Tse-Tung into a picture of a star.

Writing and painting

By and large, the important new discoveries made by contemporary artists have not taken place within the framework of the traditional artistic disciplines. They have tended rather to be interdisciplinary affairs, involving a combination of two or more normally separate branches of the arts, e.g. music and literature or art and literature. In some cases, individual works of art have contained literary, scenic, acoustic, pictorial and even architectural elements. The most recent form of musical notation, namely optical *partitura*, seems to have more in common with painting than with traditional music.

But of all the interdisciplinary works, the most common are perhaps those in which painting is combined with poetry. These compositions have been given the name of "visual poetry" or "*peinture parlante*" and have been compared to the works of Ancient Chinese and Japanese artists, for whom writing and painting constituted a single entity. This kind of pictorial writing has been known to us in Europe since the days of Mallarmé, Scheerbart, Morgenstern, Marinetti and Apollinaire.

A second source of the contemporary synthesis between writing and painting lies in the communication symbols used by the Cubists and Futurists, by Klee, Hausmann, Schwitters, van Doesburg, Heartfield, Höch and Magritte. Of recent years, there have been many pictures, in which "found" or painted letters, numbers and messages have been featured. Rauschenberg, Johns and Indiana have produced pictures consisting entirely of letters or numbers. Jasper Johns began his famous series of number paintings in the late 1950's. These include his "*White Numbers*" of 1957, his "*Gray Numbers*" of 1958 (ill. 369), and his "*Black Figure 5*" of 1960 (ill. 368). In his "*Jubilee*" of 1959 (Robert Rauschenberg Collection), Johns also incorporated colour signs.

In "*Cedar Bar Menu*" of 1960, Larry Rivers made a restaurant bill the subject of a painting whilst in "*Composition 2*" of 1964, Lichtenstein depicted a parcel label with a written address. But it is in Robert Indiana's works that letters and numbers have featured most frequently. His pictures of the figures 1 to 10, and his series on the word "Love" – which he has also treated in sculptural form (See "*The New Sculpture*", New York, London 1967) – present information in a colourful and ornamental context, thus creating a sensuous effect with what is basically a sober theme. In his "*USA 666*" of 1966 (ill. 370), Indiana combined the printed words "EAT", "DIE", "HUG" and "ERR" with the "*USA and 666*" of the title. Apart from figures, the letters of the alphabet, popular captions ("Love", "Eat", etc.) and political anagrams, calendars are also frequently featured in contemporary paintings. Oldenburg's "*August Calendar*" of 1962 is a case in point. So, too, is Carl Andre's "*Table of the Elements*".

Öyvind Fahlström and Mario Schifano have both made the word *Esso* the subject of paintings. Fahlström used it in combination with the letters LSD (ill. 371), whilst Schifano presented the letters ESS in fragmentary form in his "*Chiamato Sign of Energy*" of 1962. Edward Ruscha printed the word "SMASH" (1963) and the word "ENGINEER" (1967, ill. 373) on blank backgrounds. Arakawa used the same technique in his "*Still Life*" of 1967, which bears the printed caption "A LINE IS A CRACK" (ill. 372). In his "*Untitled*" of 1967, Arakawa presented the names of the various parts of the human body with dotted lines to indicate to what they referred – just as in an anatomical sketch – but without providing a sketch. In a number of his pictures, including "*Epico 2*" of 1960, Iannis Kounellis has tried to incorporate letters, figures, arrows and signs into a narrative sequence, and in his "*Napoleon-you*" of 1966 (ill. 379), Ugo Nespolo created a sequence of six designs each featuring the letter "N" enclosed within a stylised laurel wreath and masked to varying degrees. Although the N clearly refers to the Napoleon of the title, it could also refer to Nespolo himself, for in the bottom left design we find the letters UGO, i.e. Nespolo's Christian name. Robert Watts has presented "neon signatures" of famous masters on plexiglass. Leonardo da Vinci's signature appears in luminous blue on a white background, Picasso's in luminous red on a black background (ill. 378).

In his "*Window or Wall Sign*" of 1967 (ill. 386), Bruce Naumann executed the dictum "The true artist helps the world by revealing mystic truths" in a spiral design using luminous colour, whilst in his "*Window Screen*" of 1967 (ill. 387), he printed the dictum "the true artist is an amazing luminous fountain" in a mixture of dark and bright colours around the outer edge of a pink, transparent background made of synthetic material.

The wide variety of forms assumed by this branch of contemporary art is further demonstrated by the works of Ray Johnson, George Brecht, Joe Tilson, Richard Merkin (ill. 113), Carl Andre, Ferdinand Kriwet, Jan Henderikse (car signs) and Fabio Mauri, most of whom incorporate into their compositions prefabricated images of reality

without modifying them in any way. The authenticity of these components greatly enhances the artistic import of such paintings.

Artists like Jim Dine (*Rainbow*, 1962), Lichtenstein, Ramos, Oldenburg and Kudo also have constant recourse to written forms. For the most part these consist of the kind of prefixed signs used for *collages* and *décollages* by artists such as Hains, Rotella, Dufresne, Köthe (ill. 81), Koehler and Vostell. Allan Kaprow carried this development over into the spatial sphere by constructing environmental works consisting of walls inscribed with words ("*Words*", 1961).

In his books, Diter Rot has combined graphic art, book illustration and poetry. Eugenio Carmi has gone even further. In his "*Images*" (ills. 374, 375, 376, 377), he has used film strips, letters, colour, geometrical signs and sound in a single context. Lourdes Castro's "*Cahier de conversation*" [Book of Conversation] of 1966 contains written pages made of plexiglass, and in 1967, Alison Knowles constructed a book which the viewer literally has to crawl through, which means that he experienced it in the full spatial sense.

Even poets are using optical effects on an ever increasing scale. In his extremely well thought-out pictorial compositions, Jiri Kolar employs printed letters, which he often takes from the faded pages of old books, and sometimes contrasts with fragments of pictures from illustrated magazines. The two symmetrical circles in his "*Hommage à la poésie audifice*" of 1965 combine with the concentric circles, which pass through them and which are made up of lots of tiny letters, to create a field of vibrant force. Kolar's "*Brancusi*", a letter composition dating from 1966 (ill. 382), recalls one of the major works of modern sculpture. Edvard Ovcácek, a fellow countryman of Kolar, writes optical poems. Like Emmett Williams, who also works in this genre, he uses a typewriter, which gives his compositions a special character. Eugen Gomringer has written a poem entitled "*Schweigen*" [Silence], which consists of the single word "SCHWEIGEN" repeated throughout the whole length of the poem, with the exception of the middle word of the middle line, which has been left out. By this device, Gomringer has been able to express his subject in tangible form. Franz Mon's visual texts, which he presents either in *collage* form or in the form of torn, overlapping and distorted posters, have a calligraphic structure.

Henri Chopin, Marcel Broodhaers (ill. 380), Hamilton Finley ("*Girl au pair*") and Gerhard Rühm have all created *peintures parlantes*, using letters to convey their conceptions in visual terms. In these works, pictorial and conceptual values are expressed by the same symbol.

Gianni Emilio Simonetti dedicated his pictorial notations to John Cage, who was obliged to have recourse to visual notation in order to set down his new musical compositions. Ferdinand Kriwet has disguised his poems as pictorial *collages*. Alvero de Sa is one of a group of concrete poets in Brasil (Decio Pignatari) who use structures of signs as a medium for their poetry. Their object is "communication without words", i.e. communication that is not subject to verbal limitations. This trend is evidently widespread, for of recent years, whole series of exhibitions have been devoted to this theme.

The younger generation

The new conception of the relationship between art and society, which is a feature of our present period, has given contemporary artists, especially those born from *c* 1940 onwards, a dual sense of freedom: the freedom to use mass-production methods and the freedom to follow the imaginative currents of the personal and the collective unconscious, with the help of drugs if necessary. In either case, the object is to increase the range of human experience.

This new attitude has produced two distinct kinds of conceptional art. In the first of these, the picture is left for the viewer to complete, whilst in the second, it is

completed by mass-production methods. But, despite the radical modification of artistic form involved in these processes, the basic principles of artistic activity have remained unchanged.

Works involving the use of mass-production methods and prefabricated materials, which are prompted by a desire for complete objectivity, have been produced by artists like Peter Röhr, Fabio Mauri, Claudio Parmiggiani, Bill Kommodore, Adolfo Estrada, Mark Lancaster and Kusama. A parallel development in the photographic sphere is to be found in the additive works of Ray K. Metzker. Because it is capable of mechanical reproduction, this new art form is particularly well suited to the needs of our mass society, for which reason it has also gained wide currency in the literature, film and music spheres.

Peter Röhr's symmetrical black panels, which are arranged in sequence, present an image of a stereotyped reality (ill. 392). Fabio Mauri has also produced sequences of symmetrical forms, e.g. in his *"Drive wall"* of 1963 (ill. 390). In this painting, the symmetry and the precise organisation of the component parts create latent zones of vibration, i.e. zones of potential activity, which give the work its peculiar fascination. Pictures of a similar order have been painted by the American artist Boyd Mefferd in his early period (*"TV screen with specific light vibrations"*) and by Lygia Clark (ill. 391), whose basically mechanical works are relieved by an imaginative approach which lends them a certain variable quality. Julije Knifer has used the same technique both in individual works (ill. 388) and in the *"Gorgona"* magazine. Younger artists working in this field include: Luciano Fabro (ill. 404), Mark Lancaster (ill. 389) and Sultan (ill. 393). Commenting on his work in 1967, Sultan observed that "permutational art is not only able to satisfy the needs of a vast consumer public with a relatively low level of production, but is also able to incorporate that public into the production process."

In this particular sphere, a tremendous amount has been achieved of recent years. For the most part, the basic characteristics of the individual works are predetermined by the use of highly sophisticated technical processes developed by the electronics industry. The full potential of computer art has yet to be exploited. At present a *"Work by Paul Klee"* that has been turned out by computer is not really a fit subject for mass production. It is, at best, comparable to the sort of machine-made ornaments produced in the nineteenth century. None the less, artists in America (Kenneth C. Knowlton and Leon D. Harmon, ills. 182, 208) and Japan (*Computer Technique Group of Japan*, ills. 121, 402, 403) have already discovered new processes with the aid of computers.

What appears to be a completely antithetical conception of art is manifested in Frank Malina's light compositions, e.g. *"Interior of the Cinetic Mural"*, *"The Cosmos"* (1965) and *"Circles within Circles"* (1965, ill. 408). These are really a form of kinetic painting which extend beyond the frame. Similar works have been produced by Liliane Lijn (*"Cosmic Flare"*, 1966, ill. 407), Milan Dobeš, Siegfried Albrecht and Mario Merz (*"Roma"*, 1968, ill. 399 and *"Igloo"*), whilst the photographic compositions executed by means of Manfred Kage's crystal lens technique also fall into this category. So, too, do the paintings by Alain Jacquet and the Japanese Usami, which involve the use of laser beams.

Although this branch of contemporary painting, which currently goes under the uninspiring name of "psychedelic art", appears to be diametrically opposed to the mass-production school, it is actually seeking similar ends. By pushing back the frontiers of the mind, it, too, is intent on expansion.

Similar imaginative investigations were being conducted by *Jugendstil* artists before the turn of the century. Paul Scheerbart, who carried out experiments of this kind in the 1890's, anticipated the condition of weightlessness which plays such an important part in contemporary art. Hermann Finsterlin's pan-sexual visions are a direct antecedent of the ideas evolved by the hippies, and it was no accident that Finsterlin should have been rediscovered in the second half of the 1960's.

Today, artists are using colour processes in order to create impressions of space which, although not real in themselves, affect the way in which we see reality and adapt to it.

Among the important artists working in this field are Allen Atwell and Isaac Abrams (ills. 396, Plate XXXII). Pictures like Abrams' "*Cosmic Orchid*", "*Paysage*" [Countryside], "*Peinture de printemps*" [Painting of Spring] and "*The Dissolution of the Organic World*", which date from 1967, are typical examples of expansive works produced whilst the artist's mind was artificially stimulated. Robert Yasuda paints landscapes which are made up of a number of dissimilar pictures, all of which exercise a spatial function. These composite works are characterised by the complexity, the ambivalence, even the "multivalence", of their interlacing forms. Allen Atwell's endless spaces, which merge into one another, and Bruce Connor's mandala pictures are based on Asiatic conceptions. Tom Blackwell, on the other hand, produces electronically controlled light variations. All of these artists are concerned with the expansion of human perception. So, too, are the Austrians Christian-Ludwig Attersee (ill. 395), Ernst Fuchs and Erich Brauer, the Israeli Bat-Yosef, the Icelander Erro and Mary Bauermeister, now living in New York.

The theme of mental expansion is actually indicated in the titles of paintings executed by the Japanese artist Juuko Ikewada (ill. 394). These include her "*You are sinking in the sea wall*" and "*No one asks for the age of your moon-heart*". In Ikewada's work, ancient Japanese traditions have been combined with the Viennese *Jugendstil* of Klimt and Schiele.

The contemporary Viennese artists Rainer, Fuchs and Hundertwasser have painted phantom pictures which anticipated Hippie culture (Plate XXXIII). In 1967, Rainer produced a series of lithographs whilst blindfolded and under the influence of drugs and alcohol which he called "*Wahnhall*". These pictures, in which he expressed experiences of an entirely new kind, were evolved partly from overpaintings executed under the influence of mescalin, and partly from a type of composition which was strongly influenced by psychotic art but which Rainer himself regarded as a natural development of the great European tradition of portraiture. In 1968, Rainer turned to body painting, which had already been taken up by Kusama in New York (ill. 398), Jan Lenica in Warsaw (ill. 397) and Günter Brus in Vienna ("*Self-painting executed as part of a Viennese Happening*"). One of the pioneers in this field was, of course, Pablo Picasso, who was painting on living flesh as early as 1961 (ill. 400).

By and large, this kind of obsession has led to a preoccupation with spatial, physical and temporal considerations, and consequently with an active as opposed to a passive art form. The result has been a spate of spatial works and Happenings. Manzoni's and Hundertwasser's linear compositions, which extend beyond the picture area, Kusama's, Brus' and Rainer's body paintings, Manzoni's signed nudes and Beuy's face paintings mark important stages of this development.

Jackie Cassen and Bert Stern have produced spatial environments which incorporate both figures and colour ("*Electric Circus in New York*"). Don Snyder and Robert Watts (ill. 383) have created filmic sequences depicting colour transitions and physical movement. The mirror rooms, which Kusama and Samaras have evolved from their obsessions, and the spatial effects which Yud Yalkut produces in his films by means of lighting techniques, reveal a similar attitude to life, one that is shared by the members of the "USCO" group, who are primarily concerned with the artistic representation of newly-emerging social patterns. Light, space, movement and colour are the dominant features of this new art form, which its advocates hope will break down the barrier between the conventional proprieties and the desires of modern youth, and bridge the gap between art and life.

An important facet of this new movement is its anti-Establishment bias, which is so marked, that its adherents completely ignore any form of social, political or artistic reality that has become engrained in a set pattern. The younger generation is interested primarily in dancing and music, it finds its impetus in the vital motor rhythms of a new universal culture and it loves dreams. Yoko Ono summed up this attitude when she said: "Man is born, educates himself, builds a house and a life, and then all this vanishes when he dies. What is real? Is anything real?" This sort of thinking

implies a new morality. It calls into question all forms of traditional authority, and under-mines the accepted criteria of the past: social position, esteem and public respect. Today's youth has reverted to essentials. It has reverted to the vital life force, which is now being enhanced by the imaginative expansion of human perception at the expense of the blinkered view of reality favoured by past generations.

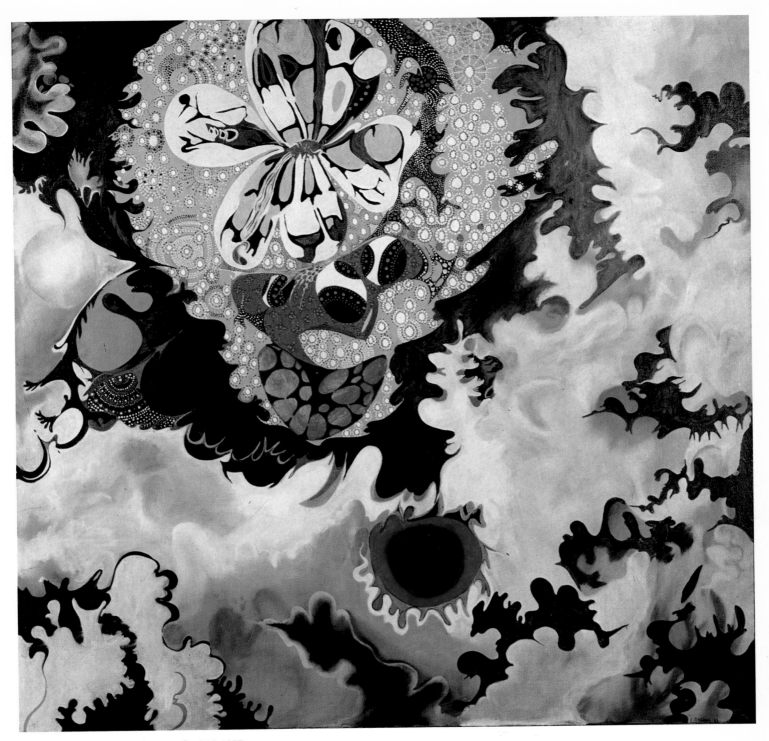

XXXII Isaac Abrams *Cosmic Orchid* 1967

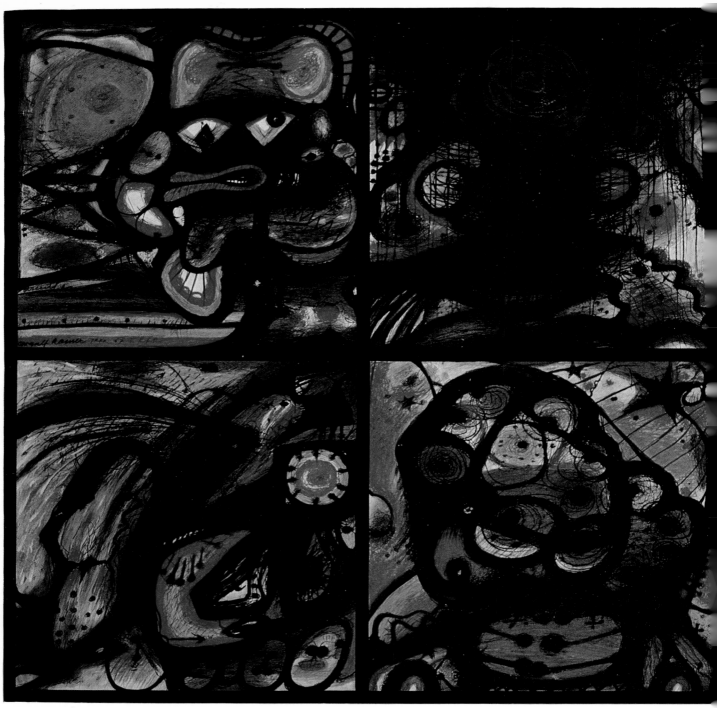

XXXIII Arnulf Rainer *Panorama berühmter Menschen* 1967

Conclusion

This book was not intended to provide a chronological survey. On the contrary, our object in investigating the various spheres of contemporary art has been to find new ways of approaching the corporate reality which lies at the heart of all pictorial forms in current use. In doing so, we have discovered a large number of common traits. As in music, poetry, and architecture, so too in painting, graphic art and photography there are many characteristic features: open structures, freedom, dynamism, variable form, the involvement of the viewer and the expansion of human perception. Another important fact is that in the present period, in which all aspects of reality are concentric, the traditional categories of painting no longer have any relevance as such.

Instead of fixed categories, we find open-ended pictorial forms which encroach on to the area occupied by the viewer, thus obliging him to furnish an imaginative response. The open or group form of present day architecture (Kurokawa, Maki, Hansen), the multiple forms and dynamic spatiality of modern sculpture and the unfinished, aleatory character of experimental music are matched by similar properties in contemporary painting, graphic art and photography. Today, the viewer has to collaborate with the artist, not in the sense of working out his meaning, but in the completely new sense of providing him with a positive response to the outgoing activity that is the principal feature of his work.

Despite the many highly pessimistic prognoses which had been advanced concerning our cultural development, a new art form has now been evolved, in which the individual is more actively concerned than at any time in history. After a period of many decades, in which the partial demands of exclusively ornamental, intellectual or emotional art forms was all he was subjected to, the viewer is now being asked for a total response similar to that required of prehistoric man.

In this respect, there is no essential difference between the lives of so-called primitive man and modern "computer man". Both are equally far removed from the kind of life which the industrial workers of the eighteenth and nineteenth centuries were forced to live, and which has remained the daily lot of the great majority of people in the twentieth century. Today, we are concerned with the whole man and not just with the small part of man which was needed for the mechanised processes of traditional work systems. Contemporary art, which depends for its effect on the relationship between the viewer and the work, is able to activate all human resources and exploit them to the full. Because it is based on this reciprocal relationship, the contemporary work of art is a highly dynamic phenomenon. It is more a process than a work, more an action than an object. Just as in Ancient Greece, so too in our own day, inner attitudes are gaining the ascendancy over the rigid, materialist ideas which characterised earlier decades. This new development has also made its impact felt in the sphere of painting, and it is essential that we should recognise its presence there, since otherwise we cannot hope to find a positive approach to the art of our times.

This new "artless art" is overcoming the rigidity of past artistic forms, and will soon usher in a period of communal creativity. Consequently, the artist now finds himself in a position which no traditional artist has ever held, for he alone is able to engender and preserve the creative powers of the masses. Today, the artist is not concerned with paraphrase, illustration or composition. He does not try to depict popular conceptions of reality. On the contrary, he tries to paint what is actually there in completely unmetaphorical and real terms.

Naturally this process is far more concentrated in genuinely spatial works, such as environments, and works involving action, such as Happenings, Living Theatre and films, than it is in pictorial works. And yet, thanks to the new forms which have now been evolved, it has also been possible for artists working in the pictorial sphere to make relevant statements about the contemporary world. By expressing concepts of universal import in concentrated form, i.e. within the context of a picture, they have overcome time and space and established links with reality, which is, of course, the

fundamental task facing us all. Art is a necessity of life, for it is the artist who shows us what life really is. Today, by placing the emphasis on authenticity, he preserves us from the insistence on creature comforts and the desire for material acquisition which have formed an inordinately large part of man's activity at all times.

BIBLIOGRAPHY

1925-1959

P. Mondrian: Neue Gestaltung – Neoplastizismus, München 1925
W. Pach: Masters of Modern Art, New York 1926
K. Malewitsch: Die gegenstandslose Welt, München 1927
A. Breton: Qu'est-ce que le Surréalisme?, Bruxelles 1934
A. Döblin: Antlitz der Zeit, München 1929
S. Dali: La conquête de l'irrationnel, Paris 1935
S. K. Langer: Feeling and Form, New York 1935
H. Read: Art and Society, London 1936 (1945², 1956³)
A. M. Zendralli: Augusto Giacometti, Zürich 1936
M. Ernst: Au-delà de la peinture, Cahiers d'Art 1/2, 1936
J. Levy: Surrealism, New York 1936
C. Zervos: Histoire de l'art contemporain, Paris 1938
R. H. Wilenski: Modern French Painters, London 1940 (1963³)
S. Cheney: The Story of Modern Art, New York 1941
J. T. Soby: Giorgio de Chirico, New York 1941
R. Frost: Contemporary Art, New York 1942
S. Janis: Abstract and Surrealist Art in America, New York 1944
S. Cheney: History of Modern Art, New York 1945
M. Nadeau: Histoire du Surréalisme, Paris 1945
A. H. Barr: What is Modern Painting?, New York 1946
W. Baumeister: Das Unbekannte in der Kunst, Stuttgart 1947
L. Moholy-Nagy: Vision in Motion, Chicago 1947
E. L. T. Mesens: René Magritte, Bruxelles 1947
L. Scutenaire: René Magritte, Bruxelles 1947
L. Venturi: Pittura contemporanea, Milano 1947
S. Dali: 50 Secrets of Magic Craftmanship, New York 1948
M. Ernst: Beyond Painting, New York 1948
H. Read: Art Now, London 1948³
L. Goitein: Art and the Unconscious, New York 1948
Illusion and Trompe L'Oeil, San Francisco 1949
A. Cirici-Pellicer: El Surrealismo, Barcelona 1949
B. Newhall: The History of Photography, New York 1949
A. Bosquet: Surrealismus, Berlin 1950
U. Apollonio: Pittura italiana moderna, Venezia 1950
W. Fowlie: Age of Surrealism, New York 1950
S. Moholy-Nagy: Moholy-Nagy, New York 1950
D. E. Schneider: The Psychoanalyst and the Artist, New York 1950
T. B. Hess: Abstract Painting, New York 1951
R. Motherwell: The Dada Painters and Poets, New York 1951
S. Dali: Mystical Manifesto, Paris 1952
S. Dali: La vie secrète de Salvador Dali, Paris 1952
H. Rosenberg: The American Action Painters, Art News, December 1952
W. Grohmann: Zwischen den beiden Kriegen, Berlin 1953
J. E. Cirlot: El mundo del objeto, Barcelona 1953
E. Kris: Psychoanalytic Explorations in Art, London 1953
K. Leonhard: Augenschein und Inbegriff, Stuttgart 1953
M. Raynal: Peinture moderne, Genève 1953
A. H. Barr: Masters of Modern Art, New York 1954

W. Haftmann: Malerei im 20. Jahrhundert, München 1954, 1955
J. E. Cirlot: La pintura surrealista, Barcelona 1955
P. Dorazio: La fantasia dell' arte nella vita moderna, Roma 1955
R. Genaille: La peinture contemporaine, Paris 1955
H. Marcuse: Eros and Civilization, Boston 1955
A. C. Ritchie: The New Decade, New York 1955
H. Sedlmayr: Die Revolution der modernen Kunst, Hamburg 1955
K. Badt: Die Kunst Cézannes, München 1956
R. Blesh: Modern Art USA, New York 1956
C. Estienne: Le surréalisme, Paris 1956
W. Hess: Dokumente zum Verständnis der modernen Malerei, Hamburg 1956
H. C. L. Jaffé: De Stijl, Amsterdam 1956
U. Kultermann: Café Voltaire, Augenblick, 1956
E. Lavagnino: L'arte moderna, Torino 1956 (1961²)
B. Newhall: On Photography, Watkins Glen, N.Y. 1956
M. Ragon: L'Aventure de l'Art Abstrait, Paris 1956
J. T. Soby: Balthus, Museum of Modern Art Bulletin, New York 1956/1957
A. Schmeller: Surrealism, London 1956
W. Boeck und J. Sabartés: Picasso, New York 1957
K. Gerstner: Kalte Kunst?, Teufen AR 1957
W. Hofmann: Zeichen und Gestalt, Frankfurt/M. 1957
N. v. Holst: Moderne Kunst und sichtbare Welt, 1957
J. Miró: Gesammelte Schriften, Zürich 1957
B. S. Myers: The German Expressionists, New York 1957
H. Platte: Malerei, München 1957
S. Rodman: Conversations with Artists, New York 1957
H. K. Roethel: Modern German Painting, New York 1957
F. Roh: Deutsche Maler der Gegenwart, 1957
M. Seuphor: Piet Mondrian, Köln 1957
M. Seuphor: Knaurs Lexikon der abstrakten Malerei, München 1957
W. Schmalenbach: Große Meister moderner Malerei, 1957
A. H. Barr: The New American Painting, Museum of Modern Art, New York 1958
G. Braque: Vom Geheimnis der Kunst, Zürich 1958
M. Gieure: La peinture moderne, Paris 1958
E. C. Goosen: The Big Canvas: Art International 8, 1958
W. Grohmann: Neue Kunst nach 1945, Köln 1958
W. Grohmann: Wassily Kandinsky, Köln 1958
W. Grohmann: E. L. Kirchner, Stuttgart 1958
R. Huyghe: Die Antwort der Bilder, Wien 1958
S. Hunter: Painting in Europe, New York 1958
B. and N. Newhall: Masters of Photography, New York 1958
R.W. D. Oxenaer: De schilderkunst van onze tijd, Zeist 1958
R. Penrose: Picasso, New York 1958
P. Pollack: The Picture History of Photography, New York 1958
F. Roh: Geschichte der deutschen Kunst von 1900 bis zur Gegenwart, München 1958
P. Waldberg: Max Ernst, Paris 1958
L. Zahn: Eine Geschichte der modernen Kunst, Berlin 1958
A. Balakian: Surrealism, New York 1959
J. Bazaine: Notizen zur Malerei der Gegenwart, Frankfurt 1959

F. Cowles: The Case of Salvador Dali, Boston 1959
S. Dali: Ich und die Malerei, Zürich 1959
H. Demisch: Vision und Mythos in der modernen Kunst, 1959
A. Dorner: Überwindung der Kunst, 1959
W. Erben: Joan Miro, München 1959
C. Gottlieb: Modern Art and Death, in: The Meaning of Death, Edited by H. Feifel, New York 1959
C. Gray: Kasimir Malevich, London Whitechapel Art Gallery, 1959
W. Grohmann: Paul Klee, Köln 1959
B. H. Friedman: Some Younger Artists, New York 1959
M. Jean: Histoire de la peinture surréaliste, Paris 1959
Y. Klein: Le dépassement de la problématique de l'art, La Louvière 1959
U. Kultermann: Der Klassiker der Malerei der Neuzeit, baukunst und werkform 1, 1959
E. Langui: 50 Jahre moderne Kunst, Köln 1959
F. O'Hara: Jackson Pollock, New York 1959
R. Pfennig: Bildende Kunst der Gegenwart, 1959
H. Platschek: Neue Figurationen, München 1959
M. Raynal: Peinture Moderne Genève 1959
H. Read: A Concise History of Modern Painting, New York 1959 (1964³)
H. Rosenberg: The Tradition of the New, New York 1959
M. Tapié: Antonio Tapies, New York 1959
S. Tillim: What Happened to Geometry, Arts June 1959
P. Wember: Joan Miro. Farbige Lithographien, 1959

1960

L. Alloway: On the Edge, Architectural Design, April 1960
G. Aust: Otto Freundlich, Köln 1960
F. Bayl: Bilder unserer Tage, Köln 1960
R. Berger: Die Sprache der Bilder, Köln 1960
J. Cassou: Panorama des arts plastiques contemporains, Paris 1960
A. Gehlen: Zeit-Bilder, Frankfurt/M. 1960
C. Greenberg: Louis and Noland, Art International, May 1960
W. Hofmann: Bildende Kunst, Hamburg 1960
S. Hunter: Modern American Painting and Sculpture, New York 1960
G. Jedlicka: Wege zum Kunstwerk, München 1960
U. Kultermann: Antonio Tapies, Papeles de son Armadans 57, Diciembre 1960
U. Kultermann: Monochrome Malerei – eine neue Konzeption, Museum Leverkusen 1960
U. Kultermann: Una nuova concezione di pittura, Azimuth 2, 1960
U. Kultermann: Eine neue Konzeption in der Malerei, art actuel international, 14, 1960
R. Nacenta: Ecole de Paris, Neuchâtel 1960
K. Pawek: Totale Photographie, Olten und Freiburg 1960
N. Ponente: Peinture moderne, Genève 1960
P. Restany: Lyrisme et abstraction, Milano 1960
B. Robertson: Jackson Pollock, Köln 1960
R. Rosenblum: Cubism and Twentieth Century Art, New York 1960
C. Roy: Arts fantastiques, Paris 1960
W. Rubin: Younger American Painters, Art International, January 1960
G. Schmidt: Die Malerei in Deutschl. 1918–1955, 1960
J. A. Thwaites: Ich hasse die moderne Kunst, Krefeld 1960

R. Hughes: Patrick Procktor's New Paintings, Studio International, May 1967

R. Hunt: The Constructivist Ethos. Russia 1913–1932, Artforum, October 1967

R. Huyghe: Sens et destin de l'art, Paris 1967

D. Judd: Jackson Pollock, arts magazine, April 1967

R. C. Kenedy: Paul de Lussanet, Art International, Septem ber 1967

J. Kind: The Unknown Grosz, Studio International, March 1967

M. Kozloff: Modern Art and the Virtues of Decadence, Studio International, November 1967

M. Kozloff: Jasper Johns, Artforum, November 1967

R. Kudielka: West-Germany, Studio International, May 1967

U. Kultermann: Neue Dimensionen der Plastik, Tübingen 1967

U. Kultermann: Lo Spazio dell'Immagine, Foligno, 1967

U. Kultermann: Piero Manzoni, Galerie Thelen, Essen 1967

U. Kultermann: Bernard Aubertin, Galerie Thelen, Essen 1967

U. Kultermann: Pino Pascali, Galerie Thelen, Essen 1967

G. Laderman: Unconventional Realists, Artforum, November 1967

K. Lal: The Cult of Desire, New York, 1967

M. Lamac: I giovani pittori di Mosca, La Biennale di Venezia 62, 1967

E. Levine: Mythical Overtones in the Work by Jackson Pollock, Art Journal, Summer 1967

L. Levine: Art, Hippies and Drugs, The Aspen Times, August 10, 1967

L. R. Lippard: The Silent Art, Art in America, January–February 1967

L. R. Lippard: Homage to the Square, Art in America, July/August 1967

N. Lyons: Photography in the Twentieth Century, 1967

H. Marcuse: Art in the One-Dimensional Society, arts magazine, May 1967

H. Martin: The Painting of Valerio Adami, Studio International, May 1967

K. v. Meier: Love, Mysticism, and the Hippies, Vogue, November 15, 1967

R. Melville: Francis Bacon, in: Studio International, April 1967

E. Neumann: Functional Graphic Design in the 20's, New York, 1967

L. Nusberg: Statements by Kinetic Artists, Studio International, February 1967

P. Overy: Justin Knowles 'Dimensional Paintings', Studio International, January 1967

J. Perreault: Union-Made, arts magazine, March 1967

N. R. Piene: Light Art, Art in America, May–June 1967

A. Pieyre de Mandiargues: Pour Magritte, Opus International 2, 1967

F. Popper: Naissance de l'art cinétique, Paris 1967

F. Popper: The Luminous Trends in Kinetic Art, Studio International, February 1967

Y. Rainer: Don't Give the Game Away, arts magazine, April 1967

M. Raysse: Refusing Duality, arts magazine, February 1967

H. Read: Art and Alienation, London 1967

H. Read: L'Arbitrio totale, La Biennale di Venezia 62, 1967

J. Reichardt: Computer Art, Studio International, April 1967

J. Reichardt: Moholy-Nagy and Light Art as Art of the Future, Studio International, November 1967

P. Reilly: The Challenge of Pop, The Architectural Review, October 1967

G. Rickey: Origins of Kinetic Art, Studio International, February 1967

B. Rose: American Art Since 1900, New York 1967

B. Rose: New Aesthetics, Washington Gallery of Modern Art, 1967

J. Russell: London. The Simplifiers, Art in America, September/October 1967

J. Russell: Master of the Nubile Adolescent, Art in America, November/December 1967

M. Salvadori: Cassa, Studio International, June 1967

L. Samaras: Cornell Size, arts magazine, May 1967

A. Scharf: Futurism. States of Mind and States of Matter, Studio International, May 1967

C. Seckel: Maßstäbe der Kunst im 20. Jahrhundert, Düsseldorf 1967

W. Sharp: Luminism. Notes Toward an Understanding of Light Art, Light Motion Space Walker Art Center Minneapolis, April/May 1967

D. Sylvester: Bridget Riley, Studio International, March 1967

S. Tillim: Scale and the Future of Modernism, Artforum, October 1967

H. Urner: Rot, die Farbe des Lebens, Neue Zürcher Zeitung, 23. 4. 1967

C. H. Waddington: The All-Round View, Studio International, March 1967

F. Whitford: The Paintings of William Turnbull, Studio International, April 1967

1968

B. Alfieri: Come andare avanti, Metro 14, 1968

L. Alloway: Roy Lichtenstein, Studio International, January 1968

L. Alloway: More Sin, More Everything in Movies, Vogue, February 1, 1968

L. Alloway: Technology and Art Schools, Studio International, April 1968

L. Alloway: Interfaces and Options, arts magazine, Sept./Oct. 1968

J. Alvard: Peinture fraîche à Paris, Art International, February 1968

U. Apollonio: Paolo Patelli, Art International, February 1968

D. Ashton: An Open and Shut Case, arts magazine, April 1968

E. C. Baker: Judd the Obscure, Art News, April 1968

R. Berger: Arte e comunicazione, La Biennale di Venezia, Gennaio–marzo 1968

R. Berger: Adja Yunkers, Art International, February 1968

J. Burnham: Beyond Modern Sculpture, New York 1968

S. Burton: A Different Stripe, Art News, February 1968

S. Burton: Big H, Art News, March 1968

N. Calas: Art in the Age of Risk, Art International, February 1968

N. Calas: The Next Revolution in Painting, arts magazine, Sept./Oct. 1968

K. Champa: Recent British Painting at the Tate, Artforum, March 1968

K. Champa: New Paintings by Larry Poons, Artforum, Summer 1968

J. H. Cone: Adolph Gottlieb, Artforum, April 1968

F. A. Danieli: Greg Card, Mary Corse, in: Artforum, Summer 1968

D. M. Davis: Art and Technology, Art in America, January/February 1968

M. Diacono: Arakawa, Art International, January 1968

G. Dorfles: Bonalumi, Metro 14, 1968

G. Dorfles: I giochi di Mari, Metro 14, 1968

M. Fagiolo dell'Arco: Warhol, the American Way of Dying, Metro 14, 1968

Ö. Fahlström: Barbro Ostlihn, Art International, February 1968

A. Fawcett: London Mystery Tour, Art and Artists, February 1968

C. Finch: Communicators, Art and Artists, February 1968

D. Flavin: ...on an American Artists Education, Artforum, March 1968

P. Gilardi: micro-emotive art, museum journal 13/14, 1968

A. Goldin: Morris Louis, Art News, April 1968

P. Gilardi: Primary Energy and the "Micro-emotive Artist", arts magazine, Sept./Oct. 1968

E. C. Goossen: The art of the Young, Vogue, August 1, 1968

C. Greenberg: Poetry of Vision, Artforum, April 1968

O. Hahn: Les multiples à Paris, Art International, January 1968

O. Hahn: Ingres and Primary Structures, arts and architecture, February 1968

O. Hahn: Positive Negatives, Art and Artists, March 1968

R. Hamilton: Roy Lichtenstein, Studio International, January 1968

C. Harrison: Jeremy Moon's Recent Painting, Studio International, March 1968

C. Harrison: London, Studio International, January 1968

C. Harrison: 'Le Muse Inquietanti', Studio International, February 1968

W. Hofmann: Turning Points in Twentieth Century Art. 1890–1917, New York 1968

A. Hudson: On Jules Olitzki's Paintings – and some Changes, Art International, January 1968

P. Hutchinson: The Perception of Illusion, arts magazine, April 1968

A. Kaprow: The Shape of the Art Environment, Artforum, Summer 1968

M. Kirby: The Experience of Kinesis, Art News, February 1968

M. Kozloff: Light as Surface, Artforum, February 1968

R. Krauss: Willem de Kooning, Artforum, January 1968

U. Kultermann: Lygia Clark, Galerie Thelen, Essen 1968

U. Kultermann: Laura Grisi, Galerie Thelen, Essen 1968

U. Kultermann: Roy Adzak, Galerie Thelen, Essen 1968

L. R. Lippard: Escalation in Washington, Art International, January 1968

L. R. Lippard und J. Chandler: The Dematerialization of Art, Art International, February 1968

D. MacAgy: Plus + Minus. Today's Half Century, Art Gallery, March 1968

R. E. L. Masters at J. Houston: L'art psychédélique, Paris 1968

J. Milner: Ideas and Influences of De Stijl, Studio International, March 1968

A. Moles: De la fascination, Art International, February 1968

R. Morris: Anti-Form, Artforum, April 1968

G.Muller: Alain Jacquet, Konstrevy 2, 1968
G.Muller: Jean Michel Sanejouand,
Konstrevy 2, 1968
T.Mussman: A Comment on Literalness,
arts and architecture, February 1968
P.Overy: The Montage-Paster Heartfield,
Art and Artists, February 1968
J.Perreault: Plastic Man Strikes, Art News,
March 1968
S.Pinto: Dell'Avanguardia, Metro 14, 1968
P.Plagens: Sam Francis Retrospective in Houston,
Artforum, January 1968
R.Pomeroy: Stamos' Sun-Boxes, Art News,
March 1968
H.Read und B.Robertson: New British Painting
and Sculpture at the University of California,
Art International, February 1968
B.Robertson: New British Painting and Sculpture,
arts and architecture, February 1968
B.Rose: A Gallery Without Walls, Art in
America, March/April 1968
E.Ruda: Jack Krueger, Artforum, April 1968
J.Russell: Derek Southall, Studio International,
March 1968
P.Schneider: From Confession to Landscape,
Art News, April 1968
N.Schöffer: Idée, Objet, Effet, Art International,
January 1968
B.N.Schwartz: Psychedelic Art, arts magazine,
April 1968
A.Seide: Plakat-Experimente von Rambow und
Lienemeyer, Gebrauchsgraphik, Februar 1968
J.B.Smith: Modern Art in Norway, Studio
International, April 1968
J.J.Spector: Freud and Duchamp. The Mona
Lisa 'Exposed', Artforum, April 1968
K.Stiles: Al Held, Artforum, March 1968
G.Swenson: Social Realism in Blue, Studio
International, February 1968
G.Swenson: The Figure a Man Makes, Art and
Artists, April 1968
S.Tillim: Rosenquist at the Met. Avant-garde or
Red Guard?, Artforum, April 1968
S.Tillim: Evaluations and Re-Evaluations,
Artforum, Summer 1968
T.Trini: Nel racconto di Pasotti. La neomitologia
quotidiana, Metro 14, 1968
R.Vance: Painting Lists, Art and Artists,
February 1968
L.Vergine: Torino '68, Metro 14, 1968
D.Waldman: Gottlieb. Signs and Suns, Art News,
February 1968
E.Wasserman: Lee Krasner, Artforum,
March 1968
E.Wasserman: Robert Irwin, Gene Davis,
Richard Smith, Artforum, May 1968
E.Wasserman: Richard van Buren, David Novros,
Charles Ross, Artforum, Summer 1968
E.Wasserman: Photography, Artforum,
Summer 1968
W.Wilson: Prince of Boredom, Art and Artists,
March 1968
A.Wilson: Paul Thek, Art and Artists,
E.Wolfram: The Ascott-Galaxy, Studio Inter-
national, February 1968
J.Yalkut: Art and Technology of Nam June Paik,
arts magazine, April 1968

1 Kasimir Malewitsch *White on White* 1917

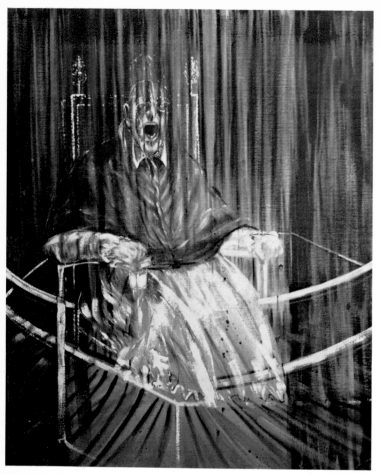

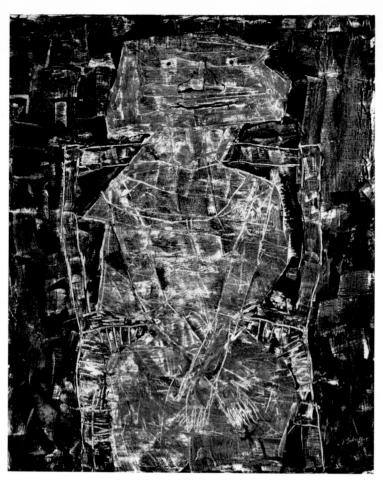

2 Francis Bacon *Study after Velasquez – Portrait of Pope Innocent X*
1953

3 Jean Dubuffet *La visiteuse* 1959

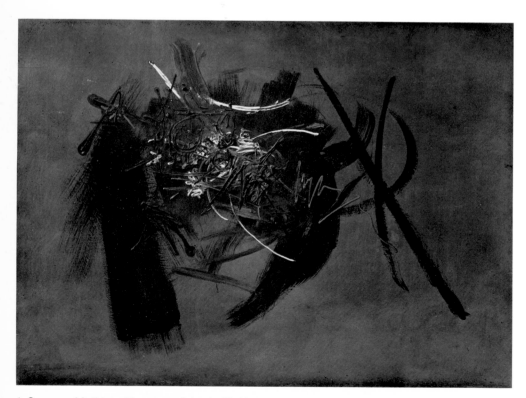

4 Georges Mathieu *Hommage à Louis XI* 1950

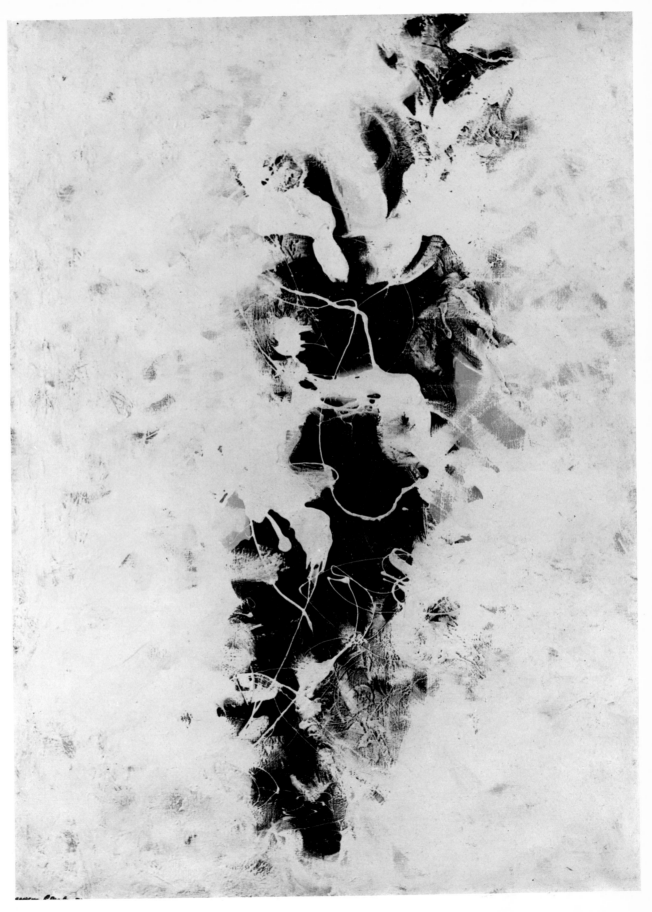

5 Jackson Pollock *The Deep* 1953

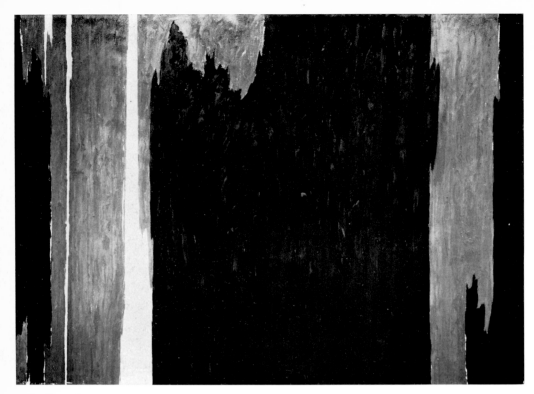

6 Clyfford Still *Red and Black* 1956–57

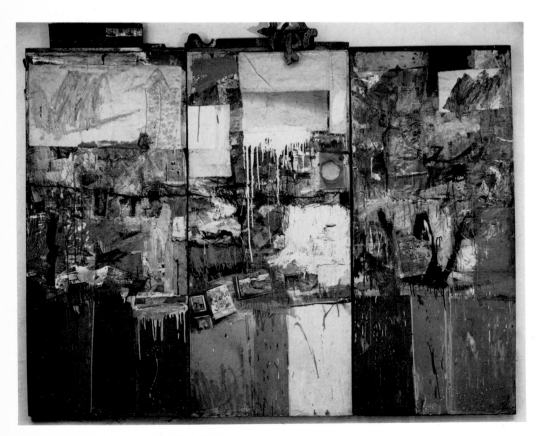

7 Robert Rauschenberg *Untitled* 1954

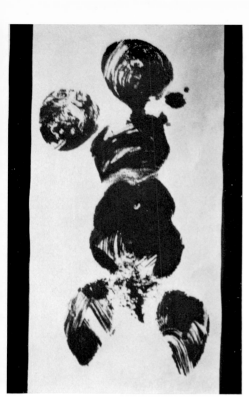

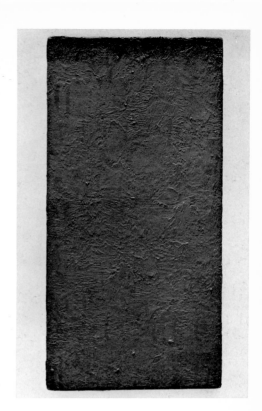

◁ 8 Yves Klein *Anthropométrie* 1960

9 Yves Klein *Bleu Monochrome* 1960 ▷

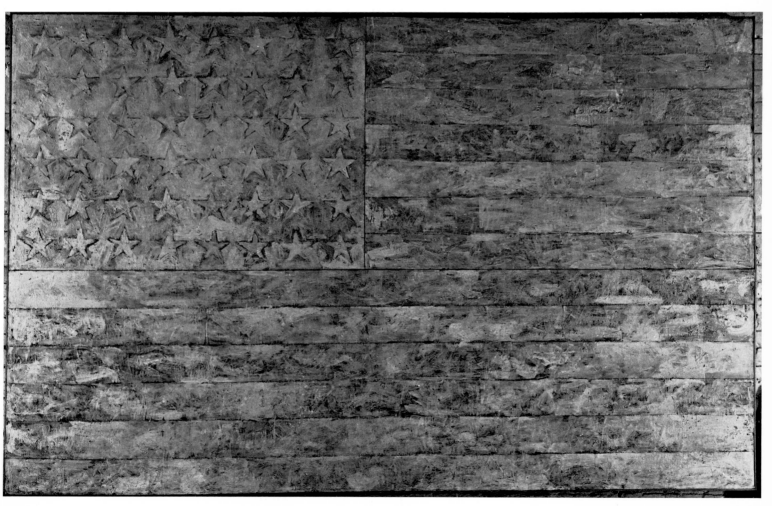

10 Jasper Johns *White Flag* 1965

11 Salvatore Scarpitta *Directory* 1960

12 Jorge Eielson *Angolare 4* 1966

13 Antonio Tapies *Arc* 1967

14 Gustav Metzger *Aktionsmalerei mit Säure auf Nylon* 1960

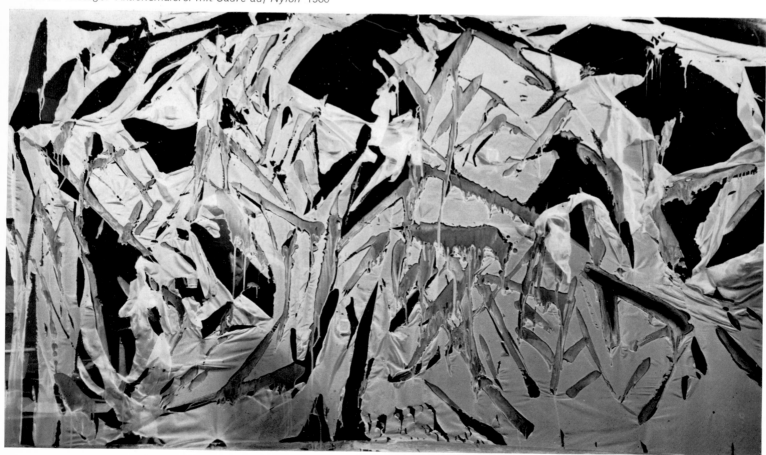

15 Piero Manzoni *Bianco* 1961

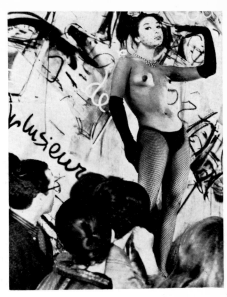

16 Gianni Bertini *Striptease Poétique* 1960

17 Roy Lichtenstein *Big Painting* 1965

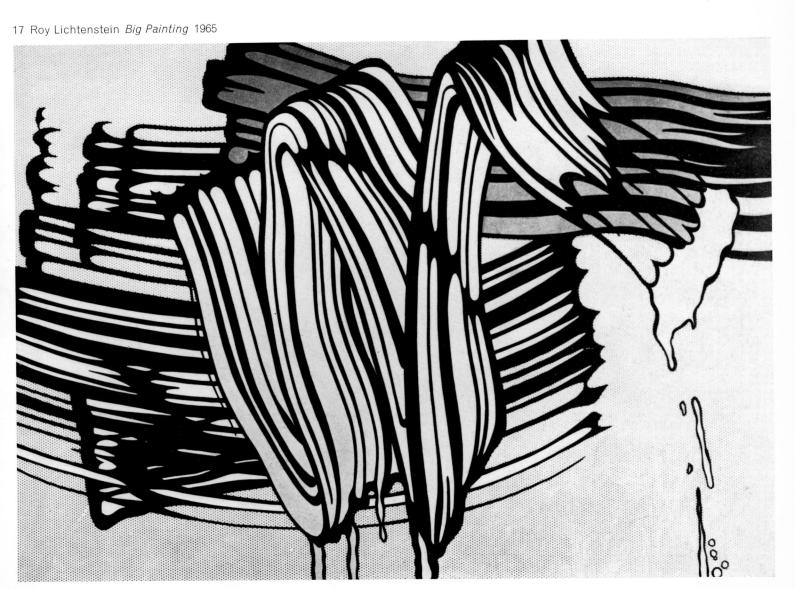

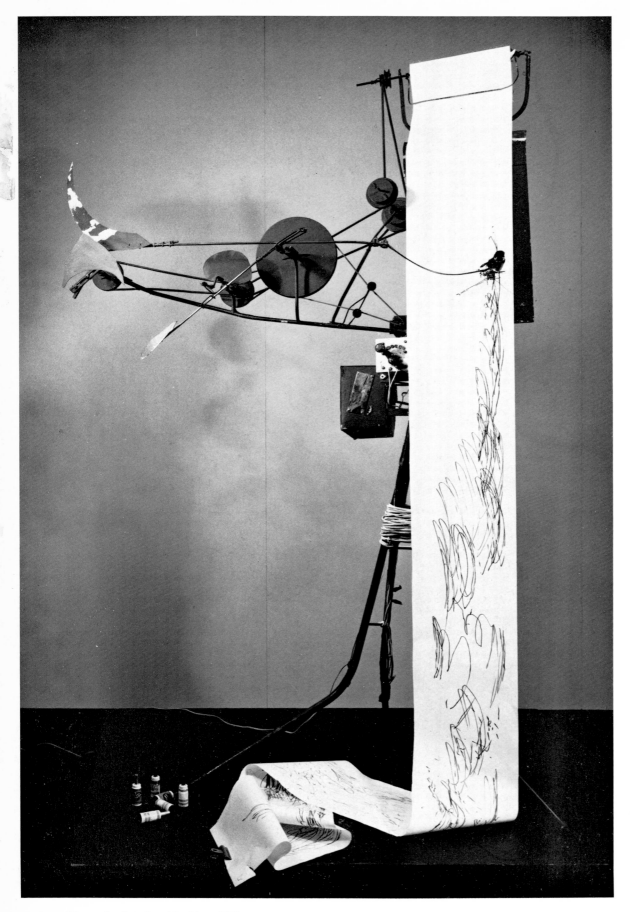

18 Jean Tinguely *Painting Machine* 1959

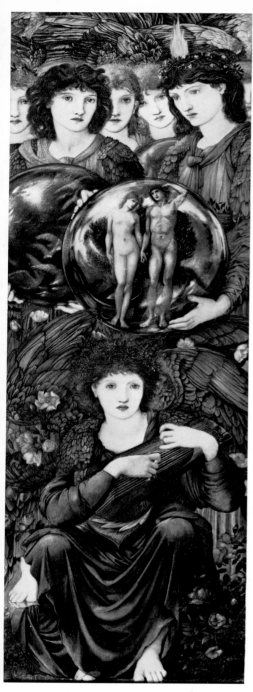

19 Edward Burne-Jones *The Angels of Creation – The Sixth Day* 1867

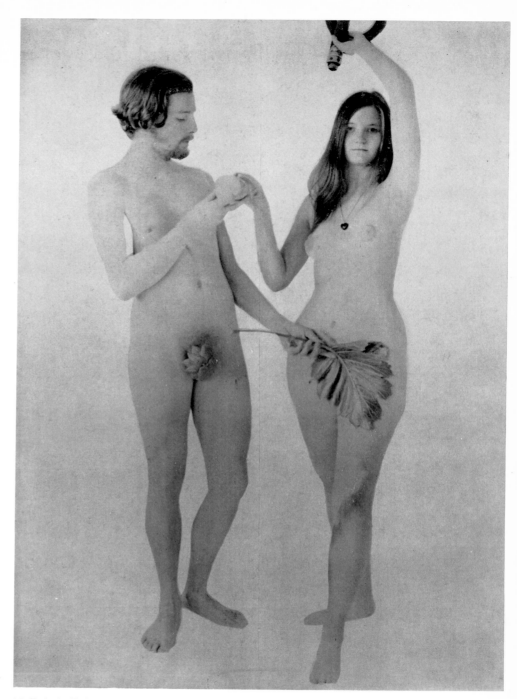

20 Dakota Daley, Nicholas Quennell *Adam and Eve* 1965

21 Rejlander *The Two Ways of Life* 1857

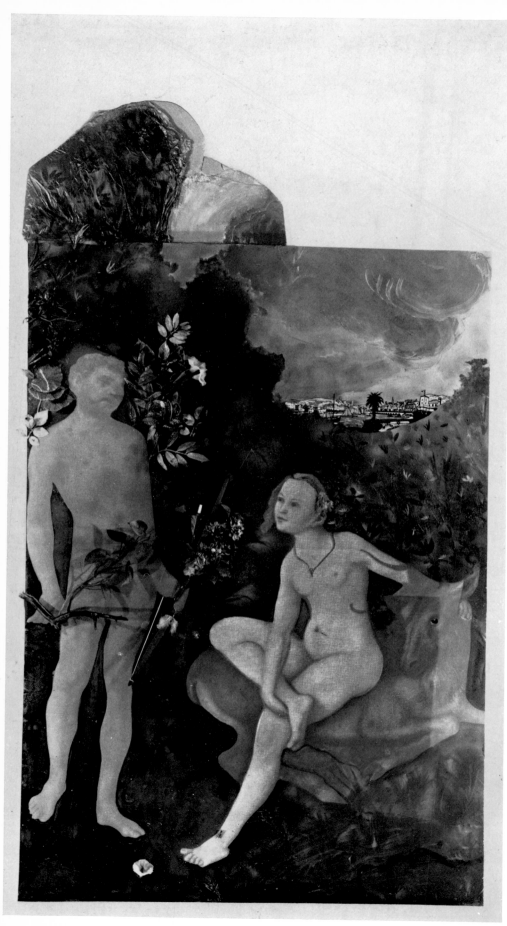

23 Richard Hamilton *Just what it is that makes today's home so different, so appealing?*
1956

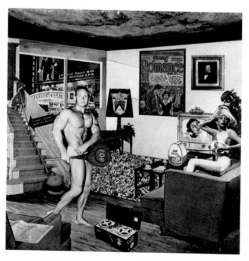

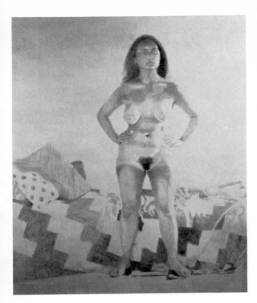

24 Howard Kanovitz *Nude Greek* (Drawing)
1965

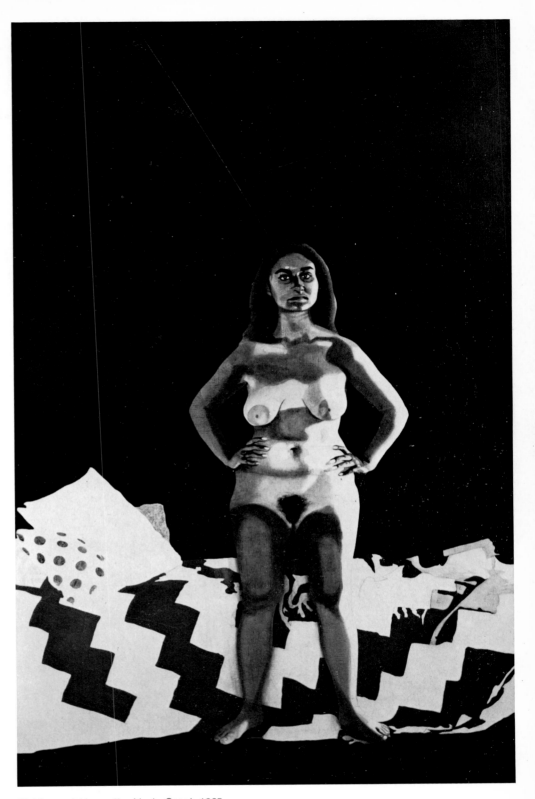

25 Howard Kanovitz *Nude Greek* 1965

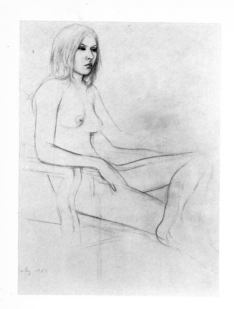

26 William Bailey *Seated Nude* 1967

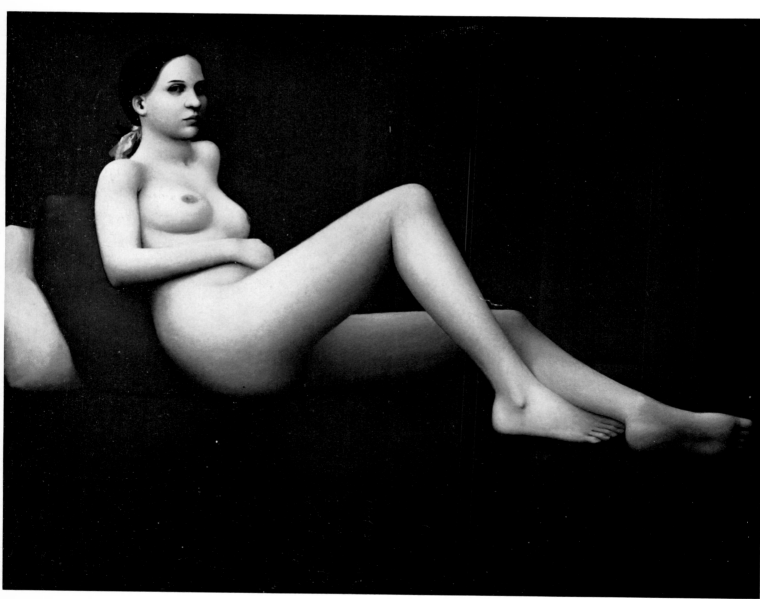

27 William Bailey *Nude* 1967

28 Philip Pearlstein *Drawing* 1961

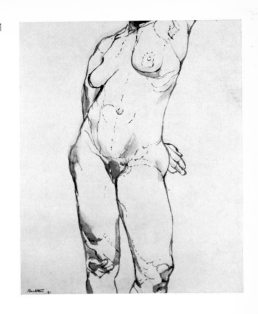

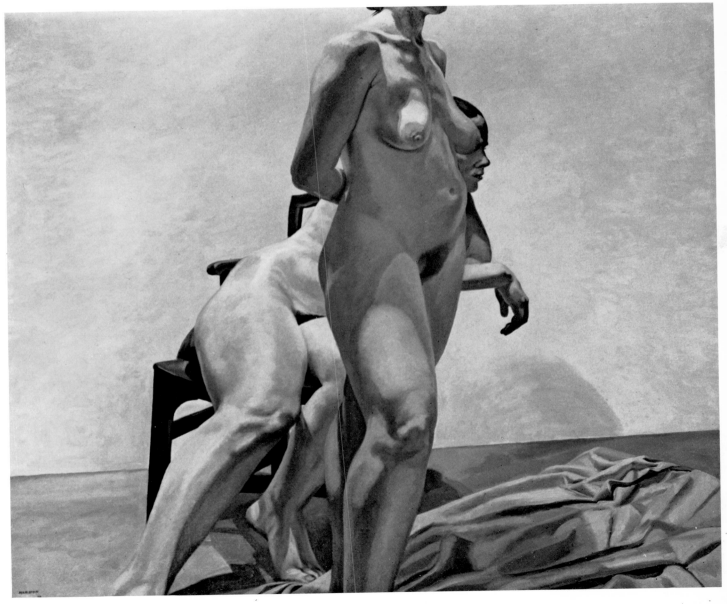

29 Philip Pearlstein *Two Models – One Seated* 1966

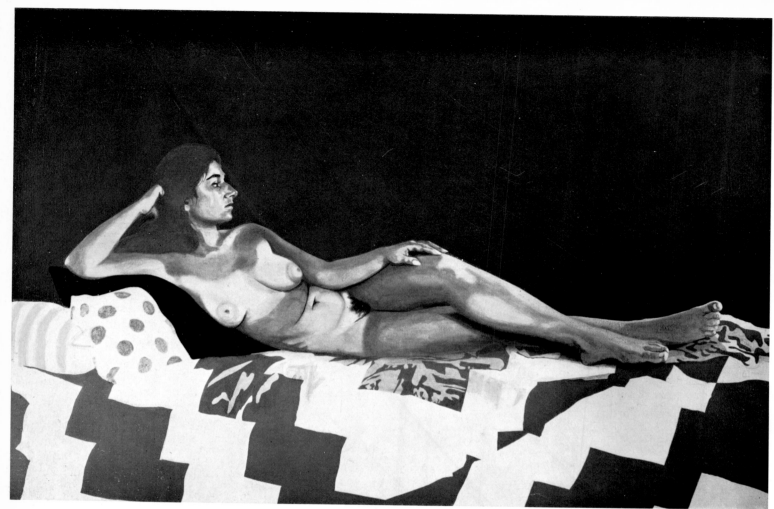

30 Howard Kanovitz *Nude Greek* 1965

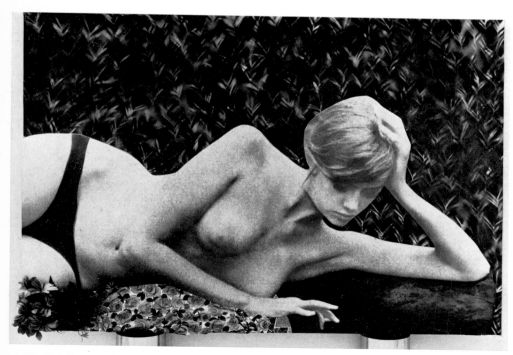

31 Martial Raysse *Simple and Quiet Painting* 1964

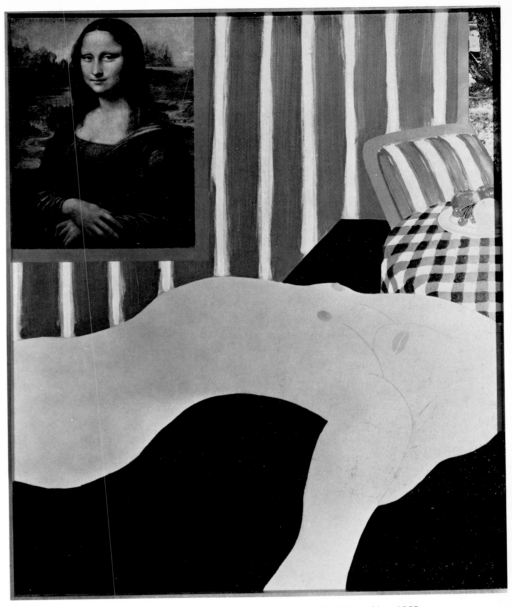

32 Tom Wesselmann *Little Great American Nude No. 31 with Mona Lisa* 1962

33 Tano Festa *La grande odalisca* 1964

34 Martial Raysse *Made in Japan* 1964

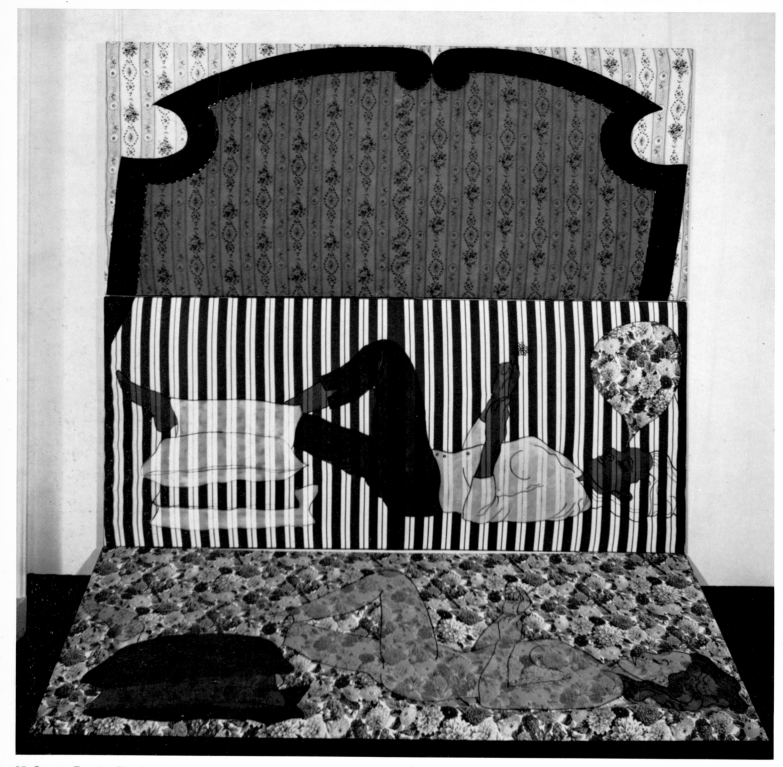

35 Cesare Tacchi *The Bed (Thinking about the Grass...!)* 1966

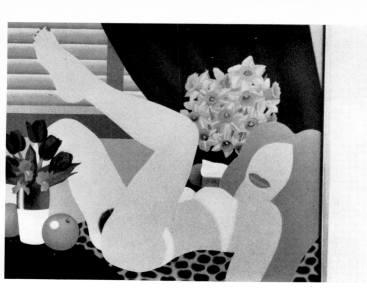

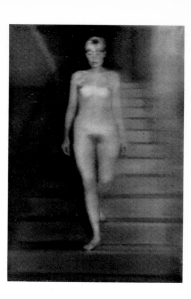

◁ 36 Tom Wesselmann
Great American Nude 1967

37 Gerhard Richter *Ema*
(Akt auf einer Treppe) 1965 ▷

8 Michelangelo Pistoletto *Reclining Woman* 1967

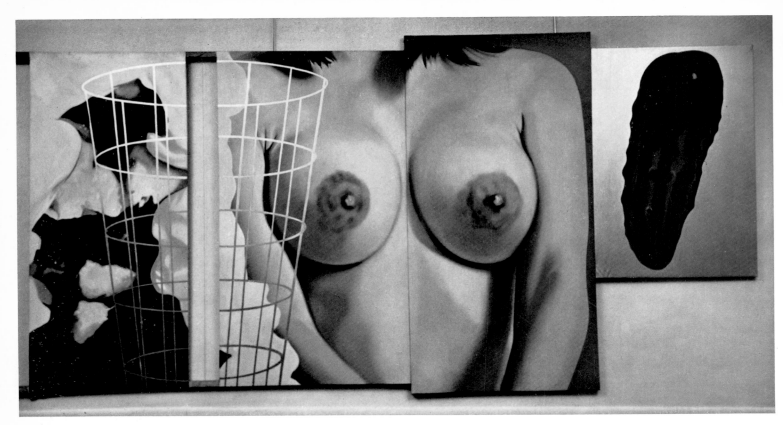

39 James Rosenquist *Playmate* 1966

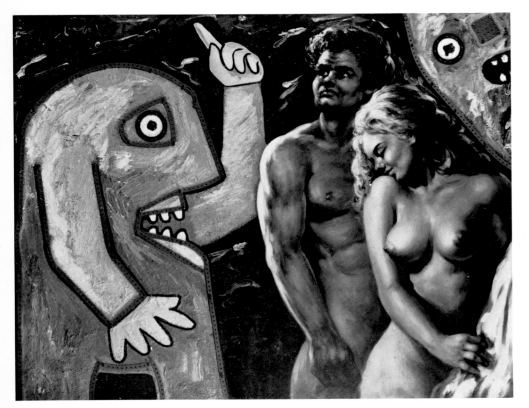

40 Enrico Baj *Adamo e Eva* 1964

41 Richard Hamilton *Pin-up* 1961

18

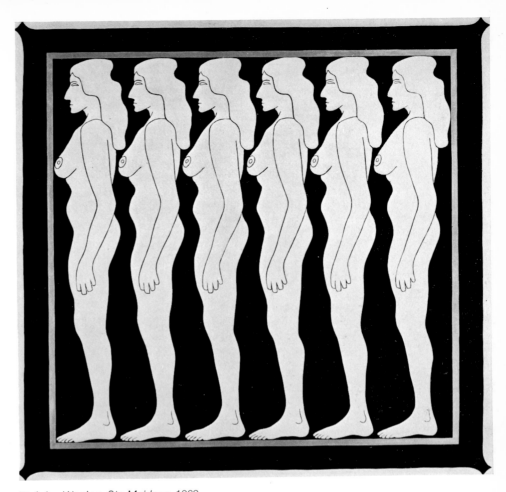

42 John Wesley *Six Maidens* 1962

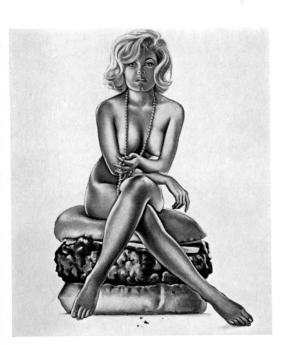

43 Mel Ramos *Virnaburger* 1965

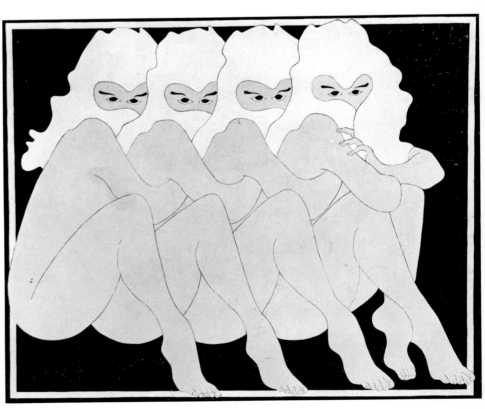

44 John Wesley *Captives* 1962

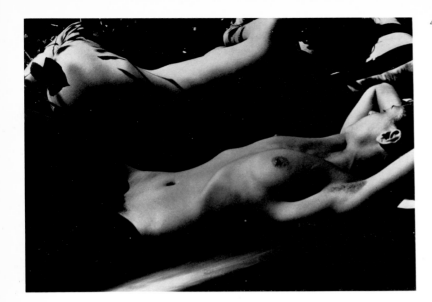

45 Laszlo Moholy-Nagy *Akte* 1927

46 Yasuhiro Yoshioka *Foto* 1968

20

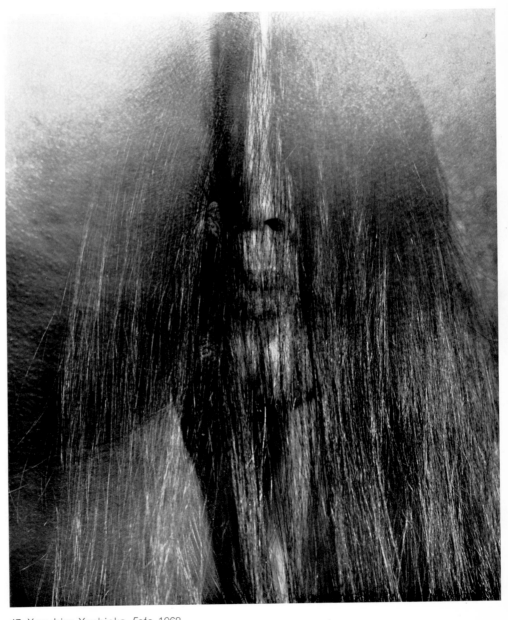

47 Yasuhiro Yoshioka *Foto* 1968

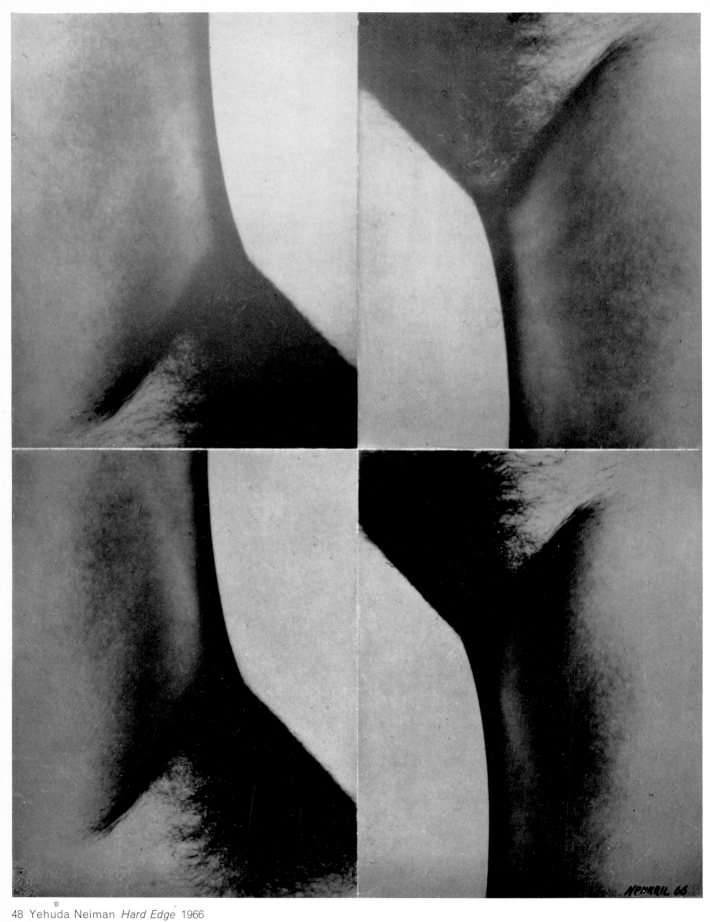

48 Yehuda Neiman *Hard Edge* 1966

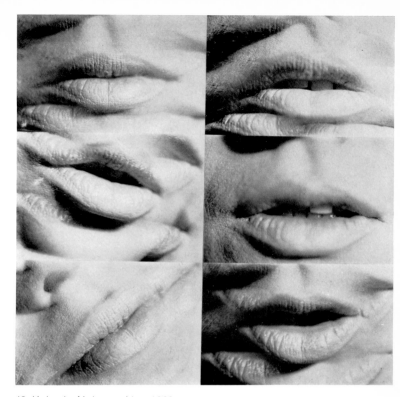

49 Yehuda Neiman *Lips* 1968

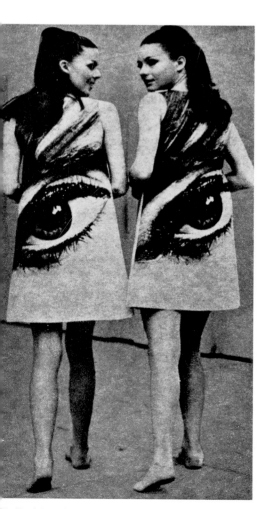

0 *Fashion design*

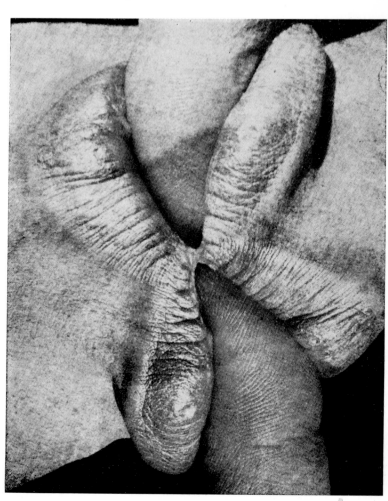

51 Tilo Keil *Lippenkreuz* 1968

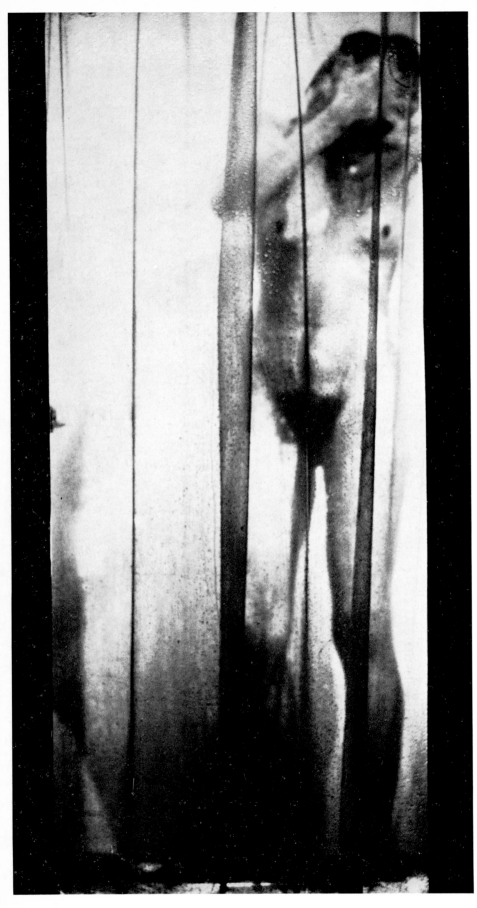

52 Robert Whitman *Cinema Piece* 1967

53 Andy Warhol *Most Wanted Man* 1963

55 Felix H. Man *Max Liebermann* 1930

54 Laszlo Moholy-Nagy *Selbstportrait* 1930

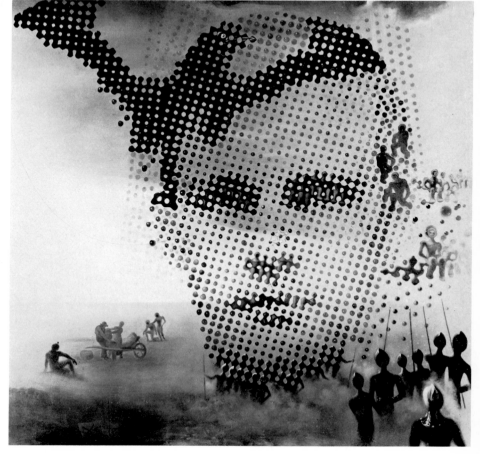

56 Salvadore Dali *Portrait of my Dead Brother* 1963

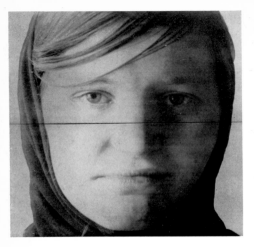

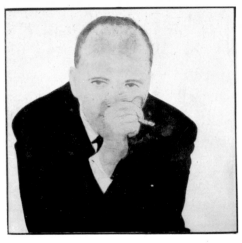

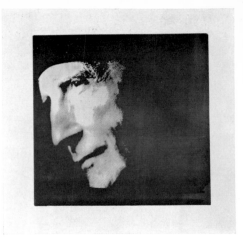

57 Dakota Daley, Nicholas Quennell *Eve 2* 1965

58 Michelangelo Pistoletto *Tête Homme avec cigarette* 1962

59 Bert Stern *Marcel Duchamp* 1967

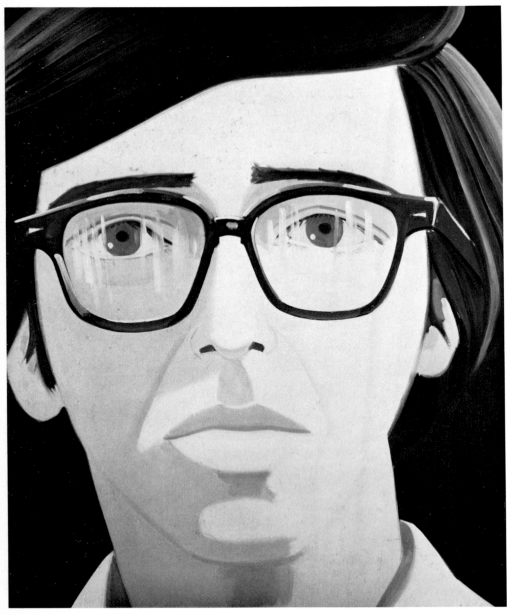

60 Alex Katz *Kenneth Koch* 1967

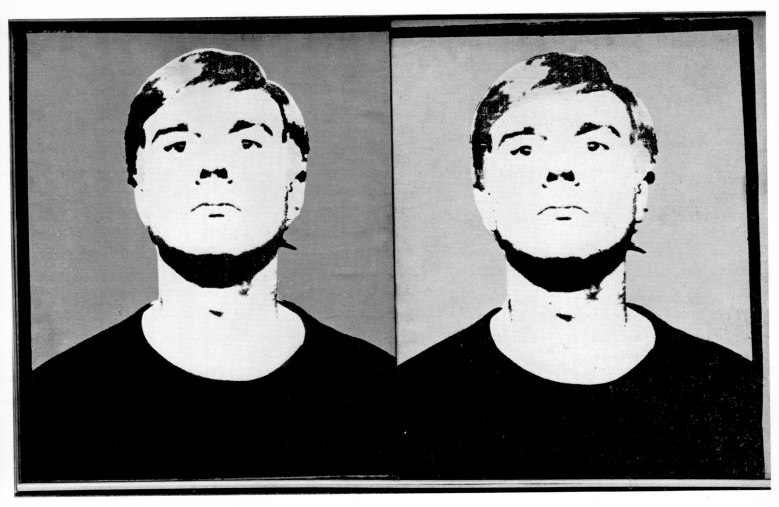

61 Andy Warhol *Self-Portrait* 1964

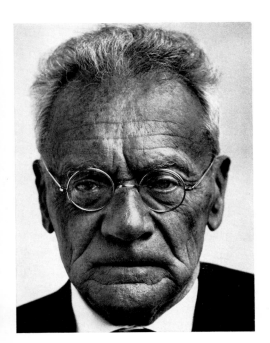

62 Otto Steinert *Prof. Karl von Frisch* 1962

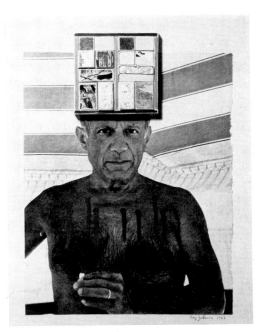

63 Ray Johnson *Picasso* 1966

64 Ronald B. Kitaj *Portrait of Robert Creeley* 1966

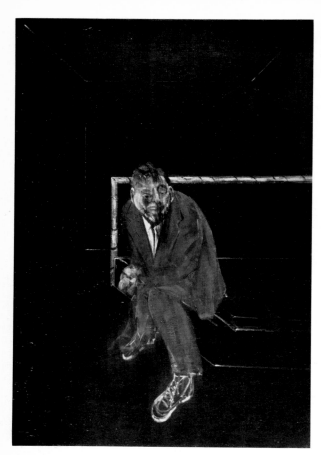

65 Francis Bacon *Self-Portrait* 1964

66 James Gill *Felix Landau* 1964

67 Pietro Gallina *Ritratto di Carl Laszlo* 1967

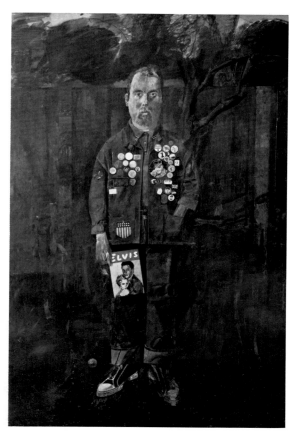

68 Peter Blake *Self-Portrait* 1961

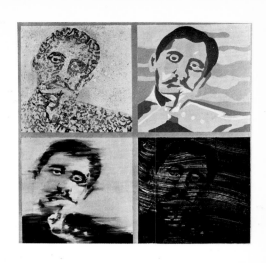

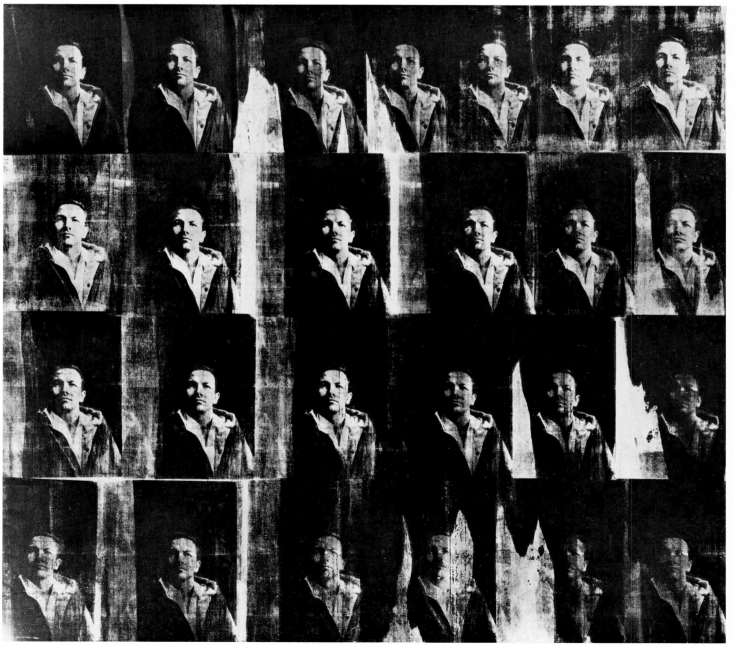

70 Andy Warhol *Texan* 1962

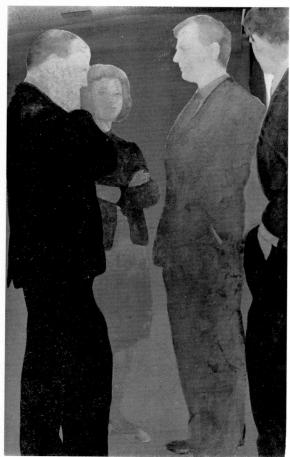

71 Michelangelo Pistoletto
Sacra conversazione 4 persone 1963

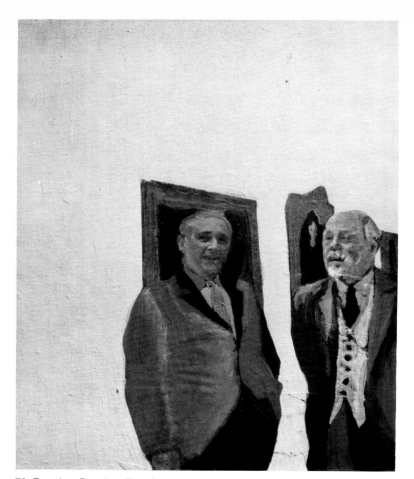

72 Rosalyn Drexler *The Connoisseurs* 1963

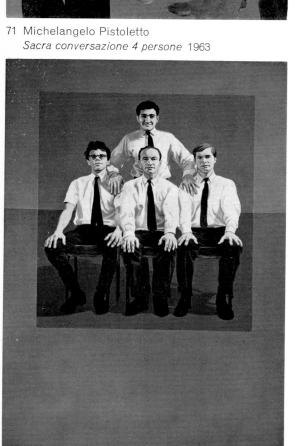

73 Wynn Chamberlain *Group Portrait* 1964

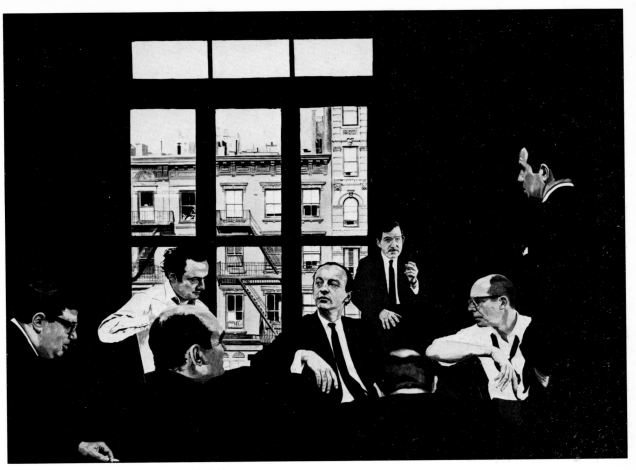

74 Howard Kanovitz *New Yorkers II* 1966

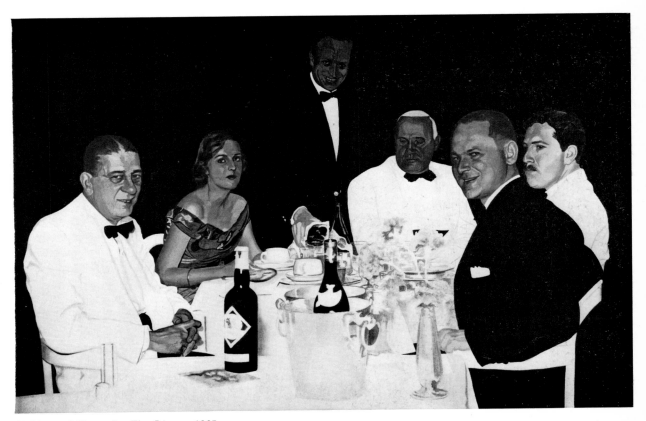

75 Howard Kanovitz *The Dinner* 1965

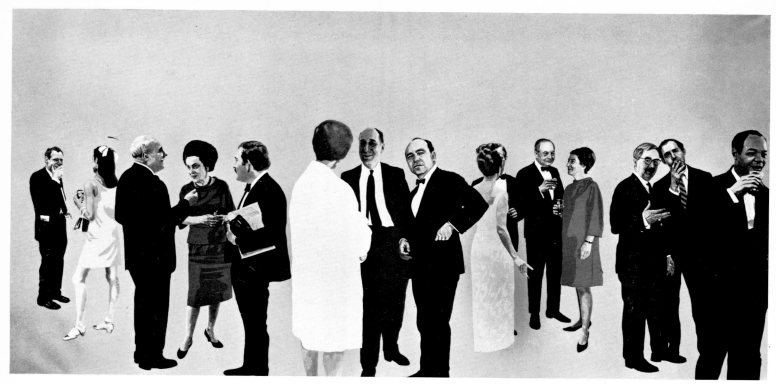

76 Howard Kanovitz *The Opening* 1967

77 John Clarke *Rembrandt – The Night Watch* 1967

78 Roy Lichtenstein *Girl* 1965

79 Martial Raysse *Bagneuse sur 4 plans* 1963

80 Gerald Laing *Rain Check* 1965

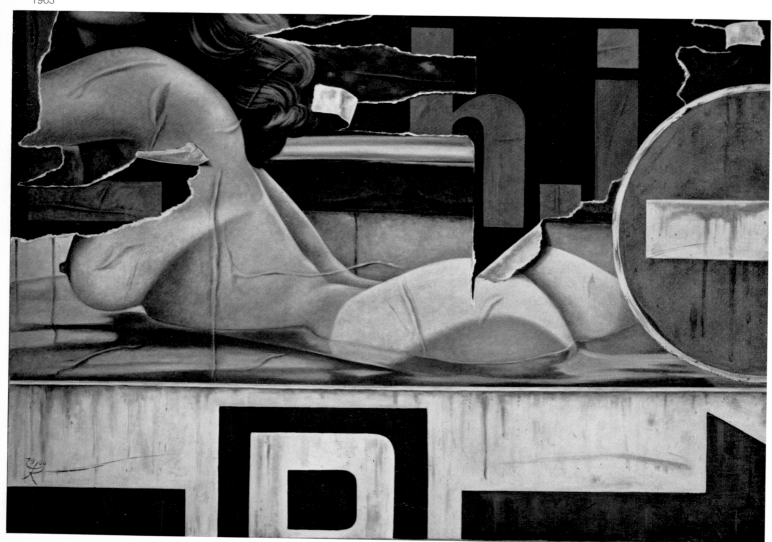

81 Fritz Köthe *Allison* 1966

82 Martial Raysse *Sur la plage – Titre intelligent* 1962

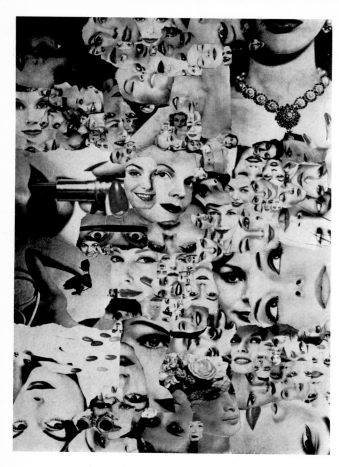

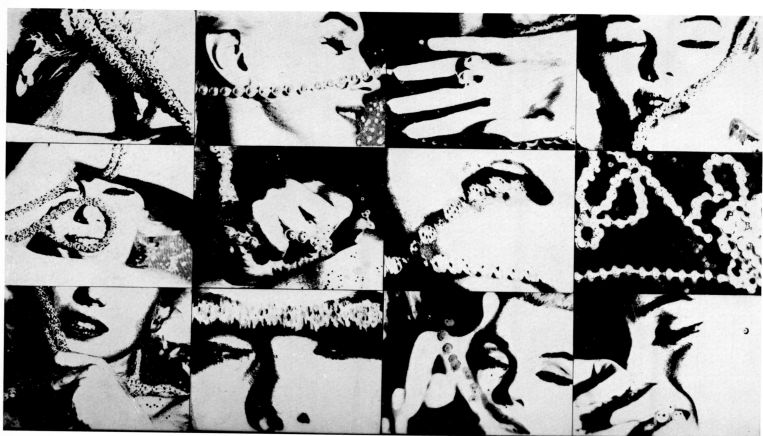

84 Bert Stern *The Last Sitting* 1962

85 Jules Joseph Lefèbre *Morning Glory* 1879

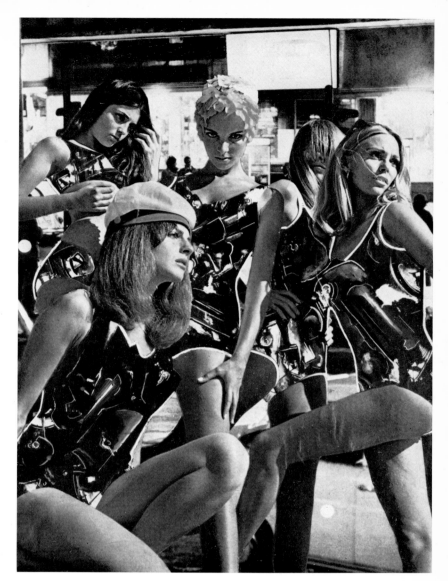

86 Gianni Bertini *Stilmec* 1967

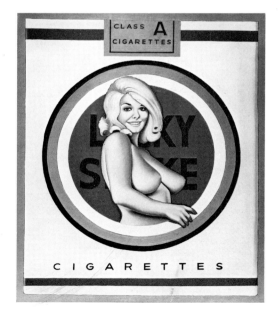

87 Mel Ramos *Lucky Strike* 1965

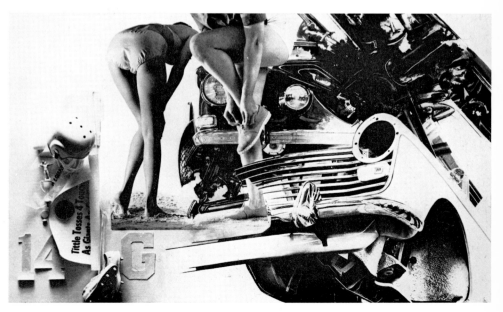

88 Gianni Bertini *Scampagnota* 1966

89 Andy Warhol *Elvis I and Elvis II* 1964

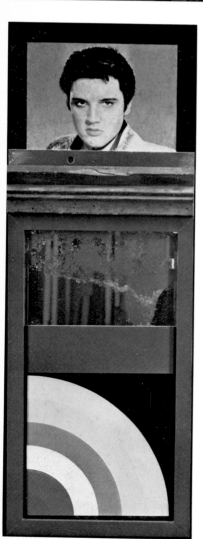

90 Peter Blake *Elvis Mirror* 1961

91 Robert Stanley
The Beatles 1966 ▷

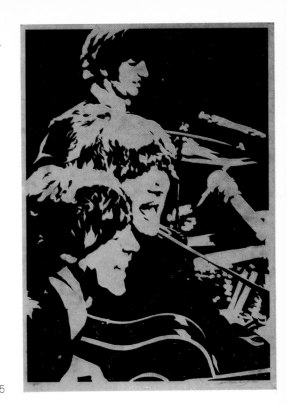

Peter Blake
▽ *The Beatles* 1963–65

92 Peter Blake *The Beach Boys* 1964

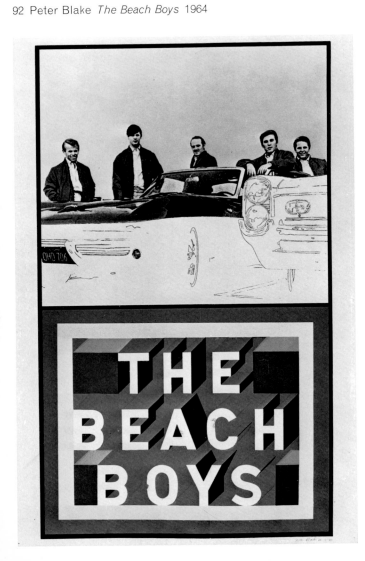

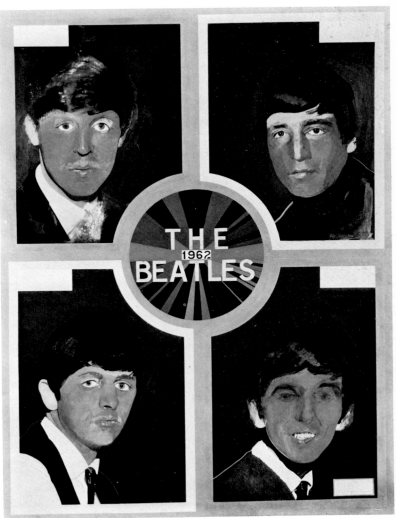

39

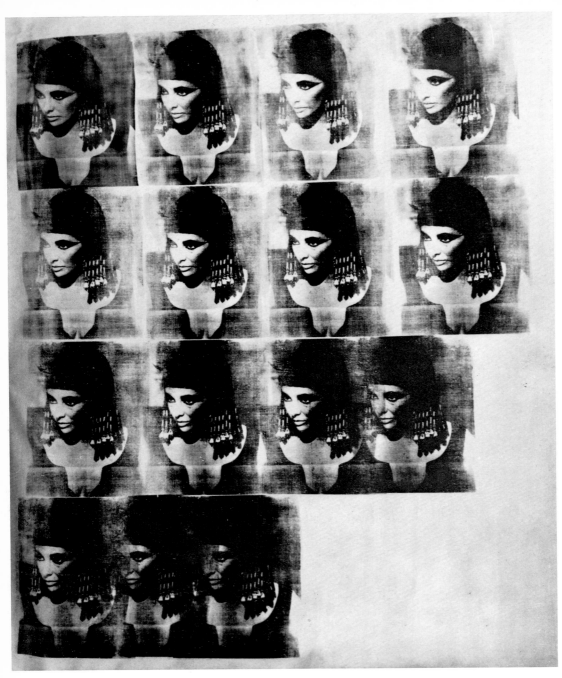

94 Andy Warhol *Elisabeth Taylor* 1965

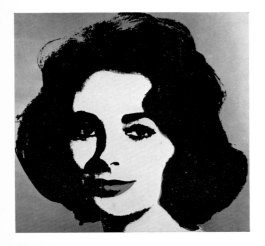

95 Andy Warhol *Elisabeth Taylor* 1965

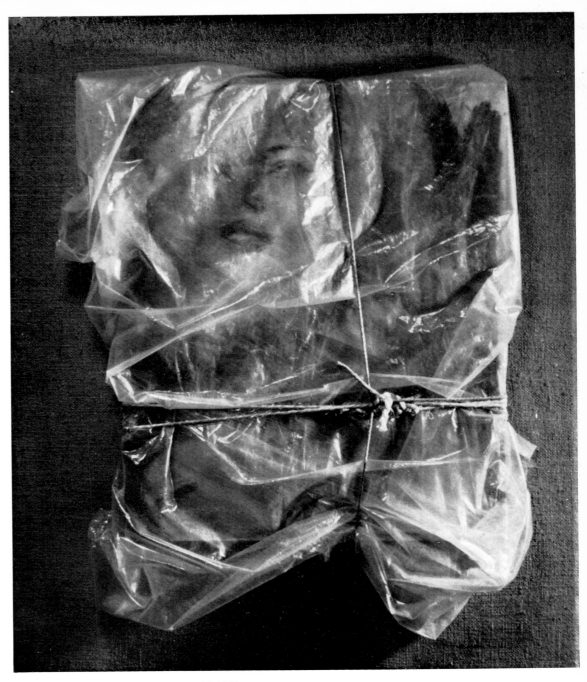

96 Christo *Portrait du B.B. empaqueté* 1963

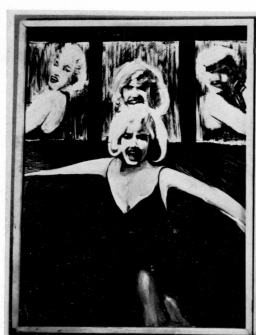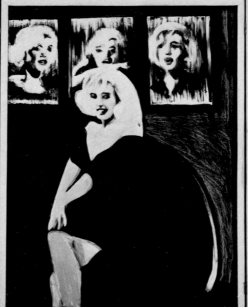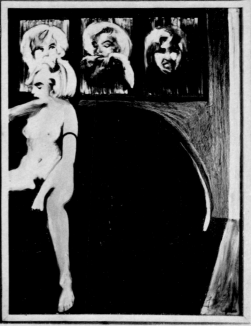

97 James Gill *Marilyn, Each Panel* 1962

98 Cartier-Bresson *Marilyn Monroe with John Huston (,,The Misfits")* 1960

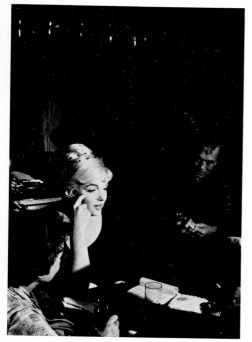

99 George Segal *The Movie Poster (detail)* 1967

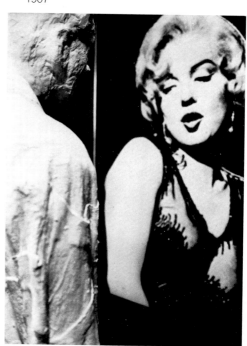

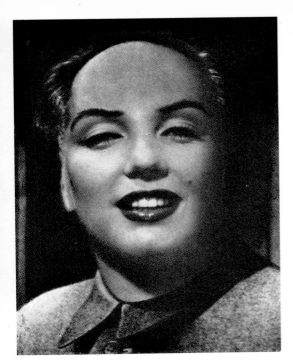

100 Salvador Dali *Mao-Marilyn (detail)* 1967

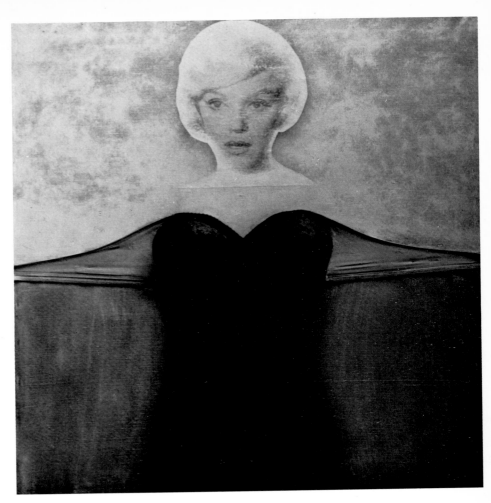

101 Jorge Eielson *Requiem* 1962

102 James Rosenquist *Marilyn Monroe I* 1962

103 Bert Stern *Marilyn Monroe* 1962

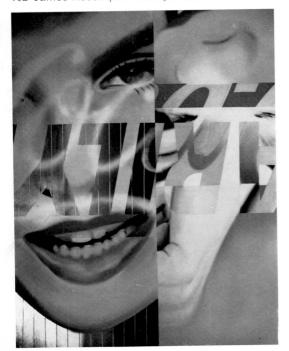

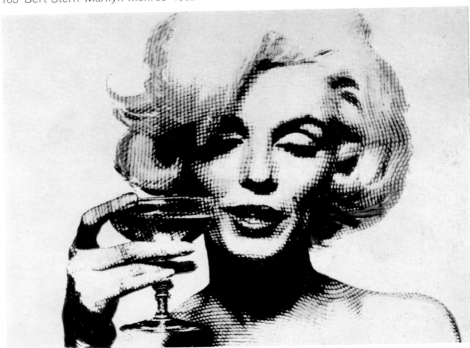

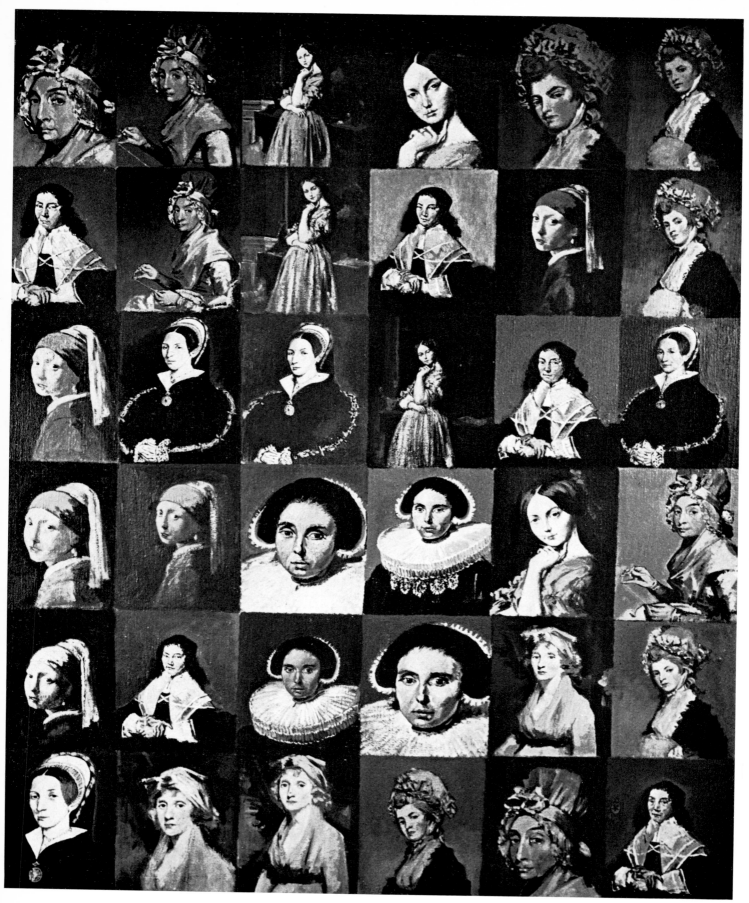

104 George Deem *Eight Women* 1967

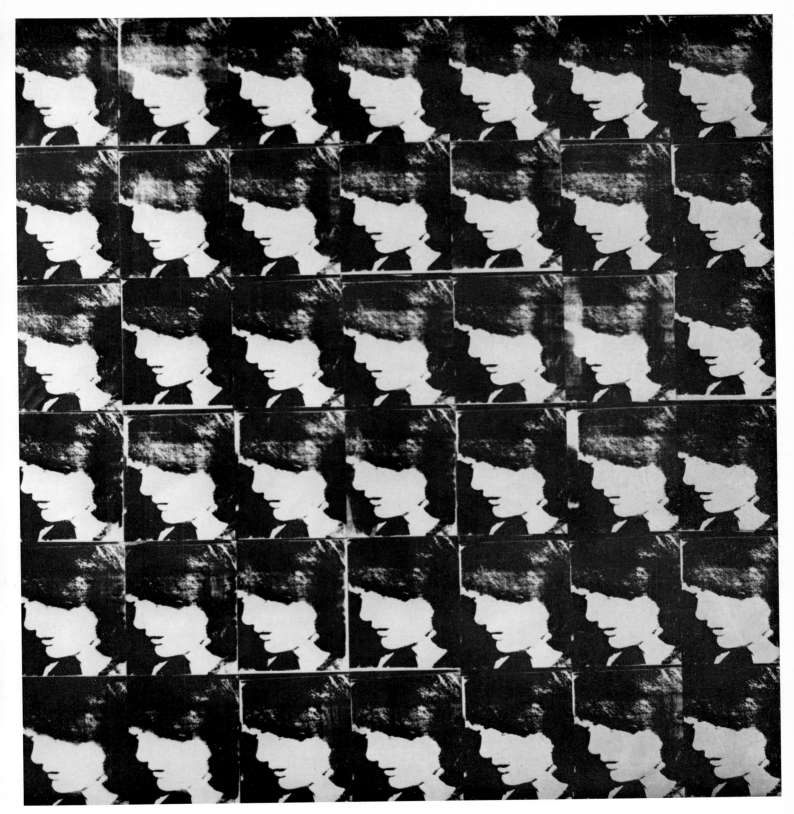

105 Andy Warhol *Jackie* 1964

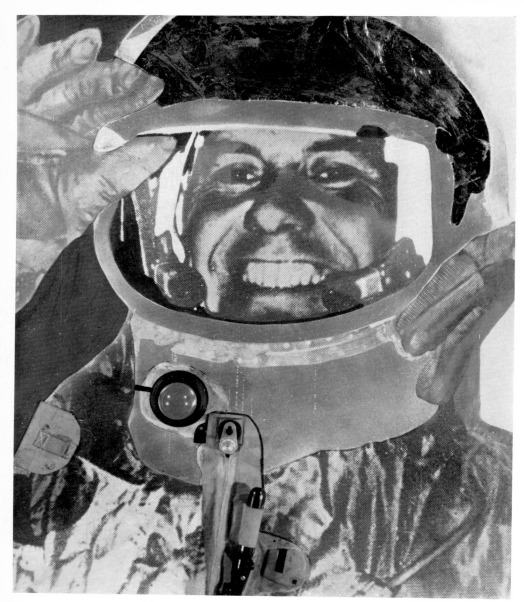

106 Martial Raysse *Gordon Cooper* 1963

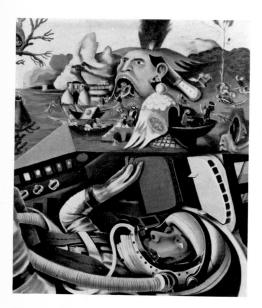

107 Gudmundur Erro *Le décollage de Bosch*
1964

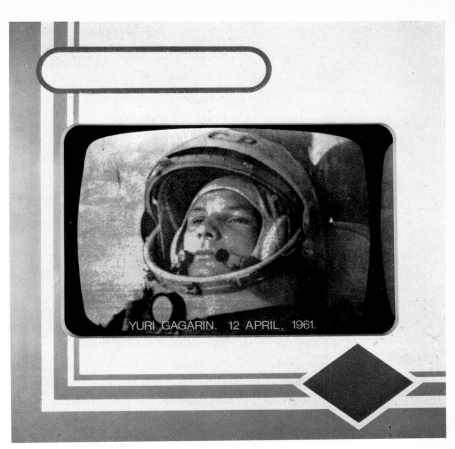

108 Joe Tilson *Transparency, Yuri Gagarin 12 April, 1961* 1968

109 Joe Tilson *Transparency, Software frame A* 1968

110 Robert Rauschenberg *Echo* 1962

111 Gudmundur Erro *American Idols* 1964

113 Richard Merkin *Every Day is D-Day Under the El* 1968

112 William Copley *Casey strikes out* 1966

114 Jacques Monory *Un autre* 1966

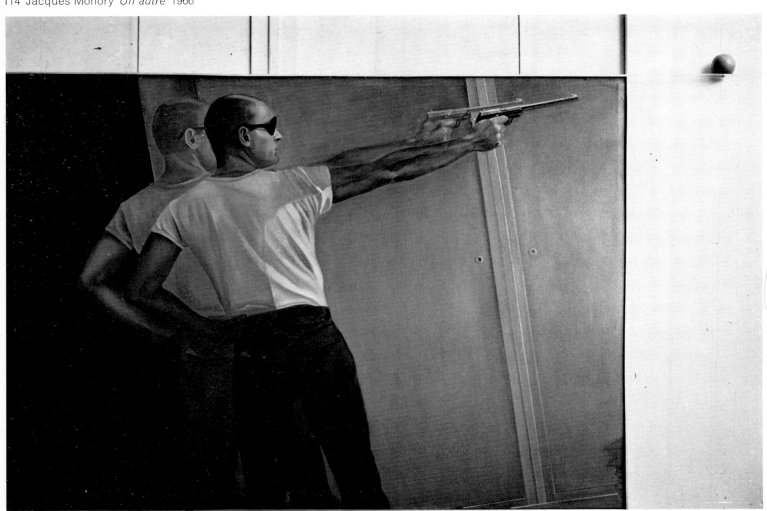

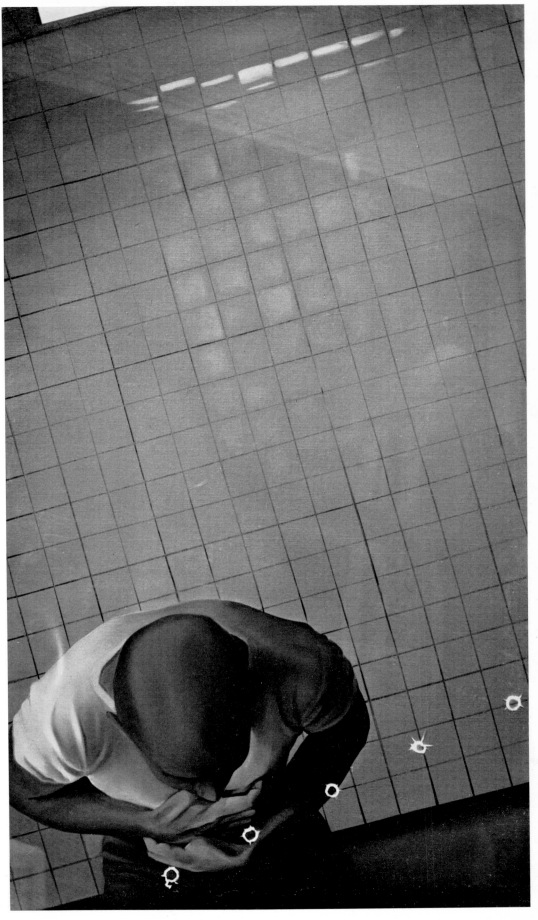

115 Jacques Monory *Meurtre No VI* 1968

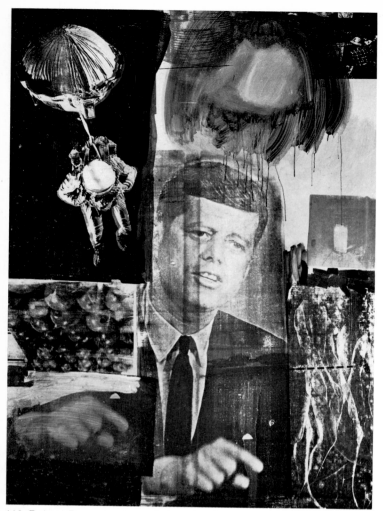

116 Robert Rauschenberg *Retroactive I* 1964

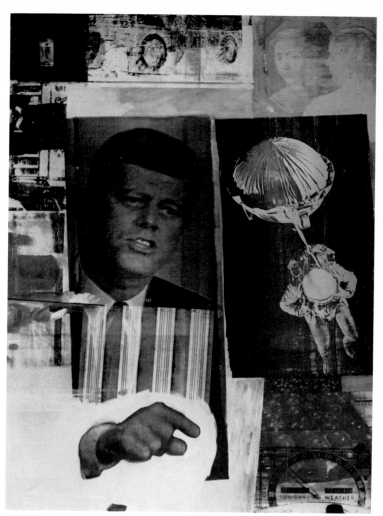

117 Robert Rauschenberg *Retroactive II* 1964

118 Richard Hamilton *Towards a definitive statement on the economic trends in men's wear and accessoires – together let us explore the stars* 1960

119 Enrico Baj *L'abbé d'Olivet* 1966

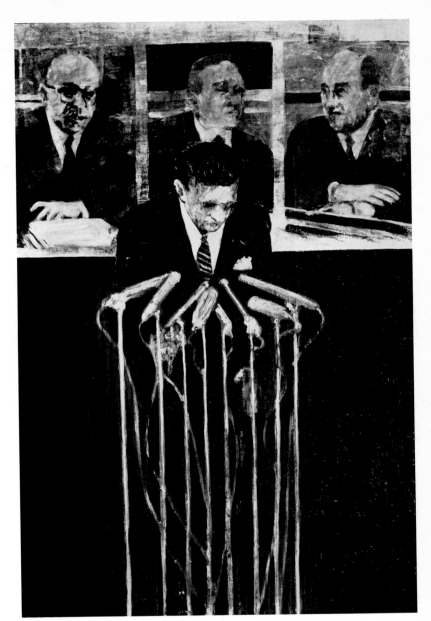

120 James Gill *In His Image* 1965

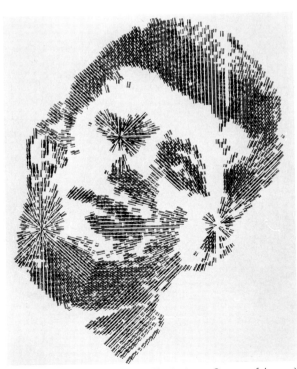

121 Fujio Niwa (Computer Technique Group of Japan)
Shot Kennedy No. 2 1968

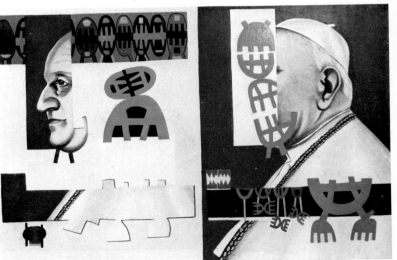

122 Gudmundur Erro *Papa Capogrossi* 1965

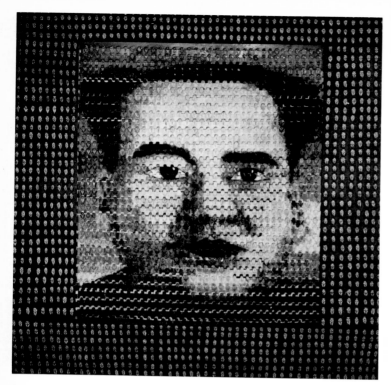

123 124, 125 Thomas Bayrle *Objekt Mao* 1967

126 Umberto Bignardi *Asia* 1965

54

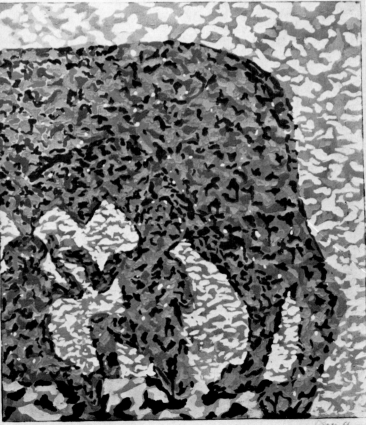

127 Drago *La Lupa di Roma* 1966

128 Sante Graziani *Red, White and Blue* 1966

129 Marcanton Raimondi

130 Wynn Chamberlain *Homage to Manet* 1964

131 Edouard Manet *Déjeuner sur l'herbe* 1863

132 Alain Jacquet *Le déjeuner sur l'herbe* 1964

134 Larry Rivers *Parts of the Body*

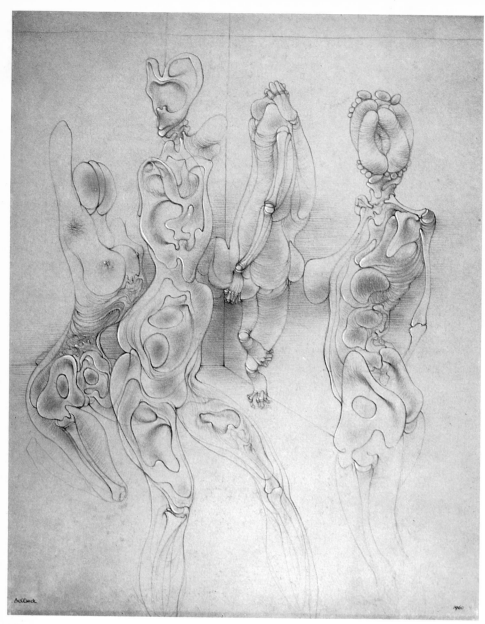

133 Hans Bellmer *Zeichnung* 1960

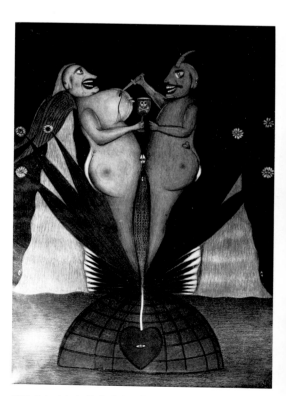

135 Friedrich Schröder-Sonnenstern
Der moralische Monddualismus 1960

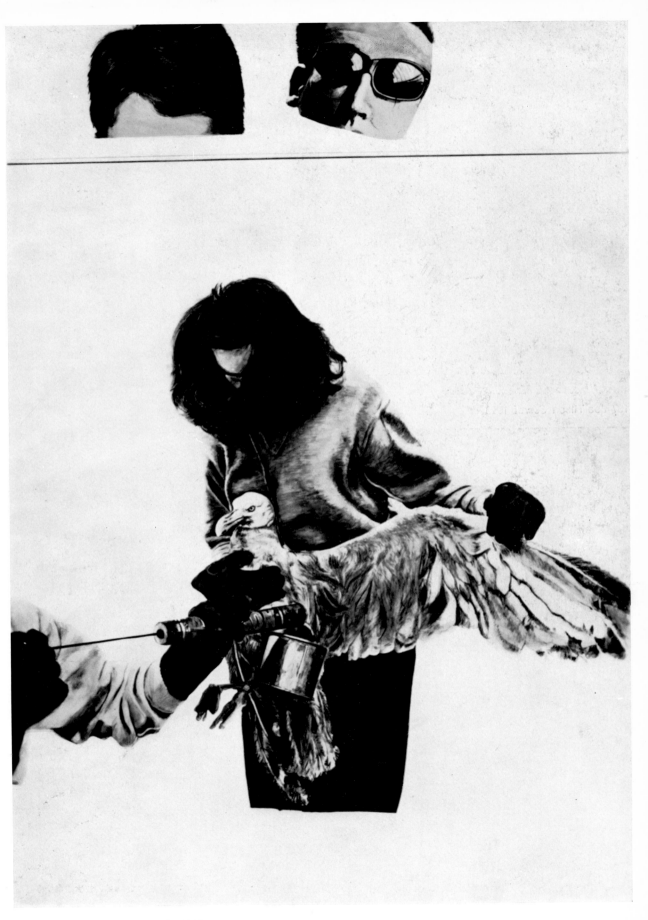

136 Joe Raffaele *Heads, Birds* 1966

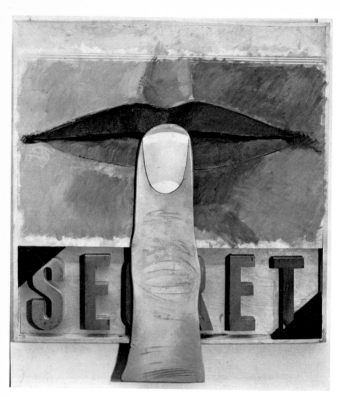

137 Joe Tilson *Secret* 1963

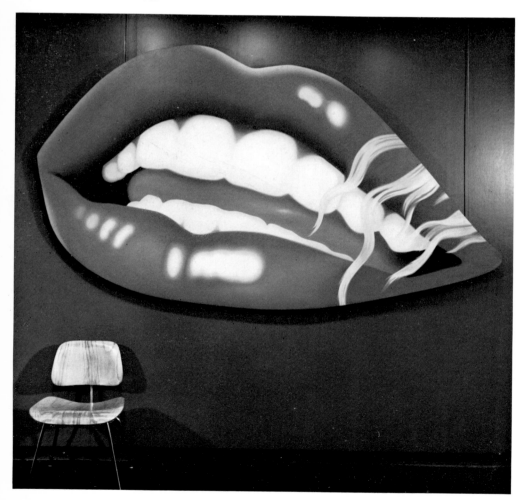

138 Tom Wesselmann *Mouth 14 (Marilyn)* 1967

139 Robert Filliou, Scott Hyde *Hand-Show.*
The key to art

141 Otto Steinert
▽ *Ein Fuß-Gänger*

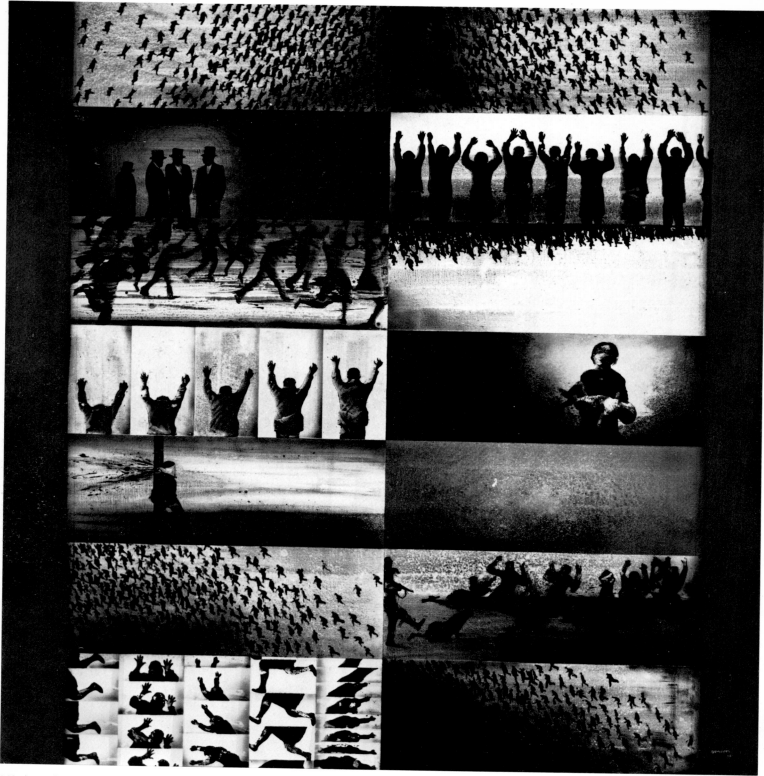

142 Juan Genoves *Calendario Universal* 1967

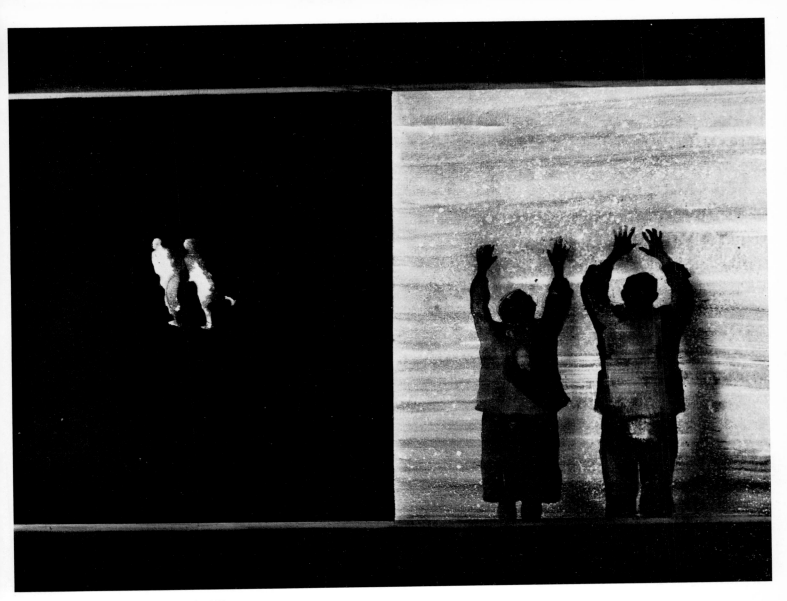

143 Juan Genoves *Cara a la pared* 1967

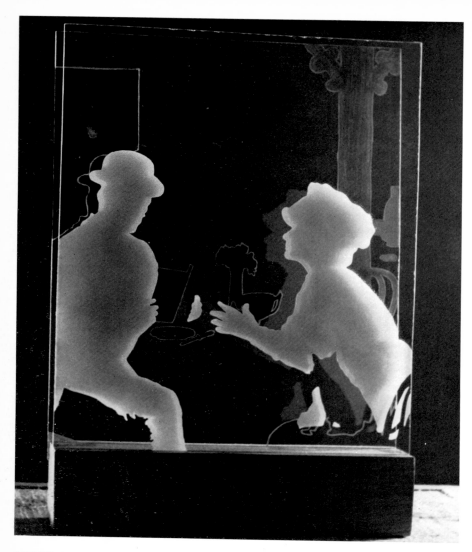

144 Lourdes Castro *Café* 1964

145 Gerd Richter *Liebespaar* 1965

146 Michelangelo Pistoletto *Self-Portrait with Soutzka* 1967

147 Howard Kanovitz *The Lovers* 1965

149 René Magritte *Unexpected Reply* 1933

148 Martial Raysse *Portrait double: série hygiène de la vision* 1968

 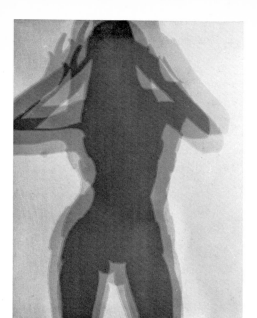 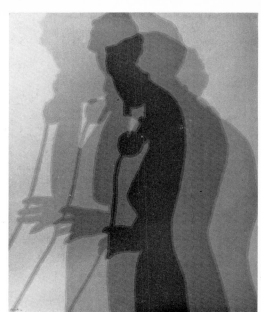

150, 151, 152 Berto Ravotti *Ombra* 1966

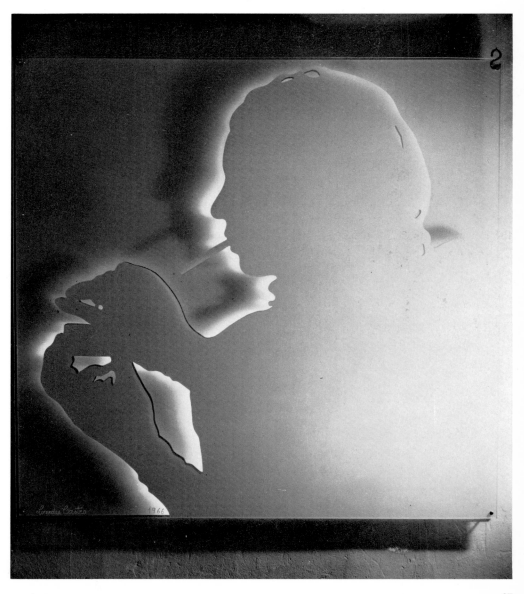

153 Lourdes Castro
Ombre portée blanc négatif et positif 1966

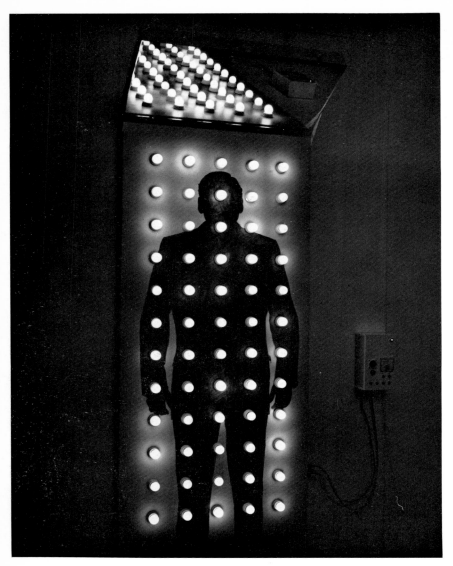

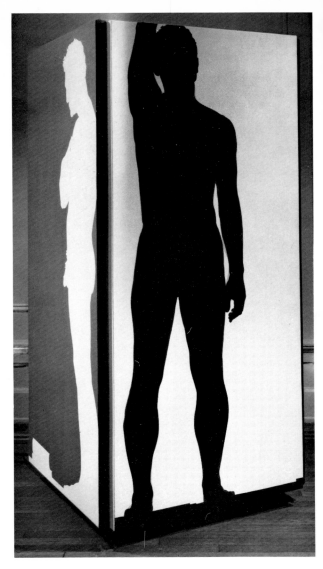

154 Howard Jones *Solo 2* 1966

155 Kendall Shaw *Gidrud* 1964

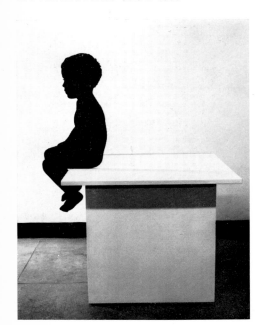

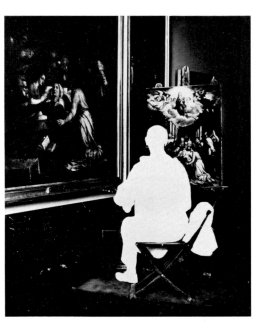

156 Pietro Gallina *Bambino* 1966

157 Wolfgang Kunz *Foto* 1967

68

158 Derek Boshier *Re-think, Re-entry* 1962

159 Ernest Trova *Falling Man* 1968

160 George Cohen *Set II A* 1966

161 George Cohen *Set II B* 1966

163 Gustav Klimt *Der Kuß* 1911

162 Lourdes Castro *Beige et beige* 1966

164 Cesare Tacchi
Quadro per una coppia felice 1965

WE
ROSE UP
SLOWLY
...AS IF
WE DIDN'T
BELONG
TO THE
OUTSIDE
WORLD
ANY
LONGER
...LIKE
SWIMMERS
IN A
SHADOWY
DREAM...
WHO
DIDN'T
NEED TO
BREATHE...

△ 165 Roy Lichtenstein *We rose up slowly* 1964

167 Andy Warhol *B Lugosi* 1963 ▷

▽ 166 Roy Lichtenstein *Kiss IV* 1963

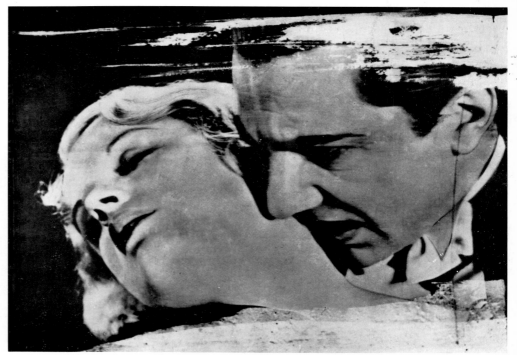

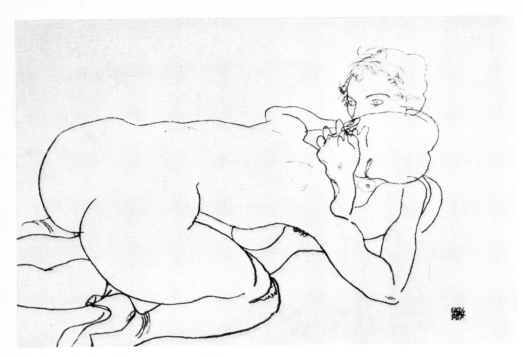

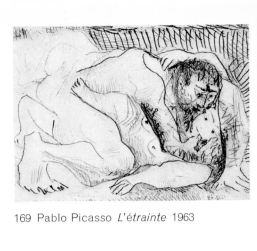

169 Pablo Picasso *L'étrainte* 1963

168 Egon Schiele *Die Umarmung* 1917

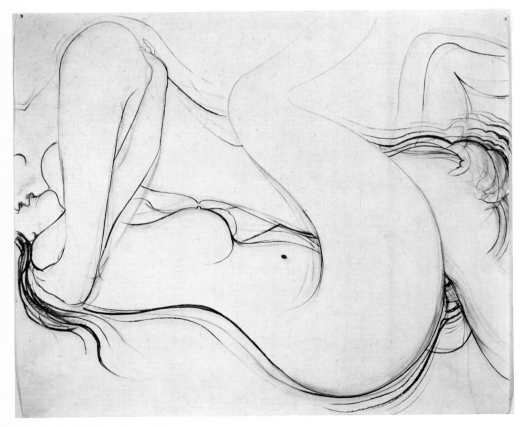

170 Brett Whiteley *Kiss* 1967

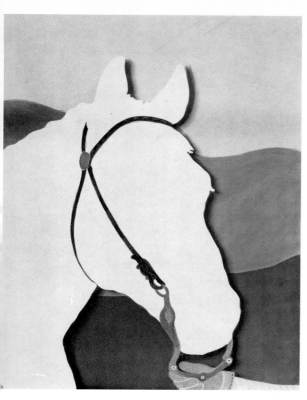

171 Gianni Ruffi *Maneggio* 1968

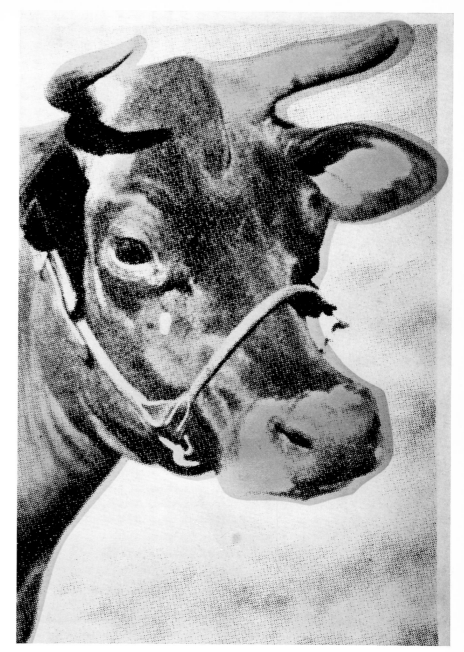

172 Andy Warhol *Cow Wallpaper* 1966

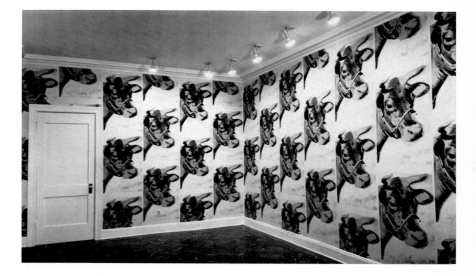

173 Andy Warhol *Cow Wallpaper* 1966

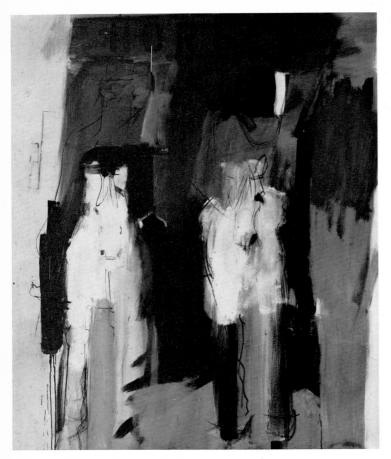

174 Larry Rivers *Horses* 1959–60

175 Malcolm Morley *Cutting Horse* 1967

176 Umberto Bignardi *Galoppo* 1966

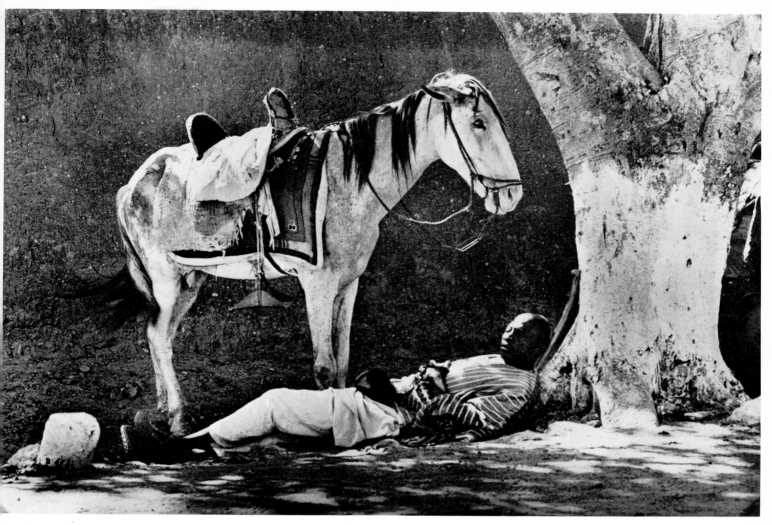

177 Jürgen Heinemann *Siesta in Kamerun* 1967

78 Wayne Thiebaud *Dog* 1966

179 William Theo Brown *White Dog* 1966

181 Jacques Kaplan *The Reassembled Zebra* 1967

180 Ugo Nespolo *Leopardeggiare* 1966

182 L.D.Harmon, K.C.Knowlton
*Gulls-Studies in perception 11
(computer generated picture)* 1968

76

183 René Magritte *Le jeu de mourre* 1966

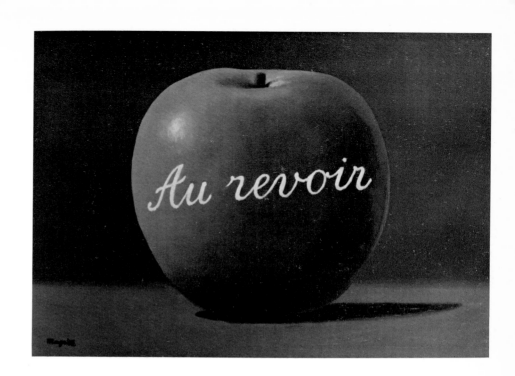

184 Peter Dechar *Pears* 1967

186 William Bailey *Eggs* 1966

187 James Rosenquist *Silhouett* 1964

188 James Rosenquist *Orange Field* 1964

189 James Rosenquist *World's Fair Painting* 1964

190 Tom Wesselmann *Still Life* 1964

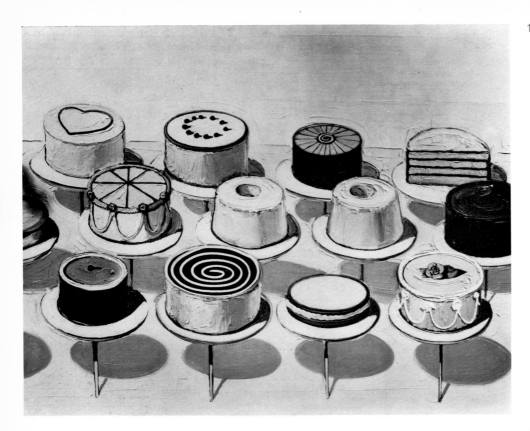

191 Wayne Thiebaud *Cakes* 1963

192 Colin Self *Hot Dog 5* 1964

COLIN SELF HOT DOG 5

193 Alain Jacquet *Peinture-Souvenir* 1963

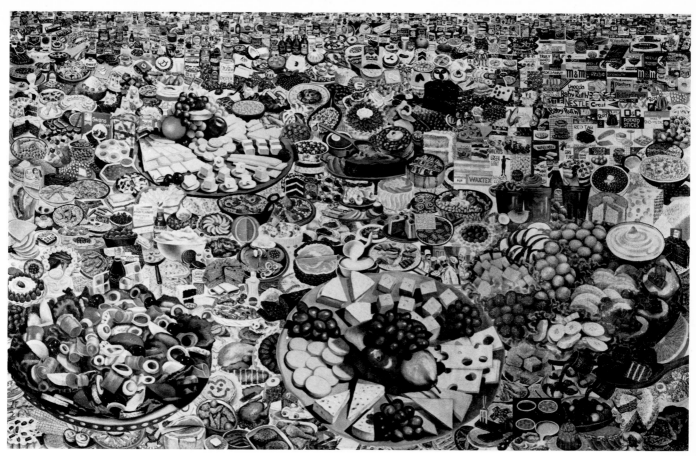

194 Gudmundur Erro *Foodscape* 1964

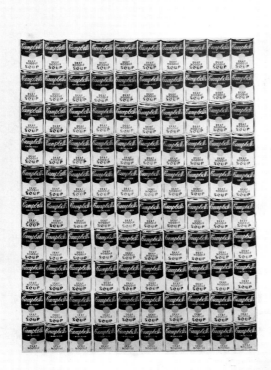

195 Andy Warhol *100 Cans* 1962

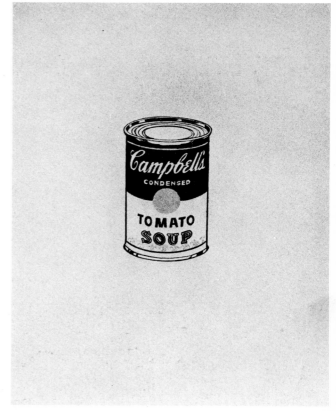

196 Andy Warhol *Campbell Tomato Soup Can (small soup)*
1962

197 Pavlos *Hats* 1968

198 Shusaku Arakawa *Light shines through the net making halt an umbrella* 1964

SHOE

199 Jim Dine *Shoe* 1961

200 Jann Haworth *Calendula's Cloak* 1967

201 Domenico Gnoli *Busto di donna* 1965

202 Thomas Bayrle *Regenmäntel* 1967

204 *Werbung für ein Bügeleisen*

203 Konrad Klapheck *Die Schwiegermutter – Mother in Law* 1967

205 Konrad Klapheck *Der Supermann – Superman* 1962

206 Lowell Nesbitt *IBM 1440 Data Processing System*
1965

207 Lowell Nesbitt *IBM 6400* 1965

208 L. D. Harmon, K. C. Knowlton
The Telephone-Studies in Perception 1
(computer generated picture) 1968

209 Harold Stevenson
Love is an offering – length of a chain IV 1965

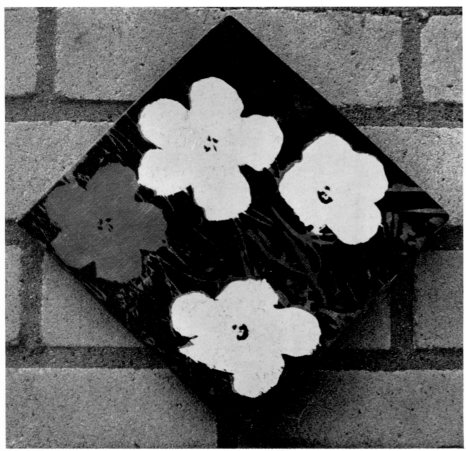

210 Andy Warhol *Flowers* 1966

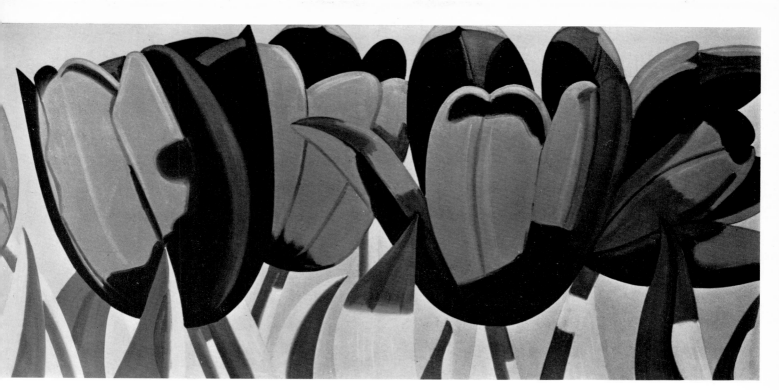

211 Alex Katz *Tulips* 1967

212 Lowell Nesbitt *Iris* 1965

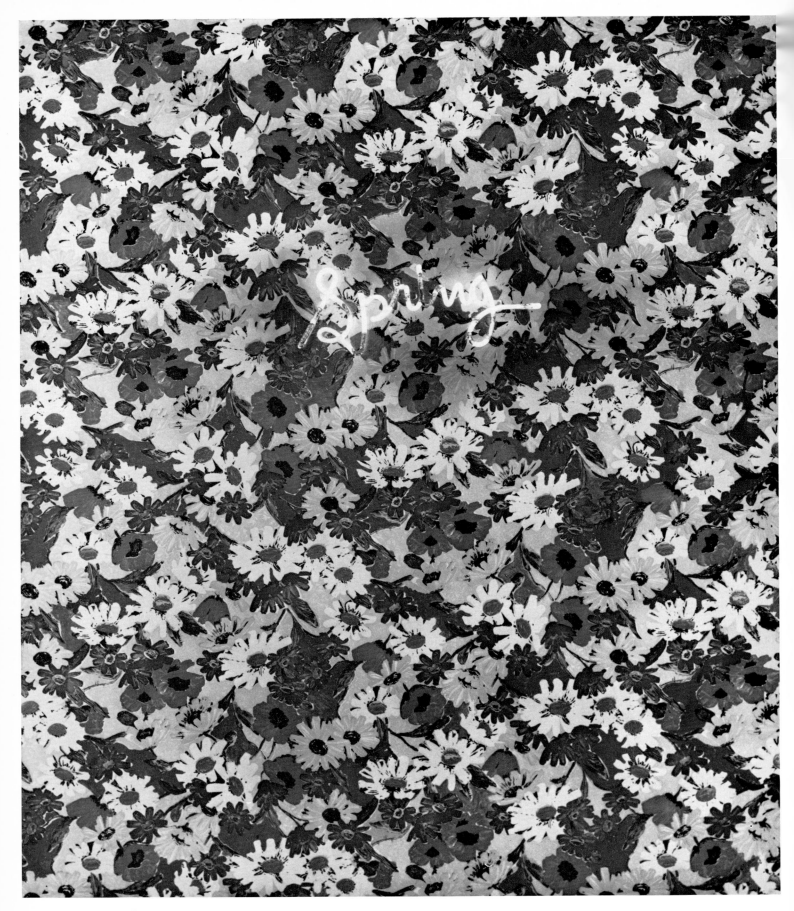

213 Martial Raysse *Spring* 1964

214 Augusto Giacometti *Maimorgen* 1910

215 Otto Steinert *Norwegische Impression* 1963–1965

216 Allan d'Archangelo *Untitled* 1965

217 James Rosenquist *Front Lawn* 1964

219 Allan d'Archangelo *US Highway No .1* 1963

220 Roy Lichtenstein *Kinetic Seascape* 1966

221 Roy Lichtenstein *Night Seascape* 1966

222 Milvia Maglione *Nuages sur le champ* 1968

223 Sante Graziani *Rainbow over Inness, „Kakavanna Valley"* 1965

224 Enrico Baj *Ultracorpo in Svizzera* 1959

225 Llyn Foulkes *The Canyon* 1964

226 Llyn Foulkes *Untitled* 1966

227 Detleff Orlopp *Taurus-Pass II* 1966

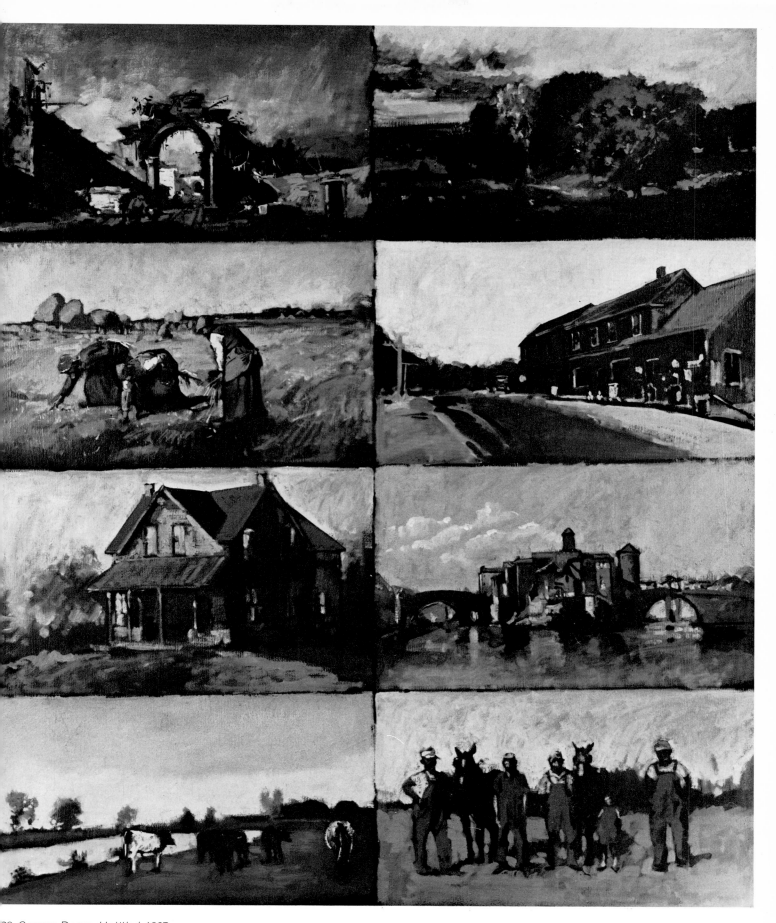

28 George Deem *Untitled* 1967

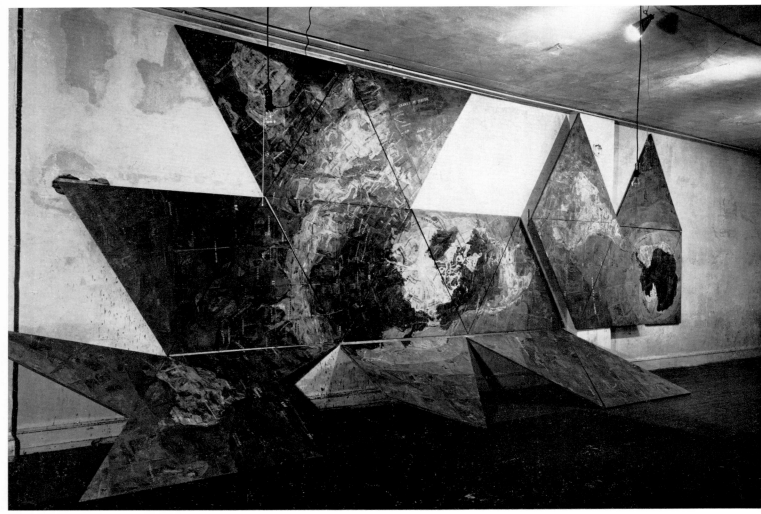

230 Jasper Johns *Map* 1967

231 Bernhard und Hilla Becher *Gasbehälter bei Manchester 1886 Foto* 1966

232 Bernhard und Hilla Becher *Doppelwasserturm in Hagen 1898 Foto* 1962

233 Lowell Nesbitt *Black Windows* 1965

234 Roy Lichtenstein *Temple of Apollo* 1964

235 Anzo *Aislamiento – 12* 1967

236 Valerio Adami *Plein Air N. 2 – Trittico* 1968

237 Gerhard Richter *Madrid* 1968

238 Peter Brüning *NY, NY, NY, NY* 1968

239 Martial Raysse *La vision est un phénomène senti-mental* 1966

240 Edward Ruscha *Burning Gas Station* 1965–66

241 Valerio Adami *Trittico: per un Grand Hotel* 1967

242 Tom Wesselmann *Gan 48* 1963

243 James Rosenquist *Untitled* 1963

244 Laura Grisi *East Village* 1967

245 Gudmundur Erro *The American Interieurs* 1968

246 Gudmundur Erro *The American Interieurs* 1968

249 George Mueller *Anton Webern, Op. 5, No. 3* 1963

247 Lowell Nesbitt *Claes Oldenburg's Studio* 1967

248 Lowell Nesbitt *Louise Nevelson's Studio* 1967

50 Anzo *Aislamiento – 29* 1968

251 Gerhard Richter *Entwurf zu 5 Türen* 1967

252 Gerhard Richter *5 Türen* 1967

253 Gerhard Richter *Vorhang* 1965

254 Kendall Shaw *Bicycle II* 1965

255 Lowell Nesbitt *Bicycle* 1966

256 Peter Stämpfli *Grand Sport* 1966

257 James Rosenquist *Director* 1964

258 Gerald Laing *Lotus 1* 1963

259 Robert Indiana *Diptych Portrait of the Artist's Mother and Father* 1964

260 Alex Colville *Truck Stop* 1966

263 Andy Warhol *Orange Car Crash* 1963

261 Robert Stanley *Crash* 1966

262 Brett Whiteley*No.* 1968

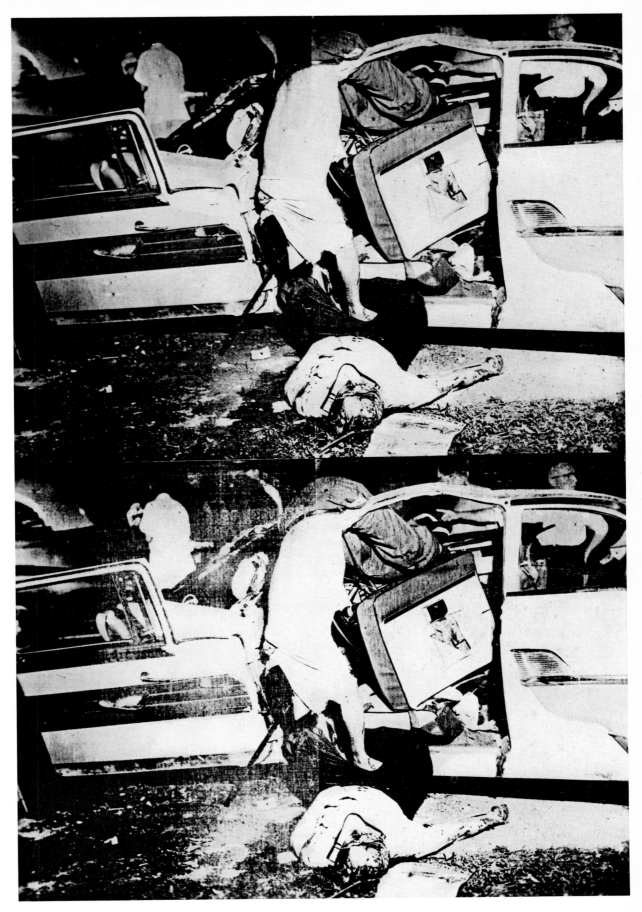

264 Andy Warhol *Saturday Disaster* 1964

265 Andy Warhol *Do it Yourself* 1962

266 James Rosenquist *TV Boat I* 1966

267 Gerhard Richter *Motorboot* 1965

268 Malcolm Morley „*United States*" *with (NY) Skyline* 1965

269 Malcolm Morley „*Amsterdam*" *in front of Rotterdam* 1966

270 Gianni Bertini *Il giorno che ha ucciso Christo* 1967

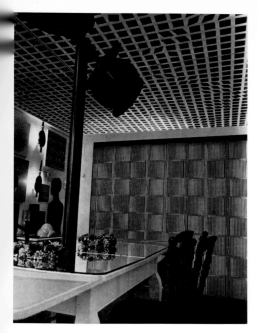

271 Vasarely, Yvaral, Sommer
Haus Carl Laszlo, Basel

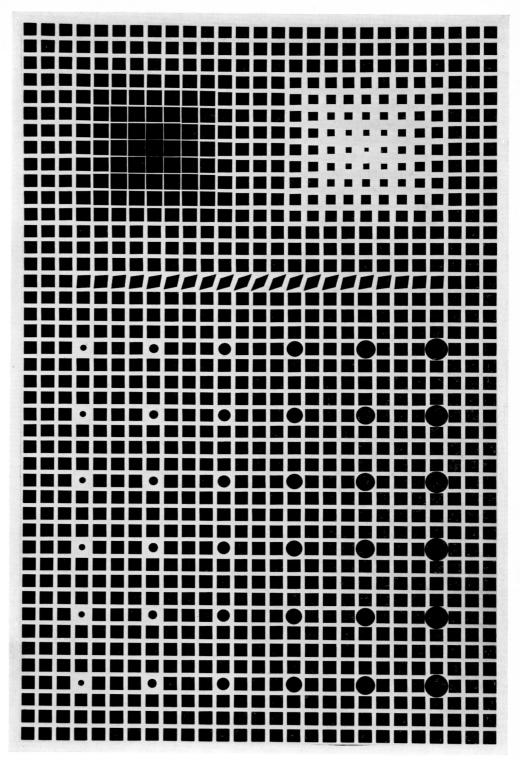

272 Vasarely *Supernovae* 1959–60

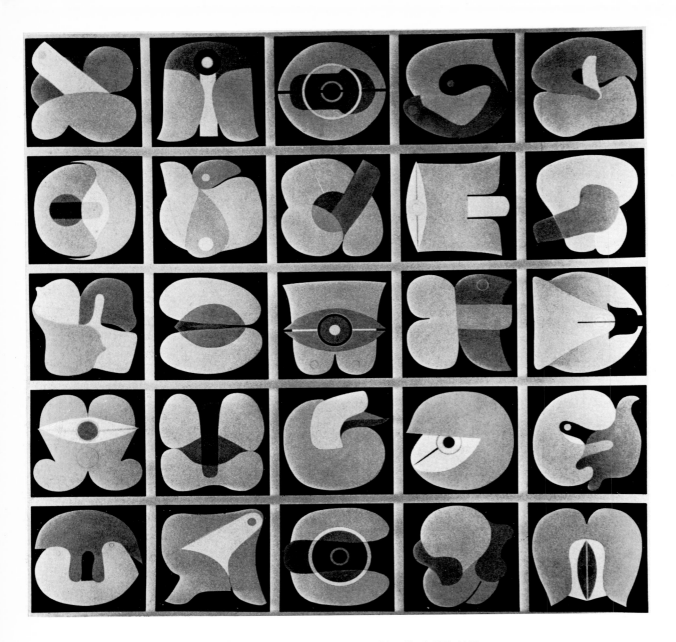

273 Kawashima *New York-XIII* 1965

274 Gernot Bubenik *Pflanze I* 1966

114

275 Larry Poons *Orange Crash* 1963

276 Larry Poons *Richmond Ruckus* 1963–64

277 Guido Molinari *Mutazione viola* 1964

278 Howard Mehring *Cadmium Crystal* 1966–67

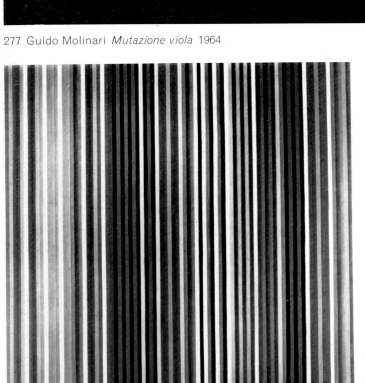

279 Gene Davis *Red Frenkant* 1966

280 Jack Canepa *Fold-Up 5* 1968

281 Miriam Schapiro *St. Peters* 1965

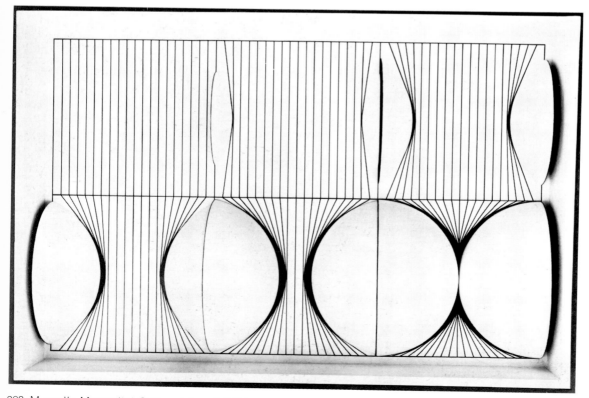

283 Marcello Morandini *Composizione 3* 1964

284 Bridget Riley *Exposure* 1966

286 Frank Stella *Jill* 1959

287 Frank Stella *Ileana Sonnabend* 1963

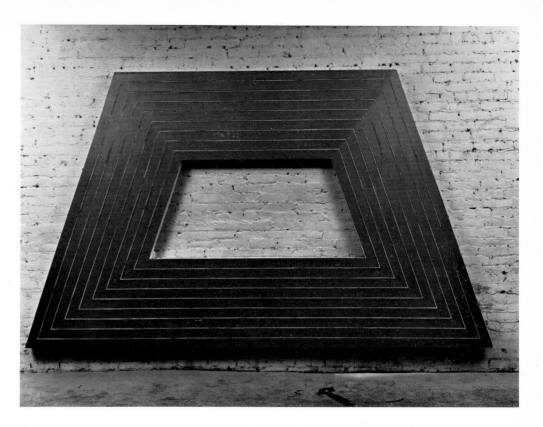

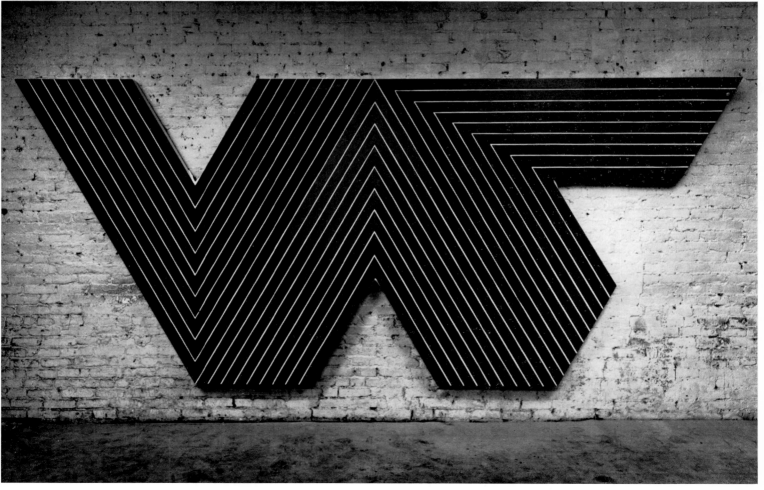

288 Frank Stella *Quathlamba* 1964

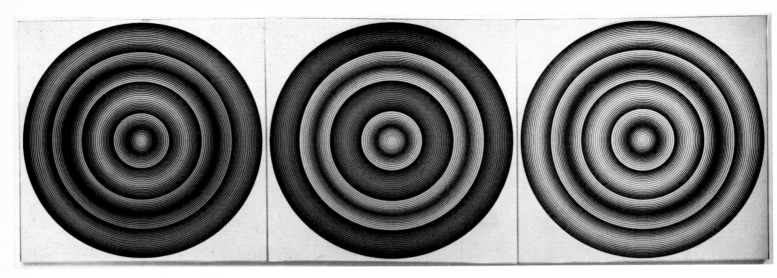

289 Tadasky *D-127; D-128; D-129* 1966

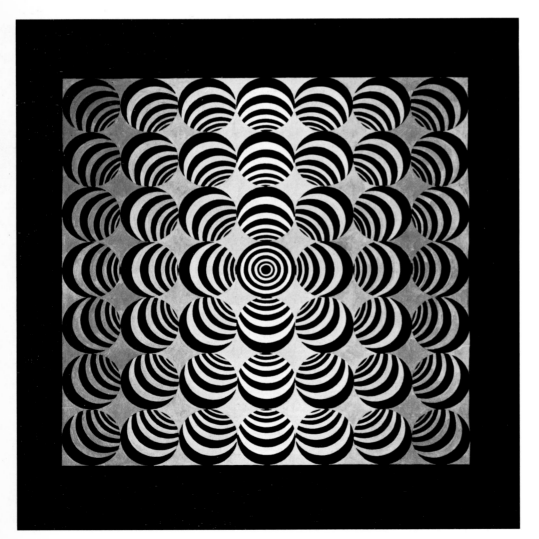

290 Milan Dobes *Der kleine blaue Brennpunkt* 1966

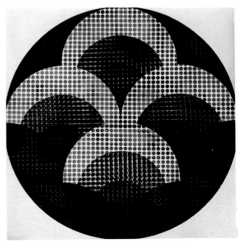

291 Rogelio Polesello *Ufo No. 3* 1967

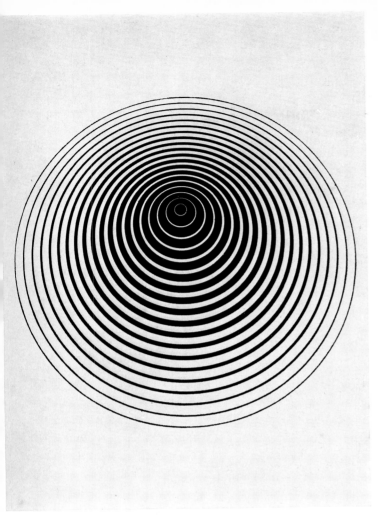

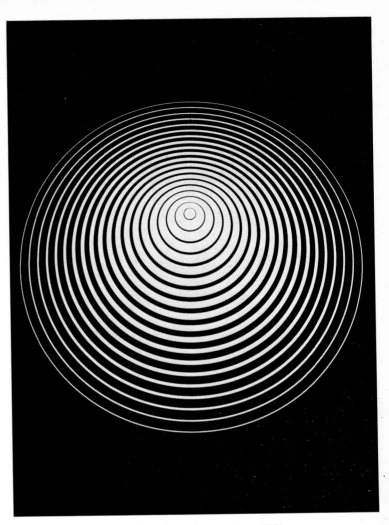

292 Marina Apollonio *Dinamica circolare 5 cp* 1965

293 Marina Apollonio *Dinamica circolare 5 cn* 1965

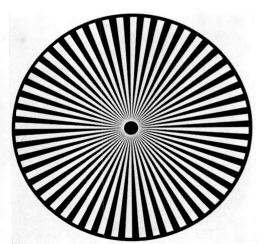

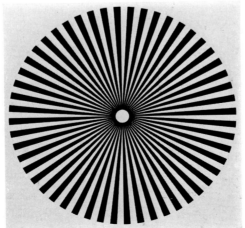

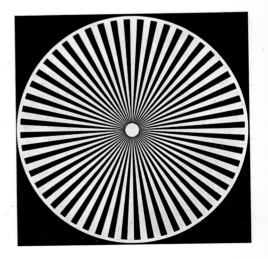

294, 295, 296 Wolfgang Ludwig *Kinematische Scheibe IX, XI, X* 1965

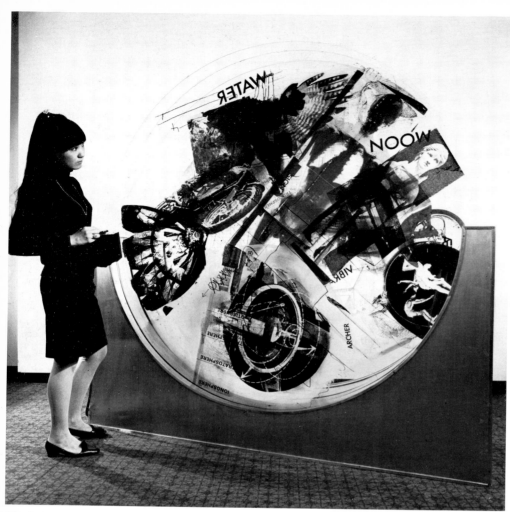

297 Robert Rauschenberg *Image Wheels* 1967

298 Masuho Ohno *Untitled* 1966

299 Getulio Alviani, Germana Marucelli *Abito* 1968

300 Getulio Alviani *Superficie a testura vibratice circolare* 1965

301 Getulio Alviani *Orecchino* 1967

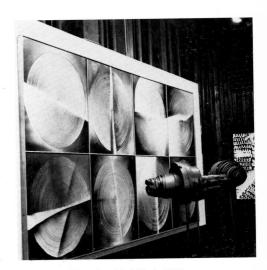

302 Juko Nasaka *Untitled* 1965

303 Dieter Hacker *Siebdruck* 1962–64

304 Dieter Hacker *Siebdruck* 1962–64

305 Getulio Alviani *Linee luce* 1962

306 Richard Anuszkiewicz *12 Quadrate* 1968

307 Josef Albers *Homage to the Square* 1964

308 Tadaaki Kuwayama *Untitled* 1966

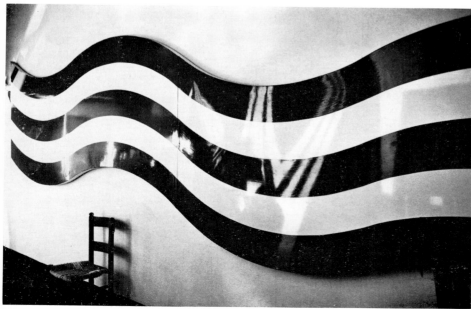

310 Sergio Lombardo *Super-Quadro* 1966

311 Piero Manzoni *Bianco* 1957–58

Illus 7

312 Robert Rauschenberg *White Painting*
1952

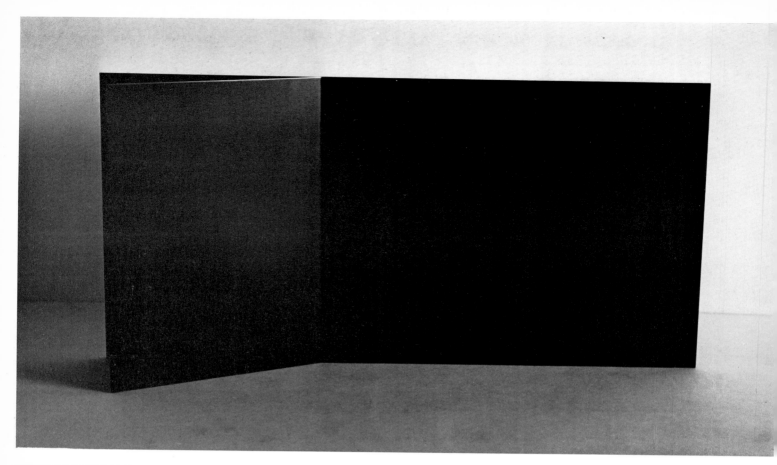

313 Francesco Lo Savio *Spazio Luce* 1960

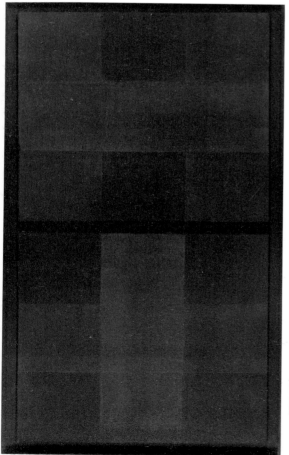

314 Ad Reinhardt *K* 1960

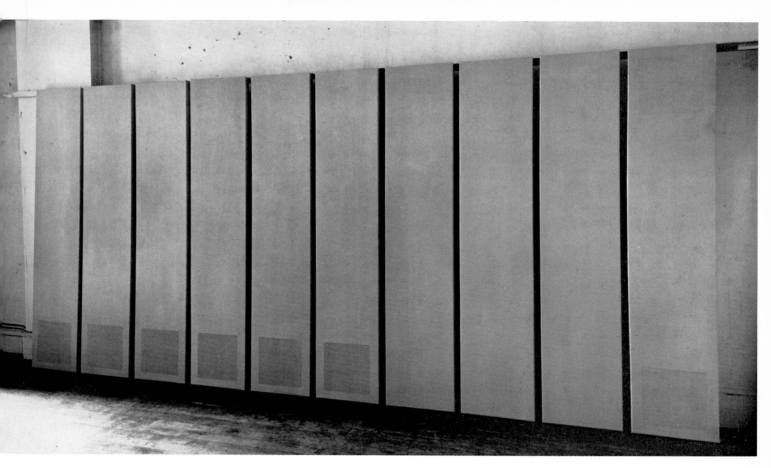

315 Doug Ohlson *Cythera* 1967

316 Nassos Daphnis *17-61 MT* 1961

317 Robert Huot
Wieland 1968

318 Morris Louis *Alpha* 1960

319 Kenneth Noland *Drive* 1964

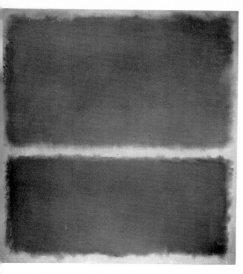

320 Mark Rothko *Untitled* 1968

322 Jules Olitski *Cross Spray* 1966 ▷

321 Seymour Boardman *Untitled* 1967

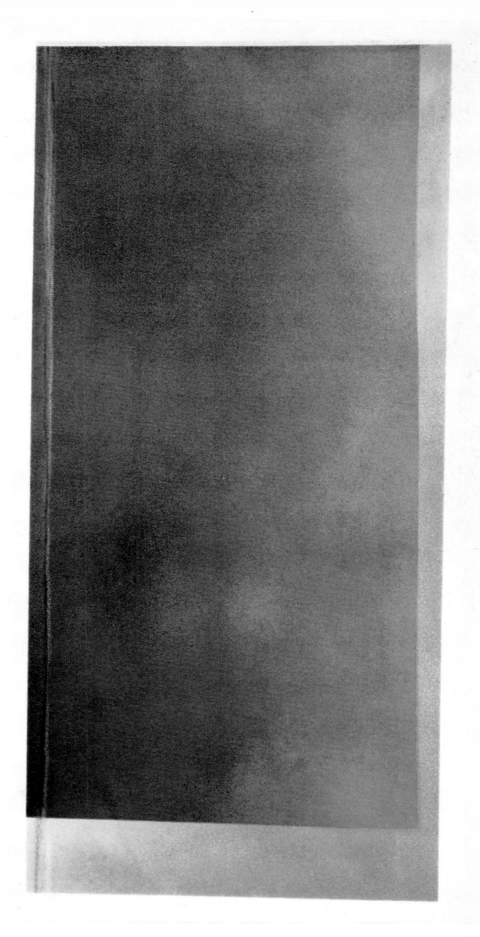

133

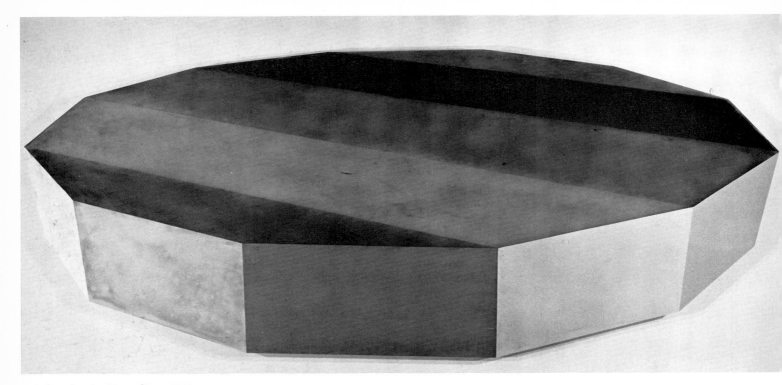

323 Ron Davis *Rings Skew* 1968

324 Ron Davis *Radial* 1968

325 Thomas Downing *Sixteen* 1967

326 Ron Davis *Blue and Brown* 1967

327 Yves Klein *Wandgestaltung im Theater Gelsenkirchen* 1959

328 Lucio Fontana *Concetto spaziale* 1959

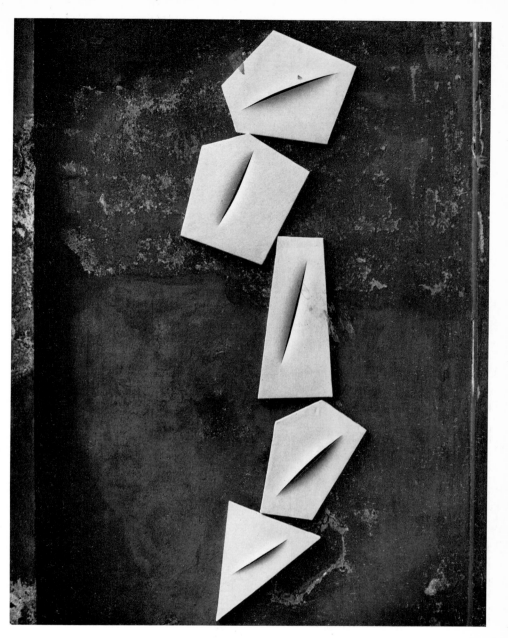

329 Nanda Vigo, Lucio Fontana
Appartamento a Milano 1963

333 Piero Manzoni *Quadri che cambiano colore* 1960

332 Yves Klein *Monochrome jaune* 1956

334 Richard Smith *Untitled (purple)* 1967

335 Richard Smith *Sea Wall* 1967

336 Richard Smith *Parking Lot* 1967

337 Robert Mangold *1/2 gray-green curved area* 1966

338 Robert Mangold *1/2 gray-green curved area* 1966

339 Robert Mangold *1/3 gray-green curved area*

340 William Turnbull
Double Red 1959

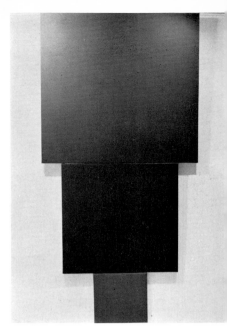

342 Paolo Patelli *Insentatez* 1968

343 Sven Lukin *Carolina Pine* 1963

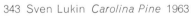

341 Sandro de-Alexandris
2 TS/P no. 2 1967

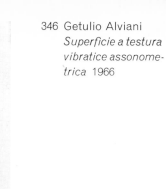

346 Getulio Alviani
Superficie a testura vibratice assonometrica 1966

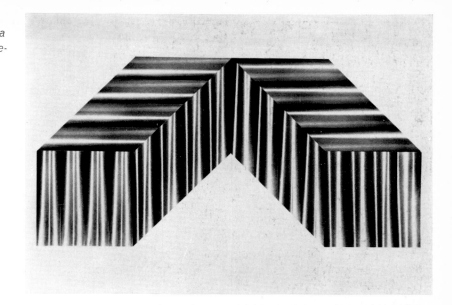

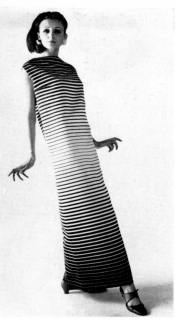

344 Getulio Alviani *Abito* 1963–64

345 Richard Anuszkiewicz
Hand Painted Pony Coat 1965

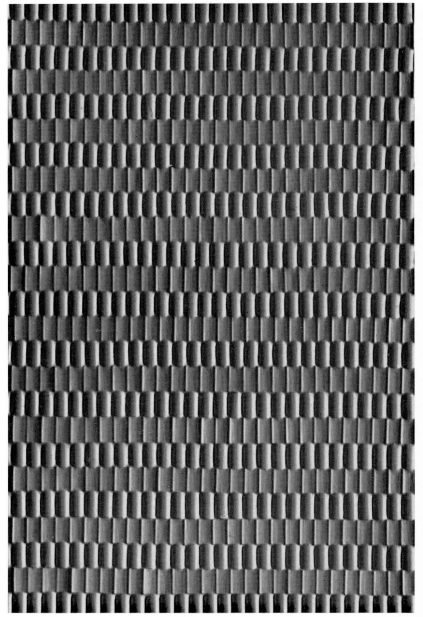

347 Franco Fabiano
Bianco 1965

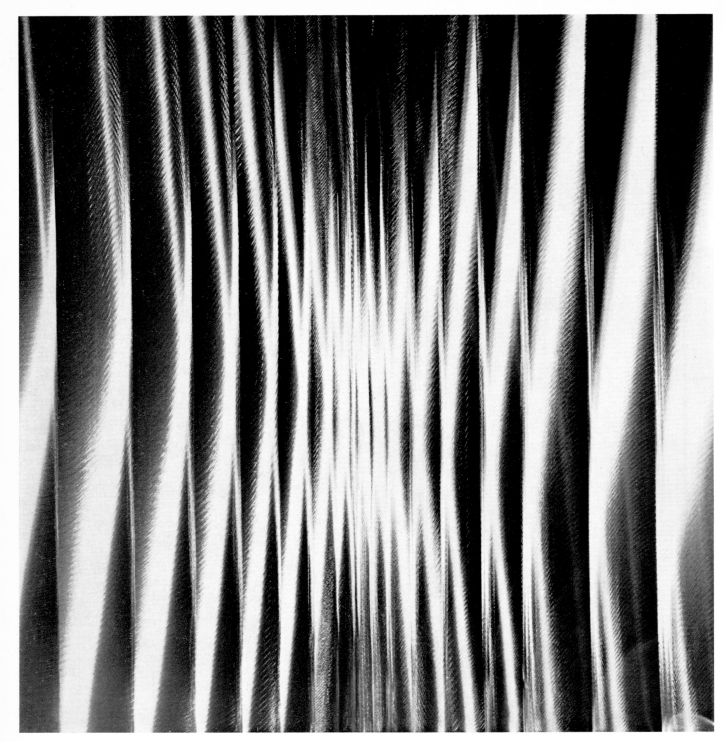

348 Getulio Alviani *Linee luce* 1962

349 Jesus Rafael Soto
Vibration sur le cercle

350 Jesus Rafael Soto *Kinetic Mural* 1958

353 Pol Bury *Ponctuation* 1961

351 Yaacov Agam *Peinture polyphone – 2 themes – couleur contrepoint* 1955

352 Yaacov Agam *Sensibilité II* 1960

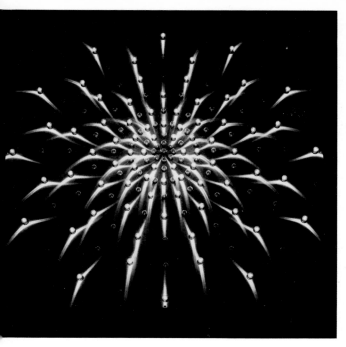

354 Howard Jones *Skylight No. 8* 1961

355 Les Levine *Light Works* 1967

356 Ronald Mallory *Organa* 1965

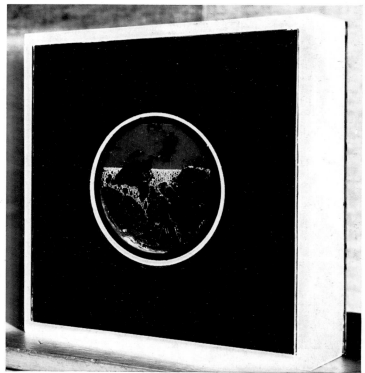

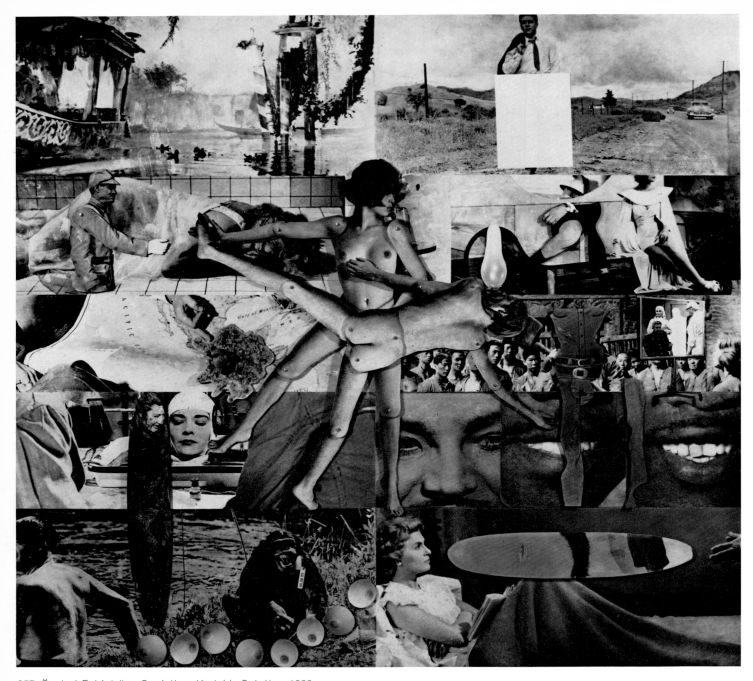

357 Öyvind Fahlström *Roulette – Variable Painting* 1966

358 Öyvind Fahlström *The Cold War, Phase 5, 6, 7* 1963–65

359 Öyvind Fahlström *Eddie in the desert · · · · · 4 phases* 1966

360 Öyvind Fahlström *Dr. Schweitzer's Last Mission (detail)* 1964–66

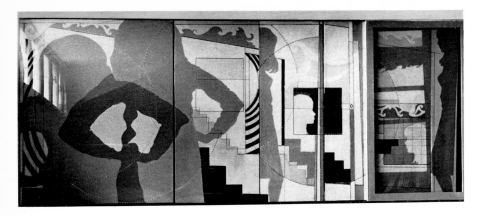

361 Laura Grisi *Transparent Door* 1965

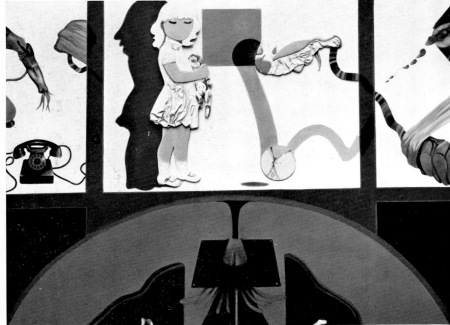

362 Carlos Revilla *Il gioco segreto* 1968

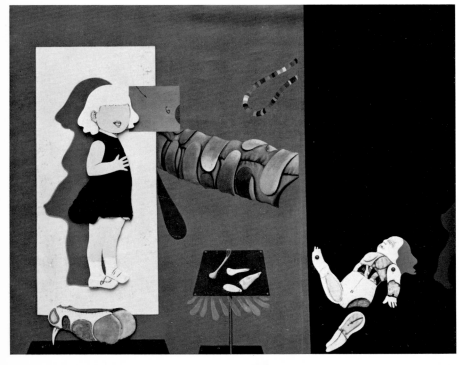

363 Carlos Revilla *Attraverso il Gioco* 1968

364 Hanlor *Le gouter* 1967

365 Hanlor *Le gouter* 1967

366 *Chinese National Games, Peking, 1965*

367 *Chinese National Games, Peking, 1965*

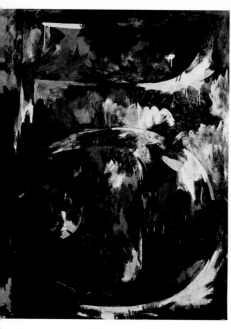

368 Jasper Johns *The Black Figure 5* 1960

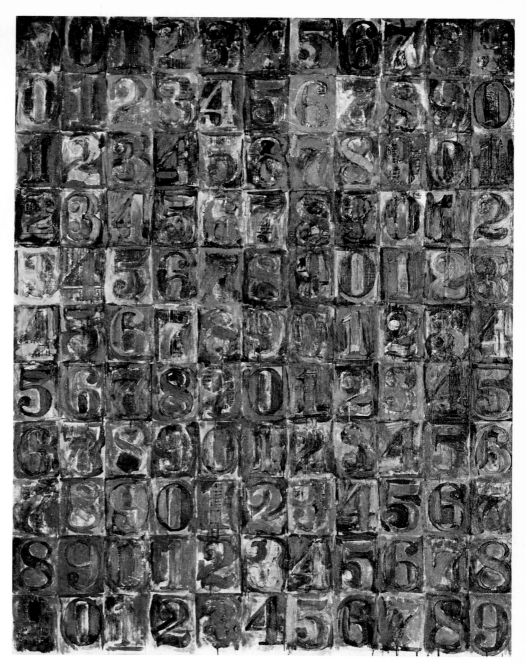

369 Jasper Johns *Grey Numbers* 1958

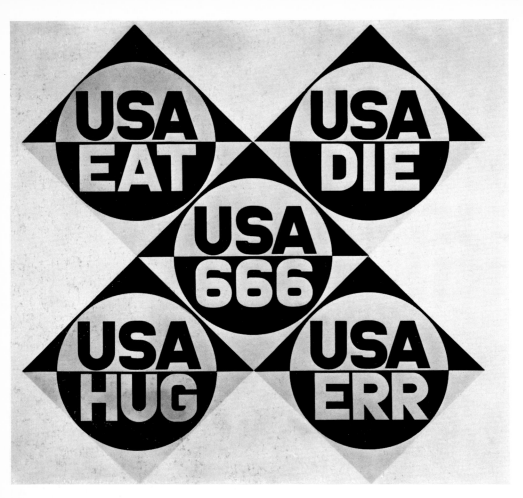

370 Robert Indiana *USA 666*
1966

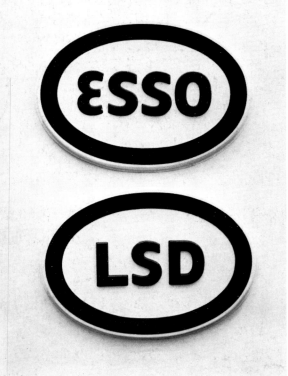

371 Öyvind Fahlström
ESSO-LSD 1967

372 Arakawa *Still Life* 1967

373 Edward Ruscha *Engeneer* 1967

374 Eugenio Carmi *SPCE Image: B 424* 1966
375 Eugenio Carmi *Image: D 255* 1966
376 Eugenio Carmi *SPCE Image: C 256* 1966
377 Eugenio Carmi *Image: A 662* 1966

378 Robert Watts *Neon Signature: PICASSO* 1966

379 Ugo Nespolo *Napoleon-you* 1966

30 Marcel Broodthaers *Autoportrait* 1968

31 Iannis Kounellis *Epico 1* 1960

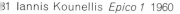

382 Jiři Kolař *Brancusi* 1966

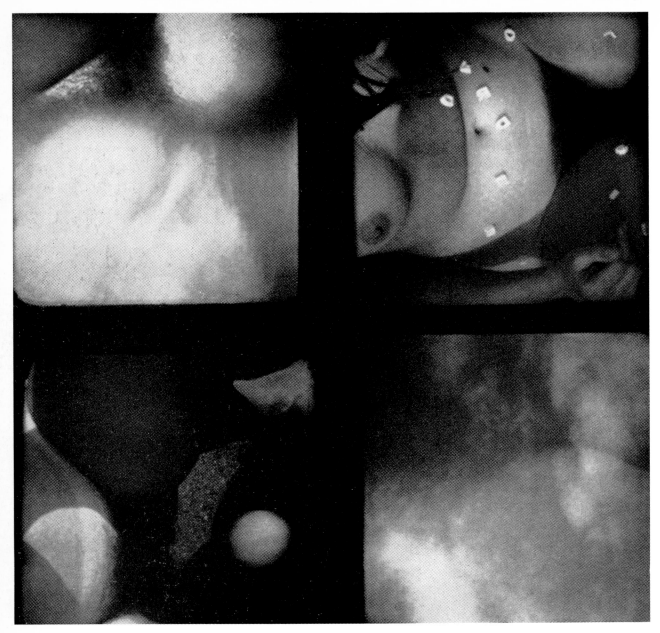

383 Robert Watts *4-Film Cinema for Environment* 1966

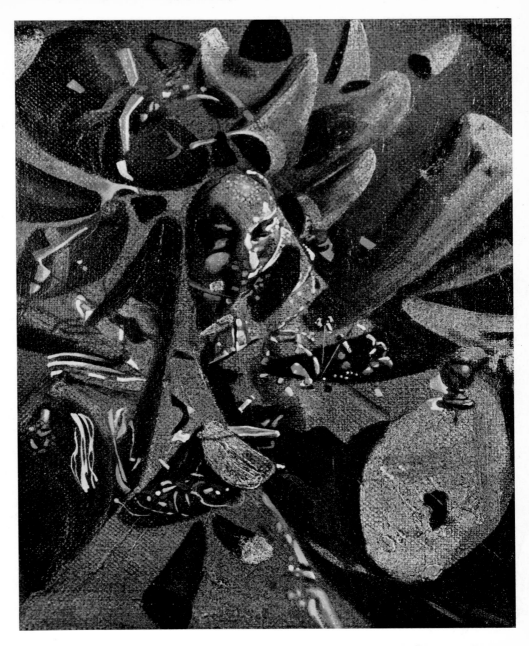

384 Salvador Dali *Paranoic-Critical Study of Vermeer's Lacemaker* 1955

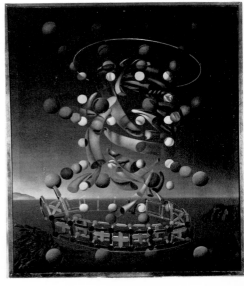

385 Salvador Dali *The Maximum Speed of Raffael's Madonna* 1954

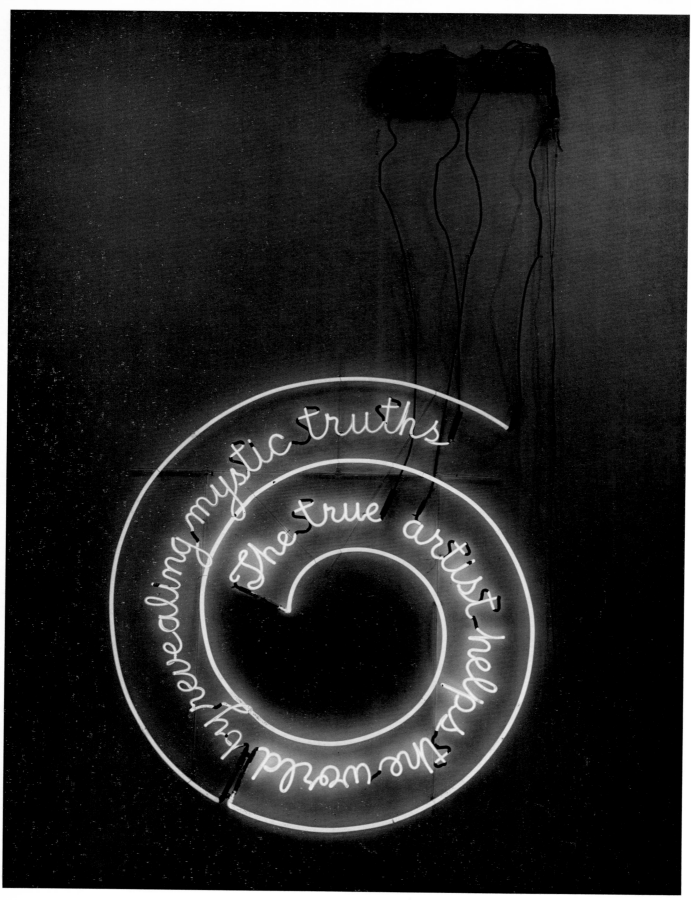

386 Bruce Nauman *Window or Wall Sign* 1967

THE TRUE

ARTIST IS AN

A

MAZING · NIV

AIN

FOUNT

LUMINOUS

387 Bruce Nauman *Window Screen* 1967

388 Julije Knifer *Studio 9* 1962

389 Mark Lancaster *Zapruder II* 1967

390 Fabio Mauri *Drive Wall* 1963

391 Lygia Clark *Untitled* 1958

392 Peter Roehr *Exposition* 1967

393 Sultan *Monowid* 1968

394 Juuko Ikewada *Aiuto, non c'è ossigeno* 1966

395 C.L.Attersee *Schönling mit Griff* 1968

396 Isaac Abrams *Untitled* 1968

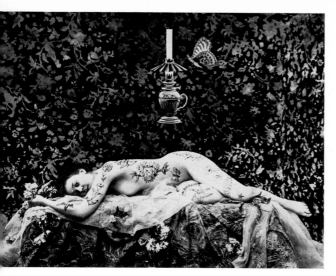

97 Jan Lenica *Labyrinth* 1962

98 *Kusama's Naked Event at Kusama's Infinity Mirror Room* 1965

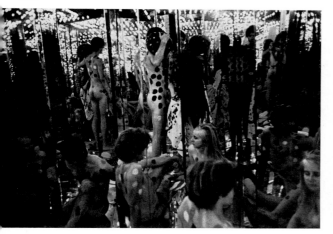

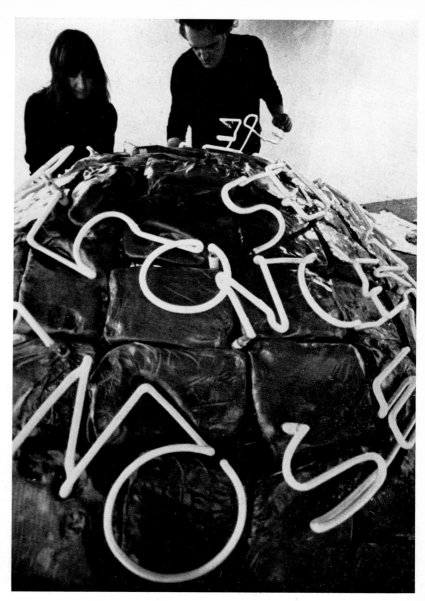

399 Mario Merz *Igloo* 1968

0 Pablo Picasso *Flesh Painting* 1961

401 Richard Long *Squares on the Grass* 1967

402 *Computer Technique Group of Japan Computer Graphic* 1968

403 *Computer Technique Group of Japan Computer Graphic* 1968

404 Luciano Fabro *Senza Titolo* 1967

5 Lygia Clark *La casa e il corpo* 1968

6 Tsuruku Yamasaki *Work No. 5 – Turning Silver Wall* 1962

407 Liliane Lijn *Cosmic Flare* 1966

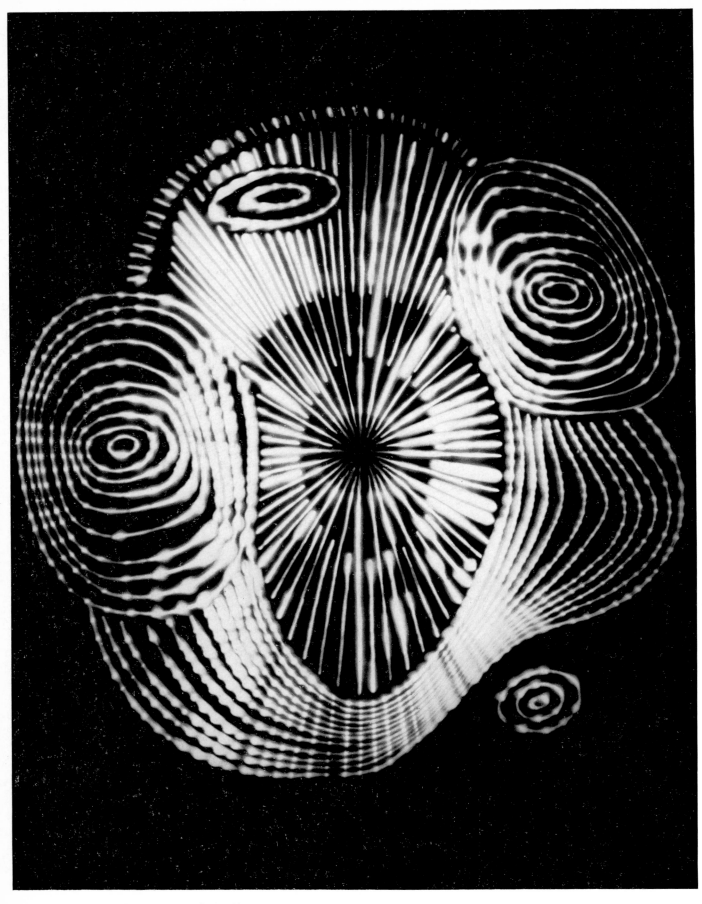

408 Frank J. Malina *Circles within Cirles II* 1965

Arman (Armand Hernandez)
New York, USA
* 1928 Nice, France
1958, 1960 Galerie Iris Clert, Paris
1960, 1963 Galerie Schmela, Düsseldorf
1961, 1963 Galleria Schwarz, Milan
1962, 1963 Dwan Gallery, Los Angeles
1962, 1963, 1965 Galerie Lawrence, Paris
1964 Stedelijk Museum, Amsterdam
1964 Museum Haus Lange, Krefeld
1964 Walker Art Center, Minneapolis
1967 Galerie Ileana Sonnabend, Paris
1968 Biennale di Venezia

Armando
Amsterdam, Holland
* 1929 Amsterdam

Arnal, François
Paris, France
* 1924 La Valette

Arp, Hans
* 1887 Strasbourg, France
† 1966 Locarno

Arroyo, Eduardo
Paris, France
* 1937 Madrid

Artschwager, Richard
New York, USA
* 1924 Washington, D.C.
1965 Leo Castelli Gallery, New York
1968 Galerie Fischer, Düsseldorf

Artymowska, Zofia
Warsaw, Poland
* Cracow
1967 National Gallery of Modern Art, Baghdad

Artymowski, Roman
Warsaw, Poland
* 1919 Lvov
1966 Galerie Lambert, Paris

Ascott, Roy
London, England
* 1934 Bath

Asis, Antonio
Paris, France
* 1932 Buenos Aires

Asmus, Dieter
Hamburg, Germany
* 1939 Hamburg
1968 Galerie Grossgörschen, Berlin

Asoma, Tadashi
Japan
* 1923 Japan
1965 Findlay Gallery, New York

Attersee, Christian Ludwig **395**
Vienna, Austria
* 1940 Bratislava
1968 Galerie Nächst St. Stephan, Vienna

Atwell, Allen
New York, USA
* 1925 Pittsburgh
1968 Galerie Bischofsberger, Zürich

Aubertin, Bernard **XXX**
Paris, France
* 1934 Fontenay aux Roses
1967 Galerie Weiller, Paris
1967 Galerie M.E.Thelen, Essen
1968 Galerie Riquelme, Paris
1968 Maison des Quatre Vents, Paris

Auerbach, Erich
London, England
* 1911 Falkenau, Germany

Avedisian, Edward
New York, USA
* 1936 Lowell, Mass.

Ay-O
New York, USA
* 1931 Japan

Bacon, Francis **2, 65**
London, England
* 1910 Dublin, Eire
1963/1964 Guggenheim Museum, New York

Baehr, Ulrich
Berlin, Germany
* 1938 Bad Kösen
1964, 1965, 1966 Galerie Grossgörschen, Berlin
1966 Galerie Tobiés und Silex, Cologne

Baer, Joe
New York, USA
* 1929 Seattle, Washington
1966 Fischbach Gallery, New York
1968 documenta, Kassel

Beartling, Olle
Stockholm, Sweden
* 1911 Halmstad
1949 Galerie Samlaren, Stockholm
1963 Galerie Hybler, Copenhagen
1952, 1956, 1958, 1961, 1962, 1963, 1964 Galerie
Denise René, Paris

Baier, Jean
Geneva, Switzerland
* 1932 Geneva
1959 Biennale Saõ Paulo

Bailey, William **26, 27, 186**
New York, USA
* USA
1968 Robert Schoelkopf Gallery, New York

Baj, Enrico **40, 119, 224**
Milan, Italy
* 1924 Milan
1957 J.C.A., London
1961 Galleria Schwarz, Milan
1963 Biennale Saõ Paulo
1964 Biennale di Venezia

Balcar, Jiri
Prague, Czechoslovakia
* Prague

Baldi, Lanfranco
Florence, Italy
* 1939 Florence

Shusaku Arakawa

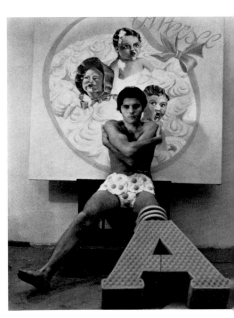

Christian Ludwig Attersee

ernard Aubertin

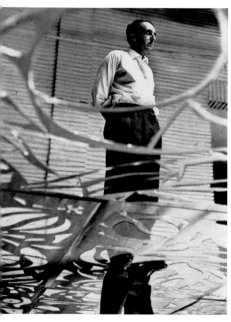

nrico Baj

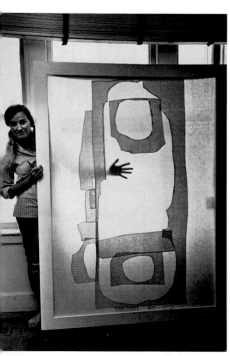

ary Bauermeister

Ballo, Aldo
Milan, Italy
* 1928 Sciacca

Balthus (Balthus Klossowski de Rola)
Rome, Italy
* 1908 Paris
1963 Pierre Matisse Gallery, New York

Bannard, Walter Darby
Princeton, USA
* 1934 New Haven, Conn.
1964 Post Painterly Abstraction, County Museum
Los Angeles
1968 Tibor de Nagy Gallery, New York

Baratella, Paolo
Milan, Italy
* Bologna
1961, 1962 Galleria Pater, Milan

Bargheer, Eduard
Hamburg, Germany
* 1901 Finkenwärder

Baringer, Richard
New York, USA
* 1921 Elkhart, Indiana
1962, 1963 Bertha Schaefer Gallery, New York
1968 documenta, Kassel

Barke, Larry
Everett, Washington, USA
* 1932 Vancouver

Barker, Clive
London, England
* 1940 Luton
1967 Englische Kunst, Galerie Bischofsberger,
Zürich

Barletta, Joel
San Francisco, USA
* 1923 Newark, N. J.

Barnard, Roger
London, England
* 1944 Kent
1966 The New Generation, Whitechapel Art
Gallery, London

Barnes, Robert
Washington, D.C., USA
* 1934 Washington, D.C.

Barron, Ros
USA
* USA
1957 De Cordova Museum
1958, 1963 Kanegis Gallery, Boston
1965, 1966 Ward Nasse Gallery, Boston

Barry, Robert
New York, USA
* 1936 New York
1964 Westerly Gallery, New York

Bartels, Hermann
* 1928 Düsseldorf, Germany
1968 Inter-Gallery, Brussels

Barth, Wolf
Paris, France
* 1926 Basle

Baruchello, Gianfranco
Milan, Italy
* 1924 Leghorn
1963 Galleria La Tartaruga, Rome
1964 Cordier and Eckstrom Gallery, New York
1965, 1966 Galleria Schwarz, Milan

Baschang, Hans
Karlsruhe, Germany
* 1937 Karlsruhe

Bassingthwaighte, Lewin
London, England
* 1928 England
1964, 1966 Piccadilly Gallery, London

Bat-Yosef, Myriam
Paris, France
*1931 Berlin
1958 Musée d'Art Moderne, Tel Aviv
1964 Galerie Sydow, Frankfurt

Bauermeister, Mary **XXXI**
New York, USA
* 1934 Frankfurt/Main
1962 Stedelijk Museum, Amsterdam
1964, 1965 Bonino Gallery, New York

Baumann, Horst H.
Aachen, Germany
* 1934 Aachen

Baumeister, Willi
* 1889 Stuttgart, Germany
† 1955 Stuttgart

Bayer, Herbert
Aspen, Col., USA
* 1900 Haag, Austria

Bayrle, Thomas **123, 124, 125, 202**
Frankfurt, Germany
* 1937 Berlin
1968 Galleria Apollinaire, Milan

Bazaine, Jean
Paris, France
* 1904 Paris

Baziotes, William
New York, USA
* 1912 Pittsburgh

Beal, James
New York, USA
* 1931 Richmond, Virginia

Beauchamp, Robert
New York, USA
* 1923 Denver, Colorado

Becher, Bernhard **231, 232**
Wittlaer, Germany
* 1931 Siegen
1967 Neue Sammlung, Munich

Bechtle, Robert Alan
Oakland, Calif., USA
* 1932 San Francisco
1959, 1964 San Francisco Museum of Art

Beckmann, Hannes
New York, USA
* 1909 Stuttgart, Germany

Beckmann, Max
* 1884 Leipzig, Germany
† 1950 New York

Beer, Franz
Vienna, Austria
* Austria
1961 Galerie Bing, Paris
1968 Ward Nasse Gallery, Boston

Béguier, Serge
Paris, France
* 1934 Paris
1965 Galerie J, Paris

Belkin, Arnold
Mexico
* 1930 Calgary

Bell, Leland
New York, USA
* 1922 Cambridge, Maryland

Bellegarde, Claude
Paris, France
* 1927 Paris

Bellini, Mario
Milan, Italy
* Italy

Bellmer, Hans **133**
Paris, France
* 1902 Kattowitz, Poland
1952, 1955 Galerie J.J.Pauvert, Paris
1953 Galerie Springer, Berlin
1966 Kestner-Gesellschaft, Hanover

Bello, Bruno di
Naples, Italy
* 1938 Torre del Greco

Belson, Jordan
San Francisco, USA
* 1926 USA

Bengston, Billy Al
Los Angeles, USA
* 1934 Dodge City, Kansas
1957, 1960, 1961 Ferus Gallery, Los Angeles
1962 Martha Jackson Gallery, New York

Benjamin, Karl Stanley
Clavemont, Calif., USA
* 1925 Chicago,
1954 Pasadena Art Museum
1962 Santa Barbara Museum of Art

Benkert, Ernst
New York, USA
* 1928 Chicago

Berges, Werner
Berlin, Germany
* 1941 Cloppenburg
1966 Galerie Grossgörschen

Bergmann, Anna-Eva
Paris, France
* Stockholm
1958, 1962 Galerie de France, Paris

Bergmann, Ella
Vockenheim, Germany
* 1896 Paderborn
1963 Museum Leverkusen
1968 Waddell Gallery, New York

Bergmann, Gerhart
Berlin, Germany
* 1922 Erfurt
1965 Grabowski Gallery, London

Berke, Hubert
Cologne, Germany
* 1908 Buer

Berlant, Anthony
Los Angeles, USA
* 1941 New York

Berner, Bernd
Stuttgart, Germany
* 1930 Hamburg

Bernik, Janez
Ljubljana, Yugoslavia
* 1933 Ljubljana
1960 Museum Zagreb

Bertholle, Jean
Paris, France
* 1909 Dijon

Bertholo, René
Paris, France
* 1935 Alhandra, Portugal
1965, 1966 Galerie Mathias Fels, Paris
1968 Galerie Birch, Copenhagen

Bertini, Gianni **16, 86, 88, 270**
Paris, France
* 1922 Pisa
1964 Galleria Apollinaire, Milan

Beynon, Erik
Paris, France
* 1935 Geneva
1960 Zoom I, Galerie Blumenthal, Paris

Biasi, Alberto
Padova, Italy
* 1937 Padova
1963 Studio F., Ulm
1965 Licht und Bewegung, Kunsthalle Berne

Biasi, Guido
Milan, Italy
* 1933 Naples
1958 Galleria Pater, Milan

Bierzunski, Jochen-Harro
Flensburg, Germany
* 1936 Germany
1968 Galerie C.-D. Rothe, Wolfsburg

Biggi, Gastone
Rome, Italy
* 1925 Rome

Bignardi, Umberto **126, 176**
Rome, Italy
* 1935 Bologna
1963 Galleria La Tartaruga, Rome
1966 Galleria L'Attico, Rome

Thomas Bayrle

Gottfried Honegger, Agostino Bonalumi,
Carlos Cruz-Diez

172

ll, Jakob
rich, Switzerland
1942 Zürich
65 Galerie 123, Krefeld
66 Op-Art Galerie, Esslingen
67 Galerie Suzanne Bollag, Zürich

ll, Max
rich, Switzerland
1908 Winterthur
50 Museum Saõ Paulo
59 Museum Leverkusen
60 Museum Winterthur
66 Galerie Suzanne Bollag, Zürich
68 Kunsthalle Berne
68 Kunsthalle Düsseldorf

nder, Douglas
ndon, England
941 Bradford
66 The New Generation, Whitechapel
t Gallery, London
68 New English Painting and Sculpture,
CLA, Los Angeles

reline, George
leigh, N.C., USA
923 Peoria, Illinois
59 University of North Carolina
60 Winston-Salem State Teacher College

rolli, Renato
lan, Italy
906 Verona

schof, Werner
916 Zürich, † 1954 in S.America
54 "Japan"
57 "Incas to Indians"

schoff, Elmer
rkeley, Calif., USA
916 Berkeley

schoffshausen, Hans
ris, France
927 Graz, Austria

shop, James
w York, USA
927 Neosho, Mo.
63 Galerie Smith, Brussels
64 Galerie Lawrence, Paris
66 Galerie Jean Fournier, Paris
66 Fischbach Gallery, New York

ney, Sue
n Francisco, Calif., USA
USA
67 Galleria del Deposito, Genoa

ackwell, Patrick
s Angeles, USA
935 Los Angeles

aine, Nell
w York, USA
922 Richmond, Virginia

ake, Peter **68, 90, 92, 93**
ndon, England
932 Dartford
62 Portal Gallery, London
65 Robert Fraser Gallery, London

Blase, Karl-Oskar
Kassel, Germany
* 1925 Cologne

Bleckert, Hajo
Düsseldorf, Germany
* 1927 Stralsund

Blizzard, Allan
Claremont, Calif., USA
* 1929 Boston

Blosum, Vern
South Elgin, Illinois, USA
* 1935 Illinois

Boardman, Seymour **321**
New York, USA
* 1922 Brooklyn, N.Y.
1955, 1956 Martha Jackson Gallery, New York
1960 Dwan Gallery, Los Angeles
1961, 1962 Stephen Radich Gallery, New York
1965, 1967, 1968 A.M.Sachs Gallery, New York

Boccioni, Umberto
* 1882 Reggio, Italy
† 1916 Verona

Boch, Monika von
Saarbrücken, Germany
* 1915 Mettlach

Boehm, Hartmut
Fulda, Germany
* 1938 Kassel
1967 Galerie Wilbrand, Cologne
1968 Galerie Fischer-Steinhardt, Frankfurt

Boezem, Marinus
Gorinchem, Holland
* 1934 Leerdam

Bogart, Bram
Paris, France
* 1921 Delft, Holland

Boje, Walter
Leverkusen, Germany
* 1905 Berlin

Bolotowsky, Ilya
New York, USA
* 1907 Leningrad
1954–1966 Borgenicht Gallery, New York

Bonalumi, Agostino
Milan, Italy
* 1935 Vimercate
1958 Galleria Pater, Milan
1959 Galerie Kasper, Lausanne
1961 Galleria Cadario, Milan
1964 Galleria Cadario, Milan
1965 Galerie M.E.Thelen, Essen
1965 Galleria Schwarz, Milan
1966 Galleria del Deposito, Genoa
1967 Gallery Bonino, New York
1967, 1968 Galleria Naviglio, Milan
1968 Museum am Ostwall, Dortmund

Bonies
Wassenaar, Holland
* 1937 The Hague

Bonfanti, Arturo
Bergamo, Italy
* 1905 Bergamo
1961 Galerie Charles Lienhard, Zürich
1962, 1965 Galleria Lorenzelli, Milan
1968 Museum Folkwang, Essen
1968 Biennale di Venezia

Bordoni, Enrico
Milan, Italy
* 1906 Altare
1958 Biennale di Venezia

Borges, Jacobo
* 1931 Caracas

Boriani, Davide
Milan, Italy
* 1936 Milan
1960 Galleria Pater, Milan

Boshier, Derek **158**
London, England
* 1937 Portsmouth
1965 Robert Fraser Gallery, London
1967 Galerie Bischofsberger, Zürich

Botero, Fernando
New York, USA
* 1932 Medellin, Columbia
1966 Galerie Buchholz, Munich

Boto, Martha
Paris, France
* 1925 Buenos Aires
1967 Galerie M.E.Thelen, Essen

Bottarelli, Maurizio
Bologna, Italy
* 1943 Bologna

Boty, Pauline
London, England
* 1938
Whitechapel Art Gallery, London

Brace, Roger
London, England
* 1943 Birmingham
1966 The New Generation,
1963 Whitechapel Art Gallery, London

Brach, Paul
New York, USA
* 1924 New York
1963 Towards A New Abstraction,
Jewish Museum, New York

Brandt, Bill
London, England
* 1905 London
1936 "The English At Home"
1938 "A Night in London"
1961 "Perspectives of Nudes"

Braque, Georges
* 1882 Argenteuil, France
† 1963 Paris

Brassai (Gyula Halasz)
Paris, France
* 1899 Brassó, Hungary
1933 "Paris de Nuit"
1956 "Fiesta in Sevilla"

Brauer, Erich
Vienna, Austria
* 1929 Vienna
1963, 1964 Galerie Karl Flinker, Paris
1967 Felix Landau Gallery, Los Angeles

Brauner, Victor
Paris, France
* 1903 Piatra Neamiz, Romania

Brecht, George
New York, USA
* 1926 New York
1968 Fischbach Gallery, New York

Breer, Robert
New York, USA
* 1926 Detroit
1950–1955 Galerie Denise René, Paris
1964 Cordier and Eckstrom Gallery, New York
1965, 1966, 1967 Bonino Gallery, New York
1968 Galerie Ricke, Cologne

Brehmer, K. P.
Berlin, Germany
* 1938 Germany
1967 Galerie Zwirner, Cologne

Breier, Kilian
Hamburg, Germany
* 1931 Ensheim

Brice, William
Los Angeles, USA
* 1921 New York
1966 Felix Landau Gallery, Los Angeles

Brisley, Stuart
London, England
* 1933 Haslemere, England
1960 Galerie Deutscher Bücherbund, Munich

Broderson, Morris
Los Angeles, USA
* 1928 Los Angeles
1964 Phoenix Art Museum

Broodthaers, Marcel **380**
Brussels, Belgium
* 1924 Brussels

Brooks, James
New York, USA
* 1906 St. Louis

Brown, William Theo **179**
Malibu, Calif., USA
* 1919 Moline, Illinois
1958–1967 Felix Landau Gallery, Los Angeles
1962 Kornblee Gallery, New York

Bruder, Harold
Kansas City, USA
* 1930 New York

Brüning, Peter **238**
Ratingen, Germany
* 1929 Düsseldorf
1957 Galleria Apollinaire, Milan
1958 Galerie Parnass, Wuppertal
1958 Galerie 22, Düsseldorf
1965 Galerie Aenne Abels, Cologne
1968 documenta, Kassel

Brunelle, Al
New York, USA
* 1934 Minneapolis

Brust, Karl-Friedrich
* 1897 Frankfurt, Germany
† 1960 Munich

Bryen, Camille
Paris, France
* 1907 Nantes

Bubenik, Gernot **274**
Berlin, Germany
* 1942 Troppau
1966 Galerie Thomas, Munich
1967 Galerie Schüler, Berlin
1967 Findlay Gallery, New York
1967 Museum Leverkusen

Bucher, Carl
Zürich, Switzerland
* 1935 Zürich
1966 Galerie Bischofsberger, Zürich

Brunce, Louis
Portland, Oregon, USA
* 1907 Lander, Wyoming
1950, 1951 Museum of Modern Art, New York

Burgering, Tony
Holland
* 1937 Barneveld
1968 Galerie Mickery, Loenersloot

Buri, Samuel
Basle, Switzerland
* 1935 Täuffelen

Burne-Jones, Edward Coley **19**
* 1833
† 1898

Burri, Alberto
Rome, Italy
* 1915 Perugia

Bury, Pol **353**
Fontenay-aux-Roses, France
* 1922 Haine-Saint-Pierre

Bush, Jack
Toronto, Canada
* 1909 Toronto

Busse, Hal
Hamburg, Germany
* 1926 Jagstfeld

Busse, Jacques
Paris, France
* 1922 Paris

Bussmann, Volker
Frankfurt, Germany
* 1945 Waldshut

Cajori, Charles
New York, USA
* 1921 Palo Alto, Calif.

Calos, Nino
Paris, France
* 1926 Messina, Italy
1960 Galleria del Cavallino, Venice
1967 Musée d'art moderne, Paris

Camacho, Jorge
Neuilly-sur-Seine, France
* 1934 Havana, Cuba

Camargo, Sergio
Paris, France
* 1930 Rio de Janeiro
1964 Signals Gallery, London
1966 Biennale di Venezia
1967 Galleria la Polena, Genoa

Campigli, Massimo
Paris, France
* 1895 Florence

Canepa, Jack **287**
St. Louis, USA
* USA
1968 Gallery Loretto-Hilton Center,
Webster Groves

Canogar, Rafael
Madrid, Spain
* 1934 Toledo
1968 Biennale di Venezia

Capogrossi, Giuseppe **XV**
Rome, Italy
* 1900 Rome
1950, 1952, 1958 Galleria del Cavallino, Venice
1953, 1955, 1959 Galleria Naviglio, Milan
1956 Galerie Rive Gauche, Paris
1957 Institute of Contemporary Arts, London
1958 Leo Castelli Gallery, New York
1960 Galerie 22, Düsseldorf
1967 Kunsthalle Baden-Baden

Carbone, Francesco
Palermo, Italy
* Cirene

Carena, Antonio
Rivoli, Italy
* 1925 Rivoli

Carmi, Eugenio **374, 375, 376, 377**
Genoa, Italy
* 1920 Genoa
1964 Galerie d, Frankfurt
1966 Galleria Arco d'Alibert, Rome

Carone, Nicolas
New York, USA
* 1917 New York

Carrà, Carlo
* 1881 Quarguento, Italy

Carrino, Nicola
Rome, Italy
* 1932 Taranto

Carter, Clarence H.
New Jersey, USA
* 1904 New York

ıgenio Carmi

rico Castellani

Carter, John
London, England
* 1942 Middlesex

Cartier-Bresson, Henri **98**
France
* 1908 Chanteloup
1955 "People of Moscov"
1956 "China in Transition"

Casorati, Felice
Turin, Italy
* 1886 Novara

Cassinari, Bruno
Milan, Italy
* 1912 Piacenza

Castellani, Enrico
Milan, Italy
* 1930 Castelmassa
1958 Galleria Pater, Milan
1959 Galerie Kasper, Lausanne
1960 Monochrome Malerei, Museum Leverkusen
1961 Galerie Denise René, Paris
1961 Galleria La Tartaruga, Rome
1964 Galleria Notizie, Turin
1965 Galerie Lawrence, Paris
1966 Betty Parsons Gallery, New York
1966 Biennale di Venezia

Castro, Lourdes **153, 162**
Paris, France
* 1930 Madeira
1965 Galerie Buchholz, Munich
1966 Kunsthalle Baden-Baden
1967 Gallery Indica, London
1967 Galerie 20, Amsterdam

Castro-Cid, Enrique
New York, USA
* 1937 Santiago/Chile
1960 La Libertad Galerie, Santiago
1963, 1964, 1965, 1966 Richard Feigen Gallery,
New York – Chicago

Caulfield, Patrick
London, England
* 1936 London
1965 Robert Fraser Gallery, London

Cavael, Rolf
Munich, Germany
* 1898 Königsberg

Cavallon, Giorgio
New York, USA
* 1904 Sorio
1961, 1963, 1965 Kootz Gallery, New York

Celentano, Francis
New York, USA
* 1928 New York

Celic, Stojan
Belgrade, Yugoslavia
* 1925 Bosanska Nova
1960 Zagreb Museum

Celli, Luciano
* Trieste, Italy
1940 Trieste
1967 Galleria La Bora, Trieste
1967 Galleria del Cavallino, Venice

Ceroli, Mario
Rome, Italy
* 1938 Castelfranco
1964, 1965, 1966 Galleria La Tartaruga, Rome
1966 Galleria Naviglio, Milan
1967 Bonino Gallery, New York
1968 Galleria Sperone, Turin
1968 Galerie Schmela, Düsseldorf

Chagall, Marc
Vence, France
* 1887 Witebsk, USSR

Charchoune, Serge
Paris, France
* 1888 Bugurusian, USSR
1960 Monochrome Malerei, Museum Leverkusen

Chamberlain, Wynn **73, 130**
New York, USA
* 1928 Minneapolis
1954, 1957 Hewitt Gallery, New York
1959 Gallery G., New York
1961 Nordness Gallery, New York

Charlton, Gene
Rome, Italy
* 1919 Cairo, Illinois
1962 Galleria Trastevere, Rome
1962 Galerie Suzanne Bollag, Zürich

Chiggio, Ennio
Padova, Italy
* 1938 Naples

Chilton, Michael
Hull, England
* 1934 Leeds

Chin, Hsiao
New York, USA
* 1935 Shanghai
1959 Galleria Numero, Florence
1961 Galeria Trastevere, Rome
1964 Galleria dell'Ariete, Milan
1967 Rose Fried Gallery, New York
1968 Pollock Gallery, Toronto

Chirico, Giorgio de
Rome, Italy
* 1888 Volo, Greece

Christen, Andreas
Zürich, Switzerland
* 1936 Bubendorf
1963, 1966 Galerie Suzanne Bollag, Zürich

Christensen, Dan
New York, USA
* 1942 Lexington, Nebraska

Christo (Christo Yavacheff) **96**
New York, USA
* 1935 Gabravo, Bulgaria
1968 documenta, Kassel

Cihankova, Jarmila
Bratislava, Czechoslovakia
* 1925

Cina, Colin
England
* 1943 Glasgow
1966 The New Generation, Whitechapel Art Gallery,
London

Claisse, Geneviève
Paris, France
* France

Clark, Lygia **391, 405**
Paris, France
* 1920 Belo Horizonte, Brazil
1963 Louis Alexander Gallery, New York
1964/1965 Signals Gallery, London
1968 Biennale di Venezia
1968 Galerie Thelen, Essen

Clarke, John Clem **77**
New York, USA
* USA
1968 Kornblee Gallery, New York

Claus, Carlfriedrich
Annaberg, Germany
* 1930 Annaberg

Claus, Jürgen
Munich, Germany
* 1935 Berlin

Cloar, Carroll
Memphis, USA
* 1913 Earle, Arkansas

Clough, Prunella
London, England
* 1919 London
1960 Whitechapel Art Gallery, London

Cohen, Bernard
London, England
* 1933
1958, 1960 Gimpel Fils, London
1961 Neue Malerei in England, Museum Leverkusen

Cohen, George **160, 161**
Evanston, Illinois, USA
* 1919 Chicago
1963, 1966 Richard Feigen Gallery, New York

Colin, Paul
Paris, France
* 1892 Nancy

Collins, Jess
San Francisco, USA
* 1923 Long Beach, California

Colombo, Gianni
Milan, Italy
* 1937 Milan
1960 Galleria Pater, Milan
1965 Galleria L'Italia, Rome
1966 Galerie Dorothea Loehr, Frankfurt
1967 Galerie Tobiès und Silex, Cologne

Colville, Alex **260**
London, England
* 1920 England

Cook, Roger
London, England
* 1940 London
1964, 1966 Rowan Gallery, London
1966 The New Generation, Whitechapel Art Gallery,
London

Conner, Bruce
San Francisco, USA
* 1933 McPherson, Kansas
1958 East West Gallery, San Francisco
1964 Robert Fraser Gallery, London
1960, 1961, 1964 Alan Gallery, New York
1963 Ferus Gallery, Los Angeles

Contemorra, Liliana
Italy
* Italy
1968 Galleria Vismara, Milan

Copley, William N. **112**
New York, USA
* 1919 New York
1961 Alexander Iolas Gallery, New York

Corneille (Cornelis van Beverloo)
Paris, France
* 1922 Liège, Belgium
1956 Stedelijk Museum, Amsterdam
1961 Gemeente Museum, The Hague

Cornell, Joseph
Flushing, New York, USA
* 1903 Nyack, New York
1967 Pasadena Art Museum

Corpora, Antonio
Rome, Italy
* 1909 Tunis

Costa, Toni
Padova, Italy
* 1935 Padova

Coviello, Peter
London, England
* 1930
1961 Neue Malerei in England, Museum Leverkusen

Cremonini, Leonardo
Paris, France
* 1925 Bologna, Italy

Creston, William
New York, USA
* USA

Crippa, Roberto
Milan, Italy
* 1921 Monza
1951 Alexander Iolas Gallery, New York
1960 Museum Leverkusen

Cruz-Diez, Carlos **XXIX**
Paris, France
* 1923 Caracas
1955 Museum Caracas
1965 Signals Gallery, London
1965 Galerie Kerchache, Paris
1965 Galleria La Polena, Genoa
1966 Galerie M.E. Thelen, Essen
1968 Museum am Ostwall, Dortmund

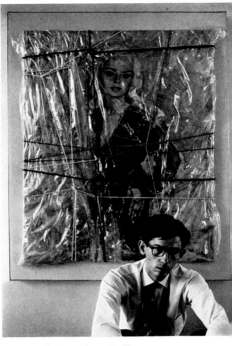

Christo (Christo Yavacheff)

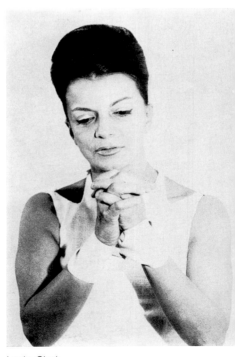

Lygia Clark

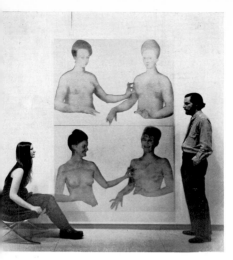

kota Daley

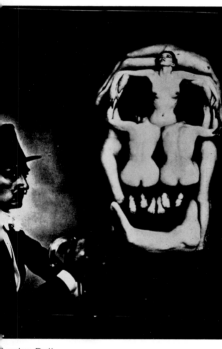

vador Dali

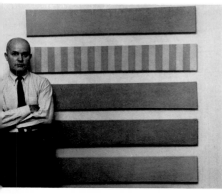

ne Davis

Cuenza, Juan
Cordoba, Spain
* 1934

Cuixart, Modesto
Barcelona, Spain
* 1925 Barcelona
1963 Galeria Métras, Barcelona

Cunningham, Benjamin Frazier
New York, USA
* 1904 Cripple Creek, Colorado

Dada Maino
Milan, Italy
* Milan

Dahmen, Karl-Fred
Stolberg, Germany
* 1917 Stolberg

Daley, Dakota **20, 57**
Los Angeles, USA
* USA
1965 Dwan Gallery, Los Angeles

Dali, Salvador **56, 101, 384, 385**
Cadaques, Spain
* 1904 Figueras

Damjanovic-Damjan, Radomir
Yugoslavia
* 1936 Mostar
1966 Biennale di Venezia

Damm, Manfred
Hessen, Germany
* 1942 Friedberg

Daphnis, Nassos **316**
New York, USA
* 1914 Krockeai, Greece
1959, 1960, 1961 Leo Castelli Gallery, New York

Darboven, Hanne
New York, USA
* 1941 Munich
1967/1968 Galerie Konrad Fischer, Düsseldorf
1968 Dwan Gallery, New York
1969 Museum Mönchen-Gladbach

D'Arcangelo, Allan **216, 219**
New York, USA
* 1930 Buffalo
1963, 1964, 1965, 1967 Fischbach Gallery, New York
1965 Galerie Ileana Sonnabend, Paris
1965 Galerie Zwirner, Cologne
1965 Galerie Müller, Stuttgart
1966 Dwan Gallery, Los Angeles

Dash, Robert
New York, USA
* 1934 New York
1960, 1961, 1962 Kornblee Gallery, New York

Dat, Simone
Paris, France
* 1927 Paris

Davie, Alan
London, England
* 1920 Grangemouth

Davis, Gene **279**
Washington, D.C., USA
* 1920 Washington, D.C.
1959, 1961, 1963 Jefferson Place Gallery, Washington
1963, 1965, 1966, 1967 Poindexter Gallery, New York
1967, 1968 Fischbach Gallery, New York
1967 Galerie Ricke, Kassel
1968 Jewish Museum, New York

Davis, Ronald **323, 324, 326**
Los Angeles, USA
* USA
1968 documenta, Kassel

Davis, Stuart
New York, USA
* 1894 Philadelphia

Debenjak, Riko
Yugoslavia
* 1908 Kanal, Austria
1964 Biennale di Venezia

Dechar, Peter **184**
New York, USA
* 1942 New York
1968 Gallery Cordier and Eckstrom, New York

Deem, George **104, 228**
New York, USA
* 1932 Vincennes, Indiana
1963, 1968 Allan Stone Gallery, New York
1963 The Art Institute, Chicago

De Filippi, Fernando
Milan, Italy
* 1940 Lecce

De Forrest, Roy
Richmond, Calif., USA
* 1930 North Platte, Nebraska

Degottex, Jean
Paris, France
* 1918 Sathonay

Dekkers, Ad
Gorinchem, Holland
* 1938 Nieuwpoort

Delahaut, Jo
Liège, Belgium
* 1911 Liège
1952 Galerie Arnaud, Paris
1958, 1962 Palais des Beaux-Arts, Brussels
1967 Galerie Falazik, Bochum

Delaunay, Robert
* 1885 Paris
† 1941 Montpellier

Delaunay, Sonia
Paris, France
* 1886 USSR

Del Marle
Paris, France
* 1889 France

De Luigi, Mario
Venice, Italy
* 1908 Treviso
1964 Galleria Naviglio, Milan
1968 Biennale di Venezia

Delvaux, Paul
Brussels, Belgium
* 1897 Anthée
1968 Biennale di Venezia

Demarco, Hugo
Paris, France
1932 Buenos Aires
1961, 1968 Galerie Denise René, Paris
1964 Sidney Janis Gallery, New York
1964 Galerie Gimpel und Hanover, Zürich

De Maria, Walter
New York, USA
* 1935 Albany

Demartini, Hugo
Prague, Czechoslovakia
* Prague

Denny, Robyn
London, England
* 1930 Abinger
1961 Molton Gallery, London
1961 Neue Malerei in England, Museum Leverkusen
1963 Galerie Müller, Stuttgart
1964 Kasmin Gallery, London

Derain, André
* 1880 Chatou, France
† 1954 Garches

De Sanctis, Fabio
Rome, Italy
* 1931 Rome

Deschamps, Gérard
Paris, France
* 1937 Lyon
1962 Galerie J, Paris

De Valle, Beppe
Turin, Italy
* 1940 Turin

De Vecchi, Gabriele
Milan, Italy
* 1938 Milan
1960 Galleria Pater, Milan

Devasne, Jean
Paris, France
* 1921 Hellemmes-Lille
1945–1966 Galerie Denise René, Paris
1961 Galleria Lorenzelli, Milan
1965/1966 Gallery Cordier and Eckstrom, New York
1966 Kunsthalle Berne

Deyrolle, Jean
* 1911 Nogent-sur-Marne, France
† 1967

Dias, Antonio
Paris, France
* 1944 Paraíba, Brazil
1967 Galerie Delta, Rotterdam
1967 Galeria Relêvo, Rio de Janeiro
1967 Galerie Debret, Paris

Dias, Cicero
Paris, France
* 1908 Brazil

Dibbets, Jan
London, England
* 1941 Enschede, Holland
1968 Galerie Konrad Fischer, Düsseldorf

Diebenkorn, Richard
Berkeley, Calif., USA
* 1922 Portland, Oregon

Dienst, Klaus-Peter
Hamburg, Germany
* 1935 Kiel

Dieringer, Ernest
New York, USA
* 1932 Chicago
1962, 1964 Poindexter Gallery, New York

Dietmann, Erik
Nice, France
* 1937 Jönköping, Sweden
1964 Galleria Sperone, Turin
1966 Galerie Mathias Fels, Paris

Diller, Burgoyne
* 1906 New York
† 1965 New York
1951 Museum of Modern Art, New York
1960–1962 Gallery Chalette, New York
1961 Whitney Museum, New York

Dine, Jim **199**
New York, USA
* 1935 Cincinnati
1959, 1960 Judson Gallery, New York
1960, 1961 Reuben Gallery, New York
1963 Sidney Janis Gallery, New York

Distel, Herbert
Berne, Switzerland
* Berne

Dix, Otto
Hemmenhofen, Constance, Germany
* 1891 Unterhausen
† 1969 Hemmenhofen, Constance

Dobes, Milan **290**
Bratislava, Czechoslovakia
* 1929 Prerov
1968 documenta, Kassel

Doesburg, Theo van
* 1883 Utrecht, Holland
† 1931 Davos

Domela, César
Paris, France
* 1900 Amsterdam
1955 Stedelijk Museum, Amsterdam

Domoto, Hisao
Paris, France
* 1928 Kyoto, Japan
1957, 1959, 1962 Galerie Stadler, Paris

Dorazio, Piero
Rome, Italy
* 1927 Rome
1960 Monochrome Malerei, Museum Leverkusen
1964 Galleria Marlborough, Rome
1966 Marlborough Gallery, London

Downey, Juan
Paris, France
* 1940 Santiago de Chile

Downing, Thomas **325**
Washington, D.C., USA
* 1928 Suffolk, Virginia
1962 Allan Stone Gallery, New York
1963, 1965 Stable Gallery, New York

Drago (Dragos Kalajic) **69, 127**
Belgrade, Yugoslavia
* 1943 Belgrade

Drexler, Rosalyn **72**
New York, USA
* 1922 New York

Drexler, Sherman
New York, USA
* 1925 New York

Duart, Angel
Cordoba, Spain
* 1930 Spain

Duarte, José
Cordoba, Spain
* 1928 Spain

Dubuffet, Jean **3**
Vence, France
* 1901 Le Havre
1955 I.C.A. London
1957 Museum Leverkusen
1962 Museum of Modern Art, New York
1966 Tate Gallery, London
1968 Pace Gallery, New York

Ducasse, Ralph
San Francisco, USA
* Paducah, Kentucky

Duchamp, Marcel
New York, USA
* 1887 Blainville, France
† 1968 New York

Dufrène, François
Paris, France
* 1930 Paris
1963 Galerie J., Paris

Dufy, Raoul
* 1887 Le Havre, France
† 1953 Forcalquier

Dugmore, Edward
New York, USA
* 1915 Hartford

Dujarri, Elisabeth
Paris, France
* 1930 Jouy-en-Josas

orge Eielson

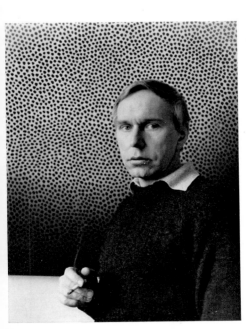
Wojciech Fangor

Durkee, Stephen
New York, USA
* 1939 New York
1960 Tanager Gallery, New York
1961 Allan Stone Gallery, New York
1963 Galleria Schwarz, Milan

Dzubas, Friedel
New York, USA
* 1915 Berlin
1961, 1962, 1963 Robert Elkon Gallery, New York

Eberle, W.S.
Zürich, Switzerland
* 1931 Switzerland

Edgerton, Harold E.
Cambridge, Mass., USA
* 1903 Fremont, Nebraska

Eichbaum, Erwin
Düsseldorf, Germany
* 1928 Düsseldorf
1961, 1968 Galerie Küppers, Cologne

Eichner, Hellmuth
Hoffnungsthal, Germany
* 1946 Schönenberg

Eielson, Jorge **12, 101**
Paris, France
* 1924 Lima
1966 Biennale di Venezia

Eller, Jim
Los Angeles, USA
* 1943 Hollywood

Ende, Edgar
Munich, Germany
* 1901 Altona

Endt, Erich von
Essen, Germany
* 1935 Cologne

Engelmann, Michael
Munich, Germany
* 1928 Prague

Engels, Pieter
Amsterdam, Holland
* 1938 Holland
1968 documenta, Kassel

Erhardt, Hans Martin
Karlsruhe, Germany
* 1935 Emmendingen

Ernst, Max
Huismes, France
* 1891 Brühl, Germany

Ernst, Wolfgang
Vienna, Austria
* 1942 Vienna

Erro, Gudmundur **107, 111, 122, 194, 245, 246**
Paris, France
* 1932 Olafswik, Iceland
1957 Museum Reykjavik
1961 Galleria Naviglio, Milan
1964 Gertrude Stein Gallery, New York
1965 Galleria L'Attico, Rome

Estève, Maurice
Paris, France
* 1904 Culau

Estrada, Adolfo
Madrid, Spain
* 1942 Buenos Aires

Etmer, Axel
Bremen, Germany
* 1934 Magdeburg
1968 Galerie Niepel, Düsseldorf

Evans, Walker
New York, USA
* 1903 St. Louis

Everett, Walker
New York, USA
* 1905 Chicago

Fabiano, Franco **347**
Milan, Italy
* Italy

Fabro, Luciano **404**
Turin, Italy
* 1936 Italy
1965 Galleria Vismara, Milan
1967, 1968 Galleria Notizie, Turin

Fadat, Michel
Saarbrücken, Germany
* 1936 Troyes, France
1964 Edizioni Danese, Milan

Fahlström, Öyvind **357, 358, 359, 360, 371**
New York, USA
* 1928 Saõ Paulo
1959 Biennale Saõ Paulo
1959, 1962 Galerie Daniel Cordier, Paris
1964 Gallery Cordier and Eckstrom, New York
1964, 1966 Biennale di Venezia
1968 documenta, Kassel

Fangor, Wojciech **309, XXV**
Madison, New Jersey, USA
* 1922 Warsaw
1963 Galerie Lambert, Paris
1964 Museum Leverkusen
1967, 1969 Gallery Chalette, New York

Fasnacht, Mary
Berne, Switzerland
* 1936 Berne

Fassbender, Joseph
Cologne, Germany
* 1903 Cologne

Fautrier, Jean
* 1898 Paris
† 1964 Chatenay-Malabry
1958 Galerie 22, Düsseldorf
1958 Museum Leverkusen
1964 Musée d'art moderne, Paris

Feeley, Paul
* 1913 Des Moines, Iowa
† 1966 New York
1958 Tibor de Nagy Gallery, New York
1960, 1962, 1963, 1964, 1965 Betty Parsons Gallery, New York

Feininger, Lyonel
* 1871 New York
† 1956

Feitelson, Lorser
Los Angeles, USA
* 1898 Savannah, Georgia

Feito, Luis
Madrid, Spain
* 1929 Madrid
1968 Biennale di Venezia

Feldstein, Mark
New York, USA
* 1937 Milan
1968 Tibor de Nagy Gallery, New York

Fenzl, Fritz
Frankfurt, Germany
* 1920 Lorraine

Fergola, Sergio
New York, USA
* 1936 Naples

Ferren, John
New York, USA
* 1905 Los Angeles
1962, 1963 Rose Fried Gallery, New York

Ferroni, Gianfranco
Viareggio, Italy
* 1927 Leghorn
1968 Biennale di Venezia

Festa, Tano **33**
Rome, Italy
* 1938 Rome
1961 Galleria La Salita, Rome
1963 Galleria Schwarz, Milan
1966 Biennale di Venezia

Filliou, Robert **139**
Paris, France
* France

Fine, Perle
New York, USA
* 1908 Boston

Finkelstein, Max
Los Angeles, USA
* 1915 New York

Flanagan, Barry
London, England
* 1941 Prestatyn

Flavin, Dan
New York, USA
* 1933 New York
1961 Judson Gallery, New York
1964 Kaymar Gallery, New York
1964 Green Gallery, New York
1966 Nicholas Wilder Gallery, Los Angeles
1966 Galerie Zwirner, Cologne
1967 Kornblee Gallery, New York
1967 Galleria Sperone, Turin
1968 documenta, Kassel

Fleming, Dean
New York, USA
* 1933 Santa Monica, California
1965/1966 Park Place Gallery, New York
1964 Museum Pittsburgh

Fontana, Lucio **328, 329**
* 1899 Rosario di Santa Fe, Argentina
† 1968 Milan
1958 Biennale di Venezia
1959 documenta Kassel
1962 Museum Leverkusen
1966 Walker Art Center, Minneapolis
1968 documenta Kassel
1968 Galerie Schmela, Düsseldorf

Foujita, Tsugouharu
Paris, France
* 1886 Tokyo

Foulkes, Llyn **225, 226**
Los Angeles, USA
* 1934 Yakima
1961 Ferus Gallery, Los Angeles
1962 Pasadena Art Museum
1963 Nelson Gallery, Los Angeles
1967 Biennale Saõ Paulo

Foyster, Jerry
Brooklyn, N.Y., USA
* 1932 Albany, New York

Francis, Sam
Berne, Switzerland
* 1923 San Mateo, California
1960 Museum Stockholm

Francken, Ruth
New York, USA
* 1924 Prague

Frankenthaler, Helen
New York, USA
* 1928 New York
1960 Jewish Museum, New York
1959–1966 André Emmerich Gallery, New York

Frascà, Nato
Rome, Italy
* 1931 Rome

Freundlich, Otto
* 1878 Stolp, Poland
† 1943 Lublin

Friedlaender, Lee
New York, USA
* USA

Friesz, Othon
* 1879 Le Havre, France
† 1949 Paris

Froese, Hans Dietrich
Karlsruhe, Germany
* 1937 Aulowönen

Fruhtrunk, Günter
Munich, Germany
* 1923 Munich
1957/1958 Galerie Denise René, Paris
1960 Gallery Chalette, New York
1967 Galerie Heseler, Munich

Barnett Newman, Yayoi Kusama

Juan Genovés

Goepfert, Hermann
Frankfurt, Germany
* 1926 Frankfurt
1964 documenta, Kassel
1967 Expo, Montreal
1967 Palais des Beaux-Arts, Brussels

Goetz, Karl Otto
Düsseldorf, Germany
* 1914 Aachen
1958 Biennale di Venezia

Goldberg, Michael
California, USA
* 1924 New York

Golden, Daan van
Schiedam, Holland
* 1936 Rotterdam
1961 Stedelijk Museum, Amsterdam
1962, 1966 Galerie Delta, Rotterdam
1968 documenta, Kassel

Golden, William
* 1911 New York
† 1959 Stony Point, N.Y.

Goller, Bruno
Düsseldorf, Germany
* 1901 Gummersbach

Golub, Leon
Paris, France
* 1922 Chicago

Gonschior, Kuno
Bochum, Germany
* 1935 Wanne-Eickel
1962 Galerie Niepel, Düsseldorf

Gooch, Gerald
Oakland, USA
* 1932 West Virginia
1967 San Francisco

Goode, Joe
Los Angeles, USA
* 1937 Oklahoma City
1966 Nicholas Wilder Gallery, Los Angeles
1967 Rowan Gallery, London

Goodnough, Robert
New York, USA
* 1917 Cortland, N.Y.

Goodyear, John
Lebanon, N.J., USA
* 1930 Southgate, Calif.
1958, 1965 Riverside Museum, New York
1960, 1964 Martha Jackson Gallery, New York
1964, 1965, 1966 Howard Wise Gallery, New York
1966 Whitney Museum, New York

Gorin, Jean
Meudon, France
* 1899 Saint-Emilien-Blain
1966 Kunsthalle Berne

Gorky, Arshile
* 1904 Armenia
† 1948 Sherman, Conn.

Gottlieb, Adolph
East Hampton, L.I., N.Y., USA
* 1903 New York
1963 Walker Art Center, Minneapolis
1968 Whitney Museum, New York

Gourfain, Peter
New York, USA
* 1934 Chicago, Ill.
1965 Bridge Gallery, New York
1966 Systemic Painting, Guggenheim Museum, New York
1967 Bykert Gallery, New York

Graeser, Camille
Zürich, Switzerland
* 1892 Geneva

Graevenitz, Gerhard von
Munich, Germany
* 1934 Schilde
1962 Galerie Röpke, Wiesbaden
1966 Signals Gallery, London
1965, 1967 Galerie Klihm, Munich
1968 Folkwang Museum, Essen

Grant, James
San Francisco, USA
* 1924 Los Angeles

Graubner, Gotthard
Düsseldorf, Germany
* 1930 Erlbach
1960, 1966 Galerie Schmela, Düsseldorf
1961 Wide Wide Space Gallery, Antwerp
1968 documenta, Kassel

Gravenhorst, Hein
Winningen, Germany
* Germany

Graves, Morris
Eire
* 1910 Fox Valley, Oregon

Gray, Cleve
Cornwall Bridge, Conn., USA
* 1918 New York

Graziani, Sante **128, 223**
Shrewsbury, Mass., USA
* 1920 Cleveland, Ohio
1964, 1965 Kanegis Gallery, Boston
1962, 1963, 1965, 1969 Babcock Gallery, New York
1965 Worchester Art Museum
1967 Biennale Saõ Paulo

Greene, Balcomb
Montauk, L.I., N.Y., USA
* 1904 Niagara Falls

Greene, Stephen
Valley Cottage, New York, USA
* 1918 New York

Greenham, Lily
Paris, France
* 1928 Vienna

Gregorietti, Salvatore
Milan, Italy
* 1941 Palermo

Greis, Otto
Paris, France
* 1913 Frankfurt

Gribaud, Ezio
Turin, Italy
* 1929 Turin
1961, 1963 Galleria del Cavallino, Venice
1962, 1966 Galleria Naviglio, Milan
1967 Galleria Schwarz, Milan

Grieshaber, H.A.P.
Reutlingen, Germany
* 1909 Rot a.d. Rot

Grignani, Franco
Milan, Italy
* Italy

Grinberg, Jacques
Paris, France
* 1941 Sofia

Gris, Juan
* 1887 Madrid
† 1927 Boulogne-sur-Seine, France

Grisi, Laura **244, 361, IX**
Rome, Italy
* Rhodes
1964 Galleria Il Segno, Rome
1965 Galleria dell'Ariete, Milan
1968 Galerie M.E. Thelen, Essen

Grooms, Red
New York, USA
* 1937 Nashville, Tennessee
1968 Biennale di Venezia

Grosse, Hannes
Oberammergau, Germany
* 1932 Berlin

Grow, Ronald
Albuquerque, USA
* 1934 Wooster, Ohio

Gruber, François
* 1912 Nancy, France
† 1948 France

Guillaume, Raymond Pierre
Paris, France
* 1907 Paris

Gunersen, Gunnar
Oslo, Norway
* 1921 Förde

Guston, Philip
New York, USA
* 1913 Montreal
1962 Guggenheim Museum, New York

Guttuso, Renato
Rome, Italy
* 1912 Palermo
1962 Stedelijk Museum, Amsterdam

Haack, Dieter
Gladbeck, Germany
* 1941 Gladbeck

Laura Grisi

Haacke, Hans
New York, USA
*1936 Cologne, Germany
1968 Howard Wise Gallery, New York

Haacker, Dieter **303, 304**
Munich, Germany
* 1942 Augsburg

Hafif, Maria
Rome, Italy
* 1929 Pomona, Calif.
1964, 1968 Galleria La Salita, Rome
1968 Galleria del Cavallino, Venice
1968 Galleria Il Sagittario, Bari

Hains, Raymond
Paris, France
* 1926 Saint-Brieuc
1960 Galleria Apollinaire, Milan
1961 Galerie J, Paris
1966 Galleria del Leone, Venice
1968 documenta, Kassel

Hajek-Halke, Heinz
Berlin, Germany
* 1898 Berlin

Halas, John
London, England
* 1912 Budapest

Hall, Nigel
Los Angeles, USA
* 1943 Bristol

Haller, Vera
Lugano, Switzerland
* 1910 Budapest
1961 I.C.A., London
1963, 1965, 1968 Galerie Suzanne Bollag, Zürich

Hamilton, Frank
San Francisco, USA
* 1923 Tennessee

Hamilton, Richard **23, 41, 118**
London, England
* 1922 London
1964 Hanover Gallery, London

Hammacher, Arno
Milan, Italy
* 1927

Hammarskiöld, Caroline
Stockholm, Sweden
* 1930

Hammarskiöld, Hans
Stockholm, Sweden
* 1925

Hammersley, Frederick
Los Angeles, USA
* 1919 Salt Lake City

Hangen, Heijo
Coblenz, Germany * Germany
1968 Museum Coblenz

Hanlor **364, 365**
Paris, France
* 1937 Germany

Hansen, Sine
Brunswick, Germany
* 1942 Hohensalza

Hantai, Simon
Paris, France
* 1922 Bia, Ivory Coast

Hara, Hiromu
Tokyo, Japan
* 1903 Nagano Pref.

Harmon, Leon D. **182, 208**
Murray Hill, New York, USA
* USA

Hartigan, Grace
Baltimore, Md., USA
* 1922 Newark, N.J.
1951–1957 Tibor de Nagy Gallery, New York

Hartung, Hans
Paris, France
* 1904 Leipzig, Germany

Harvey, Robert
San Francisco, USA
* 1924 Lexington, N.C.
1967, 1968 Krasner Gallery, New York

Hauer, Erwin
Bethany, Conn., USA
* 1926 Vienna

Hausmann, Raoul
Limoges, France
* 1886 Vienna

Hausner, Rudolf
Vienna, Austria
* 1914 Vienna
1959 documenta, Kassel
1963 Biennale, Sao Paulo

Haworth, Jann **200**
London, England
* California, USA

Hayter, Stanley William
Paris, France
* 1901 London
1968 Museum Bielefeld

Hazelton, Herb
Los Angeles, USA
* 1930 Summit, N.J.

Healey, John
Sussex, Great Britain
* 1894 London

Heartfield, John
* Germany
† 1968 Berlin

Heckel, Erich
Hemmenhofen, Germany
* 1883 Döbeln

Hedrick, Wally
San Francisco, USA
* 1928 Pasadena

Heerich, Erwin
Düsseldorf, Germany
* Germany
1966 Galerie Schmela, Düsseldorf
1967 Museum Eindhoven

Hefferton, Philip
Los Angeles, USA
* 1933 Detroit

Heibel, Axel
Hamburg, Germany
* 1943 Oberlahnstein
1968 Galerie Richter, Wiesbaden

Heidelbach, Karl
Rhineland, Germany
* 1923 Hanau
1967 Galerie Brusberg, Hanover

Heinemann, Jürgen **177**
Essen, Germany
* Germany

Held, Al
New York, USA
* 1928 New York
1959, 1961, 1962 Poindexter Gallery, New York
1963 Towards a New Abstraction, Jewish Museum,
New York
1968 documenta, Kassel

Henderikse, Jan
Ottrabanda, Curaçao
* 1937 Delft
1963 Galerie 47, Amsterdam

Hennessy, Timothy
Paris, France
* 1925 San Francisco

Henri, Florence
Paris, France
* 1895 New York
1967 Hanover Gallery, London

Herbin, Auguste
* 1882 Quièry
† 1960 Paris
1963 Kunsthalle Berne

Herms, George
Topanga, Calif., USA
* 1935 Woodland, Calif.

Hershon, Eila
New York, USA
* 1932 Boston
1968 Galerie Niepel, Düsseldorf

Hewitt, Francis Nay
Cleveland, USA
* 1936 Springfield, Vermont

Hilgemann, Ewerdt
Gelsenkirchen, Germany
* 1938 Witten
1968 Galerie Loehr, Frankfurt

Hill, Anthony
London, England
* England

Hill, Warren
Cambridge, Mass., USA
* 1928 Melrose, Calif.

Hilliard, Ashley
Nuremberg, Germany
* 1949 London, Canada

Hilmar, Jiri
Prague, Czechoslovakia
* 1937 Prague

Hinman, Charles
New York, USA
* 1932 Syracuse, N.Y.
1964, 1965, 1967 Feigen Gallery, Chicago –
New York
1966 Tokyo Gallery, Tokyo

Hockney, David
California, USA
* 1937 Bradford
1963, 1965, 1966 Kasmin Gallery, London
1967 Galerie Bischofsberger, Zürich

Hodgkin, Howard
Bath, England
* 1932 London
1962, 1964 Tooth Gallery, London

Hödicke, Karl Horst
Berlin, Germany
* 1938 Nuremberg

Höher, Inge
Berlin, Germany
* 1941 Neuhaus

Hoehme, Gerhard
Düsseldorf, Germany
* 1920 Greppin

Höke, Bernhard
Berlin, Germany
* 1939 Brunswick

Hoelzel, Adolf
* 1853 Olmütz, Germany
† 1934 Stuttgart

Hoepfner, Marta
Hofheim, Germany
* Germany
1965 Galerie Loehr, Frankfurt

Hoerle, Heinrich
* 1895 Cologne
† 1936 Cologne

Hoeydonck, Paul van
Antwerp, Belgium
* 1925 Antwerp
1961 Palais des Beaux Arts, Brussels
1964 Galerie Iris Clert, Paris
1965 Galerie M.E.Thelen, Essen

Hofer, Carl
* 1878 Karlsruhe, Germany
† 1955 Berlin

Hofmann, Hans
* 1880 Weissenburg
† USA

Holbrook, Peter
Chicago, USA
* 1940 New York
1960 Carpenter Galleries, Hanover, N.H.
1964, 1966, 1967 Richard Gray Gallery, Chicago

Hollegha, Wolfgang
Rechberg, Austria
* 1929 Klagenfurt
1961 I.C.A., London
1963 Galerie St. Stephan, Vienna

Holweck, Oskar
Saarbrücken, Germany
* 1924 St.Ingbert
1960 Monochrome Malerei, Museum Leverkusen
1960 Galerie d, Frankfurt
1962 Museum Leverkusen
1969 Galerie Lichter, Frankfurt

Honegger, Gottfried **XIX**
Zürich, Switzerland
1917 Zürich
1960 Martha Jackson Gallery, New York
1963 Galerie Lawrence, Paris
1963 Gimpel & Hanover, Zürich
1963, 1964, 1968 Gimpel Fils, London
1965 Galerie M.E.Thelen, Essen
1966 Kunstverein Stuttgart
1967/1968 Kunsthaus Zürich
1968 Museum Dortmund

Hopper, Edward
New York, USA
* 1882 Nyack, N.Y.

House, Gordon
London, England
* 1932
1961 Neue Malerei in England,
Museum Leverkusen

Hoyland, John
London, England
* 1934 Sheffield
1961 Neue Malerei in England,
Museum Leverkusen
1967 Whitechapel Art Gallery, London
1968 documenta, Kassel

Hozo, Dzevad
Yugoslavia
* 1938 Titovo Uzice
1966 Kleine Galerie, Klagenfurt

Hultberg, John
Honululu, USA
* 1922 Berkeley, Calif.
1955, 1956, 1959, 1960 Martha Jackson Gallery,
New York
1962 Pasadena Art Museum

Humphray, Ralph
USA
* USA

Hundertwasser (Friedrich Stowasser)
Venice, Italy
* 1928 Vienna

Jorn, Asger
Paris, France
* 1914 Véjrun, Denmark
1958, 1959 Galerie van de Loo, Munich

Kacere, John
New York, USA
* 1920 Walker, Ohio

Kage, Manfred
Winnenden, Germany
* Germany

Kaish, Morton
New York, USA
* 1927 Newark, N.J.
1964 Staempfli Gallery, New York

Kaks, Olle
Stockholm, Sweden
* 1941 Hedemora

Kamekura, Yusaku
Tokyo, Japan
* 1915 Niigata Pref.

Kamihira, Ben
Cheney, Pa., USA
* Yakima, Washington

Kampmann, Rüdiger-Utz
Stuttgart, Germany
* 1935 Berlin
1965 Galerie Müller, Stuttgart
1966 City Galerie, Zürich

Kandinsky, Wassily
* 1866 Moscow
† 1944 Neuilly-sur-Seine, France

Kanovitz, Howard **24, 25, 30, 74, 75, 76, 147, IV**
New York, USA
* 1929 Fall River, Ma.
1962 Stable Gallery, New York
1966 Jewish Museum, New York
1969 Waddell Gallery, New York

Kantor, Morris
New York, USA
* 1896 Minsk, USSR

Kaplan, Jacques **181**
New York, USA
* USA

Karahalios, Constantin
Paris, France
* 1923 Tripoli
1966 Galerie David Anderson, Paris

Karanovic, Bosko
Belgrade, Yugoslavia
* 1924 Bosanska

Katz, Alex **60, 211**
New York, USA
* 1927 New York
1960, 1961 Stable Gallery, New York
1964, 1965, 1967, 1969 Fischbach Gallery, New York
1967 David Stuart Gallery, Los Angeles

Kauffman, Craig
Venice, Calif., USA

* 1932 Los Angeles
1958, 1963, 1965 Ferus Gallery, Los Angeles
1958, 1960 Dilexi Gallery, San Francisco

Kaufman, Donald
New York, USA
* 1935 New Orleans
1966 Richard Feigen Gallery, New York

Kawabata, Minoru
New York, USA
* 1911 Tokyo

Kawashima **273**
New York, USA
* Japan
1967 Waddell Gallery, New York

Keetman, Peter **140**
Breitbrunn, Germany
* 1916 Wuppertal-Elberfeld

Keil, Tilo **51**
* 1931 Dresden, † 1969 Münster
1966 Galerie Alexa, Düsseldorf
1968 Galerie Casa, Munich
1968 Erotic Art, Museum Lund

Keith, Margarethe
Aschaffenburg, Germany
* 1942 Chabarovice

Kekorkian, Gabriel de
Paris, France
* 1932 Paris

Kelly, Ellsworth **XXI**
New York, USA
* 1923 Newburgh, N.Y.
1951 Galerie Arnaud, Paris
1958, 1964 Galerie Maeght, Paris
1956, 1957, 1959, 1961, 1965 Betty Parsons Gallery, New York
1961/1962 Galerie Denise René, Paris
1963 Jewish Museum, New York
1965 Sidney Janis Gallery, New York

Kerr, Leslie
San Francisco, USA
* 1934 Michigan

Kidner, Michael James
London, England
* 1917 Kettering
1964, 1966 Gallery McRoberts and Tunnard, London
1966 Axiom Gallery, London

Kiender, Ed
Hilden, Germany
* 1925 Wiesbaden
1961 30 junge Deutsche, Museum Leverkusen

Kimber-Smith
Paris, France
* 1916 Boston

Kirchberger, Guenther C.
Stuttgart, Germany
* 1928 Kornwestheim

Kirchner, Ernst Ludwig
* 1880 Aschaffenburg, Germany
† 1938 Davos

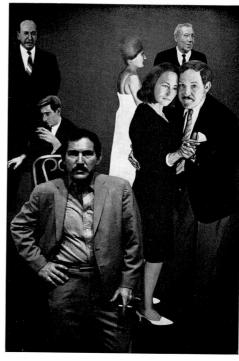

Howard Kanovitz

Konrad Klapheck

Yves Klein

lije Knifer

tz Köthe

Kishi, Masatoyo
San Francisco, USA
* 1924 Sakai, Japan
1965 Nicholas Wilder Gallery, Los Angeles

Kisling, Moise
* 1891 Cracow, Poland
† 1953 Lyon

Kitaj, Ronald B. **64**
London, England
* 1932 Chagrin Falls, Ohio

Klapheck, Konrad **203, 205**
Düsseldorf, Germany
* 1935 Düsseldorf
1959 Galerie Schmela, Düsseldorf
1960, 1963, 1968 Galleria Schwarz, Milan
1964 Robert Fraser Gallery, London
1965 Galerie Ileana Sonnabend, Paris
1966 Kestner-Gesellschaft, Hanover

Klasen, Peter
Paris, France
* 1935 Lübeck
1964 Galerie Friedrich und Dahlem, Munich
1966 Galerie Mathias Fels, Paris
1966 Galerie Ad Libitum, Antwerp

Klee, Paul
* 1879 Münchenbuchsee, Switzerland
† 1940 Muralto

Klein, Yves **8, 9, 327, 332, XXVI**
* 1928 Nice
† 1962 Paris
1956 Galerie Colette Allendy, Paris
1958 Galerie Iris Clert, Paris
1960 Monochrome Malerei, Museum Leverkusen
1961 Museum Krefeld
1967 Jewish Museum, New York
1968 documenta, Kassel
1969 Musée des Beaux-Arts, Grenoble

Klimt, Gustav **163**
* 1862
† 1918

Kline, Franz
* 1910 Wilkes-Barre, Pa.
† 1962 New York

Knifer, Julije **388**
Zagreb, Yugoslavia
* Yugoslavia

Knopp, Axel
Bremen, Germany
* 1942 Bremen
1968 Kunstpavillon Soest

Knowles, Alison
New York, USA
* USA

Knowles, Justin
London, England
* 1935 Exeter
1965 The English Eye, Marlborough-Gerson Gallery, New York

Knowlton, K. C. **182, 208**
New Jersey, USA
* USA

Knubel, Franz Rudolph
Berlin, Germany
* 1938 Münster/Westphalia
1967 Galerie Wilbrand, Münster

Koberling, Bernd
Berlin, Germany
* 1938 Berlin
1966 Galerie René Block, Berlin
1968 Galerie Wilm Falazik, Bochum

Köthe, Fritz **81**
Berlin, Germany
* 1916
1964, 1966 Galerie Springer, Berlin
1965, 1967 Galerie Tobiès und Silex, Cologne
1967 Galerie Ursula Lichter, Frankfurt

Kohn, Misch
Chicago, USA
* 1916 Kokomo, Indiana

Kohn, William
St. Louis, Mo., USA
* USA
1968 Martin Schweig Gallery, St. Louis

Kojima, Nobuaki
Tokyo, Japan
* 1939 Japan

Kokoschka, Oskar
Salzburg, Austria
* 1886 Pöchlarn

Kolar, Jiri **83, 382**
Prague, Czechoslovakia
* 1914 Protivín
1966 Galerie M. E. Thelen, Essen
1968 documenta, Kassel

Kolárova, Beela
Prague, Czechoslovakia
* Czechoslovakia

Komodore, William
New York, USA
* 1932 Athens

Kooning, Elaine de
New York, USA
* 1920 New York

Kooning, Willem de
New York, USA
* 1904 Rotterdam
1950, 1954 Biennale di Venezia
1953, 1956, 1959, 1962 Sidney Janis Gallery, New York
1964, 1965 Allan Stone Gallery, New York

Kord, Victor
Chicago, USA
*1935 Satu-Mare, Romania
1967 Richard Gray Gallery, Chicago

Koren, Shlomo
Israel
* 1932 Cologne

Kounellis, Iannis **381**
Rome, Italy
* 1936 Athens
1960, 1964 Galleria La Tartaruga, Rome
1966 Galleria Arco d'Alibert, Rome
1967, 1969 Galleria L'Attico, Rome

Kriesche, Richard
Graz, Austria
* 1940 Vienna
1967 Galerie im Griechenbeisl, Vienna
1968 Forum Stadtpark, Graz

Kriesberg, Irving
New York, USA
* 1919 Chicago

Kristl, Vlado
Munich, Germany
* 1923 Zagreb

Kriwet, Ferdinand
Düsseldorf, Germany
* 1942 Düsseldorf
1963, 1965, 1967 Galerie Niepel, Düsseldorf

Krüll, Karl Heinz
Düsseldorf, Germany
* 1936 Düsseldorf

Krupp, Hermann
Hofheim, Germany
* Germany

Krushenik, Nicholas
New York, USA
* 1929 New York
1962, 1964 Graham Gallery, New York
1965 Fischbach Gallery, New York
1966 Galerie Müller, Stuttgart

Kudo, Tetsumi
Paris, France
* 1935 Osaka
1959, 1961 Bungei Shinju Gallery, Tokyo
1966 Galerie M. E. Thelen, Essen

Kunibek, Jan
Prague, Czechoslovakia
* Czechoslovakia

Kuntz, Roger
Los Angeles, USA
* 1926 San Antonio, Texas

Kunz, Wolfgang **157**
Essen, Germany
* Germany

Kupka, Frantisek
* 1871 Opocno
† 1957 Puteaux, France

Kusama, Yayoi **398**
New York, USA
* Matsumoto, Japan
1966 Biennale di Venezia
1966 Galerie M. E. Thelen, Essen

Kuwayama, Tadaaki **308**
New York, USA
* 1932 Nagoya, Japan

1961, 1962 Green Gallery, New York
1962 Swetzoff Gallery, Boston
1964 Kornblee Gallery, New York
1967 Tokyo Gallery, Tokyo
1967 Galerie Bischofsberger, Zürich
1967 Richard Gray Gallery, Chicago

Laing, Gerald **80, 258**
New York, USA
* 1936 Newcastle-on-Tyne
1964 I.C.A., London
1965, 1966 Richard Feigen Gallery, Chicago
1964, 1965, 1967, 1968 Richard Feigen Gallery,
New York
1966 Kornblee Gallery, New York
1969 Galerie M. E. Thelen, Essen

Lam, Wifredo
Paris, France
* 1902 Sàgua, Cuba

Lamis, Leroy
Terre Haute, Indiana, USA
* 1925 Eddyville, Iowa

Lancaster, Mark **389**
Bath, England
* 1938 Huddersfield, Yorkshire
1965 Rowan Gallery, London
1966 The New Generation, Whitechapel Art Gallery,
London

Lange, Dorothea
* 1895 Hoboken
† 1965 USA
1966 Museum of Modern Art, New York

Lanskoy, André
Paris, France
* 1902 Moscow

Lanyon, Ellen
Chicago, USA
* 1926 Chicago

Lanyon, Peter
London, England
* 1918 England

Lapique, Charles
Paris, France
* 1898 Theizé

Larionoff, Michael
Paris, France
* 1881 Teraspol, USSR

Lassnig, Maria
Paris, France
* Kappel

Lataster, Ger
Amsterdam, Holland
* 1920 Schaesberg-Limbourg

Latham, John
London, England
* 1921 Northern Rhodesia

Laubies, René
Paris, France
* 1924 Saigon

Laughlin, Clarence J.
New Orleans, USA
* 1905 New Orleans

Lavonen, Ahti
Helsinki, Finland
* 1938 Kaskinen
1968 Biennale di Venezia

Lebel, Jean-Jacques
Paris, France
* 1936 Paris

Lebenstein, Jan
Paris, France
* 1930 Brest- Litovsk

Leblanc, Walter
Antwerp, Belgium
* 1932 Antwerp

Lebrun, Rico
* 1900 Naples, Italy
† 1964 Los Angeles

Lecci, Auro
Florence, Italy
* 1938 Florence

Leck, Bart van der
* 1876 Utrecht, Holland

Le Corbusier
* 1887 La Chaux-de-Fonds, Switzerland
† 1967 France

Leete, William
Rhode Island, USA
* 1929 Portsmouth, Ohio
1965, 1966 Ward Nasse Gallery, Boston

Lefèbre, Jules **85**
* 1836
† 1912

Léger, Fernand
* 1881 Argentan, France
† 1955 Gif-sur-Yvette

Lehmden, Anton
Vienna, Austria
* 1929 Neutra
1950, 1954 Biennale di Venezia
1953 Biennale Saõ Paulo
1960 Kunsthalle Baden-Baden

Leissler, Arnold
Nuremberg, Germany
* 1939 Hanover
1964 Galerie Brusberg, Hanover

Leland, Lynn G.
New York, USA
* 1937 Buffalo, N.Y.

Le Moal, Jean
Paris, France
* 1909 Authon-du-Perche

Lenica, Jan **397**
Warsaw, Poland
* 1928 Poznan

Lye, Len
New York, USA
* 1901 Christ Church, New Zealand

Lytle, Richard
New Haven, Conn., USA
* 1935 Albany, N.Y.
1961, 1963, 1964, 1966 Grace Borgenicht Gallery,
New York

Maccio, Romulo
Paris, France
* 1931 Buenos Aires
1963 Galleria Bonino, Buenos Aires
1964 Galerie Schoeller, Paris
1965 Galerie Buchholz, Munich

Mack, Heinz
Mönchengladbach, Germany
* 1931 Lollar
1957, 1958, 1960, 1965, 1967 Galerie Schmela,
Düsseldorf
1963 Galleria Cadario, Milan
1966 Howard Wise Gallery, New York
1967 Op-Art Galerie, Esslingen

Macke, August
* 1887 Meschede
† 1914 Perthes

Maeda, Josaku
Paris, France
* 1926 Toyama, Japan
1963 Tokyo Gallery, Tokyo

Magalhães, Roberto
Paris, France
* 1940 Rio de Janeiro
1967 Galerie Debret, Paris

Maglione, Milvia **222**
Paris, France
* 1936 Bari

Magnelli, Alberto
Paris, France
* 1888 Florence

Magnus, Dieter
Germany
* 1937 Schotten
1967 Galerie Richter, Wiesbaden

Magritte, René **149, 183, 185**
* 1898 Lessines
† 1967 Belgium
1954 Palais des Beaux-Arts, Brussels
1959, 1962, 1965 Galerie Iolas, New York
1960 Galerie Rive Droite, Paris
1961 Grosvenor Gallery, London
1962 Walker Art Center, Minneapolis
1962 Galleria Schwarz, Milan
1964 Hanover Gallery, London
1964 Galerie Iolas, Paris

Mahaffey, Noel
USA
* 1944 Florida

Mahlmann, Max
Hamburg, Germany
* 1912 Hamburg

Mahmoud, Ben
Chicago, USA
* 1935 West Virginia
1967 Ontario East Gallery, Chicago

Majoli, Claudio
Italy
* 1929 Cervia
1968 Galleria Vismara, Milan

Malevich, Kasimir **1**
* 1878 Kiev, † 1935 Leningrad

Malich, Karel
Prague, Czechoslovakia
* Czechoslovakia

Malina, Frank Joseph **408**
Billancourt, Seine, France
* 1912 Brenham, Texas
1953 Galerie Henri Tronche, Paris
1955 Galerie Colette Allendy, Paris
1961 Galleria Schwarz, Milan
1965 Galerie Furstenberg, Paris
1966 Galleria L'Obelisco, Rome

Malina, Jaroslav
Prague, Czechoslovakia
* 1937 Prague

Mallary, Robert
New Rochelle, N.Y., USA
* 1917 Toledo, Ohio
1962 Allan Stone Gallery, New York

Mallory, Ronald **356**
New York, USA
* 1935 Philadelphia
1966 Stable Gallery, New York

Mambor, Renato
Rome, Italy
* 1936 Rome
1963, 1965 Galleria La Tartaruga, Rome
1967 Galleria La Bertesca, Genoa

Man, Felix H. **55**
* Germany

Manders, Jos
Holland
* 1934 Eindhoven
1968 Galerie Reckermann, Kassel
1968 documenta, Kassel

Manessier, Alfred
Paris, France
* 1911 Saint-Ouen

Manet, Edouard **131**
* 1832
† 1883

Mangold, Robert **337, 338, 339**
New York, USA
* 1937 North Tonawanda, N.Y.
1964, 1965, 1967 Fischbach Gallery, New York
1968 Galerie Müller, Stuttgart

Manzoni, Piero **15, 311, 333**
* 1933 Soncino, † 1963 Milan
1957, 1958 Galleria Pater, Milan

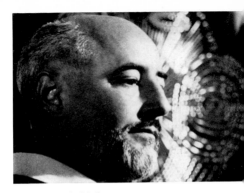

Frank Joseph Malina

Robert Mangold

Piero Manzoni

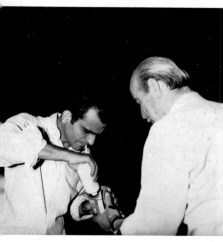

...no Marotta, Lucio Fontana

1960 Monochrome Malerei, Museum Leverkusen
1960, 1961 Galerie Köpke, Copenhagen
1964 Galleria Schwarz, Milan
1967 Galerie M.E.Thelen, Essen
1968 Teatro La Fenice, Venice
1968 documenta, Kassel

Mara, Pol **II**
Antwerp, Belgium
* 1920 Antwerp
1968 Biennale di Venezia

Marc, Franz
* 1880 Munich
† 1916 Verdun

Marca-Relli, Conrad
East Hampton, L.I., N.Y., USA
* 1913 Boston

Marchegiano, Elio
Rome, Italy
* 1929 Syracuse
1966 Galleria L'Obelisco, Rome

Marcus, Marcia
New York, USA
* 1928 New York

Marcus, Peter E.
St. Louis, Mo., USA
* 1939 USA
1967 Washington University, St. Louis

Marden, Brice
New York, USA
* 1938 Bronxville, N.Y.

Margonari, Renzo
Mantova, Italy
* 1937 Mantova

Mari, Enzo
Milan, Italy
* 1932 Novara,
1959, 1961, 1963, 1964 Galleria Danese, Milan
1963 Galleria Blu, Milan

Marsicano, Nicholas
New York, USA
* 1914 Shenandoah, Pa.

Martin, Agnes
New York, USA
* 1921 Maklin, Canada

Maryan (Pinchas Burstein)
Paris, France
* 1927 Nowy-Sacz

Marzot, Livio
New York, USA
* 1934 Iduno Olona

Masi, Paolo
Florence, Italy
* 1933 Florence

Massironi, Manfredo
Padova, Italy
* 1937 Padova

Masson, André
Paris, France

* 1896 Balagny
1965 Musée d'Art Moderne, Paris

Mathieu, Georges **4**
Paris, France
* 1921 Boulogne-sur-mer

Matisse, Henri
* 1869 Le Cateau, France
† 1954 Nice

Matsutani, Takesada
Nishinomiyashi, Japan
* 1937 Osaka

Matta Echaurren, Roberto Sebastian
Paris, France
* 1912 Santiago/Chile

Matter, Herbert
New York, USA
* 1907 Engelberg

Mattiello, Roberto
New York, USA
* 1934 Venice

Mauri, Fabio **390**
Rome, Italy
* 1927 Roma
1965 Galleria la Salita, Rome

Mavignier, Almir
Hamburg, Germany
* 1925 Rio de Janeiro

McAfee, Mara
New York, USA
* 1931 Los Angeles

McCay, A.F.
Regina, Canada
* 1926 Nipawin

McClanahan, Preston
Paris, France
* 1933 Charleston, West Virginia

McCracken, John
Costa Mesa, Calif., USA
* 1934 Berkeley
1965, 1967 Nicholas Wilder Gallery, Los Angeles

McGarrell, James
USA
* 1930 Indianapolis

McIver, Loren
New York, USA
* 1909 New York

McLaren, Norman
Montreal, Canada
* 1914 Stirling

McLaughlin, John
Dana Point, Calif., USA
* 1898 Sharon, Mass.
1952–1966 Felix Landau Gallery, Los Angeles
1956, 1963 Pasadena Art Museum

McNeill, George
New York, USA
* 1908 New York

...ues Monory

Mefferd, Boyd
Vermillion, South Dakota, USA
* 1941 St. Louis, Mo.
1966 Sound, Light, Silence, Kansas City
1968 Dallas Museum of Fine Arts

Megert, Christian
Berne, Switzerland
* 1936 Berne
1959 Galerie Kasper, Lausanne
1963 Galerie d, Frankfurt

Mehring, Howard **278**
Washington, D.C., USA
* 1931 Washington
1965, 1966, 1968 A.M.Sachs Gallery, New York

Meigs, Walter
New York, USA
* 1918 New York

Meistermann, Georg
Karlsruhe, Germany
* 1911 Solingen

Melehi, Mohamed
Casablanca, Morocco
* 1936 Asilah
1961 Galleria Trastevere, Rome
1962 Galerie Suzanne Bollag, Zürich
1967 Galerie du Livre, Casablanca

Merkin, Richard **113**
Rhode Island, USA
* 1938 Brooklyn
1965, 1968 Obelisk Gallery, Boston

Merz, Mario **399**
Turin, Italy
* 1925 Milan
1968, 1969 Galleria Sperone, Turin

Messagier, Jean
Paris, France
* 1920 Paris
1960, 1965, 1967 Galerie Schoeller, Paris

Metz, Gary
USA
* 1941 USA

Metzger, Gustav **14**
London, England
* 1926 London

Metzker, Ray K.
New York, USA
* 1931 USA
1967 Museum of Modern Art, New York

Michaux, Henri
Paris, France
* 1890 Namur

Michel, Robert
Vockenhausen, Germany
* 1897 Vockenhausen
1963 Museum Leverkusen
1968 Waddell Gallery, New York

Mieczkowski, Edwin
Cleveland, Ohio, USA
* 1929 Pittsburgh

Mier, Alfonso
Barcelona, Spain
* 1912 Barcelona

Mikl, Josef
Vienna, Austria
* 1929 Vienna

Millares, Manolo
Madrid, Spain
* 1926 Las Palmas

Miller, Peter
London, England
* 1939 Colne, Lancashire
1967 Jacey Gallery, London
1968 Alwin Gallery, London

Millonzi, Victor
USA
* 1915 Buffalo, N.Y.

Miralda, Antoni
Spain
* 1942 Barcelona
1965, 1967 Galerie Zunini, Paris
1966 I.C.A., London

Miró, Joan
Majorca, Spain
* 1912 Barcelona
1941, 1959 Museum of Modern Art, New York
1956, 1958 Palais des Beaux-Arts, Brussels
1965 Tate Gallery, London

Mirvald, Vladimir
Louny, Czechoslovakia
* Czechoslovakia

Mitchell, Joan
New York, USA
* 1926 Chicago
1953–1965 Stable Gallery, New York
1961 Dwan Gallery, Los Angeles
1962 Galerie Lawrence, Paris

Miyawaki, Aiko
Paris, France
* 1929 Atami, Japan

Mlynarćik, Alex
Prague, Czechoslovakia
* 1934 Zilina

Mogensen, Paul
USA
* USA
1968 Bykert Gallery, New York

Moholy-Nagy, Laszlo **45, 54**
* 1895 Bacsbarod, Hungary
† 1946 Chicago

Molinari, Guido **277**
Montreal, Canada
* 1933 Montreal

Mon, Franz
Frankfurt, Germany
* 1926 Frankfurt

Mondino, Aldo
Rome, Italy
* 1938 Turin
1962 Galleria Alpha, Venice
1963 Galleria Il Punto, Turin

Mondrian, Piet
* 1872 Amersfoort, Holland
† 1944 New York

Monory, Jacques **114, 115, XII**
Paris, France
* France
1966 Zoom I, Galerie Blumenthal, Paris
1966 Galleria Schwarz, Milan
1967 Galerie Blumenthal-Mommaton, Paris

Monte, James
San Francisco, USA
* 1937 San Francisco

Montenegro, Enrique
Pennsylvania, USA
* 1917 Valparaiso, Chile

Moon, Jeremy
London, England
* 1934 Cheshire
1963, 1965, 1966 Rowan Gallery, London
1967 Galerie Müller, Stuttgart

Moore, John
London, England
* 1946 England

Morais, Leroy
Albuquerque, USA
* 1936 New Orleans

Morandini, Marcello **283**
Varese, Italy
* 1940 Monaco
1965 Galleria Il Deposito, Genoa
1967 Galleria Naviglio, Milan
1967 Galerie Tobiés und Silex, Cologne
1967 Galerie Handschin, Basle
1968 Biennale di Venezia

Morellet, François
Cholet, France
* 1926 Cholet
1966 Galerie Der Spiegel, Cologne

Moreni, Mattia
Rome, Italy
* 1920 Pavia

Moretti, Alberto
Florence, Italy
* 1922 Cormignani

Morley, Malcolm **175, 268, 269**
New York, USA
* 1931 London
1964, 1967 Kornblee Gallery, New York

Mortensen, Richard
Paris, France
* 1910 Copenhagen
1948–1954, 1956–1959, 1960–1962 Galerie Denise
René, Paris

uce Nauman

Moskowitz, Robert
New York, USA
*1935 Brooklyn, N.Y.

Motherwell, Robert
New York, USA
* 1915 Washington
1957–1962 Sidney Janis Gallery, New York
1961 Biennale Saõ Paulo
1962 Pasadena Art Museum
1965 Museum of Modern Art, New York

Moynihan, Rodrigo
London, England
* 1910 Santa Cruz, Tenerife
1963, 1967 Hanover Gallery, London

Mroszczak, Józef
Warsaw, Poland
* 1909 Warsaw

Mueller, George **249**
New Jersey, USA
* 1929 Newark, N.J.
1955, 1960 Grace Borgenicht Gallery, New York

Müller, Heinz
Castell de Fels, Switzerland
* 1936 Langendorf

Müller-Brittnau, Willy
Zofingen-Brittnau, Switzerland
*1938 Winterthur
1966 Galerie Müller, Stuttgart
1966 Galleria La Tartaruga, Rome
1966 Galleria Dell'Ariete, Milan
1966 Galerie Bischofsberger, Zürich

Munari, Bruno
Milan, Italy
* 1907 Milan
1965 Museum of Modern Art, Tokyo

Munch, Edvard
* 1863 Loten, Norway
† 1944 Ekely

Muñoz, Lucio
Madrid, Spain
* 1929 Madrid

Murakami, Tomoyasu
Tokyo, Japan
* 1938 Tokyo

Murch, Walter
Boston, USA
* 1907 Toronto

Nangeroni, Carlo
Milan, Italy
* 1922 New York
1965 Galleria Lorenzelli, Milan

Nannucci, Maurizio
Florence, Italy
* 1939 Florence
1966 Galleria L'Elefante, Venice
1967 Galleria 3 A, Lecce
1967 Centro Arte Viva Feltrinelli, Trieste

Nasaka, Juko **302**
Osaka, Japan
* Japan

Natkin, Robert
New York, USA
* 1930 Chicago

Nauman, Bruce **386, 387**
Southampton, N.Y., USA
* 1941 Fort Wayne
1966, 1969 Nicholas Wilder
Gallery, Los Angeles
1968 Leo Castelli Gallery, New York
1968 documenta, Kassel

Nay, Ernst Wilhelm
Cologne, Germany
* 1902 Berlin

Neiman, Yehuda **48, 49**
Tel Aviv, Israel
* 1931 Warsaw
1967 Galerie Raymonde Cazenave, Paris

Neizvestny, Ernsty
Moscow, USSR
* 1925 Sverdlosk
1965 Grosvenor Gallery, London

Nelson, Robert A.
Grand Forks, North Dakota, USA
* 1925 Milwaukee, Wis.

Nesbitt, Lowell **206, 207, 212, 233, 247, 248, 255**
New York, USA
* 1933 Baltimore, Md.
1964 Corcoran Gallery of Art, Washington
1965, 1966 Howard Wise Gallery, New York
1965, 1966 Rolf Nelson Gallery, Los Angeles
1966, 1967 Gertrude Kasle Gallery, Detroit
1969 Galerie M. E. Thelen, Essen

Neskovic, Predrag
Yugoslavia
* 1938 Yugoslavia
1967 Grabowski Gallery, London

Nespolo, Ugo **180**
Turin, Italy
* 1941 Vercelli
1968 Galleria Schwarz, Milan

Neuenhausen, Siegfried
Brunswick, Germany
* 1931 Dormagen

Neusüss, Floris Michael
Munich, Germany
* Germany
1963 "Nudogramme"

Newman, Barnett
New York, USA
* 1905 New York
1950, 1951 Betty Parsons Gallery, New York
1966 Guggenheim Museum, New York
1968 documenta, Kassel
1969 Knoedler Gallerie, New York

Nicholson, Ben
London, England
* 1894 Uxbridge

o Nespolo

Nickel, Heinz
Kassel, Germany
* 1919 Germany

Nigro, Mario
Turin, Italy
* 1917 Pistoia
1967 Galleria Notizie, Turin

Nikos, Kesarlis
Paris, France
* 1930 Salonica, Greece
1964 Galleria L'Obelisco, Rome

Niwa, Fujio **121**
Tokyo, Japan
* 1942 Tokyo

Noé, Luis Felipe
Buenos Aires, Argentina
* 1933 Buenos Aires

Noel, Georges
Paris, France
* 1924 Béziers

Nolan, Sidney
London, England
* 1917 Melbourne, Australia
1963 Marlborough Gallery, London
1965 The English Eye, Marlborough-Gerson
Gallery, New York

Noland, Kenneth **319, XXIV**
South Shaftsbury, Vermont, USA
* 1924 Asheville, North Carolina
1960 Galleria dell'Ariete, Milan
1961–1966 Andre Emmerich Gallery, New York
1961 Galerie Lawrence, Paris
1962 Galerie Schmela, Düsseldorf
1962 Galerie Charles Lienhard, Zürich
1968 documenta, Kassel

Nolde, Emil
* 1867 Nolde, Germany
† 1956 Nordschleswig

Novelli, Gastone
Rome, Italy
* 1925 Vienna
1968 Biennale di Venezia

Novros, David
Los Angeles, USA
* 1941 Los Angeles
1967 Dwan Gallery, Los Angeles
1969 Bykert Gallery, New York

Nusberg, Lev Voldemarovic
Moscow, USSR
* 1937 USSR

Nyborg, Peter
Paris, France
* 1937 Denmark

O'Dowd, Robert
Hollywood, Calif., USA
* 1934 Grand Rapids, Michigan

Oehm, Herbert **XVII**
Ulm, Germany
* 1935 Ulm
1960 Monochrome Malerei, Museum Leverkusen

Oelze, Richard
Hameln, Germany
* 1900 Magdeburg
1961 Museum Hagen
1964 Kestner-Gesellschaft, Hanover
1968 Biennale di Venezia

Ogden, Jack
Sacramento, Calif., USA
* 1933 French Camp, Calif.

Ohlson, Doug **315**
New York, USA
* USA

Okada, Kenzo
Rensselaerville, N.Y., USA
* 1902 Yokohama, Japan
1965 Albright-Knox Art Gallery, Buffalo

Okashi, Avshalom
Israel
* 1916 Israel

Oldenburg, Claes
New York, USA
* 1929 Stockholm
1959 Judson Gallery, New York
1960 Reuben Gallery, New York
1962 Green Gallery, New York
1963 Dwan Gallery, Los Angeles
1963 Los Angeles County Museum
1964 Galerie Ileana Sonnabend, Paris
1964, 1966 Sidney Janis Gallery, New York
1966 Museum Stockholm
1966 Robert Fraser Gallery, London
1967 Museum of Contemporary Art, Chicago

Oliveira, Nathan
Piedmont, Calif., USA
* 1928 Oakland, Calif.

Olitzki, Jules **322**
Northport, L.I., USA
* 1922 Gomel, USSR
1961, 1962, 1963, 1964, 1965 Poindexter Gallery,
New York
1964 Galerie Lawrence, Paris

Olson, Erik H.
Stockholm Sweden
* 1918 Stockholm

Ono, Masuho **298**
Yokohama, Japan
* 1936 Yokohama

Ono, Yoko
London, England
* Japan
1966 Indica Gallery, London

Onoda, Minoru
Himeji-shi, Japan
* 1937 Manchuria

Onosato, Toshinobu
Kiryu-City, Japan
* 1912 Iida City
1961 Gres Gallery, Washington, D.C.

Orozco, José Clemente
* 1883 Ciudad Cuzmán
† 1949 Mexico-City

Kesarlis Nikos

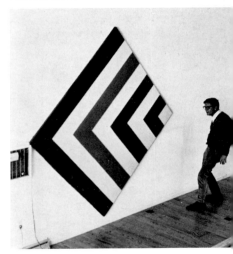

Kenneth Noland

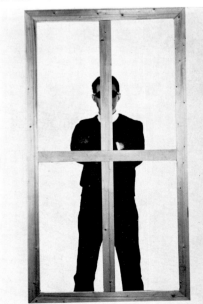

Guilio Paolino

itz, Ralph
w York, USA
1934 New York

lopp, Detlef **227**
efeld, Germany
937 Elbing
57, 1960, 1968 Galerie Ruth Nohl, Siegen

tman, George
w York, USA
926 Oakland, Calif.
57, 1960 Stable Gallery, New York
62, 1963 Howard Wise Gallery, New York

tlihn, Barbro
w York, USA
930 Stockholm
66 Tibor de Nagy Gallery, New York

asevic, Dusan
lgrade, Yugoslavia
940 Belgrade

ero, Alejandro
ris, France
921 Upata, Venezuela

cacek, Eduard
trawa-Poruba, Czechoslovakia
933 Třinec

alen, Wolfgang
905 Vienna
959 Mexico

ce, Achille
me, Italy
923 Termoli

ce, Stephen
w York, USA
918 Missouri

effgen, Claus
rlin, Germany
935 Cologne
6 Galerie Dorothea Loehr, Frankfurt

ez Torres, Armando Pablo
enos Aires, Argentina
918 Córdoba

k, Name June
w York, USA
932 Korea
3 Galerie Parnass, Wuppertal
5 Bonino Gallery, New York

nitz, Hermann
nna, Austria
938 Vienna
4 Galerie im Griechenbeisl, Vienna
5 Galerie Schütze, Bad Godesberg

atnik, Abraham
de Janeiro, Brazil
928 Natal
0 Museo de Arte Moderna, Rio de Janeiro
5 Howard Wise Gallery, New York

azuelo, Pablo
drid, Spain
16 Madrid

Palermo
Düsseldorf, Germany
* 1943 Leipzig
1967 Galerie Friedrich, Munich
1968 Galerie Konrad Fischer, Düsseldorf

Palladino, Tony
New York, USA
* 1930 New York

Paolino, Giulio
Turin, Italy
* 1940 Genoa
1965–1968 Galleria Notizie, Turin
1967 Galleria del Leone, Venice
1967 Galleria Christian Stein, Turin

Paolozzi, Eduardo
London, England
* 1924 Edinburgh
1958, 1967 Hanover Gallery, London
1960 Biennale di Venezia
1961 Stedelijk Museum, Amsterdam
1961 Musée des Arts Décoratifs, Paris

Parker, Raymond
New York, USA
* 1922 Beresford, South Dakota
1960, 1962 Dwan Gallery, Los Angeles
1961 Guggenheim Museum, New York
1961, 1963 Samuel M. Kootz Gallery, New York

Parmiggiani, Claudio
Palermo, Italy
* 1943 Luzzara
1965 Libreria Feltrinelli, Bologna
1966 Palazzo dei Musei, Modena
1967 Galleria 2000, Bologna

Parré, Michel
Paris, France
* 1938 Saint-Denis

Partin, Robert
Greensboro, North Carolina, USA
* 1927 Los Angeles

Pascali, Pino
* 1935 Bari
† 1968 Rome
1966 Galleria La Tartaruga, Rome
1966 Galleria Sperone, Turin
1966 Galleria L'Attico, Rome
1967 Galerie M. E. Thelen, Essen
1967 Galleria Iolas, Milan
1968 Biennale di Venezia
1969 Galerie Iolas, Paris

Pascin, Jules
* 1885 Vidin, Bulgaria
† 1930 Paris

Pasmore, George
London, England
* England

Pasmore, Victor
London, England
* 1908 Chesham
1954 I.C.A., London

Pasotti, Silvio
Paris, France
* 1933 Bergamo
1962, 1966 Galleria Cadario, Milan

Patella, Luca
Rome, Italy
* 1934 Rome

Patelli, Paolo **342**
Venice, Italy
* 1934 Abbazia
1963, 1966 Galleria del Cavallino, Venice
1966 Galleria Naviglio, Milan

Pauley, Hal
USA
* Chicago
1968 Krasner Gallery, New York

Pavlos **197**
Paris, France
* 1930 Filiatra, Greece

Pearlstein, Philip **28, 29**
New York, USA
* 1924 Pittsburgh
1963, 1964, 1966 Allan Frumkin Gallery, New York

Pearson, John
Chicago, USA
* 1940 Boroughbridge
1964 Galerie Müller, Stuttgart

Pechstein, Max
* 1881 Zwickau, Germany
† 1955 Berlin

Pedersen, Carl-Henning
Copenhagen, Denmark
* 1913 Copenhagen

Peeters, Henk
Arnhem, Holland
* 1925 The Hague

Peire, Luc
Paris, France
* 1916 Bruges
1968 Biennale di Venezia

Perilli, Achille
Rome, Italy
* 1927 Rome
1968 Biennale di Venezia

Peskett, Stanley
London, England
* 1939 Epsom

Petlin, Irving
USA
* 1934 Chicago

Petrick, Wolfgang
Berlin, Germany
* 1939 Berlin
1965 Galerie Grossgörschen, Berlin

Pettibone, Richard
Los Angeles, USA
* 1938 Alhambra, Calif.

Peter Phillips

Michelangelo Pistoletto

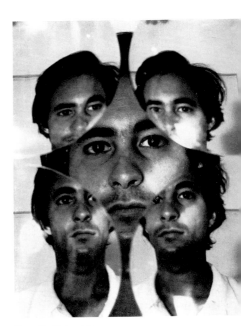

Rogelio Polesello

Pfahler, Karl Georg **XX**
Stuttgart, Germany
* 1926 Emezheim
1960 Galerie Müller, Stuttgart

Pfeiffer, Norbert
Nuremberg, Germany
* 1941 Ulm

Philipp, Helga
Vienna, Austria
* 1939 Vienna
1965 Galerie Heide Hildebrand, Klagenfurt

Phillips, Peter **X**
London, England
* 1939 Birmingham
1966 Kornblee Gallery, New York
1967 Galerie Bischofsberger, Zürich

Picabia, Francis
* 1878 Paris
† 1953 Paris
1968 Hanover Gallery, London

Picasso, Pablo **169, 400**
Vauvenargues, France
* 1881 Malaga, Spain

Piccardo, Carlo
Milan, Italy
* 1941 Genoa

Piccoli, Bobo
Milan, Italy
* 1927 Milan
1959, 1961 Galleria dell'Ariete, Milan
1964 Galleria Galatea, Milan
1967 Galeria Vismara, Milan

Picelj, Ivan
Zagreb, Yugoslavia
* 1924 Ocucani
1959–1966 Galerie Denise René, Paris

Piene, Otto
Düsseldorf, Germany
* 1928 Laasphe
1959, 1960, 1962, 1963, 1966 Galerie Schmela,
Düsseldorf
1962 Museum Leverkusen
1963 Galleria Cadario, Milan
1965 Howard Wise Gallery, New York
1967 Museum Dortmund

Pignon, Edouard
Paris, France
* 1905 Marles-les-Mines

Pijuan, Juan Hernandez
Barcelona, Spain
* 1931 Barcelona

Pinkerton, Clayton
Richmond, Calif., USA
* 1931 San Francisco

Piper, Gudrun
Hamburg, Germany
* 1917 Kobe, Japan

Pistoletto, Michelangelo **38, 58, 71, 146**
Turin, Italy
* 1933 Biella
1960, 1963 Galleria Galatea, Turin
1964 Galerie Ileana Sonnabend, Paris
1964, 1966 Galleria del Leone, Venice
1966 Walker Art Center, Minneapolis
1966 Galleria Sperone, Turin
1967 Galleria Naviglio, Milan
1967 Kornblee Gallery, New York
1968 Biennale di Venezia

Piza, Arthur Luis
Paris, France
* 1928 Saõ Paulo

Pizzo, Pia
Milan, Italy
* 1937 Palermo, Italy
1964, 1967 Galerie Suzanne Bollag, Zürich
1964 Galerie Tao, Vienna

Planell, Carlos
Barcelona, Spain
* Spain

Platschek, Hans
Munich, Germany
* 1923 Berlin

Plessi, Fabrizio
Venice, Italy
* 1940 Reggio Emilia
1965 Galleria Il Punto, Turin

Plumb, John
London, England
* 1927 Luton

Polesello, Rogelio **291**
Buenos Aires, Argentina
* Buenos Aires

Poliakoff, Serge
Paris, France
* 1906 Moscow, USSR

Polke, Sigmar
Düsseldorf, Germany
* 1941 Oels

Pollock, Jackson **5**
* 1912 Cody, USA
† 1956 East Hampton

Poons, Larry **275, 276**
New York, USA
* 1937 Tokyo
1963, 1965 Green Gallery, New York
1964 Ferus Gallery, Los Angeles
1964/1965 Sidney Janis Gallery, New York
1968 documenta Kassel

Porter, Fairfield
Long Island, USA
* 1907 Winnetka, Ill.
1953–1966 Tibor de Nagy Gallery, New York
1966 Cleveland Museum of Art

Poth, Uwe
Hamburg, Germany
* 1946 Kiel
1968 Galerie Richter, Wiesbaden

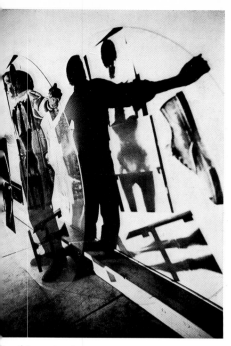

bert Rauschenberg

rtial Raysse

Pozzati, Concetto
Bologna, Italy
* 1935 Padova

Pozzi, Lucio
Milan, Italy
* 1936 Milan
1962 Galleria Trastevere, Roma

Prachensky, Markus
Vienna, Austria
* Austria

Prampolino, Enrico
Rome, Italy
* 1894 Modena

Prassinos, Mario
Paris, France
* 1914 Konstantinopolis

Pregelj, Marij
Ljubljana, Yugoslavia
* 1913 Kranj

Proctor, Patrick
London, England
* England

Protic, B. Miodrag
Belgrade, Yugoslavia
* 1922 Vrnjacka Banja

Quaitman, Harvey
New York, USA
* 1937 New York
1966 Royal Marks Gallery, New York

Quennell, Nicholas **57**
Los Angeles, USA
* USA
1965 Dwan Gallery, Los Angeles

Quentin,
Paris, France
* Paris

Quinte, Lothar **XXI**
Karlsruhe, Germany
* 1923 Neisse

Radovic, Zoran
Belgrade, Yugoslavia
*1940 Kraljevo

Radziwill, Franz
Dangast, Germany
* 1895 Strohausen

Raetz, Markus
Berne, Switzerland
* 1941 Berne

Raffaele, Joe **136**
New York, USA
* 1933 Brooklyn
1965, 1966, 1969 Stable Gallery, New York

Rainer, Arnulf **XXXIII**
Vienna, Austria
* 1929 Baden
1955, 1958, 1960, 1963, 1964 Galerie St. Stephan,
Vienna
1968 Galerie Steinbacher Hof, Frankfurt

Ramella, Giorgio
Turin, Italy
* 1939 Turin

Ramos, Mel **43, 87**
Sacramento, Calif., USA
* 1935 Sacramento

Rancillac, Bernard
Paris, France
* 1931 Paris
1966 Zoom I, Galerie Blumenthal, Paris
1967 Galerie Blumenthal-Mommaton, Paris

Rattner, Abraham
New York, USA
* 1895 Poughkeepsie, N. Y.

Rauschenberg, Robert **7, 110, 116, 117, 297, 312, I**
New York, USA
* 1925 Port Arthur, Texas
1951 Betty Parsons Gallery, New York
1953 Stable Gallery, New York
1958, 1959, 1960, 1961, 1963 Leo Castelli Gallery,
New York
1963 Jewish Museum, New York
1963, 1965 Galerie Ileana Sonnabend, Paris
1964 Whitechapel Art Gallery, London
1965 Walker Art Center, Minneapolis
1966 Biennale di Venezia

Ravotti, Berto **150, 151, 152**
Cuneo, Italy
* 1924 Mondovi
1966 Galleria Vismara, Milan

Ray, Man
Paris, France
* 1890 Philadelphia
1964 Galleria Schwarz, Milan

Raynaud, Jean-Pierre
Paris, France
* 1939 Bar-le-Duc
1965 Biennale, Paris
1968 Galerie Mathias Fels, Paris

Raysse, Martial **22, 34, 79, 82, 106, 148, 213, 239**
Nice, France
* 1936 Golfe Juan
1961 Galleria Schwarz, Milan
1962 Galerie Schmela, Düsseldorf
1962, 1964 Alexander Iolas Gallery, New York
1963, 1964, 1967 Dwan Gallery, Los Angeles
1965 Stedelijk Museum, Amsterdam
1966 Biennale di Venezia
1968 Museum of Contemporary Art, Chicago
1968 documenta, Kassel

Rebeyrolle, Paul
Paris, France
* 1926 Eymoutiers

Recalcati, Antonio
Milan, Italy
* 1938 Bresso
1958 Galleria Pater, Milan
1962 Galerie Smith, Brussels
1962 Galleria Naviglio, Milan

Reichek Jesse
Berkeley, Calif., USA
* 1916 Brooklyn
1958–1966 Betty Parsons Gallery, New York
1967 University of Southern California,
Los Angeles

Reichert, Josua
Munich, Germany
* 1937 Stuttgart
1966 Stedelijk Museum, Amsterdam
1968 Galerie Buchholz, Munich

Reigl, Judit
Paris, France
* 1923 Kapuvar, Hungary

Reindel
Oberflockenbach, Germany
* 1935 Mannheim
1968 Galerie Loehr, Frankfurt

Reinhardt, Ad **314**
* 1913 Buffalo
† 1967 New York
1947–1960 Betty Parsons Gallery, New York
1961 Museum Leverkusen
1961, 1964 Dwan Gallery, Los Angeles
1964 I.C.A., London
1965 Stable Gallery, New York
1966 Jewish Musem, New York
1968 documenta, Kassel

Rejlander, Oscar **21**
* 1813
† 1875

Remington, Deborah
New York, USA
* 1930 Haddonsfield, N.J.
1962, 1963, 1965 Dilexi Gallery, San Francisco

Renger-Patzsch, Albert
* 1897 Würzburg
† Germany
1928 "Die Welt ist schön"

Resnik, Milton
New York, USA
* 1917 USSR

Revilla, Carlos **362, 363**
Rome, Italy
* 1940 Arequipa, Peru
1968 Biennale di Venezia

Revol, Jean
Paris, France
* 1929 Lyon

Reyes, Emma
Paris, France
* Bogotà
1966 Galerie de Beaune, Paris

Richenburg, Robert
Ithaca, N.Y., USA
* 1917 Boston
1960 Dwan Gallery, Los Angeles
1959–1964 Tibor de Nagy Gallery, New York

Richter, Gerhard **37, 145, 237, 251, 252, 253, 267**
Düsseldorf, Germany
* 1932 Waltersdorf
1964, 1966, 1967 Galerie Friedrich, Munich
1964 Galerie Schmela, Düsseldorf
1964, 1967 Galerie Block, Berlin
1966 Galleria La Tartaruga, Rome
1966 Galleria del Leone, Venice
1968 Galerie Ricke, Kassel
1968 Kunsthalle Baden-Baden

Richter, Hans
Locarno, Switzerland
* 1888 Berlin

Richter, Heinrich
Berlin, Germany
* 1920 Poland

Riley, Bridget **284, 285**
London, England
* 1931 London
1962, 1963 Gallery One, London
1965, 1966, 1967 Richard Feigen Gallery, New York
1966 Robert Fraser Gallery, London
1968 Biennale di Venezia

Riopelle, Jean-Paul
Paris, France
* 1923 Montreal
1963 Pierre Matisse Gallery, New York

Ris, Günter Ferdinand
Oberpleis, Germany
* 1928 Leverkusen
1955 Museum Leverkusen
1966 Biennale di Venezia

Ritter, Hans-Rolf
Mainz, Germany
* 1942 Neuwied

Rivera, Diego
Mexico
* 1886 Guanajuato

Rivera, Manuel
Madrid, Spain
* 1927 Granada

Rivers, Larry **134, 174**
New York, USA
* 1923 New York
1951–1962 Tibor de Nagy Gallery, New York
1961, 1963 Dwan Gallery, Los Angeles
1964 Gimpel Fils Gallery, London
1965 Jewish Museum, New York

Rodriguez-Larrain, Emilio
Milan, Italy
* 1928 Lima, Peru

Rodschenko, Alexander
* 1891 Leningrad
† 1956 Moscow

Roehr, Peter **392**
* 1944 Lauenburg
† 1968 Frankfurt
1967 Galerie Dorothea Loehr, Frankfurt
1967 Adam Seide, Frankfurt

Ad Reinhardt

Gerhard Richter

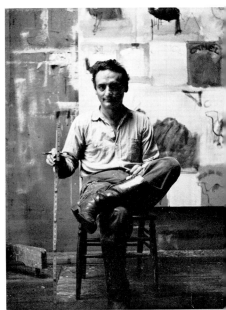
Larry Rivers

...ward Ruscha

Rosenquist, James **39, 102, 187, 188, 189, 217, 243, 257, 266**
New York, USA
*1933 Grand Forks, North Dakota
1962, 1963, 1964 Green Gallery, New York
1964 Galerie Ileana Sonnabend, Paris
1965, 1966 Leo Castelli Gallery, New York
1964 Dwan Gallery, Los Angeles
1966 Stedelijk Museum, Amsterdam
1966 Museum Stockholm

Rosny, Marc de
Paris, France
* 1938 Boulogne-sur-Mer

Rot, Diter
Düsseldorf, Germany
* 1930 Hanover
1968 documenta, Kassel

Rotella, Mimmo
Rome, Italy
*1918 Cantanzaro
1959–1961 Galleria La Salita, Rome
1962 Galerie J, Paris
1965 Galleria La Tartaruga, Rome
1966 Galleria Naviglio, Milan
1967 Galerie 20, Amsterdam

Rothko, Marc **320**
New York, USA
* 1903 Dwinsk, USSR
1946–1951 Betty Parsons Gallery, New York
1948, 1958 Biennale di Venezia
1961 Museum of Modern Art, New York

Rouault, Georges
* 1871 Paris
† 1958 Paris

Ruben, Richard
New York, USA
* 1924 Los Angeles

Rubino, Giovanni
Ischia, Italy
* 1938 Naples

Ruda, Edwin
New York, USA
* 1922 New York

Rudge, John
Rome, Italy
* 1925 Northampton
1962, 1964 Galleria George Lester, Rome

Ruehm, Gerhard
Berlin, Germany
* 1939 Vienna

Ruffi, Gianni **171**
Florence, Italy
* 1938 Florence
1966 Galleria la Salita, Rome

Rumney, Ralph
Paris, France
* England
1960 Monochrome Malerei, Museum Leverkusen

Ruscha, Edward **240, 373**
Los Angeles
* 1937 Omaha, Nebraska
1963, 1964, 1965 Ferus Gallery, Los Angeles

Russolo, Luigi
* 1885 Portogruaro, Italy
† 1947 Cerro di Laveno

Ruthenbeck, Reiner
Düsseldorf, Germany
* 1937 Velbert
1968 Galerie Fischer, Düsseldorf

Ryman, Robert
New York, USA
* 1930 Nashville, Tennessee
1968 Galerie Fischer, Düsseldorf

Saliola, Antonio
Bologna, Italy
* 1939 Bologna

Samaras, Lucas
New York, USA
* 1936 Kastoria, Greece
1967 Pace Gallery, New York
1968 documenta, Kassel

Samona, Mario
Rome, Italy
* 1925 Palermo
1962 Galleria Trastevere, Rome

Sander, Ludwig
New York, USA
* 1906 New York
1959, 1961 Leo Castelli Gallery, New York
1962, 1964, 1965 Kootz Gallery, New York
1967 A.M.Sachs Gallery, New York

Sanejouand, Jean Michel
Paris, France
* 1934 Lyon
1968 Galerie Yvon Lambert, Paris

Sanfilippo, Antonio
Rome, Italy
* 1923 Palermo

Santomaso, Giuseppe
Venice, Italy
* 1907 Venice

Santoro, Pasquale
Rome, Italy
* 1933 Ferrandina

Sarkis
Paris, France
* 1938 Istanbul

Saul, Peter
Paris, France
* 1934 San Francisco
1961, 1962 Allan Frumkin Gallery, New York
1963 Galleria La Tartaruga, Rome
1964 Galerie Breteau, Paris

Saura, Antonio
Paris, France
* 1930 Huesca, Spain

Savio

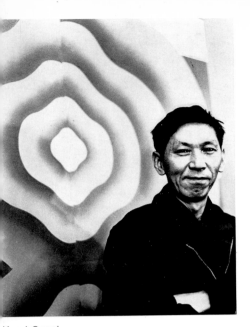

Kumi Sugai

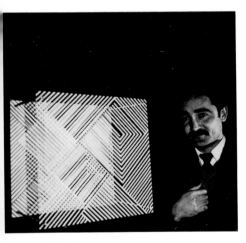

Jesus Rafael Soto

Harold Stevenson

Smith, Vic
Westminster, Calif., USA
* 1929 Grands Islands, Nebraska

Snow, V. Douglas
Salt Lake City, USA
* 1927 Salt Lake City
1952 Santa Barbara Museum of Art

Snyder, Don
New York, USA
* USA

Soldati, Atanasio
* 1896 Parma, Italy
† 1953 Milan

Sonderborg, K.R.H.
Paris, France
* 1923 Sonderborg, Denmark

Sordini, Ettore
Milan, Italy
* 1934 Milan

Sorge, Peter
Berlin, Germany
* 1937 Berlin
1964 Galerie Grossgörschen, Berlin

Soto, Jesus Rafael **349, 350, XXVIII**
Paris, France
* 1923 Ciudad Bolivar, Venezuela
1956, 1967 Galerie Denise René, Paris
1957, 1961 Museum Caracas
1963 Museum Haus Lange, Krefeld
1965 Signals Gallery, London
1966 Biennale di Venezia
1967 Expo, Montreal
1968 Kunsthalle Berne

Soulages, Pierre
Paris, France
* 1919 Rodez

Southall, Derek
Birmingham, England
* 1930 England
1965 Rowan Gallery, London

Soutine, Chaim
* 1894 Minsk, USSR
† 1943 Paris

Spazzapan, Luigi
Turin, Italy
* 1890 Gradisca

Spesshardt, Hans-J.
Berlin, Germany
* 1935 Berlin
1966, 1967 Galerie Orez, The Hague
1968 Galerie Hake, Cologne

Speyer, Nora
New York, USA
* 1923 Pittsburgh

Spoerri, Daniel
Paris, France
* 1930 Galatz, Romania

Stadler, Albert
New York, USA
* 1923 New York
1962 Bennington College, Vermont

Stael, Nicolas de
* 1914 Leningrad
† 1955 Antibes

Stämpfli, Peter **256, XI**
Paris, France
* 1937 Deisswil, Switzerland
1966 Galerie Bischofsberger, Zürich
1967 Galerie Tobiès und Silex, Cologne
1968 Instituto Torcuato Di Tella, Buenos Aires

Stamos, Theodoros
New York, USA
* 1922 New York

Stanczak **282**
New York, USA
* USA

Stanley, Robert **91**
New York, USA
* 1932 Yonkers, N.Y.
1965, 1966 Bianchini Gallery, New York

Staudt, Klaus
Offenbach, Germany
* 1932 Otterndorf

Stazewsky, Henryk
Warsaw, Poland
* 1894 Lvov
1965, 1966 Kazimir Gallery, Chicago
1966 Biennale di Venezia

Stefanelli, Joseph
New York, USA
* 1920 Philadelphia

Steichen, Edward
New York, USA
* 1879 Luxemburg

Steinberg, Saul
New York, USA
* 1914 Romania

Steiner, Klaus-Michel
Berlin, Germany
* 1940 Allenstein

Steiner, Michael
New York, USA
* 1930 USA

Steinert, Otto **62, 141, 215**
Essen, Germany
* 1915 Saarbrücken
1952 "Subjektive Fotografie"
1955 "Subjektive Fotografie 2"

Stella, Frank **286, 287, 288, XXIII**
New York, USA
* 1936 Malden, Mass.
1960, 1962, 1964, 1966 Leo Castelli Gallery, New York
1961, 1964 Galerie Lawrence, Paris
1963, 1965 Ferus Gallery, Los Angeles
1964 Kasmin Gallery, London
1967 Galerie Bischofsberger, Zürich
1968 documenta, Kassel

toni Tapies

yne Thiebaud

Verheyen

Thieler, Fred
Berlin, Germany
* 1916 Königsberg
1958 Biennale di Venezia
1959, 1964 documenta, Kassel
1968 Kunstsammlungen Bonn

Thomkins, André
Essen, Germany
* 1930 Lucerne, Switzerland
1967 Studio Villingen

Thompson, Bob
* 1927 Louisville, Kentucky
† 1966 Rome
1963, 1965, 1968 Martha Jackson Gallery,
New York
1964, 1965 Richard Gray Gallery, Chicago

Thorn, Erwin
Vienna, Austria
* 1930 Vienna

Tillim, Sidney
New York, USA
* 1925 Brooklyn
1969 Noah Goldowsky Gallery, New York

Tilson, Joe **108, 109, 137**
London, England
* 1928 London
1962, 1964, 1966 Marlborough Gallery, London
1967 Marlborough Galleria, Rome

Ting, Walasse
New York, USA
* 1929 Shanghai

Tinguely, Jean **18**
Paris, France
* 1925 Basle
1965 Jewish Museum, New York
1966 Gimpel u. Hanover Galerie, Zürich
1967 Alexander Iolas Galerie, Paris

Tirr, Willy
Leeds, England
* 1915 Germany
1967 Grabowski Gallery, London

Tisserand
Paris, France
* 1934 Besançon

Tobey, Marc
Seattle, Washington, USA
* 1890 Centerville

Toma, Tadako
Osaka, Japan
* 1922 Japan

Tomasello, Luis
Paris, France
* 1915 Argentina

Tomlin, Bradley Walker
New York, USA
* 1899 Syracuse, N. Y.

Trier, Hann
Berlin, Germany
* 1915 Düsseldorf

Trökes, Heinz
Ibiza, Spain
* 1913 Hamborn, Germany

Trova, Ernest **159**
St. Louis, Mo., USA
* 1927 St. Louis
1963, 1965, 1967, 1969 Pace Gallery, New York
1964, 1966 Hanover Gallery, London
1967 Loretto-Hilton Gallery, Webster Groves, Mo.

Tschakalian, Sam
San Francisco, USA
* 1929 Shanghai

Turcato, Giulio
Rome, Italy
* 1912 Mantova

Turnbull, William **340**
London, England
* 1922 Dundee
1950, 1952 Hanover Gallery, London
1952 Biennale di Venezia
1957 I.C.A., London
1957 Biennale Saõ Paulo
1960 Molton Gallery, London
1963 Marlborough Gerson Gallery, New York
1968 documenta, Kassel

Turrell, James
Santa Monica, Calif., USA
* 1943 Los Angeles

Tvorkov, Jack
New York, USA
* 1900 Biala, Poland

Twombly, Cy
Rome, Italy
* 1929 Lexington

Ubac, Raoul
Paris, France
* 1910 Malmédy

Uecker, Günther
Düsseldorf, Germany
* 1930 Mecklenburg
1958, 1959 Galleria Azimuth, Milan
1960, 1961, 1963, 1966 Galerie Schmela,
Düsseldorf
1964, 1966 Howard Wise Gallery, New York
1964, 1968 documenta, Kassel

Uncini, Giuseppe
Rome, Italy
* 1929 Fabriano
1961 Galleria L'Attico, Rome

Unsworth, Peter
Greece
* 1937 Durham, England
1963, 1965, 1967 Piccadilly Gallery, London

Urhausen, Romain
Germany
* 1930 Rumelange, Luxemburg

Ursula
Frankfurt, Germany
* 1921 Mittenwald
1964 Museum Wiesbaden

Usami, Keiji
New York, USA
* 1940 Tokyo
1963, 1965, 1968 Minami Gallery, Tokyo
1969 Jewish Museum, New York

Utrillo, Maurice
* 1883 Paris, † 1955 Dax

Vacchi, Sergio
Rome, Italy
* 1925 Bologna
1966 Galleria La Medusa, Rome

Vanarsky, Jack
Paris, France
* 1936 General Roca, Argentina
1965 Biennale Paris

Vandenbranden, Guy
Antwerp, Belgium
* 1926 Brussels
1959/1960 Galleria Pater, Milan
1961 Galerie Orez, The Hague
1964 Galerie Müller, Stuttgart

Vardanega, Gregorio
Paris, France
* 1923 Passagno
1967 Galerie M. E. Thelen, Essen

Varisco, Grazia
Milan, Italy
* 1937 Milan

Vasarely, Victor **271, 272, XVIII**
Annet-sur-Marne, France
* 1908 Pecs, Hungary
1944, 1946–1957, 1959–1966 Denise René, Paris
1949 Betty Parsons Gallery, New York
1962, 1964 Gimpel und Hanover Galerie, Zürich
1964, 1966, 1968 documenta, Kassel
1968 Sidney Janis Gallery, New York

Vasiri, Mohsen
Teheran, Iran
* 1924 Teheran

Vaughan, Michael
London, England
* 1938 Shipley, Yorkshire
1968 New British Painting and Sculpture,
University of California, Los Angeles

Vaux, Marc
London, England
* 1932 Swindon

Vedova, Emilio
Venice, Italy
* 1919 Venice

Vega, Jorge de la
Buenos Aires, Argentina
* 1930 Buenos Aires

Velde, Bram van
Paris, France
* 1895 Holland
1958 Kunsthalle Berne

Velde, Ger van
Paris, France
* Holland

Verheyen, Jef **XXVII**
Antwerp, Belgium
* 1932 Itegem
1961 Museum Leverkusen
1961 Biennale Paris

Verlon (Willy Verkauf)
Paris, France
* 1917 Zürich

Verstockt, Mark
Antwerp, Belgium
* 1930 Lokeren
1959, 1960 Galleria Pater, Milan
1961, 1966 Galerie Orez, The Hague

Vicente, Esteban
New York, USA
* 1906 Segovia, Spain

Vices Vinci, Kiky
Genoa, Italy
* Naples
1966 Galleria del Deposito, Genoa
1964, 1966 Galerie Objekt, Zürich

Vieira da Silva, Maria Elena
Paris, France
* 1908 Lisbon

Vigo, Nanda
Milan, Italy
* 1936 Milan

Vilander, Ico
Berlin, Germany
* Germany
1966 "Akt apart"

Villeglé, Jacques de la
Paris, France
* 1927 Quimper
1963 Galerie j, Paris

Viseux
Paris, France
* 1927 Champagne-sur-Oise
1966 Galerie D. Bernador, Geneva

Viviano, Giuseppe
Pisa, Italy
* 1899 Aguano

Volpini, Renato
Milan, Italy
* 1934 Urbino
1966 Galleria del Cavallino, Venice

Vorberg, Hans-Peter
Germany
* 1930 Radevormwald

Vordemberge-Gildewart
* 1899 Osnabrück
† 1962 Ulm

Voss, Jan
Paris, France
* 1936 Hamburg
1966, 1969 Galerie Mathias Fels, Paris
1967 Galleria del Naviglio, Milan

Vries, Herman de
Arnhem, Holland
* 1931 Alkmaar

Wagemaker, Jaap
Amsterdam, Holland
* 1906 Haarlem

Walker John
London, England
* 1939 Birmingham
1967 Axiom Gallery, London
1967/1968 Galerie Ricke, Kassel

Warhol, Andy **53, 61, 70, 89, 94, 95, 105, 167, 1**
173, 195, 196, 210, 263, 264, 265, VII, VIII
New York, USA
* 1930 Philadelphia
1962, 1963 Ferus Gallery, Los Angeles
1962, 1964 Stable Gallery, New York
1964, 1966 Leo Castelli Gallery, New York
1964, 1965, 1967 Galerie Ileana Sonnabend, Paris
1965 Galleria Sperone, Turin
1966 Galerie M. E. Thelen, Essen
1966 I.C.A., Boston
1968 Museum Stockholm
1968 documenta, Kassel

Watts, Robert **378, 383**
Lebanon, N.J., USA
* 1929 Burlington, Iowa
1966 Bianchini Gallery, New York
1967 Galerie Ricke, Kassel

Weber, Idelle
Los Angeles, USA
* 1932 Chicago

Weber, Willy
Berne, Switzerland
* 1933 Berne

Wechter, Vivienne
New York, USA
* New York

Weege (Arthur Fellig)
New York, USA
* 1900 Austria
1945 "Naked City"
1950 "Naked Hollywood"

Weeks, James
San Francisco, USA
* 1922 Oakland
1967 Felix Landau Gallery, Los Angeles

Weh, Renate
Nuremberg, Germany
* 1938 Augsburg

Wehberg, Hinnerk
Hamburg, Germany
* 1936 Osnabrück

Weiss, Hugh
Paris, France
* 1925 Philadelphia

Wells, Mason
San Francisco, USA
* New England
1963 Quay Gallery, Tiburon

204

n Wesley

n Wesselman

Wendt, Willi
Paris, France
* 1909 Berlin

Werro, Roland
Berne, Switzerland
* 1926 Berne

Wesley, John **42, 44**
New York, USA
* 1928 Los Angeles
1963, 1964 Robert Elkon Gallery, New York

Wesselman, Tom **32, 36, 138, 190, 242, III**
New York, USA
* 1931 Cincinnati, Ohio
1962, 1964, 1965 Green Gallery, New York
1965 Sidney Janis Gallery, New York
1966 Galerie Ileana Sonnabend, Paris
1968 Galerie Thomas, Munich

Wessels, Glenn
Berkeley, Calif., USA
* 1895 Capetown

Weston, Edward
San Francisco, USA
* 1911 Los Angeles

Whiteley, Brett **170, 262**
London, England
* 1939 Sydney
1962 Matthiesen Gallery, London
1964, 1967 New London Gallery, London
1966 The Australian Gallery, Melbourne
1968 Marlborough Gerson Gallery, New York

Whitman, Robert **52**
New York, USA
* 1935 USA
1968 Museum of Contemporary Art, Chicago

Wiegand, Charmion von
New York, USA
* Chicago
1965 Howard Wise Gallery, New York

Wiegert, Nelson
Munich, Germany
* 1940 Tuparendi, Brazil
1967 Galerie Buchholz, Munich

Wight, Frederick
Los Angeles, Mo., USA
* 1902 New York
1968 Ankrum Gallery, Los Angeles

Wilding, Ludwig
Hamburg, Germany
* 1927 Grünstadt
1968 Galerie Zwart, Amsterdam

Wiley, William T.
Mills Valley, Calif., USA
* 1937 Bedford, Indiana

Wilkerson, Jerry O.
St. Louis, Mo., USA
* USA
1968 McMurray College, Jacksonville, Ill.

Willenbecher, John
New York, USA
* 1936 Macungie, Pa.

Williams, Emmett
New York, USA
* 1925 Greenville

Williams, Hiram
Gainesville, Florida, USA
* 1917 Indianapolis

Winter, Fritz
Diessen, Germany
* 1905 Altenbögge

Wintersberger, Lambert Maria
Berlin, Germany
* 1941 Munich
1966 Galerie Tobiès und Silex, Cologne
1967 Galerie Niepel, Düsseldorf
1969 Galerie Müller, Stuttgart

Woelfer, Emerson
Los Angeles, USA
* 1914 Chicago
1958, 1959, 1961 Poindexter Gallery, New York
1961, 1963 David Stuart Gallery, Los Angeles

Wolf, Arne
Los Angeles, USA
* 1929 Frankfurt
1966 Galerie Niepel, Düsseldorf

Wols (Wolfgang Schulze)
* 1913 Berlin
† 1951 Paris
1968 Galerie van de Loo, Munich

Wonner, Paul
Malibu, Calif., USA
* 1920 Tucson, Arizona

Wunderlich, Paul
Hamburg, Germany
* 1927 Berlin
1962, 1966 Galerie Brusberg, Hanover
1966 Museum Bochum

Wyeth, Andrew
Chadds Ford, Pa., USA
* 1917 Chadds Ford

Yalkut, Jud
New York, USA
* USA

Yamasaki, Tsuruku **406**
Osaka, Japan
* Japan

Yamashiro, Ryuichi
Tokyo, Japan
* 1920 Osaka

Yamashita, Noboru
New York, USA
* 1929 Kofu, Japan
1961, 1963, 1965, 1966, 1968 Mi Chou Gallery,
New York
1963 Henry Gallery, Washington, D.C.
1966 Kiko Gallery, Houston

Yang, Yu-Kun
Berlin, Germany
* 1943 Hupeh/China

Yasuda, Robert
New York, USA
* 1940 Hawaii

Yektai, Manoucher
New York, USA
* 1922 Teheran

Yokoi, Teruko
* 1924 Nagoya, Japan
1961 Minami Gallery, Tokyo
1964 Kunsthalle Basle
1967 Galerie Bernard, Solothurn

Yoshihara, Jiro
Osaka, Japan
* 1904 Osaka

Yoshioka, Yasuhiro **46, 47**
Tokyo, Japan
* 1936 Japan

Youngerman, Jack
New York, USA
* 1926 Louisville, Kentucky
1959 Museum of Modern Art, New York
1963 Galleria dell'Ariete, Milan

Yrarrázaval, Ricardo
Santiago, Chile
* 1931 Santiago

Yrissary, Mario
New York, USA
* 1933 Manila
1969 Leo Castelli Gallery, New York

Yturralde, José Maria
Valencia Spain
* 1942 Cuenca
1967 Galeria Edurne, Madrid

Yunkers, Adja
New York, USA
* 1900 Riga, USSR

Yvaral **271**
Lagny, France
* 1934 Paris
1966 Howard Wise Gallery, New York
1966 Op-Art Galerie, Esslingen
1966 Galerie Ricke, Kassel
1966 Karl Ernst Osthaus Museum, Hagen

Zajac, Jack
Los Angeles, USA
* 1929 Youngstown, Ohio
1951–1967 Felix Landau Gallery, Los Angeles
1968 Landau-Alan Gallery, New York

Zakanych, Robert
New York, USA
* 1935 Elizabeth, N.Y.

Zamecznik, Juliusz Wojciech
Warsaw, Poland
* 1929 Warsaw

Zamecznik, Stanislav
Warsaw, Poland
* 1909 Warsaw

Zao Wou-Ki
Paris, France
* 1920 Peking

Zappettini, Gianfranco
Genoa, Italy
* 1939 Genoa
1967 Galleria Vismara, Genoa

Zehringer, Walter
Munich, Germany
* 1940 Memmingen

Zekveld, Jacob
Rotterdam, Holland
* 1945 Rotterdam
1965, 1966, 1967 Galerie Delta, Rotterdam
1966 Galerie 20, Amsterdam

Zimmerman, Catherine
Boston, USA
* 1939 Baton Rouge, La.
1968 Eleanor Rigelhaupt Gallery, Boston

Zimmermann, Max
Munich, Germany
* 1912 Stettin

Zimmermann, Tom
New Hope, Pa., USA
* 1938 Brooklyn

Zobel, Fernando
Madrid, Spain
* 1924 Manila
1965 Bertha Schaefer Gallery, New York

Zucker, Joseph
Chicago, USA
* 1941 Chicago
1967 Adele Rosenberg Gallery, Chicago
1967 Dayton's Gallery, Minneapolis

Acknowledgements

e following museums, galleries and collections
ve kindly provided photographs:

. Harry N. Abrams, New York 72 – John Adams,
mbridge, Ms. 113 – Avant Art Galerie Casa,
unich 51 – Attilio Bacchi, Milan 40 – Stanley
rt 174 – Studio 2B, Bergamo 293, 341 – Bianchini
llery, New York 43, 87, 379 – Bildarchiv der öster-
chischen Nationalbibliothek 163 – Galerie Bi-
ofsberger, Zürich 32, 158, 192, 397 – 180 Blacon
rporation 76 – Bonino Gallery, New York 35, 164,
– Galerie Brusberg, Hanover 109 – Camera
ss, London 369 – Gertrude Castle, Detroit, Mi-
gan 247 – Leo Castelli Gallery, New York 10, 39,
70, 89, 105, 116, 165, 166, 172, 173, 187, 220, 221,
, 234, 243, 257, 266, 276, 287, 288, 297, 323, 324,
, 361, 369, 387, 388 – City Art Museum of St. Louis,
. 85, 319 – Mr. & Mrs. William N. Copley, New
rk 41, 166 – Cordier & Eckstrom Gallery, New
rk 184 – Dwan Gallery, Los Angeles 20, 22, 57, 82,
, 134, 188, 198, 213, 216, 314, 327, 343, 373 – Jean
prennes, Brussels 90 – Robert Elkon Gallery,
w York 42 – Andre Emmerich Gallery, New York
– Richard Feigen Gallery, New York 63, 80, 160,
, 258, 285, 334, 335, 336 – Fischbach Gallery, New
rk 60, 73, 130, 211, 219, 315, 337, 338, 339, 355 –
g Art Museum, Cambridge, Ms. 19 – Robert
ser Gallery, London 68, 90, 93, 200 – Galerie Frie-
ch, Munich 237 – Allan Frumkin Gallery, New
rk 28 – Gemeente Musea van Amsterdam 79 –
en Gallery, New York 190, 242 – Grey Gallery,
icago 308 – Hanford-Yang, New York 212 – Insti-
e of Contemporary Arts, London 121, 182, 208 –
titute of Contemporary Arts, Boston 146, 241, 244,
, 356, 382 – Alexander Iolas Gallery, New York
, 374 – Galerie Iolas, Paris 110, 183, 185, 239 –
ney Janis Gallery, New York 84, 98, 99, 138, 149,
, 359, 360, 372 – Edwin Janus jr., California 23 –
e Jewish Museum 74 – Miss Francis Keech, New
rk 98 – Collection Knopka, New York 107 – Al-
ght Knox Art Gallery, Buffalo, NY. 11, 195, 275,
, 318 – Kornblee Gallery, New York 38, 77, 175, 268,
– Sammlung Udo Kultermann, Leverkusen 8, 49,
, 309, 313, 347, 348 – Felix Landau Gallery, Los
geles 66, 120, 179 – C. Lamb, Basle 135, 271 –
s. Phyllis B. Lambert, Chicago 18 – Karl Laszlo,
sle 282 – Galleria del Leone 145 – Galerie van de
, Munich 36 – Los Angeles County Museum of
297 – Louvre, Paris 131 – Manzoni, Genoa 156 –
rlborough, London 2, 64, 65, 108, 137, 168, 260 –
rlborough-Gerson, New York 5, 142, 143, 170, 262,
, 349 – Measure Graph Company, St. Louis, Mo.
– James A. Michener Foundation Collection 249
ichon Gallery, New York 298 – Moderna Museet,
ckholm 194, 358 – Galerie Müller, Stuttgart 317 –
seum Basle 267 – Museum of Contemporary Art,
cago 31, 52 – Museum of Modern Art, New York
02, 385, 386 – Tibor de Nagy Gallery, New York
254 – Galleria del Naviglio, Milan 299 – Galerie
h Nohl, Siegen 227 – Galleria Notizie, Turin 15,
333 – Obelisk Gallery, Boston 113 – Öffentliche
nstsammlung, Basle 214 – Mr. & Mrs. John
Powers, New York 99 – Galleria "Il Punto", Tu-
180 – Galerie Denise René, Paris 272, 351, 359 –
e Art Museum Waltham, Ms. 97, 128, 136, 191,
223, 225, 226, 264, 371 – Rowan Gallery, London
– A. M. Sachs Gallery, New York 277, 372 –
erie Schmela, Düsseldorf 253 – Robert Schoel-
f Gallery, New York 26, 186 – Galleria Schwarz,
n 40, 111, 203 – Adam Seide, Frankfurt 393 –
cy Singer 154, 159, 283, 354 – Galerie Ileana

Sonnabend, Paris 37, 58, 71, 110, 117, 146, 167, 196,
217, 263, 368, 408 – Stable Gallery 259 – Sosland
Collection, Kansas City, Mo. 27, 186 – Galerie "Der
Spiegel", Cologne 306 – Christian Stein, Turin 333,
353 – Kollektion Otto Steinert, Essen 54, 215, 141,
157, 177 – Alan Stone Gallery, New York 104, 178,
228 – Karl Ströher 165 – Tate Gallery, London 118 –
Temple Gallery, London 14 – Galerie Thomas,
Munich 201 – Troost, Düsseldorf 81 – Folkwang-
schule, Essen 55 – Waddel Gallery, New York 181,
249 – Washington University Collection 261 – Samm-
lung Max Wassermann 219 – Withers Swan Public
Relations, New York 25 – Wide White Space Galle-
ry, Antwerp 381 – Galerie Zwirner, Cologne 205.

The following photographers and agencies have
kindly provided photographs:

Oliver Baker, New York 149, 258 – Branko Balik,
Zagreb 389 – Bernhard Becher 231, 232 – R. van den
Bempt, Antwerp 381 – R. Bonache, Madrid 142,
143 – Bressano 332 – Rudolf Burckhardt 7, 70, 73, 89,
105, 116, 130, 165, 174, 187, 190, 216, 221, 234, 242,
257, 266, 287, 288, 315, 368, 369, 387, 388 – Barney
Burstein 18, 76 – Enrico Cataneo, Milan 347 –
Clari, Milan 329 – Geoffrey Clements, New York 63,
80, 138, 160, 161, 184, 285, 322, 335, 336, 357, 358,
359, 360 – M. A. Comor, Rome 101 – Robert David,
Paris 353 – Augustin Dumage, Paris 4, 58 – Fasolo,
Venice 395 – Fotostudio 22, Milan 348 – Richard
Frank 280 – Gallery of Modern Art, New York 56 –
Giancolombo, Milan 328 – Piero Gilardi, Turin
400, 402 – H. Gloaguen, Paris 408 – Jürgen Graaf
294, 295, 296 – Sherwin Greenberg, Buffalo 275, 286,
318 – Günther Guben, Frankfurt 123, 124, 125 –
Guilka, Berlin 81 – N. & C. Heinrich, Stuttgart 281,
317, 325 – Peter A. July, New York 385, 386 – Gernot
Kayser, Berlin 274 – Peter Keetmann, Breitbronn
140 – Walter Klein, Düsseldorf 203, 205 – Leppert,
Munich 201 – Felix H. Man 55 – Peter Mögenburg,
Leverkusen 1 – Jacques Montagnac, Paris 71, 193 –
Odile Montserrat, Paris 409 – Peter Moore, New
York 35, 277 – André Morain, Paris 148, 153, 162, 217,
222, 365 – Lida Moser, New York 44 – O. E. Nelson,
New York 170, 262, 320, 349 – Eric Pollitzer, Garden
City Park, New Jersey 72, 77, 155, 175, 189, 212, 233,
259, 268, 289, 326, 334 – Piaget, St. Louis 261 –
Nathan Rabin, New York 28, 29, 113, 356 – Lilo
Reimond 247, 248, 255 – David von Riper 52 – Le
Roi, S. Robbins, St. Louis, Mo. 85 – Jan Sâgl, Prague
83 – Oscar Savio, Rome 69, 126, 127, 176, – John
D. Schiff, New York 24, 25, 26, 30, 75, 95, 147 –
Schunk-Kender, Paris 117, 196, 263, 399 – Sergysels
& Dietens, Brussels 350 – I. Serisawa, Los Angeles
314 – H. Stebler, Berne 256 – Bert Stern 59 – Frank
J. Thomas, Los Angeles 220, 240, 323, 324 – Abisag
Tüllmann 393 – John Webb, London 93, 390 – von
Werthern, Munich 36.

The following galleries and private individuals
have generously provided colour reproductions:

Valerio Adami, Narona VI – Mary Bauermeister,
New York XXXI – Galerie Bischofberger, Zürich X,
XXXII – Galerie Brusberg, Hanover XVIII – Editions
de la Connaissance, Brussels XXVI – Druck- und
Verlagsanstalt Kassel VII, VIII, XXII, XXIV – Eidge-

nössisches Departement des Inneren, Berne XI –
Laura Grisi, Rome IX – Pol Mara, Antwerp II – Jacques
Monory, Paris XII – Galerie Müller, Stuttgart XX,
XXI – Museum am Ostwall, Dortmund XXIX – Galleria
Notizie, Turin XVI, XXIII – Herbert Oehm, Ulm XVII
– Arnulf Rainer, Vienna XXXIII – Collezione privata
Rovagnasco di Segrate, Milan III – Stedelijk Mu-
seum Amsterdam XIII – Galerie Springer, Berlin
XXV – Kumi Sugai, Paris XIV – Galerie M. E. The-
len, Essen IV, XIX, XXIX – Frank M. Titelmann,
Altona, Pennsylvania I – Waddell Gallery, New
York IV – Jef Verheyen, Antwerp XXVII.